# Yve-Alain Bois
# An Oblique Autobiography

Yve-Alain Bois
An Oblique Autobiography

no place press

for Alexandre and Benjamin,
for Paul

Introduction
9

Angels with Guns (a memoir on Guy Brett [and David Medalla])
17

J.C. or the Critic (preface to Jean Clay's *Atopiques, de Manet à Ryman*)
79

An Encounter with Robert Klein
105

Taken Liberties (on *Charlie Hebdo*)
125

Ellsworth Kelly, In Memoriam
131

When Lacquer Screen Meets Blotting Paper (on Christophe Verfaille's painting)
139

Not [on] Diagrams (on Rosalind Krauss's "Sculpture in the Expanded Field")
149

Tough Love (on Hubert Damisch's seminar)
155

The Right Touch (on Jacques Derrida)
169

From Near as From Afar (on Fabrizio Perozzi's painting)
177

Some Latin Americans in Paris
187

Why Do Exhibitions?
209

Better Late than Never (on the collection of the Musée National d'Art Moderne)
223

The Pin (on Christian Bonnefoi's painting)
235

Incompletion (on Martin Barré's painting)
245

French Lib (on the daily newspaper *Libération*)
259

The Lesson of *i10*
267

Review of Angelica Rudenstine's *Peggy Guggenheim Collection, Venice*
281

Review of Rosalind Krauss's *The Originality of the Avant-Garde
and Other Modernist Myths*
293

Writer, Artisan, Narrator (on Roland Barthes)
303

The Sculptural Opaque (on Rosalind Krauss's *Passages in Modern Sculpture*)
315

Picabia: From Dada to Pétain
347

Appendix:
Review of Hubert Damisch's *L'origine de la perspective*
Review of Hubert Damisch's *Moves: Playing Chess and Cards with the Museum*
In Memoriam: Hubert Damisch (1928–2017)
An unpublished letter to *The New York Times*
361

Acknowledgments
373

# Introduction

The idea of this book came from a collection of fortuitous circumstances. The first and most important was the colloquium organized by Raine Daston and Alina Payne at the Villa i Tatti in January 2018, bearing the title, half English, half Latin, of "Scholarly Vitae." Over two days, speakers were invited to present an encounter (with a text, an object, a person) that had precipitated change in their work and perhaps even reoriented their scholarship. But in these talks so much contextual information was disclosed that, in effect, the whole symposium surpassed the initial remit and amounted to an extraordinary collection of intellectual comings of age. (My own intervention, a draft of what would become the first half of the essay "An Encounter with Robert Klein" included in this volume, was similar to others on that score.)

The second factor had to do with guilt over an unkept promise. For several years I procrastinated, delaying the delivery of a collection of essays on noncomposition in twentieth-century art that I had committed to publish with the University of Chicago Press. There was always something more urgent and pleasant to do than face the pain of having to reread my prose, and the project was abandoned several times. Having finally vowed to overcome my reluctance, I was sorting out which of my essays were worthy of being reprinted and under what specific rubric (since I was at it, why not another volume on Mondrian, or one on postwar American art, or on Matisse?). Through this process, I quickly realized that quite a few texts didn't fit into any of the categories around which I was imagining that I could structure a volume, and actually had nothing in common other than my own interests and development—sometimes directly so, when they had an explicit autobiographical component, but often also indirectly, as in the case of reviews of books that had been important to me. In short, texts that were, before anything else, markers of my own formation. Definitively not material for a traditional academic publication.

The third impetus was the entreaty of my friends at no place press, just as I was contemplating this pile of homeless essays, soliciting a book from me. This is when I began to conceive of the present volume as a kind of involuntary auto-biography, or an autobiography in disguise: a *Bildungsroman* entirely made up of pieces I had previously published and inconspicuously testifying to the role played by others (their texts or works of art) in the constitution of one's identity. Having adopted this device—to approach the autobiography genre obliquely—

I dug deeper into my archives and found more grist for the mill, while at the same time discovering, no doubt helped by the egotistic or narcissistic nature of this particular exercise, that rereading myself was not as distressing as I had always imagined (in passing, I should note that it has been this exercise that has finally prompted me to revisit my work on noncomposition and to begin addressing the outstanding debt mentioned above). An unexpected reward of perusing the entrails of my computer was to come across short pieces I had long forgotten but that offer vistas into my "scholarly vitae" even though there is nothing scholarly about them: I decided not to censure but to welcome the heterogeneity they would impart to my selection.

Two problems emerged at once. First, given its parameters, the volume I had in mind could never be labeled an autobiography proper, since there were many important moments or turning points in my professional life about which I had not published anything. Nothing gathered here reflects in any meaningful way, for example, the cultural shock that moving from France to the US represented, nor the eight years I spent at Johns Hopkins, during which I had many fruitful discussions with colleagues such as Werner Hamacher, Herbert Kessler, and particularly Michael Fried—who had brought me to America (a redoubtable debater who spurred me to refine my argumentative chops).[1] Similarly, there is nothing here, following that, about my time at Harvard and then at the Institute for Advanced Study in Princeton, nor covering my traveling for years all around the US and to many countries in order to inspect every single painting of Barnett Newman with the conservator Carol Mancusi-Ungaro, from whom I learned so much concerning pictorial techniques. Yet another example: Except for the essays concerning Rosalind Krauss's work, nothing, in the texts reprinted here, attests to the camaraderie that linked me for decades with my fellow editors of the journal *October,* particularly Benjamin Buchloh (to whom I like to refer as the friend with whom I like most to disagree) and Hal Foster—a camaraderie that resulted in the massive textbook the four of us produced under the dowdy publisher-enforced title of *Art Since 1900.*[2] (As the mention of this last publication indicates, whole books were the result of interaction with other scholars, and this is ever truer of exhibition catalogues—for example, that of the 1985 exhibition *De Stijl et l'architecture en France* that I co-curated with Bruno Reichlin at the Institut Français d'Architecture and for which I co-wrote a book-length essay with Nancy Troy. In a bona fide autobiography, the saga of curating or co-curating many exhibitions over the years would be told at length—it makes for good narrative.)

The second problem (implicit to the genre of "collected essays") was that of choice. From the start it was clear to me that this should not be an illustrated volume, which excluded several essays that would make little sense without an abundant accompanying iconography. At first, I had planned to include

many more of my early pieces but ultimately reasoned that they were frankly too jejune. I did manage to salvage several, but in those cases, it was a matter of active rescuing as much as simply reprinting: Most had been translated into English long ago, at a time when my own command of this language was so poor that I had been entirely unaware of numerous infelicities, not to say outright mistakes. As a general rule, however, I wanted to limit revisions to the bare minimum (updating references and adding a few contextualizing notes is the extent of it on balance), and I did exactly that throughout the book but for those early essays, feeling that I could not possibly republish them without some thorough dusting. Others of the same period were simply not retrievable: There was a good reason why their translation was so faulty, which is that the French original was execrable.

Only three texts were written after I had accepted the invitation from no place press. This is to say that although they were not written *for* this volume, they were written (consciously or not) with their future inclusion in mind. The first is the essay on Robert Klein, mentioned above, and the others concern the work of two of my oldest friends, Jean Clay, whom I met when I was fourteen years old (and with whom I would later edit the journal *Macula*), and Guy Brett, whom I had read just as early but met only when I was twenty-one or twenty-two. (The piece on Guy is a long eulogy that appeared in the journal *October* in place of the obituary I could not bring myself to pen; and the one on Jean is a preface to a collection of his essays.)

This last remark—that the tone and the tenor of these texts (especially those on Robert Klein and on Guy Brett) were unavoidably conditioned by the context of their future gathering in this volume—brings up an issue that I have always frowned upon: that of "influences." One could say that, in writing these last essays (as well as a few others), I had been "influenced" by the codes of the autobiographic genre. But would "influence" really be the apposite term? Could not one say instead that in writing those texts I had *appropriated* the codes in question?

One of the most ubiquitous codes of the autobiographic genre is the litany of "influences" to which the author admits having been subjected during his or her life and particularly in the formative period of his or her youth. Students who participated in my graduate seminars know how allergic I have always been to the notion of influence (at least as much as to that of precursor)—an allergy no doubt, and this is in itself an amusing paradox, "influenced" by Roland Barthes (whose polemical declaration, "I don't believe in influences," had warmed me when I read it).[3] The abuse of the notion by traditional art history—for which it had become the central mode of causal explanation—certainly played a role in my early distrust of the discipline. I simply could not find any heuristic value, for example, in thinking that "Picasso has been 'influenced' by Ingres." In my

mind, the question worth asking is: "Why did Picasso feel the need to revisit Ingres, and why at the very moment, or moments, when he did so?" What has always seemed to me preposterous is the implication of passivity of the "influenced" with regard to the "influencer" that the notion of "influence" conveys (this connotation of passivity is less pronounced in English than in French, which is perhaps why I am especially sensitive to this: An influence is endured [*subie*] in French [from the verb *subir*], one suffers from it).

Barthes again came (temporarily) to my rescue when he stated that what interests us today is "not what the author [or artist] endures (*subit*) but what he or she takes, or steals (*prend*), either unconsciously, or, at the other end of the spectrum (*à l'autre extrême*), parodically."[4] I was not entirely satisfied by this remark in passing. Not that I read the allusion to the unconscious as a nod of approval to the implication of passivity that repelled me—the unconscious, for Barthes, was anything but passive—but I felt that by zeroing in only on the two ends of the spectrum he was leaving too many options in the dark. It is at this point in my musing that I found an unexpected ally in André Gide (on whom Barthes wrote one of his first essays). I say unexpected because Gide's assistance comes from a text written *in defense* of influences (and of the influenced as well as the "influencer," that odious word that has now become the name of a profession). The text in question is actually a lecture that Gide gave early in his career (in 1900, he was thirty-one), entitled "De l'influence en littérature" (Concerning Influence in Literature). Most of it is devoted to the "anxiety of influence" famously analyzed by Harold Bloom, how absurd and paralyzing it is and how and why to keep it at bay. But at one point Gide addresses what I would call the summons (and others would call the interpellation). "Influence," he writes, "creates nothing: it awakens."[5] Or, more emotively:

I have read a certain book; when I finished it, I closed it, put it back on the shelf in my library—but there were certain words in that book which I cannot forget. They have penetrated so deeply into me that I cannot separate them from myself. Henceforth I am no longer the one I was before I met them. Though I may forget the book in which I read them, though I may even forget that I read them, though I remember them only imperfectly—this is of little importance; no longer will I be the person I was before I read them. How can their power be explained? Their power comes from the fact that they have merely revealed to me some part of myself of which I was still in ignorance; for me they were only an explanation—yes, but an explanation of myself.[6]

What I find the most interesting in Gide's account is his analysis of what he calls the *influence d'élection* (chosen influence). The example he gives is that of travel:

Excluding unfortunate exceptions, forced trips or exiles, we usually choose the country in which we want to travel [. . .] In fact we choose a certain country for the very reason that we know it will have an influence upon us, because we hope for, wish for that influence. We choose those very places we think capable of influencing us the most. When Delacroix set out for Morocco, it was not to become an Orientalist, but rather, through the understanding he was to gain of more lively, more delicate, more subtle harmonies, to become more "perfectly aware" of himself, of the colorist that he was.[7]

This has no longer to do with the myth of a one-way trajectory from the influencer to the influenced; instead, it speaks of a click or spark between poles. It evokes the idea of an encounter. It takes two to tango. This book is an inventory of encounters.

1. A few words about Michael Fried, since his initiative had such a profound effect on my career. He not only invited me out of the blue to come and teach at Johns Hopkins (initially just for a year, as a stopgap visitor before the search to replace Nancy Troy, who had just left for Northwestern, would be concluded), but it is also in great part thanks to him that I decided to stay in America. Only a month after my arrival at Hopkins, I was offered a tenure-track position of associate professor in its Department of Art History, and had to give my answer by Thanksgiving. I was at the time correcting the galleys of an essay I had written on Richard Serra, for the catalogue of his retrospective exhibition at the Centre Pompidou, in which I criticize at length Michael's famous attack on Minimalist sculpture, his 1967 essay "Art and Objecthood." (My essay was later published in English as "A Picturesque Stroll around *Clara Clara*" in *October* 29 [Summer 1984]: 33–62). I wanted to make sure he knew that we fundamentally disagreed on certain things before I started weighing the pros and cons of staying in the US rather than returning to my research position in Paris, and told him about my Serra essay. He immediately asked me for a copy, and the next day he came to my office, visibly excited (while I was rather apprehensive), astonishing me by not only praising the essay but also saying that he "totally agreed." As I asked him to explain what he meant by that, given that he could not possibly be agreeing with my criticism of his position, he said something like: "Of course, I don't agree with that, but I agree with the way you present our disagreement. You state that I harshly judge pears by characterizing them as bad apples, while in fact I should have simply recognized that I don't like pears at all." This was indeed exactly what I had done—my take was that Michael had judged Minimalism through the criteria offered by Kant in his analysis of the Beautiful, while he should have looked instead at what Kant writes about the Sublime. It was that very evening, pondering over Michael's remarks, that I began to consider accepting the Hopkins position. Other factors played a role, of course, including Rosalind Krauss's vehement encouragement to do so, but the open-minded way in which Michael understood debate on that particular occasion was the most important. This was definitely something I would never have experienced in France, since, for better or for worse, French intellectuals are not very talented at "agreeing to disagree."

2. The title we had proposed and that was refused by the publisher (Thames and Hudson) was "Modernism and Its Discontents." The first edition of this book was published in 2004; the second and third revised editions, for which David Joselit joined us as a co-author, were published in 2011 and 2016, respectively. Joselit joined *October*'s editorial team in 2009.

3. Roland Barthes, "I Don't Believe in Influences," interview with Renaud Matignon, *France-Observateur,* April 16, 1964, trans. Linda Coverdale, in *The Grain of the Voice* (Berkeley: University of California Press, 1991), 25–29.

4. Roland Barthes, "All Except You" (dated from 1976 but published in 1983), reprinted in *Oeuvres complètes*, vol. 4 (Paris: Éditions du Seuil, 2002), 968. To my knowledge this text has never been translated into English.

5. André Gide, "Concerning Influence in Literature," in *Pretexts: Reflections on Literature and Morality,* ed. Justin O'Brien (London: Routledge, 2017), 38.

6. Ibid., 26–27.

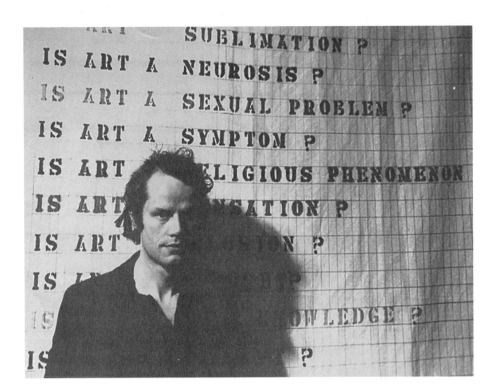

Guy Brett in front of Lea Lublin's *Interrogations into Art,
Discourse on Art*, Serpentine Gallery, London, May 1975.
Photo: Teodoro Maler.

# Angels with Guns

In the mind of anyone who knew them and their work, the British art critic and curator Guy Brett and the Filipino mixed-media and performance artist David Medalla formed a pair. Which is why, though it might sound awful, I was not overly surprised by the news that Guy had died (February 2, 2021) just over a month after that of David (December 28, 2020). It was as if the former had waited for permission to die from the latter. Guy had been diagnosed with Parkinson's at the end of 2013, and the deterioration of his health had accelerated in the last months of his life. As for David, it was Guy who had informed me of his stroke in his letter of April 25, 2018. He added: "I was profoundly shaken up by the whole event. I felt the vulnerability of David who I had always thought was invincible."

Although they had been living far from each other for some years, as David had returned to his native Philippines, they were somehow inseparable. I often met them together, and whenever I saw them separately, each would inevitably give me elaborate news of the other. If their mode of elocution was strikingly different—Guy spoke slowly and economically, while David was voluble and prone to deliciously curlicued digressions—both were mesmerizing raconteurs, with a sensuous attention to detail and a stupendous memory. There was something so similar in the vividness of their curiosity, in their availability, that it was impossible not to think of the other when hearing one of them speak. In the letter in which Guy told me about his own fatal ailment, no doubt to dampen the shock, he quipped: "Incidentally, James Parkinson was a remarkable man, an English doctor and geologist in the late 18th and early 19th century living at no. 1 Hoxton Square in the east end of London. He was the first to study what was then called 'the shaking palsy' and wrote an essay on it. It was later re-named Parkinson's Disease by the great French doctor Charcot in admiration. Besides his doctoring Parkinson took part in many liberal and progressive causes. I felt kind of honored to be so-to-speak his patient . . ." (May 10, 2014). This is exactly the kind of utterance that could have come out of David's mouth at any time during one of the innumerable long conversations we had over the years. In many ways, Guy and David were similar—united by the same internationalism, the same disdain for the parochialism of the art world, particularly the British one. And yet so different in personality, with such contrasting backgrounds.

Guy was both candid and discreet about his upbringing. He admitted to me early on that he came from the British aristocracy—when I asked him the meaning of the mention "The Hon." that I had seen affixed to his name somewhere—but he immediately added that this was a world he had left with childhood, and without any regret. The world in question: a vast estate in Oxfordshire, large eighteenth-century manor, etc., most of which would be given by his father to the National Trust, and the rest, in true upper-class fashion, inherited by Guy's older brother, along with the peerage. Guy liked to allude to his father, but only as an architect and urbanist (it is only incidentally, and probably from David, that I learned of Brett Sr.'s title after wondering who the Viscount and Viscountess Esher—listed as patrons of *Signals*, the news bulletin of Signals Gallery, which David edited—were).[1] In other words, Guy had an extraordinarily privileged youth, but nothing of that showed in the way he lived and thought—the only remaining sign of it when I met him (in 1974, I think) was perhaps his job as the art critic of the *Times* of London, a position he had obtained in his early twenties and from which he was about to be sacked (but I suspect the assumption that his appointment had been due to family or class connections to be wrong).[2]

As for David, he regaled me with stories of the large household of his youth in Manila, always filled with guests who were often roped in for improvised musical or theatrical and dance performances, his highly educated family, his early fame as a child poet, his stay in New York in 1954 during his teens (recommended by Mark van Doren, he was admitted to Columbia as a special student at age sixteen), and his encounters in bars of the Village with a Who's Who of AbEx (inserting here and there, to spice up the narrative, allusions to romantic affairs, including one with the actor James Dean). The name-dropping was a bit off-putting at first, and it tested my credulity, but I eventually came to realize that the luminaries punctuating his discourse functioned as markers, as gateways to many other possible outgrowths in his labyrinthine storytelling. I also learned—but only much later, in Guy's meticulously researched 1995 monograph *Exploding Galaxies: The Art of David Medalla*, for which I wrote a postface (see below)—that many of David's tales were perfectly documented.[3]

When immediately after their death I was tasked with writing a double obituary, I found myself unable to summon the mandatory distance, and I resolved instead to write a memoir of my relationship with both men. But that led to another conundrum: Although Guy and David have been very important in my life (in different ways), the account of our friendships could only be lopsided. I saw a lot of them for about a decade, but my connection with David loosened after I left for the United States (he did write me occasionally, until the end of the '90s, but his letters were of a professional nature—to inform me of a performance he was to give in a festival somewhere, of a show he was

mounting, of his various peregrinations around the world, and, more often than not, to enlist my support for talks, to obtain a visa, to recommend him for this or that, etc.; in his mind, I had become part of the academic establishment, no longer the youth he sought to enthrall and seduce). With Guy, the situation was very different. Our bond grew, we never ceased to learn from each other, and our correspondence of fifty years (with several interruptions) turned out to be, upon rereading it, a treasure trove ready to be mined. This is exactly what I'll do in the pages that follow, part diary, part scrapbook.

But where to start? With my first encounter with these two men? Or, several years before that, with my first encounter with their respective work? Instead, I opt to zoom in on their first meeting, in the summer of 1960, as told by Guy in his book on David, because it sets the tone and reveals much, in just a paragraph (the first of the initial chapter, titled "A Certain Way of Life"), of who they were:

> I have always thought the circumstances of my first meeting with David Medalla were both amusingly incongruous and strangely prophetic. I was seventeen and had been invited with my younger brother Sebastian to a dance at the village hall in Rotherfield Greys, near Henley-on-Thames in Oxfordshire. The party was in honor of the Yale University rowing team who were competing in the Henley Regatta, and was given by a family of near neighbors of ours, the Goyders. It so happened that David and Dan Goyder both attended a scholarship camp in the USA (Camp Rising Sun at Rhinebeck, New York, to be exact), and, since apart from a handful of relatives, he knew few people in England, having arrived only weeks previously from the Philippines, via East Africa, Egypt and France, decided to look him up. The Goyder family brought David to the dance. He gave a performance at the party, but what I remember best about the evening was his scintillating conversation about English poetry. I was attempting to produce poems at the time. His knowledge of all my favorites—Blake, Keats, Shelley, Crabbe, Hopkins, Eliot—astonished me. It is a very particular pleasure when someone from the other side of the world talks warmly and insightfully about your own culture. Only later I discovered he knew as much about French culture, and many others, as he did about English, and as much about art, music, dance and theatre as he did about literature.[4]

Like Guy, I was immediately struck by David's extraordinarily broad (and totally idiosyncratic) culture the first time I met him. Indeed, he did know French poetry remarkably well (we did not have the exact same taste: He worshipped Louis Aragon, whom I have always loathed, but we had Mallarmé in common), and it was impossible to spend any time with David without learning of his nomadic existence. Nothing about him surprised me in this account—the confidence with which he immediately blended into a public event

(no matter how foreign the context was to him) and appropriated the stage for an impromptu performance, the lack of reserve with strangers, the willingness to meet them on their own terrain . . . But what this brief passage made clear to me in retrospect was, first, how much Guy's celebrated globalism owed to his early chance encounter with David and, second, that his own roots were in poetry, particularly in British Romanticism and its yearning for what has been called a "cosmic consciousness."[5]

I met David before I met Guy—and through the same person, Lygia Clark—sometime in the late summer or early fall of 1970 (when I returned to France after being an exchange student in the States) or the late spring or early summer of 1971. He was living with his American boyfriend, John Dugger, at the time, on a houseboat (which David had christened the *Mayflower II*!) moored at the Quai des Tuileries on the Seine, next to the garden of the same name. I knew about his work through Guy's 1968 book, *Kinetic Art*, and *Robho*, the journal edited by Jean Clay, which had published David's beautiful tribute to Lygia (one passage in particular—in which he compared a work of hers in rubber to the foreskin of an uncircumcised penis—had fascinated me but also made me blush as a repressed sixteen-year-old unprepared to accept his homosexuality).[6] Lygia had urged me to go see him; she was amused by his floating abode and felt this was the ideal circumstance for me to make his acquaintance. (Fairly soon after, she would no longer be amused: David had used her name, without her knowledge, as a guarantor for the boat's rental or mortgage—which he failed to pay. Her enormous respect for him as an artist never ebbed, but she never forgave him for the legal troubles his reckless behavior created for her and forever banned him from her place.)

Although I have a perfect memory of the unusual setting, I do not remember our initial conversation—only that it was not as fluid as it would become, perhaps because of Dugger's presence and what I sensed of his proprietary attitude with regard to David. It also must have been brief, as I had to take the train back home to southwest France that very evening: I would later find out how important duration was for any interaction with David. I was invited back to the boat as soon as possible, but this never happened, as he had already left when I moved to Paris in the fall of 1971. The next time I saw him was four or five years later, when he came to visit me with Guy, whom I had befriended in the meantime.

As for the latter, I had been longing to meet him for some time before it happened at Lygia's apartment-studio on the Boulevard Brune. I had already learned so much about him that we easily skipped the first tentative steps in establishing our intimate friendship: bromance at first sight. Most of the information I had about him had come from Lygia. I have written on several occasions about my very close relationship with her, but I don't think I ever

indicated how often and lovingly she spoke of Guy (the only other person about whom I ever heard her speak so effusively was Hélio Oiticica, although her relationship with him was punctuated by terrible rows). It was probably Lygia who had showed me Guy's *Kinetic Art* soon after its publication (in a letter he wrote me in January 1977, apologizing for not having responded to a missive of mine, he recalled that our correspondence had begun with a similar failure on his part, when he had neglected to answer the "long and very friendly letter" I had written him when the book had appeared). Guy's book, short and modest in format, had been a total surprise: Its treatment of the subject had absolutely nothing to do with what one might have expected at the time—there is virtually no discussion of the titillating Op gadgets that had been invading the galleries and were soon to be relegated to the footnotes of art history, but there are lengthy analyses (and many photographs) of David's and Lygia's work as well as that of Oiticica, Mira Schendel, Sergio Camargo, and Takis, artists Guy defended his whole life and all of whom, except for Oiticica, had been exhibited at Signals. As a matter of fact, the other publication of Guy's with which I was already familiar was the catalogue he authored and designed of Oiticica's exhibition for which he secured the Whitechapel Gallery in 1969, three years after Signals had abruptly closed in the middle of a Schendel show, just as a large shipment of Oiticica's works was landing on the doorstep of the gallery, in which they had been scheduled to be installed in the next few weeks (for a long time most of the gallery's inventory was stored in care of Guy, some of it packed away in his parents' house in the countryside, the rest filling a room to the brim in his sparsely furnished apartment at Ormonde Mansions, a stone's throw from the British Museum).[7]

By the time we met and clicked, the Signals adventure was probably ancient history for Guy—I learned more about it a few months later when I first visited him in London and he showed me his collection of *Signals* bulletins. Leafing through them, I was amazed by the importance of science and the history of science in its pages, especially in its first issues (John Newell, a well-known science journalist, was a regular contributor, and texts by the likes of Werner Heisenberg and Hermann von Helmholtz were featured).[8] I was intrigued, since one of the novel aspects of Guy's *Kinetic Art* book had been the picture it gave of the movement as utterly disconnected from the techno-scientist bric-a-brac with which it had unfortunately been almost exclusively associated. He responded with the same historical and contextual answer that he offered in various essays: that "after the Second World War, kineticism was one powerful focus for the aspirations felt by young artists from colonized, 'developing' or marginalized countries to be 'absolutely modern.' It was the means of catching up and then surpassing the development of modernism in Europe, and of assuming the right to speak in visionary, utopian, even cosmic terms."[9] David's

early dream of a collaboration between art and science, which he had been calling for in the *Signals* bulletin, and which Guy had shared, was very much a part of that.

This dream notwithstanding, at the time of my visit Guy was more inclined to speak about the recent political turn his work had taken after a long trip throughout South America. The first sign I have of this is a clipping that he gave or sent me of a column he had published in the *Times* on June 19, 1974 (titled "Out of Africa"), about David's series of drawings that took as its subject the "liberation movements against Portuguese colonialism in Angola, Mozambique and Guinea-Bissau." In the article three points were stressed: These works were shown outside the context of galleries and museums, "at festivals of dance and poetry at community centers in several English cities"; almost childlike in style, they eschewed the rhetoric of propaganda through their devotion to particulars ("the aspect which is emphasized in all the drawings is the environment, the jungle, which provides shelter and camouflage and is also the symbol of the richness of the land"); and they deliberately ignored the diktats of the art market that constrain the artist to his or her own niche ("They seem miles away from the preoccupation of the avant-garde," to which the artist belonged—a sentence followed by a quick summary of David's avant-garde credentials, with an insistence on his multimedia approach and deliberate refusal of stylistic consistency).[10] Those themes preoccupied Guy all his life.

The second piece of evidence concerning his "political turn" is the first letter I still have from him, dated September 25, 1974, in which he recounts how busy he is preparing the Arts Festival for Chilean Resistance, a fundraiser for the families of the "disappeared" in Chile, to open shortly at the Royal College of Art (whose director at the time was his father, as I learned a bit later!); asks me to remind Lygia of her promise to send films about her recent work to be projected there; and informs me that David is working nonstop. The situation in Chile would become a recurrent topic of our conversation, especially since it was the home country of his wife, Alejandra, whom he met at the festival—and it led me, two years later, to introduce Guy to the *arpilleras* (small figurative patchworks) produced by mothers and wives of political prisoners or the "disappeared" in Chile, one of the very rare occasions when our roles were inverted with regard to introducing the other to works of art.[11] But the most significant passage of this short letter is this, in response no doubt to a question of mine: "About China there's so much to say; there's a kind of transformation at the most everyday level. Contemporary focal-points like the factory, the school, which in the West are wrapped in frustrations and boredom, seem to be filled with humor and creativity. It's a wonderful thing to feel. I'll tell you more about it when I see you."

And tell me about it he did over the next two years, when we visited each other frequently (he came to Paris more often than I went to London, and

several times he stayed with David at my place). I don't know exactly under what circumstances Guy had gone to China while the Cultural Revolution was still raging or how he had become a fellow traveler. He never turned into a full-fledged Maoist, unlike David, who was relentlessly trying to bring me into the fold. I kept telling David that the Red Guards would make mincemeat of him as soon as they heard him talk about free love, and that homosexuality was most certainly severely repressed in Red China. At one point he dragged me to the opening of an exhibition of Hans Richter's Dada works at the Galerie Denise René Rive Droite, where I had not gone in years, and the venerable pioneer greeted him like an old acquaintance—which led me, on the subway trip back to my flat, to try one more time to tell him that all his interests, in life as in art, were incompatible with his Maoism—but none of this made a dent. He would switch to a discussion of ancient Chinese art or of porcelain production in Ming China (of which he knew an enormous amount), as if this transhistoric essentializing of China could in any way change my views (it only consolidated them). Digression was part and parcel of David's mode of elocution, but in our jousts about Mao it had become his most efficient defense strategy, since his asides were always captivating, themselves branching into further asides. (During the crash course he gave me about Chinese blue-and-white porcelain production, he alluded to the subtle use the craftsmen made of symmetry, which led to a discussion of symmetry in general, a topic that greatly interested me at the time, with David acquainting me with something else yet: Hermann Weyl's 1952 book *Symmetry*, which he promised to bring me from London on his next visit—a promise he astonishingly kept.)[12]

But sometimes all his digressive talent would not do the trick, and in such cases he just dug in his heels. I had been horrified when I saw photographs of the *People's Participation Pavilion* at Documenta 5 in 1972, where he and Dugger had proudly hung a banner with the portraits of Marx, Engels, Lenin, Stalin—yes, Stalin!—and Mao, stitched above the slogan SOCIALIST ART THROUGH SOCIALIST REVOLUTION! He would not budge when I told him how I felt about it. Incidentally, I was relieved to read a text from 2011, titled "A Rectification," which David wrote after stumbling across the same photographs reproduced in a publication about Harald Szeemann, the famous curator of that Documenta vintage. In conclusion, it reads: "After a passage of thirty-nine years, I have arrived at this new resolution: errors of my youth must now be corrected, errors that were the results of a passionate but ill-informed belief," followed by an amended list of names (Marx, Darwin, Whitman, Rimbaud, Freud, and Einstein) for those on the banner. Of the original ones, only Marx survives. This public apology was very unlike David, but better late than never.[13]

My own political background was a mix of anarcho-Marxism (since high school I had been a reader of both Marx and Bakunin, often siding with the

latter in his struggle against the former), socialism (of the kind represented by the PSU, a French party to the left of Mitterand's Parti Socialiste that had attracted many of the intellectuals I admired and to which my father belonged), and the Internationale Situationiste (I should probably have named that first, as my father subscribed to its journal, the first political publication I ever perused). Everything I had read about Mao's authoritarianism and the madness of the Cultural Revolution repelled me.[14] It is hard today to fathom the Sinophile or rather Maophile frenzy that took hold among a large part of the French intelligentsia at the time, including artists, who turned a blind eye to the barbarity of the Red Guards despite the growing accumulation of hair-raising testimonies.[15] I had already struggled with this aberration during the revolt of May 1968 and immediately after, while I was in high school, so I was well poised to resist David's continual proselytizing; but Guy's position was much more nuanced. In China his interest had been piqued by a strange phenomenon: the pictorial production of a group of farmers, all based in the district of Huxian, which had begun in the 1950s but had greatly expanded and become popular all over the country (the works circulated in poster-size reproductions) even though (and perhaps because) they owed nothing to the official socialist-realist style directly imported from Stalinist Russia or to traditional Chinese painting. He brought me a book about the peasant-painters, long lost, published by the official propaganda machine in Beijing, as well as an article he had written about these works, and realizing that I was not indifferent, he urged me to write about them—which I eventually did![16]

Venturing to look again at this text for the first time in more than four decades, I am struck by how much it owes to Guy despite the distance I kept from his collectivist ethos. As a good student of Marxism, I tackled the topic from what seemed to me the most interesting theoretical angle: What are we to make of an enormous artistic production by nonprofessional, untrained, part-time "artists" (all of whom declared their pride in working principally in the fields) and exclusively intended for a mass audience? The text proper began with the famous quote from *The German Ideology* in which Marx and Engels state that the very existence of artists is a consequence of the division of labor, and it ends with a comparison between the situation of the Chinese peasant-painters and that of the (professional) Productivist artists in the Soviet Russia of the 1920s, who dreamed—but could only dream—of the abolition of art as a specialized, autonomous human activity. Two features of this text were clearly imported from Guy: its epigraph, taken from Christopher Caudwell, a young Marxist writer who died in the Spanish Civil War, and the idea that in these works—which borrow many tropes from folk traditions—decoration, or rather "the decorative" (near allover patterns, rejection of a central figure, etc.), is used as a visual metaphor of abundance.

This last theme had actually been expanded by Guy in a text I probably had not read when I published my piece, although he must have mentioned its central argument during one of his visits, in which case it would have substantially eased my entry into the peasant-painters' work.[17] Guy had been very tentative when he sent me this short essay, titled "Agriculture, Field, Decoration": "I would like to know if you think this approach is valid, or far-fetched and amateurish." The text knocked me out. With its sweeping hypothesis that the birth of decoration, or of the decorative impulse, had coincided with the birth of agriculture, his piece was completely foreign to what I was then accustomed to reading, save for its one reference to Walter Benjamin. At the time Jean Clay and I were already planning the first issue of *Macula*, the journal we edited from 1976 to 1979 (four issues, one per year), and I proposed to translate this text for it; I also invited Guy to be part of our minuscule editorial team.[18] For me, "Agriculture, Field, Decoration" remains a quintes-sential example of his prose and what I consider its poetic tone. And in a way, Guy himself thought of it in a similar manner: As late as March 28, 1999, when writing to me about his concept for the extraordinary exhibition *Force Fields* that he would curate in Barcelona (more on this below), he noted: "I want to do something rather similar to the essay on decoration that you printed in *Macula*—something speculative, intuitive, which brings out a chain of relationships which perhaps have not been noticed." And five years after that, out of hundreds of articles, he selected the essay for inclusion in his first collection of selected writings, *Carnival of Perception* (more on this below as well), where it appeared for the first time in English. He had been particularly pleased by the way we had followed his indications for its layout in *Macula*—something to which he was always particularly attentive—with a combination of marginal illustrations and full-page bleeds, and he reduced the four spreads of the original *Macula* design to fit a single page in his book as the frontispiece to this essay.

By the time Guy sent me his decoration and agriculture text, we had already established a relationship as each other's first readers and two-person fan club. (He liked very much an essay on the art market I had left with him on my first visit to his place in London, for example, in January 1975—I was no doubt proud of what I thought was the strict Marxist stance of the text—and he campaigned, unsuccessfully, to have it published in *Studio International*.)[19] But more important, we shared our enthusiasms about things we read—sometimes with a typical *esprit de l'escalier*: We would ask each other for the reference or even a copy of a text that had been mentioned during our encounters in person (at the end of May 1975, for instance, a month during which he had stayed for a few days twice at my place with David, he asked me in a letter to send him a copy of the small text by Bertolt Brecht on Chinese painting—then and perhaps still not translated into English—that I had read aloud to him). And we regularly

brought books and photocopies to each other when visiting. He loved the now-famous text by Meyer Schapiro "Field and Vehicle in Image-Signs," which I copied for him, but also Leroi-Gourhan's *Le geste et la parole* and Henri Focillon's *Éloge de la main*; and aside from Caudwell (the first text he sent of his was a very strange essay on love), he led me to discover Lu Hsun, a longtime favorite of Guy's, as well the literary critic and political activist José Carlos Mariátegui (he sent me two short texts by the Peruvian writer dating from the 1920s, both on Futurism). When we were together, either in Paris or London, one of our greatest pleasures was to browse bookshops and occasionally buy the same books, about which we would later comment by mail. I suppose we were exhilarated to find at once something that was exciting for the both of us (the most memorable of those occasions concerns several issues of the journal *Screen* each of us acquired at a socialist bookshop in Soho containing a vast quantity of texts from and about various writers of the Soviet avant-garde of the 1920s, including the so-called formalist literary critics of the journal *LEF*—we devoured them). For the most part, however, our exchanges of authors kept confirming how utterly different our cultural baggage was—and how much we enjoyed being each other's guide to unknown territories. He introduced me to Adrian Stokes, for example, whom, I now vaguely remember, he had met through his father (urging me to read not only *Stones of Rimini* but also *Inside Out: An Essay in the Psychology and Aesthetic Appeal of Space*, of which he gave me the exquisitely printed original edition). It is also thanks to his father's connections that in 1979, as I was attempting to interview everyone still living who had known Mondrian, he brought me to the country house of Myfanwy Evans and John Piper, members of the (soft) British avant-garde of the 1930s and '40s, who had befriended the Dutch painter while he was living in London.[20]

The most incongruous introduction of the sort occurred in a query embedded in a long letter from April 1977: "Did you read Max Raphael's essay on the struggle to understand art?" The format of the book in which the essay in question was published, *The Demands of Art*, whose existence I knew nothing about, was too large for xeroxing, so it was the first thing I acquired during my next visit to London a few months later. Despite the heavy philosophizing, I found several essays in it very rewarding, particularly the text on Cézanne, filled with extraordinarily rich and perceptive formal analyses, but I could not make heads or tails of "The Struggle to Understand Art." It is only recently, while revisiting it after having reread so many of Guy's essays and letters, that I grasped what attraction this dense and grand attempt at a universal theory of art could have held for him, given his usual aversion to philosophical abstraction: He shared with Raphael a conception of the work of art as both an interpretant (of the world, of nature, of life) and a reserve of energy that needs to be released and activated by the viewer.[21]

In 1975, in addition to preparing the first issue of *Macula*, I had been commissioned to write at top speed (two months from start to finish) a short book on Picabia, to be published in time for the retrospective of the artist at the Grand Palais opening in January of the following year. I had taken the job for purely financial reasons (my first taste of "typing for dollars"), even though my feelings about Picabia's oeuvre, especially his post-Dada work, were ambiguous at best. Only a couple months after the book came out, his daughter threatened the publisher with a libel lawsuit for my mere mention of the fact that the artist's four-month imprisonment after the Liberation had been due to his anti-Semitic and Pétainist stance during the war. The publisher panicked, even though all my sources were public (including a scrapbook Picabia's last wife had just issued), and any judge would have dismissed the charge as frivolous. Not only did the publisher have all the copies recalled and pulped, she even threatened to sue me if I were to publish anything about this sordid affair (I consulted a lawyer, who told me to go ahead, which I did in *Macula*).[22] Guy was incensed by the whole thing, which he called pure censorship, and wrote a piece about it for the *Guardian*, which his friend Caroline Tisdall, then the lead art critic of the newspaper, promised to publish. (I don't think this ever ran, but I still have Guy's manuscript of it.)

Soon after this episode, I visited Guy, who had just moved to a small house in Brixton, one of the most ethnically diverse areas of southwest London. Together we went to Artists for Democracy (AFD), a squatter community of young artists and performers that had become David's fiefdom. Unfortunately there was a temporary lull at this beehive of activity (there had been some conflicts between members of the group, it seems, and Guy had distanced himself from them), but David was as lively as usual, teeming with projects. It must have been on this occasion that he described to me the "participation-production-propulsion" piece he was planning for the space several months down the line, called *Eskimo Carver* (1977). By all accounts, and Guy's in particular, this would turn out to be one of the most successful events at AFD (it was also its last).[23] I missed it, unable to come back to London for the occasion, busy as I was both with *Macula* and finishing, in dreadful haste, my dissertation (a condition *sine qua non* of the job I was applying for, my first, at the Centre National de la Recherche Scientifique). I made the deadline and got the position, but David long begrudged my absence. As happened countless times, in order to expose to me his Eskimo project, he had shown me a notebook filled with drawings and diagrams as well as quotes and references jotted down in preparation, all in his amazingly reader-friendly handwriting. He always carried a notebook with him, and what inevitably fascinated me whenever he opened it and started rhapsodizing is how complexly sedimented all his projects already were at this embryonic level. There were always at least three or four historical and cultural narratives, both local and global, intertwined

in any single project, always several possible points of entry, always multiple levels of potential interpretation. In some ways David was a hoarder, which in itself was incompatible with his perpetual wandering—so he had learned to collect not objects but ideas and information. I was always worried that these notebooks, which over the years had become for me the essence of his work, would somehow be lost during his endless peregrinations (he shared my apprehension and, to reassure me, said that he planned to leave them with Guy for safekeeping).

In late May 1976, Guy sent me the rough draft of a text he had written on the autobiography of the Dutch documentary filmmaker Joris Ivens, which he wanted, once edited, to offer *Macula* (Ivens's many films on China were shown in Paris at the time—particularly the assemblage of twelve one-hour films, co-authored with his wife Marceline Loridan, called *How Yukong Moves the Mountain*, which had just come out and which he wanted to come and see). The essay had been long in the making, and Guy was particularly insecure about it, critical of what he called his hero-worshipping tendencies. I thought the piece needed quite a lot of work and told him so while encouraging him to pursue it, but Jean, alas, did not like it at all and did not want to publish it (Ivens's unrepentant Stalinism and the propaganda rhetoric suffusing the recent films did not help). Guy had to cancel a stay in Paris, where he could have discussed the matter with Jean and myself, because he was hastily preparing a second trip to China, this time as a guest of the Society of Anglo-Chinese Understanding (SACU), an invitation he gladly accepted in order to deepen his knowledge of the peasant-painters movement. He had been taking his role of fellow traveler ever more seriously since I had met him, and had even been persuaded by Joseph Needham to write several pieces for SACU's notoriously pro-Mao journal, *China Now*—but rereading his letters now, I notice that after this second and last tour (three weeks in July 1976), they no longer contain the slightest allusion to China. He did not even respond to my questions about it. In fact, he did not write me for several months. At the time I felt he was hurt by Jean's take on his Ivens piece (which I had dutifully but diplomatically conveyed to him), especially since he did comment on it in the first letter I received from him after his return from China, in January 1977, but in hindsight I think that the trip had led to a somewhat traumatic disillusionment.[24]

Guy's letter of April 2, 1977, which includes his suggestion that I read Max Raphael, also expresses his negative reaction to the second issue of *Macula*. The only thing he seemed to like in it is my edition of letters to the artist Jean Gorin, written in the 1920s and '30s by fellow artists such as Vantongerloo, Torres-Garcia, Mondrian, and Otto Freundlich. "Why don't you do a book," he suggested, "where the whole drama of the pioneer modern artists, their whole social situation with its freedoms and its restrictions, is revealed through their letters. I think that this would say so much more—with linking passages, of

course—than conventional art history." He is particularly acerbic about Jean's difficult essay on the painter Martin Barré. In a long postscript, probably written a day after the letter proper, he spelled out his revulsion:

> I shouldn't speak about *Macula* 2 without really studying it, but I can't help feeling it's turning back towards "art for art's sake" in many parts. It's on a high level of scholarship, but what is this scholarship being used for? I know my level of scholarship is low but I feel I can't wait until it is higher before attempting a kind of *popularization.* Why can't *Macula* develop a popular style? (I don't mean a "populist" style. I mean e.g. the style of Lu Hsun in his essays, in which you feel his need to communicate with non-specialist people who he could stimulate to act, to produce, to realize the best in themselves.) I can't take the philistinism of the specialist with his little in-jokes and snoberries, and language that is basically constipated. How can we be simple and clear without vulgarizing and without demagoguery? It's a very difficult problem. Marx was not easy to understand, was he? Once again, on cultural matters, Brecht is a model, isn't he? Brecht was not a vulgarizer, but he was so beautifully economical and clear with words; he wrote as a thinker, but one who is involved in everything that goes on, who does not blot out from his communications a consciousness of the most basic, most naive questions (what is theater? Theater is to give pleasure, etc, etc). He didn't place himself above people. I know you know what I mean.

I have no recollection of how I reacted at the time, but it must not have been very easy—I was straddling my loyalty to two friends, one (Guy) ten years older than I, the other (Jean) eighteen. Even though Guy's name still figured on the editorial masthead of *Macula* until the third annual issue in 1978, he obviously no longer felt a connection with the journal. We continued to correspond (he would send me news about David or discuss the exhibition of *arpilleras* he was organizing) and to visit each other whenever possible (he tempted me with a Lissitzky exhibition that was opening at the Oxford Museum of Modern Art). One of the oddest slivers of the past I retrieved from our letters of the period is Guy's apology for having left a guitar at my place—most probably not his as neither I nor his brother Sebastian have any memory of him playing the guitar.

Our extant correspondence in the early 1980s is sparse; no doubt many letters were lost, as I moved a few times within Paris and then definitively to the United States. We saw each other a couple times, kept in touch, but not assiduously. The intense exchanges of our beginnings resumed only in the fall of 1986, after Guy came to stay with me for a few days in the French countryside during the summer. It is telling that with his first letter of this new round, dated September 1, 1986, in response to one of mine, he sent me something he had published on David in a Philippine art magazine ("a rather disjointed patchwork

29

from the text on him I'm still hoping to make into a book"), as I often nudged him about this plan.[25] The bulk of this long letter is devoted to his trip to Mexico, from which he had just returned. Even though he had been there previously, he was predictably marveling at the Mayan sites and shocked by "one's enforced passivity and detachment as a tourist when confronted by the outrageous class system and poverty," which made him think of the "bitter-ironic little prose-poem by Baudelaire, *Assommons les pauvres!*" What enchanted him most, as it had done before, was "this vernacular culture of toys, and little objects of all kinds, which people are continually making, to load up a basket or box with them, and hawk them around. There are many traditional forms, but also many absurd hybrids made of modern materials like plastic, foam-rubber and polystyrene. Of these, you hardly ever see the same thing twice. But I think they all have one thing in common (in the way they are made, and presented): a kind of animation, an incredible ingenuity to simulate life." (It is impossible when reading this description not to think of David, of what kindred spirits he and Guy really were.)

With the next letter (November 1, 1986), Guy sent me the draft of an essay on "primitivism" that he was having a hard time writing for a book being compiled by his friend Susan Hiller (to whose work he had introduced me), no doubt including it because I had mentioned I was writing a text on Daniel-Henry Kahnweiler, Picasso, and African art, which I had roughly outlined in a talk a year earlier at the symposium MoMA organized around its "Primitivism" show.[26] More important, he informed me of the publication of his small book *Through Our Own Eyes: Popular Art and Modern History*. The following letter, dated November 10, reads almost like a manifesto. Together with several recent essays of mine I had sent the draft of a lecture whose English he had taken it upon himself to improve, in which I was grappling with the opposition, established by Hal Foster, between two kinds of "postmodernism," a neoconservative and a post-structuralist one.[27] Guy returned my manuscript with his handwritten edits, some of them explained in the letter, but it is his general comments that impressed me most and that are worth quoting in full:

> I must say that I was stirred by the last few pages of your essay (from about p16 to the end): all that you say about citation and the levelization of all things, and your exposure of Rosenblum, Picabia, Shiff, Schnabel etc. Plus the way you suggest an alternative in the work of Haacke and "feminist" artists. These pages are so well-aimed and combative that I wondered why you did not take these distinctions as a starting-point or as a guiding theme for the essay and refer to early modernism from the basis of them. Perhaps this had to do with the particular context you were speaking in, where there were particular underlying assumptions about modernism. I mean, is it being in America which means you

have to give Greenberg such importance, and say that his writings form the "second moment" of crystallization of modernist theory? Are you, for example, using the term "modernist" in a much narrower way in relation to Greenberg than you do in relation to the early modern, or "abstract" artists?

I'll try to say what I mean in another way, really as a question, or questions. Who are the successors of the early modernists? You say the Greenberg "second moment" was vastly different from the abstract "first moment," that Mondrian's, Malevich's (etc) ideas about science, technology, progress, social justice and the "dissolution of art into life"' were transformed into mysticism by the Greenbergian artists. Conditions after the war (Germano-soviet pact, collapse of the myth of progress, Cold War etc) lay behind this change. But couldn't there be a different interpretation if one took a wider historical view than the European–North American axis, and a wider artistic view open to experimentation in its many forms?

It's at least party true, surely, that the concerns of the early avant-garde, the socials ideas and the practice of experimentation, passed after the war to certain centers in what is now called the Third World, eg Brazil with its early Sao Paulo Biennales, where all the early modernists (Mondrian, Malevich, Duchamp, Klee etc) were shown very much as social and cultural activists, rather than as stars of the art market as they were later to be in the West. This cultural transfusion is one of the bases for Lygia Clark and Helio Oiticica's work I think, and I still consider them very important artists. I think in the West, the idea that something interesting could be happening in the "third world" was deliberately suppressed after the war (eg in official histories of modernism like Herbert Read's Concise History of Modern Painting (the first book on modern art I bought) in which (I mention this in the Primitivism essay) he deliberately omits modern Mexican painting). Greenberg's formalism seems to me a product of ignorance of these wider issues, (actually, modern Mexican painting was a great influence on Pollock etc, so Greenberg's position must be a product of the cold-war ethos (am I historically accurate here?)).

I do think the work of the early modernists, the work of "third world" artists produced in contestation of, and opposition to, Western colonialism, and the radical artists you refer to at the end of your piece, does tie up in vital ways. Jean Fisher puts this very well I think: ". . . We are all, to a great or lesser extent, a part of neocolonial heterogeneous populations subjected to or spoken for by corporate and media-based hegemonies." The ramifications of this interpretation could be huge.

Also I think that, for example, Hans Haacke's opposition to neo-conservative tendencies can be traced further back than the present situation. Significant for him I think, as for others, was the transformation of his kinetic into his political work. His kinetic work—with its emphasis on process, change, non-authorial ideas, experimental media etc—was as opposed to the Greenbergian dogma as his political work is to the "functioning of the artistic network in late capitalism." There is another history.

I also do believe there is another practice of quoting from the "boundless universe of visual languages and symbols," which does not imply the levelization of all things, in fact the opposite, in the work of some "feminist" artists and also in David Medalla's work as I want to try to show in my text on him: Work that does do what Benjamin asks for in your quotation, to grasp "the constellation which his own era has formed with a definite earlier one."

Around that time we tried to organize a trip for Guy in the United States (to be financed by lectures), but for various reasons this did not work out until the spring of 1988. Instead, he went to Brazil, his first visit there in twenty years, where he met several old friends, foremost among them Lygia Clark, who had returned from Paris in 1976. In an undated letter (but datable from the beginning of 1987), he described at length her current situation, as well as his visit to Projeto Oiticica:

I've much to tell you about Brazil. I was so happy to see Lygia (and also Sergio Camargo), but I found her not too well. The whole psychotherapy adventure (which she stopped anyway more than a year ago) has left her physically damaged. She is prone to all kinds of ailments (in her ears, her legs, her head, etc) and doesn't go out much—apart from a daily visit to the bar on the corner of the Av. Prado Junior, now a completely notorious part of Rio, where she eats an ice-cream among the prostitutes. She seems to have taken into herself physically the problems of her psychotic "clients" who she treated with her method based on use of the air-bags, cushions, mattresses etc which derive from her works. Nevertheless we had some wonderful conversations—rather like in the Boulevard Brune. I met a young man there with the strange name of Lulu Wanderlay, a young psychotherapist who has used Lygia's methods actually in a mental hospital, and whom she admires greatly. She asked me about you many times very warmly and likes you very much as I'm sure you know. I'm more than ever fascinated by her work and ideas, her evolution. She is very well known in Brazil, but still incredibly isolated. Very fierce. She often shows the door to reporters sent to interview her for the cultural sections of the newspapers, and so on. I'm once again trying to organize an exhibition here of her work and bring

out a publication. I want to write something about the idea of <u>efficacy</u> (ie, in a way a medical concept—remember those books on pharmacy and art you gave me once?) in relation to art in her work.

All of Helio's work is now stored in a flat and looked after by a group of his family and friends, and called the Projecto HO. I was taken there. I stayed only a short time and hardly touched or looked at anything. I couldn't stay there and start behaving like an art historian or critic, having known Helio so well when he lived in London. But again I'm going to write something more about his work for a big book they plan to bring out in Brazil. His actual exhibition in Rio was a slightly sad affair without his presence, and made me realise that the show he did at the Whitechapel in London was his largest and most daring.

In my (delayed) response I announced that I was reviewing his *Through Our Own Eyes* for *Art in America* and suggested that he write another book, this one on Lygia, Oiticica, and David (he replied that he had been thinking about it himself but saw it rather as three separate essays plus an introduction).

We were both very busy that spring, so our correspondence slackened again somewhat. On July 15, 1987, he wrote that he liked my review (the draft of which I had sent him) but was otherwise untypically discouraged about the text on Lygia that he had had enormous difficulty writing for *Third Text* over the previous two months. The journal's editor, he wrote, hated it despite multiple revisions, calling it "intellectually weak, timid, opaque, lacking critical distance, and various other pejoratives":

> I actually can't take a critical distance on Lygia's work since I identify with it so strongly, and want at this stage just to present or explicate it. [ . . .] I can't discuss Lygia's work with reference to psychoanalytic theory, representation theory, theories of sexuality and so on. Either the piece does have some other quality (I think it has a speculative, thought-provoking, poetic quality [ . . .]). Or else it's theoretically naive and simplistic, in which case it's damaging to Lygia's work. I don't know, I can't see it clearly any more.[28]

I sympathized, of course, having experienced a similarly paralyzing "lack of distance" with regard to Lygia's work—but I was glad that Guy was at last owning the poetic stance I had always admired in his critical discourse.

This fit of blues would last longer than usual; we kept exchanging pieces we were writing, but by his own account Guy was not very prolific for several months. His enthusiasm was rekindled, as so often, by a collaboration with David (he had taken photos with him—which means he was the cameraman— and planned to "do a piece about his 'photo-works,'" which would be baptized

*Medalla's Impromptus*).[29] The commercial success of *Through Our Own Eyes* in the United States was also a boost, and he exuded gratitude when my review was finally published in the October 1987 issue of *Art in America*:

At first glance, the ambiguity of Guy Brett's title is irritating (to whom does that "our" refer?); and even after his title is deciphered ("our" equals "their," and refers to the amateur artists whose works are discussed and reproduced), it is still annoying because of the spate of good intentions that it appears to summon forth. However, those ambiguities and irritations themselves reveal the difficulty of Brett's self-assigned task: without trying to hide his own role in selecting the diverse genres of popular art he describes, he wishes to analyze that work from the point of view of its creators. This predicament is the scourge of ethnographers, with whom Brett's project has something in common; indeed, it's no accident that in the single case where he could not himself carry out an in-the-field inquiry (the Shaba painting of Zaire), Brett, who is a former art critic for the London *Times*, drew on the work of two anthropologists for his source material.

Brett's approach is as far from the humanism that has sustained the recent wave of interest in "primitive" art (exacerbated by the encyclopedic exhibition at MoMA two years ago) as from the formulaic incantations of political discourse. For example, Brett shows how the vision of Africa as a land with neither history nor modernity is a product of colonialism; but he also shows how the popular art created in Africa today presents a more accurate picture of the complex transformations undergone by that continent than either the image found in the media or the one that emerges from the slogans brandished by Western anti-colonialists. Profoundly dialectical, Brett's book provides a lesson in tact: the author doesn't speak for others; instead, he tells us what the art of others has taught him about the very conditions of its creation. Without imposing our own formal categories on these works, he attempts to see them as they themselves wish to be seen—namely as documents which in their own way constitute a truthful discourse. When Moriaki Kawamura, chairperson of the Hiroshima Peace Culture Foundation, told Brett that he should "use these pictures with the utmost care so as not to wound [the] susceptibilities [of their makers]," he couldn't have addressed anyone more scrupulous in his respect for the intentions of others.

Brett's book consists of a general introduction, followed by five chapters, each of which deals with a specific artistic production that has, or has recently had, a significant impact, even if that production is generally unknown within the confines of the art world. The bodies of work treated

include: the *arpilleras* (patchwork pictures) that Chilean women began to embroider soon after the coup that brought Pinochet to power; the paintings done by Chinese peasants of Huxian during the time of the Cultural Revolution; the movement of popular painting that erupted in Zaire after that country's independence from Belgium was declared in 1960; the visual records that the survivors of Hiroshima and Nagasaki began to draw 30 years after the fact; and the agglomeration of objects and images on the perimeter fence of England's Greenham Common, the proposed site for an Anglo-American nuclear missile base (in December 1982 the fence was transformed by 30,000 women into an arena for protest). Nothing, a priori, stylistically links any one of these productions to another. The "naive" charm of the *arpilleras* (which effectively contrasts with the brutality of the events they represent) stands at a great remove from the hallucinatory precision found in the visual recollections of the survivors of the Bomb. And despite the similarity of their messages (condemnation of the use of nuclear arms), the latter drawings have nothing obvious in common with the vast collage of dolls, clothes, postcards, photographs, drawings or other personal belongings attached to the nine miles of fence encircling a wasteland destined to receive 96 American missiles.

Although the label "naive art" could serve to define the common characteristics of a painting by a Chinese peasant and another by an amateur Zairean artist, Brett nevertheless insists upon the danger of this kind of non-discriminating assimilation. He is not only concerned about the risks of setting an art market onto works whose distribution methods have, until now, for the most part protected them from the market's greedy grasp (and, indeed, that isolation has contributed a certain power to these works). What distinguishes the images he discusses from those of, say, the Douanier Rousseau is the specific manner in which they recount particular events: rather than attempting to encode the atemporal essence of a tree or a tiger, these pictures depict a swarm of flies pullulating around the only toilet in a Santiago shantytown (or the line formed in front of the region's only water faucet); or they focus on the shoes of Chinese peasants, who have left them near a gas lantern while they water their fields; or they show the passivity of a white colonialist, who is present at the whipping of a prisoner by a black policeman; or they reveal the hair standing on end and the tattered skin of a victim of the Bomb.

Picturesque detail has always been essential to the success of so-called "naive art," but here such detail consistently refers to a specific historical experience whose distinctive feature is its collectivity; if the photographs

of loved ones are among the most recurrent elements of the Greenham Common collage ("I am here for these, my 6 grand-children" reads one poster on the fence), it's because individual lives give meaning to this protest movement through their collective impact. "Making society the concrete and the individual the abstraction," such is one of the common features, according to Brett, of the diverse artistic enterprises he describes.

The corpus of Brett's study is strictly defined: it deals with the work of "self-taught or untaught artists expressing and forming the experience of whole groups of people . . . in the midst of profound historical changes." In each case, this art is the fruit of necessity. It was the mothers of "the disappeared," along with the wives of unemployed shantytown men, for example, who launched the *arpilleras* movement. For both of these troubled groups, their regular meetings for sewing and embroidery—among the few permissible crafts for working-class women in Chile's macho society—functioned at once as group therapy and as gatherings for political self-initiation. The *arpilleras* humorously recycle consumer society scraps to make politically incisive statements about life in Chile; but because of their childlike and coded style (and their distribution by the church), these patch-work pictures have been able to effectively defy government censorship.

Each case discussed by Brett reinforces the main argument of his book—that the relationship between the *global* and the *local* has profoundly changed in today's world: it's because the art of the avant-garde seeks more often than not to be universal that it no longer has much connection with the actual conflicts of our society; on the other hand, it's because they are integral parts of microcultures or of specific political struggles that the works analyzed by Brett directly concern every one of us. It's exactly because it took place in an out-of-the-way corner of the English countryside that the happening-collage of Greenham Common could focus attention on the planetary threat of nuclear arms. And it's because they are so personal ("What I saw at Kyobashi-mashi . . ." is the caption of one work) that the accounts of the survivors of the Bomb are able to collectively fight against a general amnesia.

Another argument of Brett's book is that the media lies, that photography captures action from a distance (a refutation of Walter Benjamin's utopian view of the liberating status of mechanical reproduction), and that professional artists embellish or create pathos; conversely, Brett sees the works in his book as bearing witness "from the inside": to him they are a battle over the issue of representation, a popular reappropriation of the capacity for expression that, as a result of capitalism's division of labor, has been restricted to

a small minority of artists. Only a peasant knows the priorities of the world of agriculture—the importance of diversity in repetition; the authoritative role of ordered containment in the human mastery of nature; amazement at the abundance that new technologies engender. The decorative sensibility in the paintings of Chinese peasants, which emphasize the group and gesture more than psychology or physiognomy, reveals more about their way of life and their aspirations than those "social-realist" murals created at the same time, in which peasants are depicted as sympathetic heroes. But this accuracy of expression derives from the non-hierarchical production mode of all the genres of art that Brett describes: whether anonymous (Chile) or signed (Zaire and China), the works in hand are constantly rectified by the community whose sufferings or dreams they illuminate; whether for sale (Chile, Zaire) or not (Japan, England, China), they acquire their meaning only by strengthening the identity of that community.

A good deal more could be said about Brett's beautiful and moving work. One should note that the author in no way seeks to establish the artistic practices that he has inventoried as a prescriptive model; more than anyone else, he would be saddened if today's "postmodernists," under the guise of pluralist ideology, were to exploit the "oddities of figuration" of these artists in order to add one more *frisson* to their cynical strategies. The primary purpose of Brett's study is to acknowledge the vitality of a certain type of popular culture, a visual practice that attempts to break the wall of silence. And his report, in spite of the hardening of political struggles at this century's end, is in itself an optimistic gesture.[30]

Contrary to what we had both expected, I went to see Guy in London (during Christmas break) before he could take his long-planned trip to the United States and visit me in Baltimore (in April 1988), then fly to Caracas and from there again to Brazil (in preparation for the famous exhibition *Art in Latin America*, curated by Dawn Ades at the Hayward Gallery, for which he had somewhat reluctantly agreed to organize the section on kinetic art). The long letter he wrote me on his return to London, on July 22, 1988, is very emotional: He had learned of Lygia's death on his way to Caracas and arrived in Rio just in time for her funeral (of which he provides a horrifying description à la Daumier—"I had an insight into the sort of milieu which Lygia had broken away from," he adds).

In the same breath, he announced that he had just submitted a piece on Oiticica to *Art in America* ("It's been a big stimulus to write something for somewhere far away from London"); provided comments on my essay "Perceiving Newman"; sent me a 1972 interview of James Baldwin by John

Hall in the African journal *Transition* (in response to remarks I had sent him about this writer, in whose work I was engrossed at the time);[31] asked me what I thought of a request he'd received from *Les Cahiers du Musée National d'Art Moderne* to "write something for the issue they will bring out at the time of the Centre Pompidou's awful sounding *Magiciens de la Terre* exhibition next year"; and informed me that David had told him rather unceremoniously that he wanted me, and not him, to write on a piece he was preparing for a show curated by Chris Dercon at the Clocktower in New York. ("Well, he's the second one in a week who's told me he's tired of reading Guy Brett on David Medalla. Certainly I would love to read what you would say on such a body of work.")

This was not to happen (as far as I recall, there was no publication), and eight more years would pass before I would write something on David. During this interval, my correspondence with Guy (and his with me) remained spotty, partly because we had begun to phone each other, partly because we managed to see each other several times on either side of the Atlantic, but mainly because we both had too many things on our plate. We kept sending each other our texts, Guy almost always laudatory about mine but often stricken by doubts about his and, indeed, about our role as critics. He had been exhilarated to curate the exhibition *Transcontinental: Nine Latin American Artists* ("it was in Birmingham and Manchester simultaneously [March 24–April 28, 1990] and all nine artists came over to install their work and even make parts of it"), and rightly so, as the book/catalogue he wrote for it represents perhaps the first serious discussion of the issue of globalization in contemporary art (it was certainly conceived as a response to *Les magiciens de la terre*), but the string of invitations that kept coming his way to do more of the same was weighing on him. A letter he sent me on January 31, 1992, mentioning the (crucial) supporting role he played in the touring Oiticica retrospective of 1992–94, provides a good aperçu of his frame of mind:[32]

> I've been given all these opportunities recently to write on the work of people formerly marginal to the art world—Brazilians, Chileans—but I'm beset with doubts: I'm only helping to "sell" them as new products in the bloody art world which hasn't changed and will only absorb them on its terms (writing which one thought was elucidatory, precise, "resisting," begins to look like very subtle advertising copy). I've been constantly in doubt about my involvement with this Oiticica exhibition. Is it a betrayal? how can one re-present his position—non-commercial, non-consumerist, participatory—in the conditions of 1992? And yet I can't accept an amnesia about the position he/we took.

Despite these serious concerns, passages of this sort were usually followed by lighter touches, such as the line following this paragraph, with which he

concludes his letter: "Your Lygia Clark piece reminded me of a 'cell' out of which we both grew, and the feeling of friendship warms at the thought of visiting you."[33]

I am not sure what he meant by my "Lygia Clark piece" (it seems too early for it to have been the all-too-brief introduction I wrote for the anthology of her texts that I published in the Summer 1994 issue of *October*, but it is not impossible, given the pace of the journal's editorial process). In any case, this casual remark prompted us to envision co-authoring a book on Lygia—we were dismayed by the way her work, to which people were finally paying attention, was linked to many art labels ("body art," "performance art," "feminist art") to which we knew she was fiercely opposed.[34] This was a project we would discuss for many years, envisioning all kinds of ways we could stay for a few months in Rio and do research together, but in the end we were too discouraged by the internal disputes of the estate, as well as all sorts of conflicts between supporters of her work in Brazil, of which we wanted no part.

The one project of his to which I was able to lend a modest contribution in the form of a postface was his monograph on David. Guy had long hesitated to ask me (for months I had been completely absorbed by the preparations for and catalogue of the Mondrian retrospective that would open in December 1994 in the Gemeentemuseum in The Hague before traveling to the National Gallery of Art in Washington, DC, and to MoMA), but David had continued to bug him, and in hearing Guy shyly make this request over the phone, I could not but give in. He immediately sent me a note of thanks (on September 28, 1994), with specifications about what he expected:

> Please feel absolutely free to say what you like. It could simply be your response to the book. Or it could be a reminiscence. Some who have read the book find it very "romantic." I don't know about David, but I suppose I am romantic. I expect you will immediately have a sense of the dilemmas, conundrums and unanswered questions which underlie an attempt to make an "art in life." I imagine a length of c. 500 words—but more or less if you like.

> I think certain passages will make you smile. Read the book as a leisure activity. Creleisure?? But, as you read, en passant, please tell me of anything which jars with you. David's things are often on the edge of absurdity. Or, like a joke, if they are not told well, they fall.

It was perfect timing in a way—the Mondrian catalogue was done and I was in the very preliminary stages of the exhibition *L'Informe: Mode d'emploi* that I was to curate with Rosalind Krauss at the Centre Pompidou, and in which I wanted to include some of David's early works.[35] But if the timing was right,

the amount of time I was given to produce the piece was not. Guy negotiated an extension for me, but only of a few weeks. Even though it was a short text, I found it hard to write and discarded many drafts until I jotted it all down in a single sitting one morning in early December. I sent it off to Guy on December 8, 1994, with some trepidation. He responded by fax the next day:

> I don't think your piece is horrible at all. I am extremely intrigued by it. [ . . . ] You have tried to be honest and what is intriguing is that, in interpreting David as a story-teller, you have made your own, or a further, story, or fiction.

> I think our two different texts are in interesting counter-point. In fact the three texts, including Dore Ashton's that is, are in counterpoint and represent three different stories—three different literary constructs or conceits almost—about the nature of imagination which David's "work" has made us think about, and our different understanding of what you call the "virtual" aspect of his work. Ashton, for example, refers to him as a "luftmensch," or impractical dreamer, and her tone is celebratory. You call him "the only real conceptual artist." I think I based myself as much as possible on the material evidence and diversity—I couldn't see it as virtual without this material component—but even I ignored a great deal of David's actual physical production.[36]

Just a week later I was in London for a lecture I had to give at the Courtauld on Mondrian (on my way to the opening in The Hague), and as usual I stayed at Guy's. That is where I realized that the entire beginning of my text on David had to be scrapped: I had cast myself as a doubting Thomas over the many "performances" of which I thought the only existing traces were David's own fantastical descriptions or scenarios scribbled in his notebook, only to find out, perusing Guy's vast photographic documentation, that many had actually taken place! (In retrospect, it is surprising that David never protested about my initial take, claiming all along that he liked my short essay. I think that it was during that same trip to Europe that I stayed for a night with him in a sumptuous apartment that a friend of his had lent him on the posh Place Vendôme—the last time we had a long one-on-one conversation—during which he raved about this first version.) Guy kindly helped me with the surgical editing, and the text that follows was promptly sent to the publisher under the title "Virtual."

> Though I've known David Medalla for years (we met fairly regularly during the Seventies–each time he came to Paris or I went to London), I've actually seen only a handful of his works. And nothing major at that–a few drawings from his militant period (when he was trying, or pretended to be trying, to lure me into the Maoist faith); a not-so-good sketch of myself in my early twenties

(I still have it somewhere, one of the rare evidences that I once had a beard); and then the fragile paper masks, cut out of magazines, that Guy Brett pulled out of his travel bag to show to me and Rosalind Krauss, two or three years ago, in a quaint British-looking tea house near La Madeleine in Paris. Of course I'd seen many photographs over the years—from the bubble machines of the early Sixties up to fairly recent performances—but photographs don't say much about his work (photography can't say much about flux, duration, exchange—the stuff of David's art). Furthermore, these photographs only concerned a limited proportion of his output, indeed a far smaller proportion than I thought before reading the present book.

And yet, contrary to my habit of never writing on anything I have not experienced directly and scrutinised inside out, I would not find it particularly immoral to do so on David's work. This does not mean that I would feel very competent—though, among many other qualities, Guy Brett's study enormously raises the level of my putative competence by the sheer quantity of information it contains. It just means that, in David's case, not having actually seen much of his work does not seem to constitute a confounding handicap, should I have to write about it—and this, for me, despite years of Conceptual Art, is a first.

Before reading Guy Brett's book I had often wondered if David's work, notably his performances, had ever really taken place. But I had concluded that it did not matter much, that language was the true medium of David, that his real performances were his narrations, that it was in relating them, always existing fully in his mind, always replete with multiple layers of allegory, that he performed them. David-Sheherazade: the way he knits his elaborate descriptions, unfolding one after the other the various semantic realms that are intertwined in any of his works, the rhapsodic structure of the tale. This always mesmerised me, as it did others.

In the Seventies David often carried with him a notebook, all scribbled up, filled with the script of one or another of his performances, and would read from it eventually, more often than not extrapolating from it, but always telling about events—past or would-be ones, without distinction. The quintessential oral poet, the storyteller, the seducer.

Guy Brett's study both contradicts such an impression and confirms it at what, for me, is a deeper and more paradoxical level. The book abounds with evidence that testifies to the reality of Medalla's work. Something has existed, and still does, though it is in some way intangible. To be sure,

41

objects have been made (and have been remade, occasionally, if the original was destroyed), performances and intricate participatory pieces have taken place. One of the functions of this book is to attest this, providing a unique eye-witness account.

Yet at the same time, Brett's tale does not diminish, even enhances, Medalla's predilection for fantasy and imaginative projection. Alluding to the ephemeral status of performance as an art form, Brett notes that "even the inventory of over 150 of Medalla's performances evokes something that cannot exactly be verified." The virtual aspect of Medalla's work is underscored everywhere in this book, with numerous examples of unrealised (though not always necessarily unrealisable) proposals dating from the early Sixties to the present: David, the only real conceptual artist, for whom it is enough to think of a project.

One of the structures of Medalla's poetics so perceptively described by Guy Brett is that of the "meeting." Accounting for its open-endedness, the sense of infinite unfolding that it entails (the "and then, and then" of David's narration), Brett also speaks of David's work as vastly metaphoric. But metaphors are usually not open-ended: something stands for something else, something is as something else, yet for a metaphor to work and be recognised as such, the circularity of exchange has to be arrested at some point, the chain of signification has to be broken. Medalla's work, on the contrary, proposes an endless story, that of a *perpetuum mobile*, a universe where particles rebound *ad vitam aeternam*.

In other words, Medalla builds indeed on metaphors, vast amounts of them, but I would say that it is in order to destroy metaphor per se—by excess. It is to annihilate any metaphoric centre by the sheer vastness of possibility. The "and then, and then" is designed never to stop. Which is why Medalla's participatory pieces are so cogent, why they work—unlike so many other works based on the "spectator's" participation in the Sixties and Seventies. Which is also why his work, contrary to appearances and, no doubt, to the claims that have been or will be made about it, does not provide an apologetic discourse about identity (national, racial, sexual, social or otherwise). "There is no place for static identities. . . . Everything is in constant flux," Medalla is quoted as saying. In order to cancel any identity, one has to cancel as well the structure of oppositions on which metaphors are grounded: David's strategy is that of superabundance.

This dissolution by excess is perhaps more easily explored in art than in writing, for the infinity of language is daunting once its economical rule is

broken loose. David is not the only artist to have engaged in it (one can find traces of such a radical poetic in Duchamp, or in Cage or in Fluxus for example), but to my mind he is certainly the one who carried it further and constantly remained faithful to its liberating principle: his deliberate defaulting of the laws of the art market, his nomadic refusal to remain any bit more than a fleeting moment in any place he might be assigned to by the artistic institution, in sum the casual and (somewhat heroic) detachment with which he managed his career—those were the weapons by which he consciously insured the success of his undermining enterprise.

Nothing was ever allowed to freeze, even if a lack of public recognition was the price to pay for adhering to this axiom.

Medalla invented, for me, the practice of virtuality.[37]

Alas, the printing was delayed multiple times, and it would be another full year before *Exploding Galaxies: The Art of David Medalla* finally came out. (I was none too happy about having been forced to concoct something at top speed when I could have taken my leisurely time authoring something a bit more consistent—in any event, this was not Guy's fault.)

Our exchange of ideas concerning David (and Lygia, for that matter) continued unabated. A great deal had to do with the *Informe* show—I was desperately trying to find a way to include one of David's *Bubble Machines* in the exhibition, but the only extant one was in Auckland and was too expensive to ship on our modest budget. Instead, one had to be fabricated for the occasion (neither I nor the artist was ecstatic with the result; on top of looking too slick, this version turned out to be extremely high-maintenance). I also sought Guy's advice about how to display Lygia's work from the late '60s and '70s in the show, knowing full well that the solution that she had come up with in the only retrospective she'd accepted during her lifetime would not do in Paris. (In that exhibition, a joint Oiticica/Clark retrospective curated by Luciano Figueiredo and Glória Ferreira in Rio and São Paulo, original objects—or rather non-objects—were displayed together with vintage photos of their manipulation. Scattered on tables next to these exhibits were not only duplicates to be handled but also, for the simplest of them, material from which to fabricate copies, so that one could get, if desired, a sensual experience approximating that of their early handlers).[38] Guy was tackling the same issue as a consultant for Paul Schimmel's *Out of Actions* show for LA MoCA (it opened in February 1998), and he was as pessimistic as I was, for my own show, about any possible outcome. An interesting moment in our dialogue, counterbalancing Guy's gushy comments on my essay for the Mondrian retrospective, which he saw at MoMA

after visiting me in Cambridge, was his January 22, 1996, criticism (soft-pedaled but nevertheless very acute in its specificity) of my take on David's early work in the draft of the relevant entry in the *Informe* catalogue:

I think your description of David's Bubble Machine itself is pretty accurate (especially its slowness, and the bursting and replacement of bubbles) but I think there's only a slight connection with [Pol] Bury. The Medalla is not intermittent, there's really a sort of continuity at various levels of speed. In other words, while one part is barely stirring, another is moving more quickly. Yes, there is occasionally a sudden movement as a section of foam becomes detached and falls to the ground, or falls softly on top of another part, or even floats off semi-sideways in an air-current caused by a draught, or by somebody passing. The great difference with Bury is that Bury's movement, however slow, imperceptible and intermittent, is mechanically produced (limited to mechanical effect, or agency) whereas Medalla's responds to the environment and the spectator—wind, atmospheric pressure, gravity, etc—and you are free to plunge your hands in the foam or scoop a piece off, etc. It really behaves differently on different days and in different places: this is its organic analogy, to a degree of considerable subtlety—eg, being lethargic or patchy on one day, and copious or beautifully rounded on another. There is a dialectic between mechanical repetitiveness and the random. David definitely aimed for a "peaceful" movement, in contrast to what he called the "frenetic" quality of much kinetic art, and he had a rationale for this derived from comparing the Western Baroque concept of movement with the Indian and Chinese (see my book page 61). I am sending you a copy of a short text written by the artist Gustav Metzger (the inventor of "auto-destructive art"), written when he first saw David's Bubble Machines in 1964. I have only a very faint copy and I hope it will come through the fax. Also, a short statement David made for an exhibition of kinetic art I organized in 1966. (I can give you precise references if you need them). I hope these might be useful.

The text by Metzger was, alas, illegible, but not David's, which I cannot prevent myself from quoting, as it encapsulates best, I think, the reason Guy had been so immediately taken by his work:

My sculptures breathe and perspire, grow and decay. They correspond to my view of external and internal reality. Naturally I do not see any demarcation between internal and external "reality." For me, interior space and exterior space are mutually interchangeable, in Lygia Clark's words "inside is outside"—and access from this one to the other is made possible through rhythm . . . the continuous, tangible phases of duration. I am interested in the possibilities of spontaneous growth. Like Takis, I sculpt energy. I use the elements—through the elements

I wish to express the dynamism of atomic forces. I seek to find, through these forces, continuous "melodic structures," which could arouse tenderness and love in the brutalized soul of man today.

I did take Guy's remarks into account when revising the text, but he would not be able to find that out right away, as the copy of the catalogue that I gave him in Paris when he came to see the show was snatched up by David—and predictably lost, just as he had done with the copy sent to him. (Guy's tolerance when it came to our friend's antics was phenomenal: "David is excited these days and overflowing with ideas but his cavalier behavior is impossible sometimes" was his mild reaction). I have no recollection of Guy's response to the *Informe* show, which we undoubtedly saw together, and there is no extant letter in which he would, as usual, offer his detailed comments on the catalogue. But the remarks he sent me, also in the letter of January 22, give at least some idea of his reserve. He was responding to a position paper that I had published on formalism (or on my own version of it) in the *Art Bulletin*, and in which I briefly alluded to Rosalind Krauss's analysis of a willful debasement of Pollock's legacy in the production of many artists of the '60s and '70s—an analysis that we had illustrated and extended with our show:[39]

I <u>was</u> amused to read your self-defence-by-attack in the art history journal. I see what it means to be ambushed in the overheated academic corridors and have to fight your way out. I think you convincingly demonstrated how Greenberg failed in his attention to form, and I very much like your sentence "Failing to address the interrogation raised by Picasso's papiers collés on the very nature of the sign and its function of communication, and wanting to make of them the equivalent of 19th century history paintings, are sure ways of remaining blind to their historical specificity." But for me the whole thing is full of ironies, which is why I think we need positions of fluidity rather than antagonistic antithesis. I mean, as I see it, Twombly may have read in Pollock's work "antihumanism, antisublimation and debasement," but Twombly went on to produce very precious, very aesthetic things, not lacking in humanist allusions, and far removed from nonsubjective or cosmic forces! You probably won't agree with that! But I think that Pollock's links to extra-pictorial developments like David's bubble machines or Oiticica's "acting fields" are actually more interesting than links with Twombly or Warhol.

During Guy's short stay in Paris that early summer of 1996, what we did most of the time was talk about our never-to-be project of co-writing a book on Lygia, especially since Manuel Borja-Villel had invited us both to contribute to the ambitious retrospective exhibition of her work that he was planning at the

Fundació Tàpies in Barcelona, where he had previously mounted one dedicated to Oiticica. Guy quickly overcame his reluctance (though he was tired of always being asked to write on the same artists), but I was simply too exhausted from nearly three years of curating (Mondrian and then *Informe* immediately after) while simultaneously teaching, and I bowed out.

We both admired Borja-Villel (or Manolo, as we soon called him), and our admiration never ceased to grow as he later moved on to be the director of MACBA (still in Barcelona) and then of the Reina Sofia in Madrid—a true pioneer, with an exhibition program consistently years ahead of those of his American or European counterparts. (The only miss I am aware of is an exhibition of David's work—Borja-Villel had been very warm to the idea when Guy and I had spoken with him independently about it around the time of the *Informe* show, so the difficulties must have come from David's side). At this juncture, however, we were very curious as to how he would solve the problem of showing Lygia's participatory works (from the *Bichos* on), not to mention her later post-object "propositions," to use her word. That issue, and how to prevent the commodification as well as academicization of her work, never ceased to obsess us, and for the next two years they were the topics we most consistently discussed in our correspondence (besides our plans for the book on the artist and various attempts at enticing a museum into a show of David's work). The following summer, for example, shortly after visiting Guy in his new house (he had moved to Chalk Farm, in North London, a much quieter area than Brixton), I went to see Documenta 10 in Kassel and wrote him about how disgusted I was by the way Lygia's work was displayed. Going there himself a couple months later, he shared my sentiment, to the point of writing a furious letter to the curator. "The only good thing one could say, perhaps," he wrote me on August 22, 1997, "is that Lygia's section gave Borja-Villel a sharp negative lesson and made him determined to attempt something better. We'll see."

Three months later, he was relieved to report that Manolo's show was as good as it could be "in an institution" and that it held its own in comparison with the 1986 retrospective in Rio and São Paulo mentioned above. Viewing again Lygia's rare *Casulos* [Cocoons] (reliefs from 1958 to 1965) next to videos documenting the use of what she called "relational objects" in the therapeutic practice in which she engaged at the end of her life, Guy had "suddenly felt that all Lygia's transitions or leaps had contained a certain sadness at leaving something behind: here leaving behind the Pictorial—where, in fact, there was still much she could have done" (November 5, 1997).

Guy tried to rope me into a series of symposia on Lygia that he was asked to organize in Barcelona, then in Marseille (the show's second venue), but it was absolutely impossible for me, as I was in the throes of curating a Matisse/Picasso exhibition for the Kimbell Art Museum and writing its catalogue. I

finally managed to attend the third and final round in Brussels, where I went for a quick trip in September 1998, I think (I remember my frustration at not being able to linger at leisure in the exhibition with Guy and David and instead having to rush back to my hotel room in order to correct the final galleys of my Matisse/Picasso book). I did find the time to review the exhibition for *Artforum*, though, but was not terribly satisfied with my piece. (Guy's comment was diplomatic: "I did see your Lygia review. It was good but I think that you have not yet had the opportunity to write about Lygia as you would really want to.")[40]

It is in the same long letter (March 28, 1999) that Guy first laid out the project of an exhibition he had only alluded to when we met in Brussels and that he was now proposing to Manolo, who had just moved to MACBA: "The show is on a theme which has always intrigued me: a thread of 'cosmic speculation' running through twentieth-centurys art, art works as 'models of the universe'. (Language like this is too poetic for Manolo, and he is always pressing me, probably rightly, to ground the selection of works in a logic which has historical validity)." After jotting down a sentence (quoted earlier) about his text on agriculture and decoration for *Macula* as being akin to what he had in mind for this exhibition, Guy turned slightly more specific:

The nucleus of the show is two bodies of work: Calder's very early mobiles, before he went naturalistic, when he was inspired by astronomy; and Vantongerloo's post 1945 painting and sculptures (the atomic bursts and the little nucleuses and universes). Neither body of work is over familiar. Then it will branch out with a re-evaluation of the best in kinetic art: 1960s Takis, Tinguely, Soto, Medalla, etc (ie, the "moment of discovery"). Actual movement will be intricately related to a large collection of static works, mainly drawings: eg Michaux's mescaline drawings, certain Wols "plasma" etchings, Matta-Clark's "arrow" and "force-field" drawings, Gego, Fontana, Schendel and others: all transcriptions of energy in very direct but very different forms.

The paradox is that the more you enter into the cosmos the more you enter into your own mind: a conundrum for today's physics. I think that Ad Reinhardt was very aware of this and I would like to include his Black paintings (although Manolo will need persuading). You probably remember something very brilliant which Reinhardt said about Chinese art: "The Eastern perspective begins with an awareness of the 'immeasurable vastness' and 'endlessness of things' out there, as things get smaller they get closer, the viewer ends up by losing (finding?) himself in his own mind." (1954)

I think the core of the idea is good. The problem is setting limits. This is what I'm grappling with at the moment. I'd be extraordinarily interested to know of

any thoughts, positive or negative, that this subject prompts in you, or any artists who I might have forgotten.

I responded enthusiastically, telling him how much I had always been fascinated by those late Vantongerloos, which I knew mostly from reproduction, but warned him about the difficulty of obtaining loans from the estate. I added:

> As far as missing artists are concerned, I thought of Len Lye (is that the way it's spelled?) I remember visiting him and he had tons of interesting little films), perhaps of early Hans Haacke, and Gutaï. You probably should have one Pollock, since he did talk about cosmic energy. I'm sure there are other things (one problem is Yves Klein, hard to avoid but also hard to include because of his mystical/rightwing shit). In any case, I'll keep thinking about it. Who is Gego?

As usual, Guy had gently nudged me to write for the catalogue, and I said I was interested but could not make any promises. In retrospect, I am stupefied by my question about Gego: I am baffled by the fact that as late as 1999 I still did not know who she was.

Guy's follow-up letter—the first to arrive by email, on April 20 (we would not be true e-correspondents for another six months or so)—is to be quoted almost in full:

> Your letter cheered me greatly. It was very gratifying to know that you liked the idea of the show I'm doing. I'd only outlined it sketchily, so I was delighted that the artists you suggested—Len Lye, early Hans Haacke—are already on my list (Manolo Borja remade two very large early Haacke's, a floor-level piece of wind-blown cloth, and a large layout of branching capillary tubes, for a previous show at Fondacion Tapies). I'd wrestled with the idea of Pollock, and even decided there should be one! Of Yves Klein, I'm thinking of including a group of "fire-paintings" (really, scorched surfaces, but elegantly so) because they are both "cosmic" and not nearly so well-known as the blue monochromes. Gego, incidentally, was a Venezuelan artist, a German immigré (contemporary of Soto). Her work is uneven but she did some beautiful metal net-work constructions she called Reticulareas (late 60s, early 70s). All the pieces are joined by a simple articulated joint she invented. But it's her drawings I'm particularly keen on for this show.
>
> It's marvellous that you might consider writing an essay. Manolo, too, is very keen on the idea. Let me tell you a bit more about the idea for the show—so you can gauge if you find it sympathetic enough. First, I'll give an alphabetical list of the artists (not completely complete yet): Brancusi, Bury, Calder, Camargo,

Clark, Denes, Duchamp, Fontana, Gabo, Gego, von Graevenitz, Gysin, Haacke, Hoenich, Houedard, Klein, Le Parc, Lewitt, Li Yuan-chia, Lye, Malevich, Manzoni, Matta-Clark, Medalla, Michaux, Moholy, Mondrian (?), Morellet, Pollock, Réquichot, Schendel, Soto, Takis, Tinguely, Tobey, Vantongerloo, Wols. There will probably be another curator to organise a film-programme.

The first thing to say is that it's highly selective within the work of these artists. I'm choosing certain works by some artists whose remaining work I often don't like. The second thing is that I want to bring together artists who have always been considered poles apart, opposites, as a paradoxical way of exploring this theme of the "universe," and energy. Take, for example, Morellet and Michaux. For this, I want to have 3 or 4 of Morellet's Trames paintings of 1958–60—those square canvases in which he simply applied a system of straight lines crossing one another to produce a field of visual energy, and a group of Michaux's Mescalin drawings of the mid-50s, which are also extraordinary transcriptions of energy, but coming from a sort of hallucinogenic/ psychosomatic abandon or automatism to set against the supposedly fully-conscious rationalism of the Morellet.

I'm hoping these juxtapositions would perform a kind of conjuring trick . . . to avoid the boring aspects of both "concret" and "informel," and change both into something else. The amazing, and rather weird, thing is that opposites keep colliding: for example there is an element of "automatism" in the method of Morellet, since he is working with a system which has "a very large variety of configurations . . . to such a point that it would not always be possible to know what the result would be beforehand." Vantongerloo is a guiding figure because in those late works there is a sort of personal intuition of the equivalence of biological and electromagnetic energies, which of course you also find, in different ways, in Fontana (pierced paintings around 1960, and drawings), Takis, von Graevenitz, Manzoni (Achromes with little polystyrene balls), Schendel, etc. Scale I'm also mixing up, from a vast machine like Len Lye's Universe to a tiny microcosmic Wols (I'm choosing only Wols's abstract pen doodles of "plasma"). Also the tiny Wols is very comparable to the vast Pollock (as Oiticica pointed out in the early 60s). Etc, etc.

I don't know if you will think these ideas have "historical purchase" (that's a phrase I took from you, from your review of Supports/Surfaces when you spoke of "strange stylistic amalgams that have little historical purchase").[41] But perhaps you would find it interesting to look in a fresh way at the history, to look with a certain ironic detachment (but with specific documentary detail) at the polemics that divided tendencies, and rescue perhaps something larger which has been obscured by every kind of vested interest.

For several months Lygia and David took a back seat in our exchanges. However, we did have to get involved, often by phone, as facilitators in negotiations between various institutions and the Clark estate (Guy on August 12, 1999: "It has only gradually hit me that we've entered another era with the phenomenon called 'Lygia Clark,' full of almost tragic ironies"), and Guy kept me informed about David's activities. (During one of our phone calls over the summer he briefly mentioned David's ironic new project of a "London Biennale." At my request he sent me more information, which I forwarded to an editor at *Artforum* who ended up commissioning a piece from him about it for the journal.)[42] Most of what we discussed until the opening on April 18, 2000, and even beyond was Guy's show, which at some point had acquired the title *Force Fields: Phases of the Kinetic*, and in which both Lygia's and David's early works were of course included.

Since Guy wanted me to write for the catalogue, he kept sending me material—notably about artists whose work I told him I did not know very well (if at all). His enthusiasm as a scout always fascinated me—and this until the end of his life (I experienced it once again during the last visit I paid to him, a little more than a year before his death). Every time I came to visit him he showed me works of young artists I had never heard of. On January 1, 2003, for example, speaking about an artist Guy had written about in a recent exhibition catalogue but whose name I did not remember, I noted: "I liked this drawing you showed me—as a matter of fact I don't remember not liking the work of an artist you had found. I always admired your scouting flair, it presupposes a kind of optimism that I seem to have lost, which is why I became a historian." He wrote back two weeks later with a brief memo about the artist and his show,[43] adding:

> I've been thinking about what you wrote (and you've often said this too) about me being an optimist and you a pessimist (or, maybe not pessimist, but not able to feel optimistic). These words are a typical case of opposites that slide into each other. I'm actually very pessimistic, about the whole world situation, but the only way I can deal with my pessimism is to be optimistic, to look for, to crave, hopeful signs (they could be a very brilliant text or just a gesture somebody made on the bus). If I find an artist whose work I like I feel they are a kindred spirit, dealing with the same dilemmas I'm dealing with, and they become an inspiration. Also, I remember once reading something somebody said about Kropotkin—that he had a "lust for praising." I think I have that in a way too.

Charmed by one of his messages about *Force Fields*—particularly this sentence: "it is partly a re-assessment of early kinetic art but it sets it in a much wider context,

and the irony is that it brings together tendencies which themselves were often convinced they were in violent opposition to one another" (August 31, 1999)—I gave in and agreed to write for the catalogue. But alas, I sheepishly had to renege, and my contribution to this venture consisted mainly in my attempts, some successful, some not, in helping Guy and Manolo secure loans. I made amends, in a way, by going to see the exhibition (in the ghastly MACBA building by Richard Meier) and reviewing it in *Artforum*:

> Kinetic art suffered the unhappy fate of a flash in the pan. Drawing crowds and saturating the art market for a brief moment in the mid-'60s (at least in Europe), it faded from sight as rapidly as it had burst on the scene. Behind the quick demise was the confusion with Op art in the mind of the public, fueled by exhibitions such as *The Responsive Eye* (MoMA, 1965). Because kinetic art was (wrongly) perceived as an art based almost entirely on easy optical tricks, it would soon be trashed as utter kitsch, on a par with such risible by-products as the Courrèges dress and the lava lamp. The kiss of death was the awarding of the Grand Prize for painting at the 1966 Venice Biennale to Argentinean artist Julio Le Parc, followed two years later by Nicolas Schöffer winning the prize for sculpture: Through the official success of these two mediocre artists (though it should be said that Le Parc did produce some interesting work at the very beginning of his career), kineticism came to be seen as an art of gadgetry.

> Guy Brett stands out among the very few critics who never lost faith, in great part because he had done his homework. In *Kinetic Art: The Language of Movement* (1968) he completely dissociated its topic from the discotheque bedazzlement offered by Op. Unfortunately, Brett's slender volume appeared too late in the game for anyone to notice. The main protagonists in his story were Lygia Clark, Hélio Oiticica, and David Medalla (Brett, more than any other critic, has helped further the reputation of these three artists); Pol Bury, Sergio Camargo, Gianni Colombo, Liliane Lijn, Mira Schendel, Takis, and Jean Tinguely were the supporting cast. The same names show up in *Force Fields: Phases of the Kinetic*, the superb exhibition Brett recently curated for the Museu d'Arte Contemporani de Barcelona, where I saw it, and for the Hayward Gallery in London, but many others have been added, forming a wholly unexpected constellation. The result is revelatory: At least bad timing will not prevent Brett's voice from being heard.

> It should be noted here that what's at stake for Brett is less "movement" per se than "energy"–the specific desire of a tremendous number of artists in

the twentieth century to materialize energy, to give form to something that is eminently nonvisual. Movement, in this account, is only one of several formal possibilities in this quest, but a particularly efficient solution; no matter how concrete, movement can always be expressed as an equation, like energy itself. The qualities that define movement (slow/fast; continuous/discontinuous; regular/irregular; accelerating/decelerating; etc.) are shared by every object or being that produces and expends energy. This very universality, which is an abstract quality, makes of movement an ideal metaphoric switchboard: Every work exhibited in "Force Fields" alludes to either the organic, the mechanic, or the cosmic—in all cases concepts of energy that we, as human beings, have learned to apply in our daily life without a second thought. One of the premises of the exhibition, writes Brett, is that "artists, no less than scientists, make 'models of the universe.'" Some of these "models" are dinky, others grand, but their vast stylistic range underlines all the more how serious and steady such a metaphoric impulse has been.

The visitor to "Force Fields" enters the exhibition by moving through Jesús Rafael Soto's *Penetrable*, thousands of thin plastic tubes hung from the ceiling (a re-creation, in fact, of the artist's great invention of the late '60s): The room's atmosphere becomes vibratile, and one is transformed into a passerby from Boccioni's *States of Mind: Those Who Stay*, walking through solidified rain. On each side of Soto's piece replicas outdo their originals: The viewer can at last see Duchamp's 1920 *Rotary Glass Plates (Precision Optics)* at work (the fragile original, at the Yale University Art Gallery, is only on rare occasions set in motion), and László Moholy-Nagy's *Licht-Raum Modulator* (Light-space modulator), 1922–30, is exhibited according to its author's intentions (at least to one version of his specifications)—that is, rather than being enthroned, inert, in the middle of an evenly lit museum space, as it is in the Busch-Reisinger Museum at Harvard, it is a prop projecting its multiple cast shadows on the surrounding walls of a large room (the fact that the room is circular in Barcelona, accentuating the distortion of shadows, significantly helps deflect our expectations). One feels grateful that these two famous automata have had some of their disquieting goofiness restored. But there is more: On exiting Moholy-Nagy's circular room, one immediately stumbles upon an extraordinary series of colored Plexiglas and wire objects, as well as several paintings, realized by Georges Vantongerloo after World War II. Rarely exhibited, these garlands of prisms and translucent loops—not to mention one of the few figurative works in the show, *The Comet*, 1962—remind us that the Paris-based Belgian artist developed a deliberately childlike vein after his De Stijl years that makes him the Douanier Rousseau of the Space Race era. Though three neighboring early '30s Calder mobiles

are in no way insignificant, the Vantongerloo ensemble steals the show and sets the tone for the rest of the exhibition.

After this debut, chronology is not the major issue, though Brett's foray is tinged with nostalgia, particularly for work from the '50s and '60s. It is clear that he endeavored to rescue from oblivion a whole array of artworks (though his lifeboat was not directed toward the artists themselves, as some of the show's heroes didn't produce much of interest after the period). Brett succeeded with utmost brio, and I can foresee the pile of dissertations that will stem from the exhibition. His strategy was simple: Instead of overkill, he selected the best works and, through startling juxtapositions, electrified them. For example, the slo-mo of the early Burys—particularly *Ponctuation (points blancs)*, 1964, in which the movement of one among tens of thousands of tiny white dots, always unforeseeable, mercilessly teases the viewer—is set against the jazzy effect of Francois Morellet's 1958–60 grids. The latter are in turn compared, in a magnificently eye-opening move, to Henri Michaux's obsessive drawings, realized under the influence of mescaline roughly around the same time as the Morellet pieces. Not far from this, the psychedelic, ever-changing mandala of James Whitney's animated films (*Yantra*, 1950–57; *Lapis*, 1963–66), projected on a large screen, echoes the silent, almost bucolic *perpetuum mobile* of the three *Liquid Reflections* by Liliane Lijn nearby (in which one or two balls slide on a large rotating Plexiglas plate sprinkled with water; spotlighted in an otherwise dark space, the high-tech water lily floats). In another room, four Soto reliefs, dating from 1959–61, are on display; the works combine an *informel* look (heavy impasto, brushwork, a tangle of mesh wire) with the parallel striations to which the artist owes his trademark moire effect. Brett reminds us that Soto was once as inventive as Piero Manzoni (most prominently represented by several polystyrene-pellet *Achromes*) and Lucio Fontana (the dark, punctured, glitter and sand *Concetto spaziale* is one of the best I've seen), who in fact greatly admired the Venezuelan. As for Tinguely, his *Meta-Matic* and *Baluba* sculptures, on view in the exhibition, make us forget the artist's vacuous production after his self-destructive *Homage to New York* in 1960 (documented here by a video).

Brett's staged confrontations work because they are never dogmatic—and never marred by pseudomorphism. He could have chosen, for example, to hang Gordon Matta-Clark's cartoonlike doodles of fighting arrows alongside Fontana's touchingly clumsy cosmic diagrams on paper or Vantongerloo's swirling spirals on canvas. Instead they adorn the antechamber of a room where Hans Haacke's *Sphere in Oblique Air-Jet*, 1967, conspicuously

defies gravity and Takis's *Signals*, 1964, blinks at us as if trying to convey a message in Morse code sent from God knows where.

Sometimes an artist is given a whole room: Takis, whose magnetic fields pulse in an astounding variety of ways (producing sound, making balls bounce, asynchronically jolting the needles of compasses on a sci-fi dashboard), is an example; another is Gego, whose metallic spiderwebs, spanning the immaculate white cube, make consenting prey of us. In some other cases, a single work, by virtue of its sheer size, dominates a whole space, such as Haacke's mesmerizing *Circulation*, 1969, in which water courses through a complex circuit of plastic tubing sprawled across the floor; the liquid, like some colorless blood, is endlessly propelled at enormous speed by a mechanical heart. But such isolates are rare. Even when large pieces are grouped because of obvious space limitations, Brett points to a link between them by adding a smaller work: Haacke's oceanic *Narrow White Flow*, 1967–68, for example, a huge piece of white fabric whose animal-like undulation (one thinks of the bloated abdomen of a termite queen) is produced by a powerful blower, is found a few yards away from Len Lye's orgasmic *Blade*, 1967–76, a pendulum that gradually escapes inertia every ten minutes, accelerating the rhythms of its oscillations to reach a furious, noisy climax before retreating to its quiet existence as a dull geometric sculpture perched on a pedestal. In both works, the conversion of the strictly mechanical into the sexual or at least the bodily is obvious, but their humor might have been lost on the spectator if Brett had not offset their somewhat overstated metaphors with David Medalla's modest, funky *Sand Machine*, 1964, whose deliberately lumpish movement underscores the absurdly grotesque bombast of the neighboring machines.

Not only was this show by far the best I've seen this year, but it reopened a chapter in the history of postwar art that was too promptly closed and forgotten. It did so with exquisite taste and rare intelligence, and without the now common pretense of the curator-as-artist-as-entrepreneur. Brett visibly loves the objects he has unearthed. One can only hope that he has future exhibitions in mind.[44]

That review appeared in November 2000, unfortunately after the close of the last venue of the show, at the Hayward Gallery in London, where it had been a huge success. (The only sour point was a public row with David at the opening—I had witnessed several disputes between them before, quickly followed by a reconciliation, but this one took a long time to heal. "It was horrible and the evening was hell. I remember the way Helio used to sometimes complain

54

vehemently to me about Lygia. He said she was a great artist but sometimes did not behave towards him in an ethical way, and it pained him. This is how I feel," Guy wrote me a few days afterward, on July 17, 2000. This is the only time I ever heard him utter anything negative about Lygia—and that at a moment when he was once again advising institutions, the Generali Foundation in Vienna, among others, on how to deal with her work. I took this sudden reminiscence of something he had, if not repressed, at least never mentioned to me as a sign that the clash with David had been really upsetting.)

He was very busy, thankfully, and soon forgetting all the troubles he had gone through to obtain loans for *Force Fields*, he went on to organize at the Camden Arts Centre an exhibition of Li Yuan-chia, a little-known Chinese artist. (Spotted by David in 1965, Li Yuan-chia had shown his work at Signals, but after that he had deliberately kept his distance from the London art world, moving to a small town in England's Cumbria County and transforming an old farmhouse into an interactive museum). "The work approaches the viewer with great delicacy: it's maybe a reminder of what artists were looking for before the advertising values of immediate impact took over," Guy wrote me on February 3, 2001, a few days after the opening. And then there was the whole episode of his invitation to a symposium on Latin American art at Harvard in March, his delight at discussions with students, soon followed by my visit to London in the early summer, where he introduced me to his friend the actress and performance artist Rose English, on whom he had decided to write a book even though he knew little about theater ("I really enjoy discovering things about a subject I don't know," he wrote on October 2, 2001—in our private idiom we called this the pleasure of having "a vertical learning curve"). He kept me regularly informed about the slow progress of this book, which took him more than ten years to complete.[45] It might have been during my week-long stay at his house in summer 2001 that we went to see the other Rose among his multimedia and performance-artist friends, Rose Finn-Kelcey, on whom he would also write a book.[46] (I might be wrong about the timing, though, because I vaguely remember that David was with us for this visit, in which case it would rather date from the following summer, after he and Guy had reconciled, and at the time of one of David's hilarious London Biennales, which, if I recall right, took place on even years).

After 9/11, there was a year's gap in our correspondence, which began again in January 2003 with a belated thank-you note I wrote after another trip of mine to London in late fall. A great deal of our written (and phone) exchanges that year have to do with my plan to have him invited by Harvard for a term (I succeeded, but for various reasons his appointment would not take place until the spring term of 2005, my last semester at the school), as well as discussions of the dreadful political situation in the United States, the

demonstrations everywhere against the Iraq invasion, etc. On October 6, Guy asked me if I would write a preface for a selection of his essays that he wanted to publish as *Carnival of Perception*. Sending me the table of contents, he noted: "It was hard to make a selection because it meant excluding a lot. Apart from those on Lygia and Hélio I've left out all my other writings on Brazilian artists (I'm preparing another book, specifically on Brazilian artists, for a publisher in Rio)."[47] Welcoming the prospect of having many of his texts gathered into one volume—the existence of quite a few of which I discovered on this occasion—I accepted immediately (provided that the deadline was not imminent), even though I let Guy know that I didn't see why he thought a preface was necessary. His counterargument was persuasive—from any other pen than Guy's I would have dismissed it as flattery: "I like the idea of a preface because then the book comes into the world not entirely on its own but is midwifed so to speak. Then, also, the book appears along with its first reader, who is a delightfully different person to the writer, and in your case hyper-discerning. I remember many many years ago, in an early letter you wrote me, you said you liked the 'tone' of my writing. I don't know if you will still like the tone of this book, but 'tone' is something only the reader can describe" (October 8, 2003). We had a chance to discuss the project at some length just a week later as I went to London for a symposium on Hubert Damisch at the Tate (Guy was sorry to have to miss my talk: at exactly the same time he was to give one himself, in some other part of the Tate vessel, on Ronald Moody, "a Jamaican sculptor who lived most of his life in London from the 1930s to '80s, and recently gained a measure of recognition"; looking later at images of Moody's work, which I found absolutely hideous, I too regretted having missed this, curious as I was as to what Guy could possibly have said of it). Owing to my teaching schedule this stay was more rushed than my last, but we still found the time to go see a splendid exhibition on British Gothic art at the Victoria and Albert, with a long detour by the Persian carpets room—a kind of pilgrimage of ours—and Guy inevitably showed me works of artists I did not know, notably of those to be included in his book in progress. At the time, he had not yet decided on the eventual title of *Carnival of Perception*. He disclosed it to me on December 2, 2003, with this "gloss" (his word): "it implies a multitude of individual visions, senses of beauty, methods, investigations, strategies, devices, media, poetics, amounting to the perception of a collective reality expressed in a play of wit and spirit, full of paradox and reversal." I sent my preface a month later, and even though the book was delayed by the defection of the designer (Guy himself had to step in as a replacement), it appeared on July 15, 2004 as "Angel with a Gun" (a miraculously smooth and fast process, if one compares it to the slog of the monograph on David):

Perhaps the text that epitomizes best for me Guy Brett's inimitable tone, which is also what I would call his method, is his discussion about the recurrent images of angels in post-conquest Latin American art, particularly the deeply troubling and ambiguous image of the angel with a gun—an image which, were I the present book's editor, I would have suggested as a frontispiece. Entitled "Being Drawn to an Image," this essay begins with the question that lies at the core of all of Brett's writings: "Why do certain images matter to one, and why is the desire to answer this question as involuntary as the response itself? Why does it seem important that the answer should have some 'objective' quality about it, an insight into history, society, knowledge, rather than point to a merely personal obsession?"

In several passages of the book (notably in the Introduction and in "The Limits of Imperviousness," where he responds to the challenge put before him of speaking about his own "cultural identity"), Brett mentions his reluctance to "impose his vision," his longing for "self-effacement": "I have always wished to position myself as an open-minded observer, rather like the ingenuous adventurers in picaresque novels who encounter situations along the way and respond to them as they can, or will." The image of the traveler carries some historical weight. In "New Measures," Brett notes in passing that "much early art writing was a branch of travel writing: fewer objects were collected in museums and were seen therefore as part of a whole exposure to another land, another culture," and in "Dust Clouds: Eugenio Dittborn," while writing on the precarious transit of the Chilean artist's *Airmail Paintings*, he refers to Goethe's detailed geological survey of each place where he stopped during his journeys. But—despite the fact that Brett did travel a lot, and still does, and that most of his essays concern artists that do not belong to the rarefied art world of his country nor to the international institutions that recently welcomed it (or they did not belong to it at the time of Brett's writing)—his picaresque gaze is not lured by exoticism. Rather, his wish "to be an expert at not being an expert" (Rose English) leads him not only to be "a doubter" (which is what I meant when I wrote that his tone was also his method) but also to look for fellow doubters, for artists or art practices that reveal paradoxes and celebrate ambiguity.

Paradoxes and ambiguity are Brett's "personal obsession"—the dialectical struggle of opposites and their collusion/collision in one object is the leitmotif of these essays (there is no text in this volume that is not exploring this logic). How appropriate that he should ask himself what drew him to the enigmatic figure of the angel with a gun ("both official and coercive, and unofficial and subversive") and ponder about its popularity in the

Andes during the eighteenth century! One thinks of another dialectical angel, Paul Klee's *Angelus Novus* (1920) as dreamt by Walter Benjamin in his famous 1940 "Thesis on the Philosophy of History." There are two fundamental differences, of course: the first is that, unlike Benjamin, Brett pays superb attention to the objects he involves (Benjamin's description is both perfunctory and inadequate); the second is that Brett's discourse is neither melancholic nor messianic. But the similarity in purpose and strategy is striking: to identify the indissoluble link, in a single object (event, artwork, text, etc.) of two contradictory themes, and rather than attempting to find a synthesis, a solution to the contradiction (à la Hegel), they both magnify the shock of this impact so that a situation which the comfortable certainties of dualistic thought was freezing can unlock. For Benjamin, allegory was the vehicle that conveyed best such "dialectical images"; for Brett (and there is something surprisingly refreshing about it after several decades of "postmodernist" deconstruction), it is metaphor. Every work of art on which he amorously lingers is the metaphoric translation of at least two opposite concepts, each having the capacity to morph into the other thanks to the spark created by their brutal or at least unexpected conjunction. It is this capacity of the work of art that provides for him a direct insight into history.

Neither melancholic nor messianic—but that is not to say that Brett's mode is indifference. "Is it possible to combine the reconciliation of opposites with the celebration of difference?," he asks himself in an essay on the Chilean-Australian artist Juan Davila. The answer is yes, but only if maintaining an attitude that he calls (borrowing the term from Hélio Oiticica) "critical ambivalence": "only by this means could one remain aware of the apparently unavoidable process by which things turn into their opposites, and once-emancipatory ideas become new sources of oppression." This dark turn of the dialectical process that governs our modernity is not ignored by Brett, who is particularly attentive to its effect on the institutionalization of art and thought and their ever-growing transformation into spectacle. But rather than lament, he looks for means of escaping from this encroachment. One solution is the constant invention of new genres (which Brett optimistically heeds), even though the liberation that such an invention provides can never be more than temporary given the rapaciousness of the art market, of which we are reminded every day.

It is not by chance that this book begins with essays on Hélio Oiticica, Lygia Clark, and David Medalla, whom Brett was the first to support in Europe, and to whom he often refers. What these three artists have in common is a refusal to fossilize at all costs (thus their constant recourse to the ephemeral

as a kamikaze attack on institutions), and a deep desire to question the stable identities of the author, the object, and the spectator so as to change the transaction between these three terms of the aesthetic equation. Brett's early encounter with, and passionate defence of, their work led him to two intertwined convictions. Firstly, even though marginality is only a provisional heaven, it is a condition that needs to be cherished for only it can guarantee a position of critical ambivalence, of productive doubt. Secondly, the reception of a work of art is always an interactive operation, not only in the sense that the object's meaning can radically change according to the context (and this book is full of anecdotes recording such transformations, and of questions concerning the threshold of perceptibility in a work, or its condition of recognizability), but also in that it alters its various contexts. A work's radicality (and Brett would say "universality") is defined, then, as its potential to bring this transformative capacity to the consciousness of its receptor and thus change him or her as well in the process.

Brett heralds the necessity of such an awakening in some of his titles ("Being Drawn to an Image," already mentioned, but also "To Be Joao Penalva's Public" or "Notes of a Spectator: Mona Hatoum"). He also pays tribute to the marginality advocated by his three mentors in his persistent references to authors that do not belong to the standard academic discourse (such unusual references constitute one of the most refreshing pleasures afforded by his writing). Finally, he celebrates their carnivalesque strategies by adopting one of them, the sudden linking of the present (even the most technologically advanced present) to the most archaic past–a strategy which, in turns, he delights in uncovering in the work of younger artists. Goya, that other great admirer of the carnival, looms large in Brett's pantheon.

I do not know exactly how and when Brett discovered Bakhtin, one of the few heroes of the current literary canon to which he refers, but I imagine this to have been a moment of intellectual elation. There is no better entry into the artistic practices analyzed in this book than the Russian writer's concept of the dialogic, in its emphasis both on the polyphonic structure of any discourse and on the fact that any utterance has an addressee (in any rate, Brett's intimate knowledge of the work of Oiticica, Clark and Medalla must have been a powerful stimulation on this score). I would not point to this aspect of Brett's intellectual apparatus if it did not bring us back to Benjamin's angel as well as to the angel with a gun–for Bakhtin too promoted a dialectical critique of dichotomies that would not result in any synthetical third term; for him, too, ambivalence was the figure of hope in a world doomed by an ever-growing reification.

Brett concludes "Being Drawn to an Image" in invoking the Brazilian film-maker Glauber Rocha on the revolutionary potential of dream ("the dream is the only right which cannot be forbidden"). Bakhtin subscribed to this idea, though he probably would not have used the word revolutionary, Revolution signifying more often than not—and it became utterly clear during his lifetime—the mere substitution of one form of tyrannical power for another. Dreams are carnivalesque, irreverent-they welcome contradictions, they invert or collapse high and low as well as all hierarchical opposites; by nature they pervert any monologistic discourse, they cast doubt on all affirmations. Guy Brett tells us that certain "dialectical images" can perform the same function—provided, that is, that someone is curious or patient enough to interrogate them. Thinking of the angel with a gun, I would like to conclude in turn with another invocation of dreams—Benjamin's definition of ambiguity in his 1935 essay "Paris, Capital of the Nineteenth Century": "Ambiguity is the pictorial image of dialectics, the law of dialectics seen at a standstill. This standstill is utopia and the dialectic image therefore a dream image."[48]

Meanwhile, as planned, Guy had applied for a fellowship under the Visiting Scholars and Fellows Program at the David Rockefeller Center for Latin American Studies at Harvard and sent, as requested, an extraordinarily detailed research proposal dealing with three separate subjects, all focused on a period roughly between 1950 and 1980. In a brief abstract (I had coached him about this mandatory and offensive practice of America academia), he summarized them as such:

1) Differences in the origins of conceptual art in Latin America, the United States and Europe as regards formal and socio-political concerns.

2) The role played by the box-format and the book-format in Brazilian avant-garde art from 1960. Why were these forms so popular and intensively pursued?

3) The notion of the "void" in the work of Lygia Clark, Hélio Oiticica, Mira Schendel, Antonio Manuel and other Brazilian and Latin American artists. Void as philosophical-cosmological concept and socio-political strategy.

He was at first slightly panicked when I told him on the phone that he'd gotten the fellowship ("I was having an attack of nerves, a sort of Jean Clay reclusive attitude of fearing to leave home. I must get over such faint-heartedness!" he wrote on March 29, 2004). I had to coax him during a trip to London, as the hurdles created by both the Bush administration and the Harvard bureaucracy were very dissuasive, but in the end he was delighted to confirm his acceptance.

Another thing we discussed that summer and fall, aside from all the preparations required for his gig at Harvard, was the ambitious project by Suely Rolnik, an old friend from Lygia's time in Paris (she had been among the regulars in the Boulevard Brune studio), to video-interview everyone who had been a familiar of the artist. For budgetary reasons Suely had to scale down her plan (she had hoped to interview close to seventy people), but she still managed to record and edit twenty testimonies (I was filmed in New York in June 2004, David and Guy a month later in Paris, and I would be filmed again in São Paulo in October 2006). I could not go to the launch of Guy's book, though this might have been for the best as his father died at that very moment (I would have been in the way, both physically and mentally). Rereading what he wrote me after the funeral, at which his father had asked him long in advance to speak, I could not but think of what I felt at the time of his own death: "It's strange the way someone's death draws intense attention to them, their uniqueness is suddenly articulated on all sides, things are said which are just latent during their life, and they themselves can never know it" (August 2, 2004).

Guy arrived in Cambridge in early February 2005, and since we saw each other at least weekly there is no written trace of our dialogue then—except for later allusions in our correspondence, once Guy was back to England, interspersed with harrowing discussions about the horrific terrorist attacks that plagued London (and the murder of an innocent young Brazilian man by the police in a subway station). One of the things Guy mentioned, besides our visit to Louis Kahn's library in Exeter, is the works I had shown him as he was testing out ideas he had for a show on drawing (I loved his motto, which I gleaned from a parenthetical remark in a text on Gego he sent me the following year while I was trying to write one on her myself: "nobody ever claimed the 'end of drawing,' as they did of painting"). Of these works, he was particularly impressed by Daumier's very gestural sketches, Louise Bourgeois's *Insomnia Drawings* (of which I had a beautiful facsimile publication), and Matisse's book *Thèmes et Variations*. Alas, Guy never succeeded in interesting a museum in this project, but it regularly came up until the end of his life. I am not sure which topic among the three he submitted he chose to work on while at Harvard, but the second of them would become an absolutely stunning exhibition that he curated and installed in 2012 at the Pinacoteca do Estado de São Paulo, *The Enclosed Openness: Box and Book in Brazilian Art*, which I had the good fortune to see.

In March 2006 he passed through New York, where we met. He was unusually subdued, as his mother had died two weeks earlier. What he wrote me about the strange feeling he was having as his parents' house and their belongings were being dispersed is typical of him: "Every item in their house, in all the cupboards, was in some way held together and given meaning by their

presence. When they've gone it suddenly loses its meaning and looks forlorn. But I continue to cherish some books from their (separate) libraries, and if things are re-contextualized and cherished they seem to stay alive. . ." (April 7, 2006). Just a month later I was visiting him in London, where again we pursued the discussion we had started regarding our respective takes on Gego. (I had liked and learned a lot from his text on the artist but criticized the fact that he was undiscriminating in his praise, while my view was that her extraordinary *Reticulárias* were in some ways her own attack against her earlier boring works in the good old Max Bill/Bauhaus tradition of geometric abstract art and design. He actually agreed with my critique, blaming again his own Kropotkinian "lust for praise," but he in turn corrected some ambiguity in my prose that could have led the reader to believe that I disliked both the works that preceded the *Reticulárias* and those, such as the *Chorros*, that came after. What I remember best about this trip was our visit to the remarkable exhibition curated by Dawn Ades at the Hayward Gallery, *Underground Surrealism: Georges Bataille and Documents*, as well as wandering the London streets looking for impromptu exhibits of artists participating in David's Biennale.

Speaking of Biennales, we both went in the fall to the much more official one in São Paulo but were unable to find a way to be there at the same time. We nevertheless had ample occasion to compare notes in person, as I went to London three times that same fall, in September and October, for a project organized jointly by the Tate Gallery and Angelica Rudenstine at the Mellon Foundation, and in November for a lecture I gave at the Whitechapel about noncomposition in twentieth-century art. I had discussed the latter topic on numerous occasions with Guy, but I think this was the first time he heard me publicly talk about it. As for the workshop, the official title of which was "Inherent Vice: The Replica and Its Implications in Modern Sculpture," its impetus was a specific problem encountered by the Tate conservators: how to deal with the suddenly deteriorating Plexiglas models that Naum Gabo had made for his sculptures and that his estate had bequeathed to the museum (the issue was: What to do with these objects, which were literally turning to dust while oddly emitting a vinegary smell? Exhibit duplicates of them along with photos of the originals?). Some of the models dated from the 1930s and early '40s and were infinitely more interesting than the geometric, "rational-ist"-looking, often symmetrical sculptures Gabo was known for (and which, thanks to a gross misinterpretation of this movement by Alfred Barr, had long passed as the pinnacle of Russian Constructivism). I warmed to those miserably crumbling objects (empathy!) and was at last able to understand Guy's fondness for Gabo—and, taking advantage of my softening, he brought me to Annely Juda's gallery, where we were shown, removed from storage, several of Gabo's small stone sculptures, which I had only seen in dull reproductions—that

truly did the trick. Besides informing each other of our current work (he was co-editing *Oiticica in London* with Luciano Figueiredo for the Tate, a publication documenting the historical exhibition he had curated in 1969, as well as beginning to think about the Cildo Meireles show the same museum had invited him to mount), we also greatly enjoyed spending some time in a Cézanne exhibition at the National Gallery.

I ended up going several times again to London in the following months (in part thanks to the replication workshop), notably in February 2007, when I saw the extremely disturbing and very courageous installation by Mark Wallinger at Tate Britain.[49] My most memorable visit was the fourth, at the end of May and the beginning of June. I had been asked by the organizers to take part in a symposium on Oiticica at the Tate (which was importing the beautiful retrospective exhibition curated by Mari Carmen Ramirez that I had seen in Houston), and after months of their (and Guy's) persistent rebuttal of my arguments for declining (basically that I did not know Oiticica's work well enough), I finally gave in when told that I would not have to give a paper, just participate in a roundtable. This was stupid of me—I should have trusted my intuition—as my performance was subpar. Fortunately, no one really noticed, as everyone's attention was gripped by the vicious shouting match between various members of the Oiticica estate, to the great chagrin of the Tate's team. Most astonishing of all was the behavior of David, who suddenly emerged as the Great Conciliator! Another high point of that visit was the interview that Julian Stallabrass, Margaret Iversen, Guy, and I did with Wallinger at Guy's place.[50]

There were other visits, and other missed occasions as well (we kept failing to find ourselves in Brazil at the same time), and our correspondence slackened again (I was curating a large Picasso show in Rome, he was preparing his Meireles exhibition at the Tate). It picked up in the summer of 2008. I had asked him if I could reprint his text on Gabriel Orozco in the little anthology of essays on the artist I was editing for the *October Files* series published by the MIT Press, and he responded immediately with a long and joyful letter (June 26, 2008) recalling his recent trip in New Zealand on which his wife joined him:

> I'm picturing you, emerging from your library and sitting on your porch with birds around. How delicious. Birds could be the link with my time in New Zealand, where, before the Maori arrived in AD 800, birds ruled. There were no predators, birds flourished without fear and many didn't need to fly. They just walked around, including the giant Moa, 9 feet tall with a tiny head and huge body. The Maori basically ate all the Moas and they became extinct. But for millions of years before humans arrived New Zealand developed in its own way. When Joseph Banks, on one of Cook's voyages, put into Queen Charlotte Sound in 1770, he put it like this:

"This morn I was awaked by the singing of the birds ashore from whence we are distant not a quarter of a mile, the numbers of them were certainly very great who seemd to strain their throats with emulation. . . . [Their] voices were certainly the most melodious wild musick I have ever heard, almost imitating small bells but with the most tuneable silver sound imaginable."

I can't resist quoting that for you! Thousands of years of singing. I had a great time in New Zealand: six weeks in late summer with a little flat provided overlooking Wellington harbour. A few lectures to give, otherwise freedom. I love visiting new cities, with time to find one's way around and assess the character of the place, the way of life, as a flâneur I suppose. Alejandra came for two weeks in the middle and we roamed over the South Island. The population of NZ is only 4 million. Not knowing anything when I arrived I read quite a lot in NZ history and became very interested in the whole saga of European/Maori relations. A typical colonial situation in one way, but Maori survived the onslaught, leading to a complex process of twin development of two opposed cultures, etc.

There was also troubling news concerning his health (a false alarm, it turned out), but the most consequential part of this letter was the announcement that he had accepted the offer to curate a Vantongerloo show for Manolo (who by that time had moved to the Reina Sofia), with the inevitable invitation for me to contribute to the catalogue. This project was at the center of our exchanges almost until the opening of that show in November 2009. A lot happened by telephone, as my intervention was often urgently required in complex negotiations with lenders—several of whom we had already had to deal with for the *Force Fields* show—and Guy also came to spend a few days with me in April 2009 (a visit to the Barnes Foundation was the only distraction to our Vantongerloo business). Not that there was the slightest disagreement between us. On the contrary, I was in awe of Guy's highly original point of view on the subject—I only wanted to know more about it so that the text I had agreed to write (and this time there would be no rescinded promise) would not duplicate what he himself would say.

The synopsis he had written for Manolo (and forwarded to me) soon after his New Zealand birds letter was brilliant, and perfectly in keeping with what I would call Guy's curating philosophy.[51] His Vantongerloo envy had been stimulated by a circulating retrospective of the artist that had begun in the Musée Matisse (!) at the Cateau-Cambrésis but which he had seen in its Oostende venue. He had been terribly disappointed by the conventional conception of the show and by its installation, which he found very flat ("in such a way as to make nothing of the spatial qualities of Vantongerloo's late works, but rendered them inert"). This surprised me, as the French curator of the show, Jean-Etienne Grislain, whom I knew from Hubert Damisch's seminar in the early '70s, had

sent me the catalogue, in which the late works were quite forcefully highlighted (they were well reproduced, in far greater quantity than the paintings and sculptures from the much better-known De Stijl period, and accompanied by interviews with friends of the artist in his later years). Guy in fact made use of one of these testimonies in his pitch to Manolo (quoting François Morellet's reminiscence of his first visit to the old Belgian artist: seeing "all these pieces in Plexiglas, those constructions in wire, they were completely baffling, outside anything one could imagine coming from someone who was considered one of the great inventors of concrete, geometric art").[52] But in his mind the flaws of the show began with its subtitle ("A Pioneer of Modern Sculpture"):

> To locate GV's work within a history of "sculpture" misses its essential drive and originality. Media were separated: for example, the late drawings—wonderful things, most of which I'd never seen before—that could have been closely integrated with the display of objects, were kept in a category of "drawing." The installation was conventional too, following the academic discourse, giving equal emphasis to all periods and completely failing [ . . . ] to convey the poetry, even the oddness of GV's late work and their relationship to space and energy.

Guy's plan was draconian: He would include a strict minimum of Vantongerloo works from his De Stijl period, and only in order to give a sense of his trajectory—of the rebellion that his largely forgotten "Curve" paintings of the late '30s were already fomenting against the geometric dogma, a rebellion that came into full view with the late works at the core of the show, with their "reconciliation of the physical and the biological in plasma-like fluxes" (or, in Vantongerloo's word that Guy appropriated, their "incommensurability").

I teased Guy a bit about his insistence on the "cosmic," wondering if he was not simply returning to the somewhat naive faith in the marriage of art and science that had been one of the tenets of Signals at its beginning, and he responded with a truckload of texts by Vantongerloo about cosmology (which he reprinted in the catalogue), many containing autobiographical inflections, in which a certain type of innocence, that of the child and its unschooled perception of space, was validated (to help me get the point, Guy reminded me of similar autobiographical fragments by Malevich, at which we had marveled decades earlier). He agreed with my contention that in some of his late works Vantongerloo contradicted his highfalutin principles concerning abstraction (derived from mathematics) and flirted with a traditional form of iconology (comets, planets, etc.), but he urged me to admit that none of this toned down the off-script playfulness and almost rococo weirdness of these objects in colored Plexiglas of which I was so fond. I met him halfway, still underlining Vantongerloo's contradictions in my essay, but to my surprise he was more

complimentary than ever about it (providing me with its title, "Unknowable").
He was also unusually self-complimentary about the installation of the show
(but he knew that I knew his compliment was also addressing Manolo's
infallible knack at hanging exhibitions): "I have to say it does look really beau-
tiful—and unfamiliar. It's a special terrain all of its own: transparent, molecular,
endless" (November 7, 2009).

Once again I had to miss the opening, but this time, what was much worse,
I missed the show altogether. I had planned to take a day trip to Madrid from
Montpellier, where I spent several months taking care of my father, who was
dying of leukemia, but in the end this proved impossible. Guy was his wonder-
fully empathetic self during this very painful period of my life; he loved the clip
of Desmond Tutu telling a joke about the Virgin Mary's pregnancy, a favorite
of my father that I sent to friends in remembrance and homage to him (he died
at Christmas).[53] Things went on. The letter in which Guy rejoices about the
Vantongerloo opening is also filled with his reaction to the warehouse fire that
destroyed all the works in the Oiticica estate, that is, the vast majority of his
production: "I suppose the destruction of objects will give Hélio's presence
a virtual character: his notes, writings, workbooks, photos, letters, etc were
digitized and therefore survive." I was somewhat shocked by the detached tone,
given the important role that Hélio and his work had played in Guy's life—but
would soon reckon that this reserve was a remnant of his aristocratic upbringing.
Guy delegated his sorrow by forwarding me a beautiful letter sent to him just
after the catastrophe by Antonio Manuel, one of the many artists whose work he
had introduced me to.

Along with Manuel's elegy was also a reminder of something Guy had
persuaded me to do, which I had completely forgotten as I was dealing with my
father's illness: a three-way conversation with Susan Hiller, to be published in
the catalogue of her retrospective exhibition at the Tate. This project, the last
one on which we collaborated, would occupy us for most of 2010. Guy prepared
a batch of questions for Susan, to which I added suggestions—to no avail, in any
event, as she found them all "too abstract." After several frustrating exchanges
to and fro, the Tate organized a trip for me to London, and Guy and I found
ourselves in Susan's studio for a long afternoon in mid-May, tape recorder in
hand. Things did not go well; Susan being "strangely on the defensive, cutting
things short not to have to discuss this or that, which did not make it easy for
us to be pertinent," as I wrote to him after reading the full transcript, sent to
me at the end of June. Despite Guy's dedication to shorten and transform this
rambling mess into something worth reading (Susan's fitful interventions during
this agonizing editing process were not helping), the emulsion never did take.
Somehow, oddly enough, the Tate liked the result, and Susan apparently did too,
and it was published, but Guy agreed with me that it was a failure ("I know that

something somehow hindered the discussion from really taking off, despite our efforts" [October 1, 2010]). For various reasons I was unable, once again, to see the show (and I had to decline participating in a symposium on it in spring 2011, to Guy's disappointment).

In September of that year we (finally!) found ourselves together in Brazil, as Suely had invited us both to a conference on Lygia at the launch of the DVD box set with her archival interviews.[54] It was rushed, alas, with Guy having to run around for the preparation of his forthcoming "boxes and books" show (we did manage to go to several artists' studios—I remember in particular our visit to Anna Maria Maiolino). Not quite fulfilling the grand hopes we had nourished for years of a prolonged stay in Rio working together on Lygia, but still . . . Back in London he sent me a text he had written on "the other Lygia" (Lygia Pape), whom I never met and about whom Lygia Clark had always observed an eloquently conspicuous silence. He was reassured by my positive comments, as he had felt his "writing lacked lustre" lately, and in that particular case that he could not compete with the "knowledge of the cultural and intellectual vicissitudes in Brazil," from which other authors in the Pape catalogue benefited. "But I give a foreigner's view I suppose," he conceded in response to my praise, adding: "On the whole, Brazilian critics write only on Brazilian artists, which is rather limiting"—a sentence that brought me back to our discussions with David forty years earlier, and to Guy's deliberately anti-nationalist stance in his art criticism right from the beginning. In the same letter he also announced that he was beginning to work on a small Wols exhibition for Manolo. This had to be postponed slightly, as a major retrospective of the artist was planned at the Kunsthalle Bremen and the Menil Collection in Houston for 2013–14—Guy worried his project would be canceled, but Manolo knew full well that it would have little in common with the massive Germano-Texan show. *Wols: Cosmos and Street*, which opened in Madrid in February 2014, was a typical Guy affair: mainly drawings and prints (all tiny), some photographs, only six canvases (he had insisted on a low number), and a catalogue in which the expected (e.g., a reprint of Sartre's famous essay on the artist) brushed against the utterly unexpected (a text in which Oiticica compares Wols and Mondrian).

Having put this show on hold, Guy spent the better part of 2012 working on the "boxes and books" one. He was delighted to learn that I would be able to see it, having been invited to take part in a symposium on Picasso organized in São Paulo that November by our common friend Sônia Salzstein: "I will be so interested to know what you think of the show (you are my ideal viewer) and if you think the tack I've taken makes sense. I have a secret desire to push Brazilian art towards the poetic and away from academic dissertation which has rather captured that art in recent times" (March 12, 2012). (For anyone who saw the show, that desire would no longer be a secret.) There were other

topics in our exchanges throughout the year, of course, including his positive response (on March 14) to a text I wrote on John Baldessari's work from the 1960s and early '70s[55]—a letter I quote here less for the compliment than for what it says of our interaction:

> It didn't matter that I didn't know the work because I read your piece as an essay on humour and this was a pleasure. I'm always amazed by your ability to find quotes—how did you remember the Sherlock Holmes story well enough to get such a pertinent quote? Somehow I didn't imagine you had Sir Arthur Conan Doyle in your library! The Paul Valéry passage was equally to the point. This doesn't mean of course that I enjoyed the quotes more than your writing. Not at all! I loved your path of thoughts. I remember you always liked cartoons and jokes (like New Yorker jokes and French equivalents). Have you ever thought of writing about how you see that liking in relation to your art historical work. Perhaps it kills it to write about it.

There is a gap in our email correspondence, at least in what I can retrieve from the innards of my computer, so I do not know how he reacted to my enthusiasm for *Box and Book in Brazilian Art* and its stunning installation in the Pinacoteca building (fantastically gutted and renovated by Paulo Mendes da Rocha), and maybe all this was just conveyed over the phone as we got into the habit of calling each other more often once the Internet had made that free. I know he was relieved, as he had been more anxious about this enterprise than I had ever sensed him being when curating an exhibition.

Curating—how often we spoke about it, and how much one learns from it! In the same long letter (May 10, 2014) in which he announced to me his Parkinson's diagnosis, he sent me this amazing yet typical paragraph:

> It seemed to take years to organise the Wols show even though it was quite small. But I did learn some things about curating. For example: I had been very anxious about the frames of Wols's drawings and watercolours, which I knew would have been done at the whim of the owners and be all different and not changeable. In fact the frames were a huge asset. In their variety they were much more interesting than a row of "neutral" museum frames would have been. Also, my dream of a kind of cosmos with pictures floating in clusters in the space was really unworkable and was replaced by an absolutely traditional layout of works in a line from beginning to end. With Wols's book etchings in the only vitrine. And it worked! The works became jewels with the vast barrel-vault of the Reina Sofia's old galleries above them. Unfortunately this is not possible to see in the catalogue. Even with the best printing something is missing in Wols reproductions. In a way the conventional-looking exhibition one sees on entering

the room is a kind of mask, disguise, for the realm of extraordinary richness and delicacy which is revealed by proximity.

That letter also contained the news of Finn-Kelcey's death and at least one piece of hopeful information: that Guy would come to New York to see Lygia's retrospective at MoMA during the summer and then would spend some time with me in rural New Jersey, where I live. Alas, this joyful plan had to be canceled. The pretext Guy gave was the printing of his book on Rose English, which he wanted to supervise (the publisher wanted it to appear in September of that year so as to coincide with an exhibition of the artist in Denmark), but in hindsight I think the real reason was that his illness was beginning to take its toll.

It was obvious that his vigor was dwindling, that writing required from him much effort—even video calls became taxing. I did not want to deplete his energy, especially since in spite of all his ailments (direct or indirect effects of Parkinson's, such as falls and broken bones) he had embarked on new projects. One of them was a new collection of essays, the other a retrospective at the Tate of the Greek artist Takis, whom he had championed ever since the Signals years. In June 2018, I jumped at the invitation to a conference provided by the Camberwell College of Arts in London, and arriving at his place I found him toying with miniature versions of Takis's works in the cardboard model of the galleries where the show would be installed. He was physically diminished and very frail—climbing the steep stairs to the office in his tiny but multistory house was exhausting—but his mind was all there; only his days were much shorter than during my previous visits. That trip miraculously coincided with not just one but two exhibitions devoted to Signals, which were a pleasure to see in his company—a memory lane for him, which summoned again so many anecdotes about the artists whose works were on display.[56] We also spent two hours, he in a wheelchair pushed by Alejandra, in a wonderfully focused exhibition devoted to Picasso's production in 1932, curated by his friend Achim Borchardt-Hume at the Tate—he had insisted on that, specifically waiting for my visit to see it and making plans in advance (he had been very sorry to miss my Matisse/Picasso show at the Kimbell twenty years earlier and felt this could count as a worthy substitute). On my way out he made me promise to come to the opening of his Takis show in July 2019.

As so often in the past, I failed at that, but in September I made a special trip to London just to see it—and to see him, above all, with the sad presentiment that it would be the last time. We went to the show together, the beautiful expression on his face when looking at artworks he admired unchanged, but his elocution was more difficult. Along with the catalogue he gave me his brand-new collection of essays, *The Crossing of Innumerable Paths,* many of those, as usual, on artists he had led me to discover as well as

69

others I had yet to hear of. Back in the States I thought about ways to stave off my dreary premonition. But then the pandemic struck, and coincidentally the downturn of his health gathered speed. Direct communication became impossible. Alejandra, always so attentive, kept me informed as best she could. It was she as well who told me of David's passing, barely four hours after the fact, adding that she had not yet communicated the news to Guy. She was so right to be anxious about that.

Speaking of the essays gathered in *The Crossing of Innumerable Paths*, on a postcard inserted in the copy he gave me, Guy wrote: "It is the relationships produced by bringing them together, while revealing their diversity, that really interested me." I feel the same about the heterogeneous bits gathered in this collage of a memoir.

First published in *October* 179 (Winter 2022): 11–77.

1.   Although both Guy and David were among the founders of Signals Gallery (and its precursor, the Center for Advanced Creative Study), together with Paul Keeler, Gustav Metzger, and Marcello Salvadori, I will not expand on the remarkable experiment the space represented in the stiff London art world of the 1960s, given that I only learned about it after it had ended—and above all from Guy's and David's direct accounts and from the gallery's bulletin. Guy wrote extensively about it, notably in his monograph on David, and the latter published a short memoir about it (simply titled "Signals") in *The Other Story: Afro-Asian Artists in Post-War Britain*, the catalogue of an exhibition curated by Rasheed Araeen at the Hayward Gallery, London, in 1989. This text (supplemented in the same catalogue by Guy's "Internationalism among Artists in the 60s and 70s") is probably the first instance in which an institution (a museum) acknowledges the existence of this bustling hub, whose commercial activity was minimal. The literature is still scant; the most consequential contributions are an essay by John A. Tyson, "Signals Crossing Borders: Cybernetic Words and Images and 1960s Avant-Garde Art" (*Interfaces*, [January 2017], 65–103), and the elegant and hefty book by Eleanor Crabtree, *Signals* (2018), which functioned as the catalogue of an exhibition at the Sotheby's-owned gallery S/2 in London. Also to be consulted is Paul Overy's essay "Other Stories," in *Art History* 20, no. 3 (September 1997): 493–501, offered as a review of Guy's monograph on David and of the facsimile reprint of the complete run of the Signals bulletin that appeared in 1995 (published by the Institute of International Visual Arts); and the second chapter of Pamela M. Lee's *Chromophobia: On Time in the Art of the 1960s* (Cambridge, MA: MIT Press, 2004), particularly 125–33. Signals remains largely marginalized in the history books (even in books on "the margins"): It is quite telling that in Thomas Crow's recent publication, *The Hidden Mod in Modern Art: London 1957–1969* (London: Paul Mellon Centre for Studies in British Art, 2020), neither it nor David is even mentioned.

2.   Before he became the art critic of the London *Times* (from 1964 to 1974), Guy had regularly written for the *Guardian* in 1963–64 and, according to his younger brother Sebastian, for the *Yorkshire Post*. His firing from the *Times* at the end of 1974 was lambasted by Michael McNay, arts editor of the *Guardian*, in that publication (February 21, 1975: 10).

3.   On David's name-dropping as part of storytelling, see Guy's *Exploding Galaxies: The Art of David Medalla* (London: Kala Press, 1995), 18–19.

4.   Ibid., 13.

5.   I have a recollection—too vague, alas—of a specific conversation with David and Guy, David speaking about Walt Whitman, Guy about William Blake, during which this concept was invoked. It would have been characteristic of both, but particularly of David, to have brought out the name of its Canadian coiner, a close friend of Whitman's named Richard Maurice Burke, who published a book about it in 1901.

6.   See Medalla, "Participe présent: L'art de Lygia Clark," *Robho* 4 (1968): 16–17. Having no access to David's original manuscript, which is probably lost, I retranslate from the French: "The first time I touched a work made with rubber by Lygia Clark, I was struck by its resemblance to the foreskin of an uncircumcised penis. Lygia's rubber sculpture resembled, for me, the foreskin of an uncircumcised penis not for its form, or its size, but due to its elasticity and reversibility, its wonderful aptitude to develop and to fold onto itself as it is touched by the participant."

7.   Signals was forced to close after its backer, a wealthy American manufacturer of optical instruments (and the father of Paul Keeler, the director of the gallery),

was scandalized by David's publication, in the eighth issue of its bulletin (June–July 1965), of two texts: Lewis Mumford's address to the American Academy of Arts and Letters and a letter from Robert Lowell to President Johnson declining an invitation to the White House, both in protest of the Vietnam War. (Naum Gabo had provided a copy of the texts.) According to Guy, the abrupt closing occurred midway through the Schendel show, in October 1966, but in various publications (notably in Eleanor Crabtree's *Signals* and in the catalogue for the 1993 Takis retrospective at the Galeries du Jeu de Paume in Paris), an exhibition of the Greek artist is listed as having taken place at the gallery in December 1966.

8. There was also some pseudoscience, mostly on the part of artists, particularly Marcello Salvadori, but he disappeared from view after the fourth issue.

9. Brett, *Exploding Galaxies,* 40.

10. The drawing illustrating Guy's text in the *Times*, bearing the inscription "Frelimo Freedom Fighters Crossing a River in Mozambique," was later reproduced in *Exploding Galaxies* (88), along with four others from the same series.

11. In a letter dated July 10, 1976, Guy writes: "It's interesting what you say about the Chile patch-works your father has. Can you tell me more about them? Any photos? Are they an example where culture is used as a form of resistance? It could be an idea to try to exhibit them here in London. I'd be in quite a good position to do that." At that time my father was head of CIMADE, a French NGO founded in 1939 to help political refugees (and, during the war, to hide Jews or help them leave Nazi-occupied France). It was involved in all kinds of actions in support of the resistance to the Pinochet regime, including the distribution of *arpilleras.* On April 2, 1977, Guy confirmed that he was working on an exhibition of those, adding that it was "gradually coming together, but very

slowly. The Arts Council won't support it officially. I'm now looking around for other possibilities." The show actually opened in Scotland later that year, at the end of October, under the aegis of Oxfam, with the title "'We Want People to Know the Truth': Patchwork Pictures from Chile," accompanied by a modest catalogue with detailed captions for each of the fifty-two works on display and an essay by Guy, which he later revised and augmented as the first chapter of his 1986 book *Through Our Own Eyes.*

12. Being a dud at math, I could not follow the numerous demonstrations that punctuate Weyl's book and wondered if David was able to (in his short memoir on Signals, he claims that he "had the good fortune to attend [the famous mathematician's] lectures on symmetry at Princeton University when [he] was a boy" (118). As was often the case with David, I was somewhat skeptical at first, for several reasons—Weyl was not at Princeton University at the time but at the Institute for Advanced Study (IAS), and he was retired and living half the year in Zurich. But David's statement seems to be perfectly genuine. It works for both Weyl's and David's calendar. According to Purissima Benitez-Johannot, David flew from Manila to New York on July 7, 1954, and returned home in March 1955 (*The Life and Art of David Medalla* [Quezon City, Philippines: Vibal Foundation, 2012], 247–48). He attended classes at Columbia in the fall of 1954 and the beginning of the spring term. As for Weyl, not only was he in the States during exactly the same period but he gave a series of lectures at the IAS in the fall and, more important, delivered a famous address ("Knowledge as Unity") at the fifth of Columbia's Bicentennial Conferences (on the theme of "The Unity of Knowledge"), which took place from October 27 to October 30, 1954, a talk at which David might very well have been present. (My thanks to Caitlin Rizzo, Jocelyn Wilk, and Juliette Kennedy for helping me sort this out.) As serendipity would have it, I was appointed to the IAS faculty in 2015.

[Addition 2022] To return to David's vast knowledge and extremely heterogeneous curiosity: soon after this essay was published, I stumbled in my library upon another book that David gave me (with his usual calligraphic inscription), Bernard Smith's *European Vision and the South Pacific 1768–1850: A Study in the History of Art and Ideas* (Oxford University Press, 1960). I do not precisely recall the occasion of the gifting, but it might have followed one of our discussions on Gauguin, whose art David knew very well, and loved.

13. David Medalla, "A Rectification," in Purissima Benitez-Johannot, *The Life and Art of David Medalla,* 207–08.

14. The Situationists were notoriously anti-Maoist. Some of their attacks were humorous, using their well-known device of *détournement*. I specifically remember two films, one in the kung-fu genre, the other a Japanese porno, whose subtitles had been transformed into political jousts (the title of the first was *Can Dialectics Break Bricks?*, the other, *The Girls of Kamare,* both the work of René Vienet, a French sinologist who had gone to China and come back utterly disillusioned). Most of the time the Situationist critique of Mao's China was frontal. It was Vienet, for example, who engineered the publication of Simon Leys's pamphlet *Les habits neufs du president Mao,* perhaps the first denunciation of the Cultural Revolution from a leftist point of view. "Simon Leys" was the pseudonym of Pierre Ryckmans, a renowned specialist of Chinese painting whom I met on several occasions around the same time that David was trying to convert me (we made some plans to publish Ryckmans's translation of a Chinese treatise on painting in *Macula,* but with the sudden fame of his "Simon Leys" investigative journalism he was far too busy).

15. The most perturbing was probably the loud support for the Cultural Revolution by the *Tel Quel* group, controlled by Philippe Sollers, which in 1971 published Maria-Antonietta Macciochi's *De la Chine,* one of the most grotesque hackworks of propaganda ever, in its otherwise reputable publication series (which includes almost all the books by Roland Barthes, from his 1966 *Critique et vérité* onward, as well as Jacques Derrida's 1967 *L'écriture et la différence* and *La dissémination* in 1972). Another grotesque effect of *Tel Quel*'s sycophantism was the full embrace of its Maophile position by the artists of the Supports/Surfaces group, closely allied to Sollers's clique, in its own journal, *Peinture, Cahiers Théoriques,* in issue after issue.

16. Yve-Alain Bois, "La peinture des paysans chinois d'aujourd'hui," *Critique* 337 (June 1975): 615–23.

17. He sent me a first version of the essay on April 12, 1975, and my article appeared in June 1975 in a special issue of *Critique* on China. The editorial pace of this journal was not swift, especially in the case of special issues, so I had probably submitted my text before receiving Guy's.

18. The text was published as "Terre fertile. Champ, agriculture, décoration" in the first issue of *Macula* (1976, 50–57), perhaps the first writing of Guy's to appear in French.

19. He sent it to *Studio*'s editor, Richard Cork, who liked it as well and had it translated, but who then stalled and eventually dropped it. I am not sure that the essay could really qualify as Marxist, but it is certainly an earnest period piece. It was eventually published in French as an appendix of *Le phénomène Beaubourg*, a book written almost entirely by Jean Clay under the pseudonym of Marie Leroy (Paris: Éditions Syros, 1977).

20. In 1937 Evans published *The Painter's Object,* an anthology of texts and reproductions by artists of the international avant-garde (Moholy-Nagy, Max Ernst, Calder), established modern masters (Picasso, Léger, Kandinsky), and British artists (Henry Moore, Paul Nash, Graham

Sutherland, John Piper). Mondrian does not figure in it, so I would not have been aware of her friendship with him if Guy had not alerted me to it.

21. The following sentences from Raphael's essay could very well have been written by Guy: "Every work of art contains within it spiritual energies, the release of which can increase our own productive capacity," and "The creative theory of art . . . requires that the spiritual energies released by the work of art be used to further the viewer's own creative powers" (*The Demands of Art* [London: Routledge and Kegan Paul, 1968], 189 and 199).

22. On this whole affair, see "Picabia: From Dada to Pétain," in this volume, 347–59.

23. See Brett, *Exploding Galaxies,* 103–17.

24. Guy published several essays in *China Now,* including one about Mao's views on art in an issue of the journal published just after the death of the Great Helmsman ("A Challenge to Artists," *China Now* 65 [October 1976], 11–13), which is the only truly embarrassing piece of writing I have read by him. Much more interesting and informative is "Lu Xun and the Woodcut Movement," published in the February 1976 issue of the journal (no. 59), 9–12. As far as I know, he published only two other texts in *China Now* after his second trip to the country. The first was about the Huhsien peasant-painters (December 1976), the other an interview of Ivens and Loridan (March 1977), both of which had been commissioned in advance of that final visit.

25. Guy Brett, "David Medalla," *San Juan (The Liberated Bimonthly Magazine of Art),* December 1985, 10–17. This issue of the journal also contains the facsimile of a handwritten and illustrated account by David of his encounters with Louis Aragon and a letter he sent to *San Juan*'s editor, Michael A. P. Adams. One half of the issue, in fact, was dedicated to David.

26. Guy's essay, "Unofficial Versions," is published in *The Myth of Primitivism: Perspectives on Art,* ed. Susan Hiller (London: Routledge, 1991), 113–36. With his *San Juan* essay on David included in his letter from September 1, 1986, Guy had also sent his review of a show by Hiller at the Gimpel Fils Gallery in London (October–November 1985), in which he stresses her conception of art as "something *efficacious,* something that works, not simply aesthetic" (Guy Brett, "Home Truths: New Works by Susan Hiller," *Studio International* 199, no. 1012 [March 1986]: 60–61).

27. This lecture was published in French a year later in *Les cahiers du musée national d'art moderne* 22 (December 1987), 57–69.

28. No matter how gloomy his letters could be at times, Guy always included a codicil about some pleasure he had felt. This paragraph was followed by one such account: "My only break (from what in other ways was a labour of love) was to go to Germany for Documenta (I'm reviewing it for *Studio*). Oh God! All your feelings about the state of the art world came back to me going round this enormous and stupid show. Luckily I was able to get away to Wurzburg and see the marvelous Tiepolo ceiling there (the card I'm sending you, Tiepolo's self-portrait, comes from one corner and shows him looking, with an indefinable expression, towards the allegory of 'Europe' he has created on one side to complement the allegory of India, Africa and America on the other three sides). I was amazed by the dialectic in Tiepolo (which I hadn't realized before) between the ethereal/allegorical and the earthy/realistic."

29. Guy's essay, "Impromptus: David Medalla," appeared in the November 1989 issue of *Art in America,* 157–63 and 211.

30. Yve-Alain Bois, "Popular Culture," *Art in America,* October 1987, 25–27.

31. See John Hall and James Baldwin, "James Baldwin: A Transition Interview," *Transition* 41 (1972): 21–24, https://doi. org/10.2307/2935113. On the history of *Transition,* which folded in 1976 and was brought back to life by Henry Louis Gates, Jr. in 1991, see the website of the journal, https://hutchinscenter.fas.harvard.edu/ transition.

32. The exhibition *Hélio Oiticica* was at the Witte de Wit Center for Contemporary Art, Rotterdam (February–April 1992); Jeu de Paume, Paris (June–August 1992); Fundació Antoni Tàpies, Barcelona (October–December 1992); Centro de Arte Moderna da Fundação Calouste Gulbenkian, Lisbon (January–March 1993); and Walker Art Center, Minneapolis (October 1993–February 1994).

With regard to Guy's "globalism," I should mention an exhibition project about contemporary African art on which he worked for months in 1976–77 with curator and administrator John Mapondera at the invitation of Andrew Dempsey of what was then the Arts Council of Great Britain. The exhibition would have taken place at the Hayward Gallery, but the project was suddenly cancelled (not only for financial reasons but also with regard to the diplomatic complexity it entailed), for the great frustration of Dempsey and Guy's anger, all the more since this abrupt administrative decision was taken shortly after the success of the Second World Black and African Festival of Arts and Culture (FESTAC'77) in Lagos. According to Dempsey, whom I thank for the information he generously shared with me, Guy had "developed a way of doing this exhibition focusing on particular art manifestations or groups across the continent, at different times in the post-war period" (letter to the author, April 23, 2022). I remember driving Guy to the suburban town of Fontenay-aux-Roses to meet Jean Laude, the renowned scholar of African art with whom he wanted to discuss his project.

33. Another warming-up tidbit from the same letter, in response to my complaint about the tendency of graduate students to write papers much longer than needed, is a quote from Auden about the courage it requires to be brief:

In the eyes of every author, I fancy, his own past work falls into four classes. First, the pure rubbish which he regrets ever having conceived; second—for him the most painful—the good ideas which his incompetence or impatience prevented from coming to much; third, the pieces he has nothing against except their lack of importance; these must necessarily form the bulk of any collection since, were he to limit it to the fourth class alone, to those poems for which he is honestly grateful, his volume would be too depressingly slim.

34. This dismay around the appropriation of Lygia's work recurred in our exchanges. On November 23, 1999, Guy asked for my advice on a letter he had received from Stephen Melville: "He wanted help in tracking down works by Lygia for a show he's doing at the Wexner Center. I doubt if Lygia would want to be included in a show which 'argues a view, or explores the situation, of painting in a broadly post-minimalist context.' Or to be associated with painters like Hantaï, Buren, Parmentier, Supports-Surfaces, Degottex, etc. Do you think I should collaborate on this (I haven't replied yet)? I don't want to aid Lygia's insertion into beaux-arts or mainstream contexts she emphatically rejected." Despite my sympathy for this project, which was undertaken by Melville, Philip Armstrong, and Laura Lisbon at the Wexner (their 2001 exhibition *As Painting: Division and Displacement*, in which French artists I defended, such as Martin Barré—to whom Lygia had introduced me!—and Christian Bonnefoi, would be prominently displayed), I responded on January 16, 2000, that I agreed that Lygia's work would be utterly out of place in this context. I added: "There is something comic in observing the artworld retrospectively projecting onto her

its own fantasies. A few days ago she was named by the *New York Times*, in a review article on Valie Export, as a pioneering woman artist dealing with the body, along with Carolee Schneemann, Adrian Piper, Niki de Saint Phalle, among others: can you imagine? Lygia would have puked."

35. Two year earlier, in June 1992, we had converged briefly on Paris (Guy from London, I from Barcelona) in order to meet Rosalind and together show material on David to her. I do not remember why (maybe I had the idea that a dossier could be published in *October*?). In any event this helped me later to convince her that his work should have a place in our *Informe* show.

36. Dore Ashton wrote a foreword for *Exploding Galaxies*, "An Impromptu for David Medalla and Guy Brett," 8–11.

37. *Exploding Galaxies,* 212–14.

38. The double exhibition *Lygia Clark e Hélio Oiticica* took place at the Paco Imperial in Rio de Janeiro in November–December 1986, and in São Paulo exactly a year later. The catalog, probably printed between the two venues, contains many photographs of the setup (raw material on tables out of which people fabricate Lygia's props and then use them, copies of her various *Sensorial Masks* being tried on, etc.).

39. Yve-Alain Bois, "Whose Formalism," *Art Bulletin* 78, no. 1 (March 1996): 9–12.

40. My review was published in the January 1999 issue. As usual with this publication, I was never consulted about the title of the piece (it was billed as "Lygia Clark: Palais des Beaux-Arts, Paris"). I never received any complaint about this, but I imagine that the curator of the Brussels venue was not too pleased with it.

41. Guy is referring to my review of the exhibition *Les Années Supports/Surfaces dans les collections du Centre Georges Pompidou* at the Jeu de Paume, which appeared in the December 1998 issue of *Artforum.*

42. Guy's piece, "The London Biennale," appeared in the February 2000 issue.

43. "The artist whose drawing you liked is Boris Gerrets. He's half Bulgarian and half Dutch and lives in Amsterdam (where few people have heard of him) and has had an interesting history as an artist. He never got into a career mode with a dealer but has done all sorts of things, from performance to sculpture and drawing to documentary film-making. The show (it was small) was in Helsinki and the director of the Museum, Maaretta Jaukkuri, one of the best museum people I've met, liked it a lot. There is a catalogue (more a parallel publication which Boris and I worked on together) and it gives me much pleasure to send you one (by mail, soon—I'm waiting for more copies to arrive)" (January 15, 2003).

44. Yve-Alain Bois, "'Force Fields: Phases of the Kinetic,' Museu d'art contemporani de Barcelona (MACBA)," *Artforum*, November 2000, 145–47.

45. *Abstract Vaudeville: The Work of Rose English* was superbly published in 2014 by Ridinghouse.

46. This other book gave him less trouble; he began working on it long after he had started writing the monograph on English and finished it before. The main text is by him, but there are also two shorter contributions by other authors, which probably sped up Guy's writing process. *Rose Finn-Kelcey* appeared in 2013, also published by Ridinghouse; the artist, suffering from a degenerative disease, died a few months later, in 2014.

47. Guy Brett, *Brasil Experimental: Arte/vida: Proposições e paradoxos,* ed. Katia Maciel (Rio de Janeiro: Contra Capa Livraria, 2005).

48. Yve-Alain Bois, in Guy Brett, *Carnival of Perception* (London: Institute of International Visual Arts, 2004), 8–11.

49. My review appeared in the April 2007 issue of *Artforum* as "Piece Movement" (title provided by the editors), 248–51.

50. This interview was published in *October* 123 (Winter 2008): 185–204.

51. On this, see Guy's "Elasticity of Exhibitions" published in *Tate Papers,* the Tate Gallery's online research journal, issue no. 12 (Fall 2009).

52. See Jean-Etienne Grislain, "Entretien avec François Morellet," in *Georges Vantongerloo 1886–1965: Un pionnier de la sculpture moderne,* ed. Jean-Etienne Grislain (Paris: Gallimard, 2007), 241. I am quoting from Guy's own translation. He used it in the synopsis joined to his letter of August 3, 2008, but also in the catalogue of the show (in fact, Morellet's quote is the first sentence of Guy's introductory text in *Georges Vantongerloo: A Longing for Infinity* [Madrid: Reina Sofia, 2009], 16–31).

53. There was some technical problem in the transmission of the clip, so I had to send it a couple times. While waiting for it to work, Guy wrote me (January 9, 2010): "I have never met your father but it was from him, through you, that I first heard about the Chilean patchworks that I made an exhibition of in the mid-70s."

54. There are actually two editions of this set of DVDs. One was published in 2010 in Paris (with French subtitles where necessary) by Carta Blanca, with the title *Archive pour une oeuvre-événement*; the other one, which includes a booklet with essays by Rolnik, was published in São Paulo by SESC Press. Each contains the same twenty interviews, but the Brazilian edition lists an additional forty-five interviews already taped and in need of proper formatting.

55. My essay "Is It Impossible to Underline in a Thermometer?" appeared as the preface to *John Baldessari: Catalogue Raisonné,* vol. 1 (New Haven: Yale University Press, 2012), 1–11.

56. One of the exhibitions was at S/2, the art gallery of Sotheby's in London (April 27 to July 13, 2018), and it is on this occasion that the book/catalogue *Signals,* mentioned in note 1, was published; the other was organized by José Kuri, the director of Kurimanzutto in Mexico City, and held at Thomas Dane Gallery (June 8 to July 21, 2018). While Guy and I were looking at these twin shows, we were joined by my friend John Tain, from Asia Art Archive in Hong Kong, with whom we spoke at great length about David.

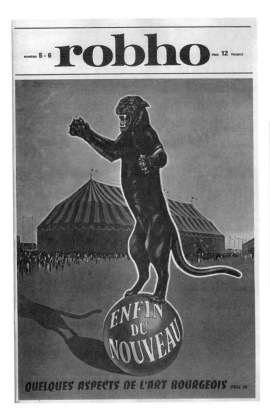

*Robho* 5–6 (Spring 1971). Layout: Carlos Cruz-Diez.
*Macula* 1 (Spring 1976). Layout: Jean-Louis Germain.

# J.C. or the Critic

*A detailed account of my first meeting with Jean Clay, a few months before my fifteenth birthday, is given in another essay included in the present volume ("Some Latin Americans in Paris;" see page 187), so suffice it to say here that I was then an aspiring artist eager to be chaperoned into the complex labyrinth of contemporary art. Jean was extraordinarily generous in this regard, introducing me to numerous artists, and always available to respond to my insatiable questioning. I was immensely impressed by his vast culture—notably with regard to Western painting and sculpture from the Renaissance on, with, of course, a particular emphasis on twentieth-century art—and I relentlessly picked his brain. As far as art is concerned, he was my first teacher. At the time, he was one of the most sought-after art critics in France, and our friendship might not have blossomed so rapidly if our encounter had not occurred just as he was launching a small avant-garde zine called* Robho *(he never disclosed to me the meaning of this title, and I eventually stopped asking).[1] What I found electrifying in this journal was the lack of decorum, the militancy—and the fact that this militancy was overtly political as well (Jean had long been involved in various left-wing underground movements, notably in opposition to the Algerian war). The journal not only carried the utopian dream of an art that would "transform the world," but it actively sought to rethink the relation between art and politics. In this, it was very close to the model provided by the Russian Constructivists soon after the October Revolution in its rejection of social imagery; "not making political art but making art politically" was the motto.*

*For several years my artistic education with regard to modern and contemporary art was pretty much confined to Jean's direct mentoring, to* Robho, *and to the ridiculously meager crumbs one could get visiting Paris museums and galleries. This changed when, immediately after graduation from high school, I spent a year in the United States as an exchange student. Not that I rejected anything Jean and his journal had taught me, but my frame of reference expanded exponentially. I maintained contact with him, but our next meaningful connection occurred when I went to Paris as a student. By then, I was no longer a bright-eyed teenager; but he too had changed—notably, he was far less sanguine about the art he had previously defended. And I dare say that in terms of mentoring, the roles switched a bit: I introduced him to the world of theory I was myself discovering and brought him to Hubert*

*Damisch's seminar. He was reluctant at first but almost instantly became a pillar of that course.*

*Aggravated by the mediocrity of the French* Kunstliteratur, *we had discussed starting a journal a year prior, but our plan gathered steam and clarity of purpose with the input of Damisch's vibrant seminar. In academia, art history was dominated by a reactionary and nationalist faction fixated on French artists from* le grand siècle *(the seventeenth, for those who might not know) and utterly opposed to any attempt at interpretation.[2] With regard to art history publications in France, very few existed that were not about French art, and/or were not written by French art historians. One of our goals was to bring into circulation texts, notably from the corpus of German, English, and American art history, that interested us.*

*The second source of our discontent was the state of art criticism, which we found appalling in its absolute lack of rigor (one searched in vain for any precise descriptions of works of art, or for any assessment grounded in history). We were particularly disgusted by the belletristic prose that dominated exhibition catalogues issued by galleries, in which famous writers pompously rhapsodized without ever saying anything specific about the works. We loathed this kind of discourse, all the more when coming from writers we otherwise admired, irritated by the fact that they had not done any homework whatsoever before starting to blather. But although we had no intent of exculpating the* littérateurs, *we admitted mitigating circumstances: Especially with regard to modern and contemporary art, it was actually extremely difficulty to do said homework, given the deficiencies of French museums and the quasi-absence of available published documentation at the time. We had been very impressed, by contrast, with the high standard of American art criticism (I, for one, had devoured* Artforum *during my year in America, which coincided with perhaps the best vintage of the journal), and we attributed this to the fact that most American critics were actually art historians or curators, with access to (and interest in) a vast repository of knowledge (scholarly books and catalogues, public collections) concerning twentieth-century art. One way to alter the dismal French situation, we thought, was to publish translations of critical texts we admired and to offer critical editions of historical documents, particularly texts written by artists.*

*At the same time, we wanted to intervene more directly in the contemporary scene—not just as purveyors of source material. The high voltage of theoretical production in the field of literary studies stimulated us, and we saw no reason why a similar quality could not be attained in discussions about art (Damisch's seminar provided the best encouragement we needed). Wary of the famous-writer-on-art genre, we refrained from soliciting philosophers for contributions about art per se; instead, we asked them to comment upon issues of aesthetics*

*and philosophical texts pertaining to them. We also enjoined artists whose work we liked, and about which we wrote, to help us frame what were the most urgent theoretical issues they faced in their practice. Each issue of Macula, for such was the name of the journal we co-founded, was conceived as an assemblage in which texts coming from utterly different horizons would interact.³ Like Robho, it lasted only four years, and Jean spent as much energy editing one as the other. The essay that follows concerns his writings, with a particular insistence on what distinguishes the pieces he published in Robho from those in Macula.*

●

As I write these lines, Jean Clay (J.C.) is as forgotten as was Félix Fénéon in 1945, when *F. F. ou le critique* (Jean Paulhan's book on him) was published, and equally reluctant to come out of the shadows. Like Fénéon, whom he admires, J.C. has lived many lives (political activist, journalist, art historian and critic, publisher); like Fénéon he was entirely self-taught, and, like Fénéon, he stopped writing.[4]

J.C.'s writing occurred in three successive phases, corresponding to the periodicals (very different from each another) in which his texts appeared. The first of these was *Réalités*, a rather lavish monthly, much focused on the quality of its color photos, that J.C. joined in 1958, staying until 1971. Next came *Robho*, a journal that he launched in 1967 with his friend Julien Blaine. It appeared intermittently, in a tall format (16 × 11 inches: the bane of librarians and bookstore owners), rather fanzine-like, and with a wild layout due to the Venezuelan artist Carlos Cruz-Diez. Its last issue was in 1971. Finally, there is *Macula*, a review that J.C. directed with me from 1976 to 1979, graphically much more thoughtfully designed by Jean-Louis Germain, more refined in style, and with one issue per year, increasingly sizable, and running to almost three hundred pages for the last one, no. 5/6. There was a certain chronological overlap between the *Réalités* years and those of *Robho*; however, the gulf separating them, in terms of tone, style, and politics, was such as to make one think that *Robho* was conceived as an anti-*Réalités*. In any event, *Robho* was a lifeline enabling J.C. to remain on the payroll at *Réalités* while his interests were increasingly moving in a different direction (it was a secret lifeline since J.C.'s boss at *Réalités* was not aware of this parallel activity). Chronologically speaking, on the other hand, there was a clear break, a hiatus of five years, between the *Robho* years and those with *Macula*.

At the time when I met him (in 1967, right at the beginning of the *Robho* years), J.C. was already constantly trashing his pieces for *Réalités*, thundering against the imperatives of the journalistic condition (perpetual sense of urgency, frustration at never being able to go into depth with a subject, always having to abandon a topic for the next one, and before having fully mastered it). But

he was wrong to see himself as condemned to superficiality. Although written for a review with a big circulation, J.C.'s articles for *Réalités* contrasted markedly with the asinine and pompously belletrist productions of most of the art critics at the time, and they show how much he had his finger on the pulse of contemporary events (it was here, I think, that the first published interpretation of American Minimal art appeared in France). Furthermore, his interviews/portraits of artists—from Jean Arp in 1961 to Josef Albers in 1968—remain small masterpieces of the genre.[5] In fact, the pedagogical stance one detects in all of J.C.'s texts published in *Robho* is something that he honed during all his years at *Realités*. From his journalistic experience there he also retained the idea, which he had tested in his gallery of portraits, that in order to best understand an artist's work, and to locate and relate its specificities, one had to know its *entire* trajectory. What he did drop was the tendency to look for psychological, biographical, and subjective motivations therein. Henceforth the evolution of an artist's work was to be read as something directed ineluctably by its own internal formal and structural logic, in response to a particular artistic context that was, itself, composed of a galaxy of other trajectories, recent or otherwise.

The most remarkable example, from this point of view, is his magisterial study of Lygia Clark in the fourth issue of *Robho*. This article was to remain for decades the most complete, and certainly the most detailed, analysis of her work. From the very outset, J.C. rules out invoking all of the biographical and psychological material from the artist's own abundant commentary as explanatory (information that, on the contrary, later studies of Clark would not hesitate to draw on directly):

> Approaching this work on the level of the concepts that it has given rise to, we mean to describe neither its personal, psychological motivations, nor its obvious and deep links with the Brazilian tradition. Besides, Lygia Clark has done this herself in her autobiographical writings.[6] All the same, let us look at the fundamental impulse behind her work: a generalized need for fusion with the *en face*, an obsession with synthesis, a rejection of antinomies and categories. For Lygia Clark, possessed by the idea of borderless unity, there is no difference between up and down, the past, present, and future, two or three dimensions, the visual and the non-visual, the body and what is outside of the body, the earth and the cosmos, the art object and the world around it, life and death. Categories are, for her, things that are learned, provisional classifications, signposts of circumstance, laid out by humans as they try to situate themselves in the complexity of the real.[7]

The title of this piece was "Lygia Clark: Fusion Généralisée" (A generalized fusion) and, indeed, the artist's entire trajectory is seen here under the sign of fusion, from her declared opposition to the Concrete art of Max Bill (of whom

J.C. has been a great admirer)[8] to her dialogue with Mondrian, whom she reads against the received interpretation of the time (she stresses what the artist himself called the "destructive element" in his approach), followed by Josef Albers, whose spatial ambivalences she shamelessly redirects and perverts. One after the other, her works (or, as she called them, "propositions") are described by J.C. as so many stages, most often marked by irreversible breaks on the way toward the dissolving of art into the praxis of everyday life—what Clark called the *vivantiel* ("livingness"). The subheadings punctuating the article are like a mantra: "fusion of picture and frame," "the line as hinge," "fusion of real and fictive space," "fusion of the work and viewer," and "fusion of inside and outside."

We find a similar framework in all of J.C.'s monographic studies from the *Robho* years. Looking at an artist's entire production, he pinpoints an essential motif, a conceptual nucleus, and then, from this embryonic piece, he retrospectively reconstructs the various strategies that brought about its progressive fulfillment. Thus, for example, the "perfectly logical evolution" that was to lead Jesús Rafael Soto in 1967 to the *Pénétrable* was the result of an objective that the artist had set himself fifteen years earlier, at the time of his discovery of Mondrian, i.e., "the methodical destruction of all stable forms."[9] (Like Clark, Soto read Mondrian against the received opinion, but he did it in a very different way; focusing on the modular grids of 1918–19, and then on the artist's final works, Soto saw Mondrian as the father of Op art.) It was this same "desire to be done with the fixed form, static painting, and all the lying images of a world too long taken as immutable" that J.C. saw as the innermost force behind Albers's entire production, from the glass pictures made of bottle fragments around 1921 to the eighty *Treble Clef* paintings of the 1930s, "abstract art's first serial undertaking," and then to the innumerable versions of *Homage to the Square*, painted from 1950 on.[10] With Takis, Hans Haacke, and the later Georges Vantongerloo, J.C. brings to light an obsession with capturing directly, without mediation and without representation, the invisible energies of the real—magnetic for the first, ecological for the second, and cosmic with the third.

Throughout all of J.C.'s writings during the *Robho* years, the concept of "le réel" (the real) recurs incessantly, along with "le vécu" (the lived), and yet these terms were to disappear almost completely in his work during the *Macula* years, the term "réel" appearing only in the syntagm "effet de réel" (reality effect), and "le vécu" only once (in his text on Manet), and then in quotation marks.[11] I see this change of vocabulary as a symptom of a deep mutation in his philosophical underpinnings, as well as in what he was expecting from art, and in the instruments that he used to write about it. To put it briefly, during the *Robho* years, J.C. was still very much affected by Jean-Paul Sartre (in a text, discussed below, where he rails against the devolution of Kinetic art into kitsch, he quotes this phrase from Sartre: "All [creative] technique relates back to a metaphysics").

And he was affected also by Maurice Merleau-Ponty. There were to be a few rare references to the latter in his texts from the *Macula* years, notably in his drubbing of the concept of "pure visuality" or "opticality" (favored by Clement Greenberg and Michael Fried), but no more references to Sartre.[12] During the aforementioned five-year hiatus, they were replaced by references to Roland Barthes, Michel Foucault, Jacques Derrida, and, above all, Hubert Damisch, whose seminar J.C. attended for several years.

This move from phenomenology to structuralism and what came after (again, to put it briefly) took place in parallel with another major shift. The *Robho* years saw that great burst of utopian thinking that was to culminate in "May 1968," only to be followed by a reactionary backlash that was sometimes brutal and, at other times, merely tawdry, but always demoralizing. Pierre Francastel defined art, laconically, as "one of the human languages"—an idea that seems obvious today but was much less so at the time. J.C. unpacks it, explaining that what the sociologist/art historian meant was that art was "one of the constitutive structures of the collective intelligence, one of the instruments of our apprehending of the real, one of the most essential means we have for understanding and transforming the world." He adds:

> Today, any ideology that tries to separate people's productive activity from their capacity to question our mental structures through art is a mystification. There does not exist, on the one side, the consumption of aesthetic objects (beautiful for some unknowable reasons), and, on the other side, the production of goods by others, inter-reacting among themselves (among which artistic creation plays a determining role).

This is an extract from an essay entitled "Le cinétisme est-il un académisme?" (Is Kinetic art an academism?) that was published in issue 2 of *Robho* (November–December 1967), where J.C. made clear how sickened he was to see a movement in which he had put so much hope descending to the level of a gadget-market worthy of the Concours Lépine. His protestations were, in places, strictly sociopolitical:

> In the best Kinetic art, and in its current manifestations, there is a dual moral involvement. [ . . .] It takes account of reality such as it is, with all of its metamorphoses, wanting neither to blind us nor console us; rather it seeks to expand our knowledge of the real, and to give us the instruments of a new praxis. On the other hand, Kinetic art, by stressing the dematerialization of the object, creates habits of thought that cannot avoid having consequences in our everyday life. The desire to systematically question fixed matter, the stable, permanent, and concrete data of the world, gives rise to an overall attitude against ownership.

There is, subjacent to it, in the best Kinetic art, an opposition to owning that leads, through the habits it creates, to taking a certain stand in society. In its way, Kinetic art is "committed." [...] Yet it is "committed" in the specific field of art—the structuring of the collective intelligence. This is why the gadget is something reactionary. By fixating on the object at the expense of the thought, it contributes, in an insidious way, to the reification of the artist's message, taking away its liberating character.

One of the themes running through the *Robho* years was the denunciation of the society of the spectacle and the idea of art as a leisure activity. The argument here was often very close to that of Guy Debord (*The Society of the Spectacle* appeared in 1967), and it went along with collective street interventions, most often spearheaded by Julien Blaine, using strategies of provocation and *détournement* that were obviously borrowed from the Situationists. One hilarious *Robho* exhibition project, published full-page in spring 1968 in the third issue of the journal ("L'éphémère et sa suite" [The ephemeral and what comes after])—unsigned, but with many references indicating that J.C. was the main author—gives a good idea of the occasionally playful atmosphere of the times. The first sentence reads: "The exhibition's main aim: the disappearance of all material traces of the works at the end of the shows. As to what happens next, that is your business." After a long list of often very comical proposals, such as "Plagiarism workshop. For the price of the material, visitors are invited to create by themselves, and to take home, works by their favorite artists. A plagiarism technician will be on hand to explain the nature, size, and spatial arrangement of the materials to be used," the text concludes with this invitation: "We are making this project available to anyone who would like to carry it out."

The participatory utopia underlying these activities had already been evoked in "Le cinétisme est-il un académisme?" It became more clearly delineated in an article-manifesto whose title drew on Merleau-Ponty, "Unité du champ perceptif" (The unity of the perceptual field), published in the last issue of *Robho*. Here, the tone is almost lyrical, and the piece stresses the polysensory along with all artistic experiences aiming at removing the visual from its privileged throne:

What is in question here—through manipulation and displacement—is: 1) the space between the viewer and what he or she stands before: the work; 2) the physical passivity of the spectator. The work is apprehended by an act—and no longer solely through seeing. [...] Since the Renaissance, painting and sculpture have been characterized by the primacy of the viewer's gaze (in the case of sculpture, dominated by the concept of frontality), and by the viewer's conditioning as static. [...] This passive conditioning of the viewer has been articulated over four centuries in a language that offered itself, above all, as a system of signs,

an intellectual projection, a reduction to essentials of any given relation to the real. [...] This is now the end of vision's vis-à-vis and "framing," brought about through a perceptual apparatus that encompasses motricity, the muscular system, the tactile, etc. . . . Such are the consequences of the viewer's intervention and of the physiological apprehending of the object through Kinetic art.[13]

This text, however, concludes with a warning. Following an enthusiastic description of Hélio Oiticica's artistic explorations (celebrated in the same issue of the journal) and a denunciation of the Brazilian military junta whose regime had sent the artist into exile, J.C. shares his doubts and concerns. His remarks could be applied unchanged to a recent and rather tiresome artistic movement called "relational aesthetics":

Through its inability to go right to the end of its collective logic—censorship, more or less hypocritical, exists in most countries—the polysensory current is in danger of closing in on itself and being reduced to:

- either a therapeutic adaptation to the dominant system. This is already the role played by bourgeois psychoanalysis and by all those "institutes of the body" that repair, on the weekend, the damage caused during the week, allowing their clients to go back, fresh and readily available, to the wheels that grind them. The job being to domesticate "savage" violence and to channel it in the flow of the social mechanism.

- or "cultural" demonstrations put on in museums and institutions that would have a dual mission: to transform the experiences into spectacles, objects, and signs of social belonging, and to prevent their proliferation outside of the narrowly demarcated territory of "culture."

Surrounded everywhere by sociopolitical constraints, polysensory explorations cannot escape the contradictions of the society in which they take place. They can only be models allowing us to glimpse, in a fragmentary way, the sorts of human relationships that would be possible in a society that had moved beyond alienation, separation, and taboos.[14]

Reading between the lines, these concluding remarks (especially the last paragraph) signal the end of a dream. At the end of 1971, as the rebellious wave of 1968 was giving way in many places to authoritarian regimes, the role for art that J.C. had specified throughout his time at *Robho*—i.e., "to expand our knowledge of the real and to give us the instruments of a new praxis"— appeared scarcely tenable.[15]

In this same last issue of the journal, there appeared the longest article that it had ever published—again, unsigned, but obviously written by J.C.—"Quelques aspects de l'art bourgeois: la non-intervention non intervention (A few aspects of bourgeois art: non-intervention)." The article, very Debordian in tone, ends with an appeal to "intervention" understood as a "revolutionary" act:

> To turn creativity back against the society of reification, to analyze and dynamite the instruments (mass media, middle-class education) designed to accelerate the cretinization of the masses—these are the urgent tasks of today. All art is revolutionary that expands and proliferates outside of its traditional boundaries, setting off irrepressible and uncontrollable disturbances, contributing to the general intellectual revolt against the established order.

And yet, coming after an interminable full-on attack against the art world and the quasi-totality of avant-garde artistic production of the time, seen as willing cogs in the machinery of the capitalist economy (the most recent American art finding itself in the middle of the target), it is hard for us to see anything in this appeal other than a desperate message in a bottle. J.C. attacks everything: Conceptual art, Process art, Land art, Arte Povera, even what was not yet called "Institutional Critique" (poor Daniel Buren, whose work had been favorably reviewed by the journal in 1967 and 1968, is pilloried[16]). The steamroller here is pitiless; it is a tidal wave drowning everything, and it seems very clear that the polysensory experiences, proposed as a lifeline in the text that accompanies this one, will not long resist their being engulfed, along with all art, by the culture industry.

A curtain is drawn. *Robho* ceased publication, and at the same time, in fact, J.C. left *Réalités*. Or rather, he left *Réalités* as a journalist, but he stayed involved there with a series of in-house books on painting (in the category "Beaux Livres"). He was asked to produce the series after the phenomenal success of his first attempt, a big tome that had just come out on Impressionism, and that had been published (no doubt at his own request) pretty much anonymously.[17] Two others were to follow: the first, in 1975 (almost at the end of the "five-year hiatus"), entitled *From Impressionism to Modern Art*, and the last, *Romanticism*, written entirely during the *Macula* years (it appeared in 1980). In all three books, the stance taken is identical: Special attention is given to the selection of images (hundreds of illustrations in large format, all in color), a careful choice of well-known masterpieces (but with selected details revealing an unexpected modernity) next to works that were, at the time, unknown, above all those drawn from outside the world of French art. The chapters are not based on themes, or rather, since painting is seen as a language, the themes are formal, concerning the constituents and procedures of pictorial language (in *Romanticism*, for example, the chapter titles include terms such as surface,

J.C. or the Critic

87

line, blurring, color, and assemblage). Each of the chapters is introduced by a dense historical-theoretical text providing a solid and up-to-date introduction to the topic, but the more impatient reader could skip the theory and move on directly to the "practical applications," the highly detailed commentaries accompanying each plate. These were formal analyses of a rigor rarely seen in books of this sort, and one feels that J.C. must have taken pleasure in perverting the "coffee-table book" genre. The layout is the same for all three books but not the references, and one can easily track the evolution from the first volume (still very much marked by Merleau-Ponty) to the last one, consciously deconstructionist (Jean-Luc Nancy and Philippe Lacoue-Labarthe's *Literary Absolute* is much called on), particularly so in J.C.'s desire to show as outdated the opposition between Romanticism and Neoclassicism. The formal continuity throughout these three books, aiming, above all, for maximum pedagogical effect, tended to eclipse the theoretical differences.[18] However, these differences leap out at anyone who, having in mind the militant prose of *Robho*, so much as glances at *Macula*.

The changing social and political context certainly contributed to the shift in J.C.'s thinking. By 1976, when *Macula* began, it was no longer possible to believe that art could change the world, or, at any rate, that it could do so directly and in an unmediated way. In the texts from the *Robho* years, the "sign" had always been considered the bad object par excellence, it had always been seen as a sad and scrawny leftover from the "vécu." Now it was assumed that the only life possible was one lived under the empire of signs. Yet J.C. did not exactly go through a semiological phase. He discovered structuralism shortly after its positivist moment, and at a time when its foremost representatives, Barthes and Foucault, had already moved on to other things, and when Derrida was unknitting it. J.C. was more enthused by Saussure's research on anagrams than by the idea of the arbitrariness of the sign—abstraction having long been, for him, a settled affair.

One premise, or counter-premise, that was often at work, and sometimes stated loudly and clearly in the texts from the *Macula* years, offers a good way into the subject. This was the categorical denial of Émile Beneviste's theory according to which language was the sole interpretant of all other systems of signs (a thesis that was still maintained by Barthes despite the logocentrism on which it was based). This rejection was so programmatic that it figured even in the ostensibly lacunary editorial (unsigned, but written by J.C. and myself) that opened the first issue of the journal.[19] It follows from this premise not only that a work of art can be interpreted by another work (something that painters had always known, and that an art historian like Leo Steinberg had spent his life demonstrating), but also that a medium can be interpreted by another medium—that the crossing over of practices could give rise to novel interpretations.

Presenting, for the first time without the cropping that they had always undergone, the photographs that Hans Namuth had taken of Pollock at work, J.C. entitled his introductory text "Hans Namuth: Art Critic" (published in 1977 in issue 2 of the review, and then reworked and augmented a few years later in *L'atelier de Jackson Pollock* (Jackson Pollock's studio), the first book to appear from Macula Publications).[20] Ignoring the "artist's studio-porn" aspect (for which these images are famous), J.C. showed how the photos were an incisive commentary on Pollock's work, so much the more relevant for being purely visual, a "non-language-based interpretation," revealing, much more subtly, and certainly more economically than could discourse, the dialectical entrechat between the allover and the fragment.[21] Conversely, it was precisely because he was confined to the "prison-house of language" that the (professional) art critic Gabriel-Albert Aurier—the great champion of Gauguin at the cost of a misunderstanding that would have blown up if he (Aurier) had lived longer—"misses one of the revolutionary components of [for him] contemporary art, that of the Impressionists and also the Symbolists—namely, the progressive deconstruction of the iconic sign, the revealing of what in the work exceeds the description, the designation, and the object."[22]

One obsession during the *Robho* years had been the expansion of pictorial practice beyond itself (for example, expansion from the painting to the wall, from the wall to architectural space, from architectural to social space). It was as much a question of retracing the history of this expansion, starting with the avant-garde productions of the 1920s, as it was of promoting its more recent avatars. But the nature of the expansion changed radically in the texts of the *Macula* years. It was no longer seen so much as lateral extension (although it could still be that—the importance of the wall for painting remained a recurring theme and is very much present in the texts on Pollock, Martin Barré, and Robert Ryman), but rather as a change in focal distance. J.C. was asking this question: What happens, for example, if we look at pictorial practice from the perspective of drawing, gauging it with drawing as a model? Well, the history of painting is immediately turned upside down:

> In this case the modernity that stretches from Cézanne to Ryman can be defined also as the art of transposing the properties of drawing onto the field of painting. And drawing [ . . . ] poses directly the question of the subjectile in all its various forms —from the fifteenth century prepared parchments that receive the indelible silver tip, to the highly textured paper grazed by the Conté crayon—as that which constitutes both stroke and spot, as part of an historical sequence in which painting tends on the contrary to require instead only a prepared, prefabricated, standardized *support*—a *projective* surface as opposed to the *inductive* surface whose untouched area, called in French the "réserve," constitutes the matter.[23]

The history of painting is turned upside down, since it now appears to be slug-gishly following drawing, since it is with the practice of drawing that, against the neutral notion of the support, the idea of the subjectile as an integral and meaningful part of the work had been invented.[24] And, by this move, the manner of writing history was completely overturned as well. From Cézanne's well-known use of the "reserved" areas in his works on canvas, one backtracks to his watercolors, and from these (underlining the anachronism of the connection) to the whites of the virgin paper animating the wash-drawings of Poussin and Guercino. Pollock is examined through the lens of Seurat and Vuillard, but so is Mondrian through the lens of Pollock (history is no longer unidirectional).

Previously—that is, in his articles from the *Robho* period—J.C. was often discovering little known "precursors" and pointing out foreshadowings; history there was chronological and linear, and this fitted in with his general project of the time, namely, to articulate the coherence of a trajectory. In the texts from the *Macula* years, by contrast, the linear trajectory is replaced by an ever changing moiré effect of threads running in all directions, by what J.C. called the "paradigmatic declension" (the approach to historical investigation that Walter Benjamin advocated, using the term "constellation," was very important here— we were keen readers of Benjamin at the time). He concentrated, moreover, on artists such as Manet and Ryman whose work showed practically no stylistic evolution. It is in the text on Barré, it seems to me, that we see the move from one conception of history to the other. Here, J.C. is still tracing a trajectory, but this time it is stratified, its limits forming less an alignment along a horizontal axis of time than a vertical section, with each significant moment seen as reactivating some procedure in the panoply bequeathed by Western painting (and perhaps even more so by drawing) over the course of centuries. The past is summoned by the present, in other words, as a means of dissecting and perturbing each time a specific component of the pictorial or graphic language.

It is also in this text on Barré, moreover, that we see the first reference to the Saussurian anagram (J.C. associates it with another model of siphoning, the Barthesian photogram) to explain the nature, at once analytical and predatory, of the historical method to which, through mimetism, Barré's production had led him. Seen through the prism of the anagram (it was to turn into "paragram" in the texts on Namuth/Pollock and Manet, i.e., the more appropriate term that Saussure himself proposed to differentiate the object of his research from the invention of new words by a simple permutation of letters),[25] Barré's work becomes

> a structure with multiple entrances and interpretations where the same set of components is used to elaborate, according to a certain relevance (color, format, compatibility of inscribed traces), various mutually exclusive "sentences," visual concatenations, modalities of reading. Combinatory: an immaterial web held

up "in the air," a borderless weaving shot through by numerous back-and-forth paths, and that only contains all these readings to the extent that it is unlimited by their proliferation.[26]

Saussure's (almost crazed) quest after paragrams, like J.C.'s paradigmatic declension, was a formalist endeavor—a generalized, "open" formalism of the sort practiced by the Russian Formalists, and that J.C. promoted in opposition to the more "limited" and purely morphological formalism for which, in his writings on art, Clement Greenberg was the great champion.[27] "The formalist method," J.C. notes,

> considers with equanimity all factors: textural, chromatic, figurative, etc., and designates as a work the full range of their configurations. Art history is nothing other than the way in which a given element (or group of elements) becomes (according to relations of co-existence, fusion, subordination, etc.) dominant, before it cedes its place to others (only to re-emerge later into the foreground, in a new combination).[28]

For J.C., the declension had to do, more often than not, with the material components of painting, i.e., all of the nonmimetic factors that Meyer Schapiro had investigated in his famous inaugural article in 1969 for the scholarly review *Semiotica*, "On Some Problems in the Semiotics of Visual Art: Field and Vehicle in Image-Signs."[29] Yet, taking as a model the Russian Formalists (for whom the literary theme was a structural, thus formal, element), J.C. also identified figural declensions:

> Some, for example, will see a figurative poverty in the way in which Gauguin carries a single motif (a woman in a wave of water, a couple facing each other) through all sorts of practices (engraving, painting, pottery, relief). But the formalist will see the ordered declension of an unchanging graphic scheme in a variety of materials that, each in turn, *produce* it. A particular work is less the graphic scheme than the scheme's declension.[30]

The most elaborate analysis of this sort concerned the "declension down widely differing subjectiles" that Manet carried out with that most treacherous of subjects, horses galloping towards the viewer, in his series of nine works, *The Races at Longchamp*.[31] This recurrent transfer from one medium to another is only original in Manet (and in Gauguin) because it is so headstrong. More astonishing, for J.C., was the persistence of

> certain figures [ . . . ] whose strength and frequency can be compared, in some cases, to an effect of traumatic images. It is not a matter of indifference that the

91

crowd watching the execution of Maximilian, even if it comes from Goya, is the same one as in *The Dead Toreador* (before the painting was cut up). And that the firing squad that executes communards in *The Barricade* is the very same one, reversed, that shot the emperor of Mexico. Or that the body lying at the foot of the barricade in *Civil War* is that of *The Dead Toreador*.[32]

The most subtle form of declension, or rather its exposition by the critic, relates to what denizens of the Internet call "a visual meme," i.e., a schema that repeats from image to image but is independent of what is represented:

> There is a similar persistence of a graphic element—or a portion of layout: the line that winds across the whole breadth of *Little Cavaliers* (Manet's copy of a supposed painting by Vélasquez, c. 1856) reemerges to scatter the dancers in *The Spanish Ballet* (1862). The same horizontal development of a line, but softer, controls the crowd in *Music in the Tuileries* (1862) or *Masked Ball at the Opera* (1873). Another, more angular line distributes the irregular group in *The Old Musician* or the firing squad in *Maximilian*. Other echoes, but here we enter the domain of unconscious memory: the bottom of the dress in *Jeanne Duval* (1862) recurs in the parterre in the *Exposition Universelle* (1867).[33]

We are very close here, in fact, to the way in which Saussure hunted down paragrams in canonical texts, and the meticulousness of the collecting is the same. Any reader of J.C. is necessarily obliged to pay such attention to detail. In his text on Manet, he makes precise allusion to a great number of works from among those on view at the unforgettable retrospective at the Grand Palais in 1983. These were works that, by a miracle of the calendar, his readers could examine for themselves at the exhibition with his text under their arms.[34] It is not possible to fully appreciate J.C.'s ideas without, minimally, making the effort to consult reproductions of the works mentioned (a task facilitated today by the Internet). I say "minimally" because in many cases that is not sufficient. Moreover, J.C. notes this himself:

> Examining Manet's paintings (*the paintings, not photographs of them* [emphasis mine]), one can see that the artist, as though seeking to overcome in the texture the old distinction between form and background, ends up producing, by weaving, overflowing, and overlapping, a new subjectile.[35]

J.C. gives several examples of these interwoven layers, all very hard to notice in reproductions, and all requiring, on the part of the viewer, a lover's myopic gaze, a close-up look:

The "background," very often painted last, clearly encroaches on the figure, which—a new aporia—all of a sudden finds itself emerging from a lower layer of paint (*Soap Bubbles*, 1867; *The Brunette with Bare Breasts*, 1872, etc.). [ . . . ] One can observe that the overlapping of strata of color operates even in the details of works, and may involve more than two depths: in *Girl Serving Beer* (1879), the "background" covers the singer who, in her turn covers a woman spectator in the middle ground, and so forth.[36]

J.C. was fond of saying, "A little formalism limits us to the object; a lot of it frees us from it," adding:

> by exposing the process in all of its components, the object appears only for what it is: an assemblage, the effect of a series of series, the temporary result of a moving play of plastic and discursive formations—a *monument* in Foucault's sense, whose laws of formalization are always historical, and must be determined.[37]

This widened, "open" formalism J.C. was calling for did not just contain a carefully controlled myopia among its panoply of tools; rather, this myopia opened it onto the historical:

> I have suggested above that Manet may have been the first artist to feel constit-uent elements of the painting (of his time)—surface, border, color, texture, gesture—to be dissociable. And that where painting had hitherto tended from the outset towards unity [ . . . ] Manet, for his part, made use of these constituents as in a play of variables that one might test, "try out" one by one, favoring this or that element in such a way that the work was not the governed resolution of tensions, but just the opposite: the coalescence of conflicting elements *at work*.[38]

Manet was the first to "tear painting to shreds," as J.C. said of Ryman, but it was only thanks to the fierce, obsessional work of Ryman (and also Barré) that J.C. was able to catalogue the dissociations that Manet adroitly managed among all of the pictorial constituents as well as within each of them, and that he was able to examine the multiple aporias to which these dissociations inevitably led ("aporia" was a fetish word of J.C.'s during the *Macula* years: "Good painting is always aporetic," he wrote in his article on Aurier).[39]

One of the aporias that J.C.'s generalized formalism brought him to examine, more and more closely, concerned what he called, in connection with Pollock, "profondeur plate" ("flat depth," although it would be better to call it "surface thickness" to avoid any confusion with Greenberg's [essentially illusionist] "shallow depth" as well as to point out [as J.C. often did in his notes] what the

concept owed to the discussions that he and I had, all through the *Macula* years, with the painter Christian Bonnefoi). The first of Bonnefoi's texts published in the journal focused on an aspect of Albers's *Homage to the Square* paintings that had never been noticed, namely, the grain of their surface (the verso of Masonite), to which the artist was so attached. Bonnefoi's second article, on Ryman, was entitled "À propos de la destruction de l'entité de surface [On the destruction of the surface entity]," and the third one, in the final issue, was a very long interview in which the question of surface thickness comes up on every page. J.C.'s remark, cited above, on the infringement of layers in Manet's *Girl Serving Beer* is one example among so many others of the extremely careful attention that he gave to material, haptic overlaps, particularly when they contradicted the (optical) data supplied by vision. Another example is this brilliant paragraph of his text on Namuth/Pollock in which, before extrapolating from it an especially close reading of two disjointed periods (1915–16 and 1942–44) in Mondrian's career, he emphasizes a similar articulation of surface thickness in both Seurat and Pollock:

> With Seurat, every touch is reactive. Point calls upon counterpoint. Each touch reinforces or contradicts a touch that is already there. The proceeding is like a bombardment of *discrete units*, distributed according to layers that articulate themselves on already existing layers. It is because the texture is made up of "relatively homogeneous" discrete elements that the work appears to us an ordered superimposition of layers. The pigmentary mass "unfolds" itself in a certain number of overlapping strata that have between them enough similarity to make a system. Pollock's "contrapuntal" painting (to take up an old word of Motherwell's) also presents this quality of an ordered articulation of discrete elements. Even if, *morphologically*, Pollock's meshes have nothing to do with Seurat's little points, *structurally*, they have similar qualities. Despite their diversity in terms of thickness and treatment, these meshes establish between themselves a relation of solidarity that has to do with their continuity, their curves, and, more generally, the physical procedure that made them possible. When the ability to articulate was lacking, Pollock's painting became stuck, clogged—the netting that had once been interlaced became fixed in an opaque and viscous mass. *The Deep* (1953), with its heavy, creamy flows, and its mortuary void, was a last hiccup.[40]

There is, of course, much more to say about J.C.'s very densely written texts. We could, for example, go back to what he calls the artist's situation of "proclivity" (nonmastery, expectancy) in front of the work as it is being created, or on the always unexpected ways in which the concepts of psychoanalysis (taken not from texts on art or culture but from clinical writings) emerge in his texts.[41] My purpose here has been only to provide an overall framework, a guide for

those readers sufficiently interested by these few quotations to want to enter this teeming labyrinth. I would like in closing, however, to refer to an aporia that is as productive, it seems to me, as others that J.C. almost affectionately tracks down, and that concerns a recurring aspect of his endeavor. I would characterize it as his dual attachment to the dialectical method and to what deconstructs it.

To conclude, therefore, with a few choice selections. On the dialectical side, we have (among many other examples):

> Such is the case in a work where Ryman claims to make incomplete what is completed and complete what is incompleted, the production of the incomplete taking on meaning only through the questions it raises concerning the incompletion of any painting.[42]

> We know how allover painting, coming to prominence in the 1930s and '40s, brought every canvas back to the status of a fragment. As soon as there was no internal compositional hierarchy organizing the visible surface, there was nothing to stop the surface from extending itself *ad infinitum*, and nothing to stop the frame delimiting it from appearing as the arbitrary effect of a cut-out in an unbroken fabric. Martin Barré's painting both encompasses allover painting and takes it further. It can only be thought after it. His painting makes visible the unsaid of fragmentation. It makes of each canvas a detail—but *décadré* (with the dual meaning of "sans cadre" (without frame) and "décalé" (offset).[43]

> [On Manet:] The procedure merges with the work: it must be foreseen [ . . . ] for the work to be unforeseeable.[44]

On the side of deconstruction, we would have to quote, perhaps, all the texts from the *Macula* years—the map perfectly overlaps the territory here. Nonetheless, we must point out that the very subtitle of the text on Aurier, "Notes on the material *reversal* of Symbolism" [my emphasis] clearly marks it as an exercise in deconstruction. J.C. is concerned, in this article, with putting an end to the hackneyed fin-de-siècle opposition between Naturalism (typically classified under the heading of "materialism") and Symbolism (defined by its defenders, including Aurier, as the apogee of Idealism, and which the Russian Formalists took as their foil). There was certainly materialism in the approach of the Naturalists. However, what is less expected (except for those, like J.C., who rarely spend a day without dipping into Mallarmé)s is that there was a good dose of materialism in the work of the Symbolists. There was a real divorce here, a radical separation between Symbolist theory (Aurier had invented a new name for it: "la théorie idéiste") and the actual practice of the Symbolist painters that the theory defended.

The entire effort of ideist theory is to repress the potential expressivity of the physical constituent parts of the painting: color, texture, surface, limit—and this goes quite against the evidence of a pictorial practice that was increasingly engaged in the investigation of those same material components.[45]

J.C. notes that this divorce between practice and theory was not entirely new, adding: "Idealist discourse, from Winckelmann to Mondrian, was a red herring, a diversion from and a covering over of a working practice that was always able to find within itself the elements of its own formal advance." And this comment is followed by a brief incursion into the ideal world of Neoclassicism in the eighteenth century, whose program is subjected to the same critique as Aurier's. Paraphrasing, it runs like this: "Watch out, theorists of Neoclassicism: The painters you defend dare not tell you, or perhaps they themselves have not understood, but their art shows that you are wrong." Coming immediately after is this pearl that I have left until last:

> The same reversal is there in Hegel when, in a very perceptive page, he points out a painter's most challenging "motif," the human cheek: ". . . the most difficult thing in the matter of colour, the ideal or, as it were, the summit of coloring, is 'carnation', the colour tone of human flesh which unites all other colours marvel-ously in itself without giving independent emphasis to either one or another. The youthful and healthy red of the cheeks is pure carmine without any dash of blue, violet, or yellow; but this red is itself only a gloss, or rather a shimmer, which seems to press outwards from within and then shades off unnoticeably into the rest of the flesh-colour, although this latter is an ideal interpenetration [*Ineinander*] of all the fundamental colours. Through the transparent yellow of the skin there shines the red of the arteries and the blue of the veins . . ."

> Is it not obvious that, in this analytical approach to the color of a cheek, Hegel's attention is focused precisely by the example of painting in its materiality: glazes, color chords, pigmentary opacities. Hegel is only able to so well enumerate the combinations that produce the translucence of a human cheek because he takes painting (whether or not it is of a cheek) as his propaedeutic. With language such as "transparently deep" [*durchsichtig tief*], "interpenetration of different colors," "the result of different surfaces and planes," "transitions," it is clearly artistic practice that hones Hegel's gaze onto the natural world (as well as his vocabulary)– the revenge of the sensory and the "haptic" over the "view exempt from desires."[46]

Alas, materialism's revenge can never be anything but provisional. Still, in the meticulous and demanding work that he did during the *Macula* years, J.C.,

always the pedagogue, shows himself an unceasing optimist. The *Robho* years, so joyful at the start, did conclude with doubts and a burst of nihilism, but the final bouquet of the period that followed, the exuberant essay on Manet, is, in its way, a slogan: "This is only the beginning, the fight goes on! It is up to you, dear reader, to take it up!" All the editorial work that J.C. devoted himself to, exclusively, after this salvo had no other goal than to polish our weapons.

Translated by Nicholas Huckle.

Forthcoming as a preface to Jean Clay's *Atopiques, de Manet à Ryman* (Strasbourg: Editions L'Atelier Contemporain, 2023).

1. To my knowledge there is only one (short) scholarly essay about *Robho* and its history, Isabel Plante's "*Les Sud-américains de Paris*: Latin American Artists and Cultural Resistance in *Robho* Magazine," *Third Text*, vol. 24, no. 4 (July 20100: 445–55. Its author does not address the issue of the journal's title.

2. If I recall correctly, there were only two full professor positions in the University of Paris—that is, carrying the right to advise dissertations—that were exclusively dedicated to the history of modern art at that time. They were held by scholars for whom Cézanne represented the beginning of decadence: Bruno Foucart's main book was about French religious painting in nineteenth-century church buildings, and among Pierre Vaisse's high points was his unrepentant defense of the French state's famously grotesque refusal of the Gustave Caillebotte bequest. Jean Laude, also a full professor, saved the reputation of the Sorbonne with regard to the history of modern art, but he only taught it part-time as his official charge was African art. His courses, notably that on Cubism, were truly exceptional in the conservative atmosphere of French art history, attracting crowds, and he was inundated by requests from graduate students that he be their advisor.

3. The title of the journal was Jean's doing. In French the word *macula* (directly imported from the Latin) designates a small yellow spot on the retina that plays an important role in our central, focused vision. The French word *macule* was also part of the connotative riches that seduced us. It has two meanings: The first is that of spot, stain, smudge, etc. (which we felt was particularly suited to a journal devoted in large part to painting), and the second sense, clearly derived from the first, belongs to the craft of typography; it is the name given to the sheet of paper that the printer intersperses between two freshly inked sheets in order to avoid any smudge.

4. I should say, rather, that although J.C. stopped writing as an author, he continued to write as an editor. Some of the notes in his critical edition of the French translation of Barnett Newman's *Selected Writings and Interviews* are close to being small treatises.

5. A number of these are collected in *Visages de l'art moderne* (Faces of modern art), which J.C. published in 1969 with Éditions Rencontre. This work was reissued in 2016 as an e-book and with a new title, *Paroles d'artistes* (Artists' words), by Éditions Thierry Marchaise.

6. J.C.'s article on Clark was accompanied by a great many of the artist's own writings from 1960–68 that they had translated together from Portuguese. The publication also included the "Manifesto of Neo-concretism" (co-signed by Clark in 1959), as well as a very suggestive article by the Filipino artist David Medalla.

7. Jean Clay, "Lygia Clark: Fusion Générralisée," *Robho* 4 (Winter 1968): 12.

8. To my knowledge J.C. never published anything specifically on Max Bill in *Robho*; however, he often referred to him, and in his essay on Richard Paul Lohse (Bill's brother-in-arms on the adventure that was Concrete art), he is very clear about his interest in the principle of a "systematic" art where the works are mathematically programmed in advance by the artist and whose actual production takes place without any subjective intervention on the part of the latter.

9. Jean Clay, "Soto. De l'art optique à l'art cinétique" (Soto: From optical art to kinetic art), Galerie Denise René, Paris, 1967, unpaginated. We should note that, for J.C., the *Pénétrable* was a culminating point, in the dual sense of apotheosis and conclusion (when used as a singular noun, *Pénétrable* refers to the whole class of site-specific pieces built by Soto in various architectural settings, all of them consisting of thousands of vinyl threads

hung from above and densely filling up the space through which the beholder must pass). How much it dazzled him is clear in the very long essay just mentioned, written for the catalogue of Soto's retrospective exhibition at Denise René, where the artist had installed his first *Pénétrable*. J.C. took up part of this text again, taking it further, in "Les pénétrables de Soto" (Soto's Pénétrables), published in the third issue of *Robho* (Spring 1968), an article that, in 1979, he again took up and extended in "Le tableau, le mur, l'infini" (Picture, wall, infinity). The conclusion and final illustrations of this last essay deal with the giant *Pénétrable* constructed by Soto between the Musée d'art moderne de la ville de Paris (the MAM) and the Palais de Tokyo in 1969. J.C. was never to mention any of Soto's subsequent works, and this is no doubt a sign that, for J.C., everything that came after was redundant and had lost its edge. We should note also that although "Le tableau, le mur, l'inifini" came out in 1979, and therefore during the time of *Macula*, the fourth and last part of the text, the one devoted to Soto, was quite obviously written from notes going back to the *Robho* years, contrasting thus with the three other parts (on, respectively, Mondrian and Malevich, Monet, and Pollock) that clearly are of the *Macula* vintage. "Le tableau, le mur, l'infini," whose original title was "Contre-épreuve" (Counterproof), makes up the third chapter in *Architecture, arts plastiques: Pour une histoire interdisciplinaire des pratiques de l'espace* (Architecture, visual arts: An interdisciplinary history of spatial practice), a voluminous research report, edited by Christian Bonnefoi, J.C., and myself, with the participation of Nancy Troy and Hubert Damisch, and published by CORDA (a governmental organization devoted to research in architecture) in a very small edition (200 copies, if I remember correctly).

10.  Jean Clay, "Albers: Trois étapes d'une logique" (Albers: Three stages of a reasoning), *Robho* 3 (Spring 1968), unpaginated.

11.  Jean Clay, "Onguents, fards, pollens," in *Bonjour Monsieur Manet* (Paris: Éditions du Centre Georges Pompidou, 1983), 19. This text was published in English as "Ointments, Makeup, Pollen," trans. John Shepley, in *October* 27 (Winter 1983), but in this version the quotation marks I just mentioned have disappeared: "les changements de tempo propres au 'vécu' d'une capitale moderne" is rendered as "the changes of tempo characteristic of life in a modern capital" (33).

12.  As Fried stressed, his and Greenberg's interpretation of, the concept of "opticality" are not perfectly identical, but this does not matter here, for J.C. rejected both. On this issue, see Michael Fried, "An Introduction to My Art Criticism," in *Art and Objecthood* (Chicago University Press, 1998), 19–23.

13.  Jean Clay (the text is anonymous, but clearly written by him), "Unité du champ perceptif," *Robho* 5/6 (Spring 1968): 9.

14.  Ibid., 11.

15.  Jean Clay, "Le cinétisme est-il un académisme?" unpaginated.

16.  A very positive article by Grégoire Muller on the BMPT group (an acronym for Buren/Mosset/Parmentier/Toroni) was published in issue 2 of *Robho* (November–December 1967) with the title "Quatre non peintres" (Four non-painters). In issue 4, a short, anonymous item on Buren, with four photographs as illustrations, takes up more than a third of a page (11), devoted to various activities in the urban milieu grouped under the heading "Art Sauvage: La fin des galleries" (Wild art: The end of galleries).

17.  This was corrected in the later editions, most probably because the publisher had understood the advantage to be gained from its being seen retrospectively as a series. In the first edition, however, issued in 1971, J.C.'s name appears only in the

colophon, on the very last page of the book, along with that of the designer, his friend Jean-Louis Germain, who was to be the unpaid graphic designer of *Macula*, while the name of the author of the preface, René Huygue, "from the Académie Française," was displayed in large lettering on the title page. We should add that J.C. often published anonymously (a great number of his texts appear unsigned in *Robho* and elsewhere)—another thing he has in common with Fénéon.

18. They were all designed by Jean-Louis Germain, J.C.'s faithful comrade-in-arms.

19. The refutation of Benveniste's position on this point concludes with these words: "Critical and analytical function of the copy, of the diagram, of photography, of reproduction, of framing—as methods of reading. And now here is the mute Juggler of Notre Dame, juggling away with his *text* at the foot of a statue of the Virgin Mary, or this tap dancer in front of a Mondrian . . ." ("Extraits de l'éditorial," *Macula* 1, 3). The "Juggler of Notre Dame" is an allusion to a miracle from the Middle Ages, made famous through a short story by Anatole France and an opera by Jules Massenet. Our head-on opposition to Benveniste only concerned his logocentrism, and it should not obscure the great admiration that we had for his work as a whole; J.C. and I often made reference to him during the *Macula* years.

20. There were two editions of *L'Atelier de Jackson Pollock*. The first of these, dating from 1978, does not include any text from J.C. but an essay by Rosalind Krauss, in which she criticizes the piece that J.C. had published on Namuth's photos in *Macula* (she remains surprisingly faithful to Greenberg's idea of "medium specificity" when she questions the parallel that J.C. had set up between Pollock's allover works and some of Vuillard's pieces). J.C. replied to this text in the second, largely revised and expanded 1982 edition of the book, with his essay "Pollock, Mondrian, Seurat:

La profondeur plate" (Pollock, Mondrian, Seurat: Flat depth).

21. "Non-language-based interpretation" is a formula that appears in "Pollock, Mondrian, Seurat: La profondeur plate," and it was taken directly from "Hans Namuth: critique d'art" (Hans Namuth: Art critic), published five years earlier. It was followed in this article by this very explicit formulation that concludes it: "Language is not the sole interpretant of all other systems."

22. Jean Clay, "Gauguin, Nietzsche, Aurier: Notes sur le renversement matériel du symbolisme" (Gauguin, Nietzsche, Aurier: Notes on symbolism's material reversal), 48. This text first appeared in the catalogue of the exhibition "Éclatement de l'impressionnisme" at the Musée Départemental du Prieuré (since renamed the Musée Maurice Denis) in 1982. The article was then republished in the psychoanalytical journal *L'Inactuel* 5 (Spring 1996). I refer here to this later, more accessible, republication.

23. Jean Clay, "La peinture en charpie" (Painting in Shreds), trans. Daniel Brewer, *SubStance* 10, no. 2, (1981): 51 (translation slightly modified).

24. "Subjectile," J.C. notes in his text on Aurier (59), is "a term valued by Fénéon." And it was one of the terms that J.C. favored the most—the word recurs constantly in his articles from the *Macula* years, especially each time the concept of "surface thickness" was discussed.

25. The Greek prefix "ana" means "from bottom to top"; "para" means "to the side of," "alongside of." No doubt because this whole field of Saussure's research was first revealed by Jean Starobinski, and the latter chooses the term "anagram" from among the various names that the linguist proposed for it, this is the one most used. Julia Kristeva's essay "Pour une sémiologie des paragrammes," published in 1967 and

included later in the collection *Sèméiotikè: Recherches pour une sémanalyse* (Paris: Éditions du Seuil, 1969), 174–207, is an exception (and we should say, in passing, that this indicates that J.C. had read Kristeva's important essay).

26. Jean Clay, "La peinture en séton" (Painting in seton), in *Martin Barré* (Paris: Arc, Musée d'art moderne de la ville de Paris, 1979), 16.

27. See, among others, this statement in "Le tableau, le mur, l'infini" (alias "Contre-épreuve," 138–39): "It's not that we subscribe to the Neo-Kantian essentialism underlying Greenberg's general aesthetic ideas. On the contrary, we want to counter the American critic's *restrained* formalism (based on the search for 'the essence' of painting) with our principle of an *open* formalism, one that begins by rendering suspect the idea of the impermeability of the genres and of medium specificity, and by denying there might be somewhere, in its undiscoverable purity, something like PAINTING (motility of fragments of codes bringing themselves into discursive formations, figures, rhythms, only to break up again and then reappear in other forms, other arrangements, caught up in another economy). Therefore: no immutable and localized structures, systems, codes, or models as such, but, rather, the interaction of codes and systems, enlightening and in-forming themselves in each new relation that establishes them." It is useful to note here that the discovery of Greenberg, during what I have called the five-year hiatus, played a huge role in the transformation of J.C.'s discourse. Even if he rarely adopted it just as he found it, Greenberg offered him a new vocabulary that fit better with what he was seeing in the works of the artists that interested him. The same is true, although to a lesser extent, for certain writings of Michael Fried. During the *Robho* years, for example, J.C. was struggling to define the rather vague notion of *rapports plastiques* (visual relations), which referred to something he saw as the bête noire of most of the artists he was discussing, and this idea disappears completely in his later writings. Looking back, it seems clear that what J.C. understood by that term was the compositional rhetoric that Frank Stella had denounced in postwar European painting, and he would have greatly benefited, at the time, from having known the essays in which Fried talks about Stell and where he invents the concept of "deductive structure." We should note, in conclusion, that *Macula* published all of Greenberg's texts on Pollock (in the same issue that had J.C.'s article on Namuth's photos), and that the journal published later, in book form, the French translation of Greenberg's *Art and Culture*.

28. Clay, "Gauguin, Nietzsche, Aurier," 56.

29. This article was reprinted in Schapiro's celebrated book *Theory and Philosophy of Art: Style, Artist, and Society* (New York: Braziller, 1994).

30. Clay, "Gauguin, Nietzsche, Aurier," 56.

31. Clay, "Ointments, Makeup, Pollen," 7.

32. Ibid., 7.

33. Ibid., 7–8 (translation slightly modified).

34. The retrospective opened on April 22, 1983, and closed on August 1. The exhibition *Bonjour Monsieur Manet*, for the catalogue of which J.C. wrote this text, went from June 8 to October 3 (the catalogue's colophon gives the printing date as June 6!). One can see the difference between museum practice in France and the United States in that during the interval between the openings of the two shows J.C. had time to go to the Grand Palais to check up on certain details, looking at the works themselves, before sending the final version of his article to the publisher.

35. Clay, "Ointments, Makeup, Pollen," 13.

36. Ibid.

37. Clay, "Painting in Shreds," 62.

38. Clay, "Ointments, Makeup, Pollen," 22.

39. Clay, "Gauguin, Nietzsche, Aurier," 58.

40. "Pollock, Mondrian, Seurat: La profondeur plate," in *L'Atelier de Jackson Pollock*, unpaginated.

41. J.C. was always fiercely critical of applied psychoanalysis, seeing it as no less limited than the Marxist interpretations found in social art history. He notes in "Painting in Shreds," "This is a cryptography that is supposed to be insightful, brought in from the outside, as violent and peremptory as any socio-economic reading that is limited to expelling the pictorial series to the heavens of superstructure" (62), and, in the same section of his essay, he aptly reproaches Freud for his blindness with regard to the famous drawing in "The Wolf Man," stressing what the psycho-analyst could have learned from only a minimum of formal analysis. But this did not prevent him from borrowing terms from *The Interpretation of Dreams* or from Freud's clinical works such as his case studies, cheekily redirecting them for other purposes.

42. Clay, "Painting in Shreds," 57.

43. Clay, "La peinture en séton," 9.

44. Clay, "Ointments, Makeup, Pollen," 28.

45. Clay, "Gauguin, Nietzsche, Aurier," 49.

46. Ibid., 49–50. The quotation from Hegel can be found in G. W. F. Hegel, *Aesthetics: Lectures on Fine Art*, trans. T. M. Knox (Oxford: Clarendon Press, 1975), 846–47. The French translation used by J.C. is by the eminent philosopher and musicologist Vladimir Jankélévitch, and with regard to the sentences or single words that he quotes and upon which he bases his comment, this translation seems to be closer to the original German text than Knox's rendering of it in English, which is why, with the help of Daniel Heller-Roazen, I have slightly modified Knox's text on two occasions. His translation for *Ineinander* was "inter-association," while that of the highly unusual *durchsichtig tief*, crucial for J.C.'s argument, was "transparent, profound."

**Bibliothèque des SCIENCES HUMAINES**

# La forme et l'intelligible

par

**ROBERT KLEIN**

Écrits sur la Renaissance
et l'art moderne

*Préface d'André Chastel*

**nrf**

Éditions Gallimard

Cover of Robert Klein, *La forme et l'intelligible: Écrits sur la Renaissance et l'art moderne* (Paris: Éditions Gallimard, 1970).

# An Encounter with Robert Klein

*The following text is a montage of two short presentations I delivered in the same room of the Villa I Tatti at symposia held less than a year apart, in January and November of 2018, respectively. The first event, titled "Scholarly Vitae," was organized by Lorraine Daston, then director of the Max Planck Institute for the History of Science in Berlin, and Alina Payne, the current director of I Tatti. It was not a public affair, and aside from the speakers (including the hosts), only the small group of fellows in residence at I Tatti were in attendance. The usual publication of proceedings had been proactively abandoned so as to encourage the fourteen orators—literary critics, anthropologists, and historians of science, art, and culture—to feel as free of super-ego infringement as they possibly could. The second symposium, by contrast, was less intimate and followed the standard protocols of international academic conferences. Jointly organized by Alina Payne, Jérémie Koering of the Centre André Chastel in Paris, and Alessandro Nova of the Kunsthistorisches Institut in Florence, it was entitled "Robert Klein, Art Historian and Philosopher." The sixteen speakers, most of them Renaissance scholars, were from France, Italy, and the United States.*

*If I felt bold enough to accept the gracious invitation to speak at this intimidating celebration of Klein's work, it was, firstly, because Alina Payne— along with Jérémie Koering—suggested that I follow up on my remarks at the "Scholarly Vitae" conclave and, secondly, because apparently none of the participants had volunteered to discuss Klein's take on contemporary art—which, as I had disclosed a few months prior, had profoundly affected my own life and work. When the request ultimately came for a publishable version of my presentation at this second symposium, I simply could not manufacture it: In my mind it made no sense except as a complement to the previous talk, yet at the same time it did not seem to me that the autobiographical nature of that first contribution was suitable for academic proceedings. I planned instead to produce the text that follows for the present volume, divided in two parts roughly corresponding to the two separate talks. I sent it nevertheless to Alina and Jérémie with a sheepish note announcing that I had to withdraw my contribution to the book they were editing, as what I had come up with would obviously not fit in. To my surprise, they assured me to the contrary, and therefore what follows is forthcoming in a volume of the "I Tatti Research Series" (Harvard University Press, 2023).*

## I. Trigger

When it was first announced by its organizers, the topic of the "Scholarly Vitae" meeting was to be that of "conversations among and about disciplines"— interdisciplinarity, in short: a not exactly thrilling brief, given how much this concept had been defanged by overuse during the previous decades. But a corrective came fast, perhaps in response to an initial lack of enthusiasm on the part of the invitees:

> As we wrote in our initial invitation, we envision short (20 minutes maximum), informal presentations followed by lots of discussion. We would suggest the following format: enough intellectual autobiography to give us an idea of your training, academic trajectory (some of you have pursued multiple careers, in multiple languages), and major interests; an account of one or more intellectual encounters (with an article, a book, a person) from outside your own specialty that decisively reoriented your work; and a double perspective on that episode, from both your standpoint at the time of the encounter and now, in light of its consequences for your subsequent career.

> As background for our discussion (and also because we're all curious about what made you set out in a new direction), we would request that you send us a brief excerpt [...] of one book or article that made you sit up and take notice.

Now, that was definitively unusual, and titillating: Who could forgo the anticipated pleasure of hearing the likes of Carlo Ginzburg, Leonard Barkan, Katherine Park, and many others speak about a turning point in their career, even if it meant revealing something of one's own trajectory in turn?[1]

I had trouble at first with the excerpt assignment. There are many written works that made me "sit up and take notice," but the text that best fitted one of the selection criteria—that is, a person or publication encountered that "decisively reoriented [my] work"—did not exactly meet another, that of being "from outside [my] discipline," given that I had nothing one might describe as an academic discipline at the time of the encounter. At best, one could say, I had a practice.

The brief text I chose to share is excerpted from an essay by Robert Klein— who, incidentally, had taken his life in 1967 while a fellow at I Tatti (which no doubt played an unconscious role in my zeroing in on the text for that occasion). Klein was a brilliant scholar of the Italian Renaissance, to which he dedicated most of his publications, but he was also interested in both contemporary art and philosophy (notably, phenomenology). It is to the conjunction of these two last interests that we owe several remarkable short essays, such as the 1964 "Art and the Attention to Technique" (in which Klein compares the attitudes of the

mechanic and the connoisseur), or the one from which my excerpt is drawn, "The Eclipse of the Work of Art," dating from the year of his death. The latter text is surprisingly well informed, coming from a nonspecialist, about what could be called the anti-aesthetic trend in the development of twentieth-century art, as Klein astutely parses false (decorative) negations and truly suicidal ones. What struck me in particular is the last section of the essay, which deals with historicization:

> The villain of the piece,[2] I mean the Renaissance, invented the notion of art on which we still live, though less and less well. It conferred on the production of objects—which has always been the acknowledged raison d'être of the artistic profession—that solemn investiture of which we may rid it only by ridding ourselves of the object at the same blow. We dream of an artist without privilege, an engineer (Tatlin), an artisan (the first Bauhaus), or in any case an equal of his public (pop art). De Stijl wanted to abolish the very profession. The Dadaist-Surrealist current tended to exempt the artist from the production of objects; they demanded only that he be, or—what is harder still but was brought off by Cravan and Crevel—that he liquidate himself.

> These attacks upon the Renaissance legacy are almost unanimous, albeit contradictory; but they do not prevent us from continuing to build upon that legacy the entire social and economic organization of artistic activity. Galleries and museums, competitions and prizes, commerce and criticism still pretend to believe that artistic value is something deposited in works and visible only within them; we still behave as if the best artist was the one who produced the best works. Marcel Duchamp was needed to contradict flagrantly all these fictitious principles, while nonetheless serving the organization that exploits them. But the exemplary value of an artist lies rather in what we call his "contribution" and sometimes simply in his line of development, rather than in the aesthetic quality of his works taken individually. It is difficult, if not impossible, to judge a work without knowing "where it comes from." What would Brancusi's egg be without its history, and without all of Brancusi? Everybody senses in the Abstract Expressionist the contradiction in spirit between the mistreatment of his canvas at work and the lavishing of his attentions upon it for its exhibition: a reflection of the contradiction between art for oneself (the experience of the road traveled) and art for others, bound to the fetishism of the work.

> No new or coherent conception has yet arisen that would allow us, in practice, to overcome this dilemma. But there are indications (which we should not overestimate) that the values once attached to the art work, and which nobody wants any longer, have in some sense been transferred. The unfolding in time of the

art of each important artist, of each group, and even more, of great collective experiments or schools—such unfolding presents in effect certain symphonic characteristics in which we can recognize the extension or substitution of the artistic values of yesteryear. We have almost unconsciously acquired the habit of historicizing every new object and of embracing historical development in one comprehensive glance, judging it according to its richness, its synthetic power, its quality of invention, the importance of the problems tackled, the justness and boldness of the solutions. There are indubitably aesthetic criteria in such a context, of course; and at the same time purely historical considerations of time and priority become artistically relevant (just as, because of the interest and attitude of collectors, the rarity, or authenticity of a signature, or attribution to a great name, effectively augments the beauty of a work). This shift from absolute artistic value to a historical "value of position" springs also from the anxiety to be current, which is as widespread with contemporary artists as the concern for anatomical accuracy or the fear of anachronism in historical painting once was. In fact, the obsession with the value of being up to date and the ambition to achieve priority are almost incompatible: a watch which is on time cannot move faster, but a generation's values, especially in matters of art, have rarely been compatible each with one another.

It seems that this "historicization" of the value incarnated in the work of art has begun to influence even the material machinery of our artistic life. The manner in which public exhibitions are organized, the interest of museums and collectors, the vocabulary and formation of critics—all take it into account. But the crisis of the work of art is not overcome by these means alone, and the crisis of the concept of art is far from being resolved in this way.[3]

There would be many things to unpack from these dense pages, but what amazed me most when I encountered them was the idea that the actual date (and eventual priority) of a work, in our historicist culture, had become an aesthetic criterion—that, like rarity or "the attribution to a great name," it "effectively augmented the beauty of a work." Not the market value—which would be a banal thing to point out, although of course it plays a role in that as well—but the aesthetic value and the amount of pleasure it gives us. This statement accorded with my personal experience as a visitor to a museum or gallery—but until I read it, I had not realized how much historicization had taken hold of my aesthetic judgement, particularly in the way I rated originality. Basically, I was uncritically following the classic model of scientific invention as a (datable) breakthrough—a convenient habit it was not easy to break.[4] Later on, although I still felt naturally inclined to look for the "eureka moment" (and wrote many studies in which this hypothetical moment is highlighted, notably

on Piet Mondrian, Barnett Newman, and Ellsworth Kelly), I did endeavor to uncover instances of refutation—moments in the history of art when priority loses the competition for excellence. (A poignant one is the story of Braque and Picasso's brief synergy during their Cubist years: Braque would come up with a new formal or technical device, and inevitably Picasso would do far more with it, simply because he had understood far better its potential, one could say its theoretical impact.)[5] Furthermore, the historicizing impulse diagnosed by Klein paradoxically fueled my interest in the phenomenon of pseudomorphism, especially in the context of twentieth-century art: how to deal, say, with the similarity between the now famous *Green Stripe* that Olga Rozanova painted in Moscow in 1918 and Barnett Newman's *Onement I*, painted in New York exactly thirty years later in complete ignorance of the preexisting work—what to make of the stunning formal similarity, when traditional explanations (transmission, human nature) are clearly indefensible?[6]

But let's go back to the moment of my encounter with Klein's text. Plucking the book from the shelves of my library, I found out exactly when it happened, because, as I did for a while, I had inscribed the volume itself with the date and place of my purchase: 1970, Pau. This must have been in the early fall of that year, as I had returned to France at the end of July after spending twelve months in America as an exchange student. Finding this inscription reminded me of countless hours browsing new arrivals in the one bookshop worth frequenting in this sleepy city, and of the moment when the title of Klein's book hit me: *La forme et l'intelligible.*[7] That—the relationship between form and intelligibility—was precisely the mystery I (presumptuously) most wanted to crack! The book's subtitle was "Écrits sur la renaissance et l'art moderne," but I flipped only through the essays on modern art (it was some time before I would attend to the more voluminous section on the Renaissance), and I imagine I was particularly stunned by the passage of "The Eclipse of the Work of Art" I excerpted above: I was not alone in my doubts and ruminations; this writer, of whom I had never heard, was speaking to me! I bought the volume on the spot, a rarity at the time given my very limited budget. Nostalgia, one could say—but not only; for reading Klein, and notably this text, made me do much more than "sit up and take notice." It might not have been the single cause of a radical change of orientation in my life, but it was crucial in my decision to swerve and take the course that I took. The change in question was, simply, to renounce an artistic career.

Before I explain why Klein's text had such a powerful effect on me, and at the risk of seeming too self-indulgent, I should divulge a bit more about who I was then. It is probably hard to believe, but since the age of fourteen or fifteen I had developed an artistic practice that had brought me into contact with many avant-garde artists of the time, as well as some art critics (I'll recall one such encounter later on). At age seventeen, shortly before my exchange-student

▲ ▲ ▲

year in the United States, I was offered an exhibition at a gallery in Paris—not a commercial one per se but a kind of alternative space that had shown several artists I highly respected. Thankfully the (mistaken) memory of a movie I had seen as a child about a musical prodigy directing orchestras at the age of eleven (my age exactly when I saw the film) warded me off:[8] I was not going to be a circus animal, the "teenage abstract artist"—and after much wavering I turned down the exhibition offer. Yet it precipitated an existential crisis, arousing many questions about the art world and so forth in my mind.

The circus-animal aspect was not the only reason I pulled out of the exhibition. The other, probably more important reason brings me back to Robert Klein.

I knew I was not ready. More precisely, I had come to the conclusion that my work was derivative, no matter how much I tried to be "original." Every time I thought I had found something that was truly mine, I would later discover that another artist had done something identical or almost identical—a year, five years, ten years, or even fifty years earlier: Anxiety of influence meets pseudomorphismphobia! In retrospect, I think that the last straw must have been something that happened around the same time as the exhibition offer. I had done a "body art" piece in the space of the gallery—and I showed photographs of it to my friend Jean Clay (with whom I would later found the journal *Macula*). Looking at them, he told me about the Japanese group Gutaï, which had done similar things in the 1950s! He would eventually publish some of the photos I showed him in an issue of *Robho*, a journal he was editing at the time, containing a dossier on Gutaï but also a short text of mine introducing an interview with the German artist Franz Erhard Walther, as well as material on the Brazilian artist Lygia Clark.[9]

I vividly recall my disappointment when Jean showed me the documents on Gutaï. I felt like Khakheperresenb, the ancient Egyptian scribe whom Walter Jackson Bate quotes in *The Burden of the Past and the English Poet*: "Would I had phrases that are not known, utterances that are strange, in new language that has not been used, free from repetition, not an utterance which has grown stale, which

men of old have spoken."[10] I left for the United States, hoping that a year off would help me rebuild my confidence, and I continued to converse (mostly via mail) with artists, who were always very encouraging—but there were more and more signs that I was drifting away from the idea of pursuing an artistic career myself. In my correspondence with Franz Erhard Walther, whom I met in New York in the spring of 1970, and which was recently excavated and published by the Reina Sofia Museum, a great deal is devoted to literature and philosophy or aesthetic questions in general: It seems that one of the books with which I was engaged at the time was Umberto Eco's *The Open Work*.[11] In any event, at some point during this year of introspection, I reckoned that issues of anteriority should not be of concern to a "real artist"—that if they were, it was a sign that you did not "have it in you" to become an artist, or in any event a good one. Naively, I decided that such questions were to be addressed by art historians.

Alas, this did not bring much consolation, as I also already had an idea as to how ridiculously antiquated the state of art history was in French academia. I was immediately confirmed in this view on my return to France. During my year abroad, my parents had moved from my beloved Toulouse to Pau, a city I detested, and in those years, you had to go to the university of the town where your parents resided. Although as a high school student I had audited several dreadful art history classes at the university in Toulouse,[12] I decided to give it another shot, most probably prompted by my encounter with Klein's book: Maybe, after all, the field of art history in France was not as mediocre as my previous experience had led me to believe? I enlisted in the one art history class on offer at the university in Pau, a course on English painting. It was such a disaster that it took me a good thirty years to be able to look again at a Gainsborough, or any other British painter but Turner, without a feeling of utter disgust. Fortunately, I was able to escape to Paris the following year by being admitted to Roland Barthes's seminar at the École Pratique des Hautes Études— and had not Barthes suggested that I explore Hubert Damisch's seminar, I probably would have given up art history forever.

Now, even though I fairly abruptly stopped wanting to be an artist— and never regretted the decision in the slightest—this early identity of mine continued to infuse my relation to art. Nothing pleases me more than the rare compliments about my work I receive from artists whose work I admire. I should add that the dialogue I had and still have with artists has occasioned several of the kinds of "changes of direction" we were invited to discuss. I'll refer to one in particular, concerning the work of Mondrian, on whom I would end up writing a good deal.

With the exception of a serendipitous childhood visit to the Musée National d'Art Moderne in Paris, which I still remember vividly as it was my only exposure to art until my teens,[13] my first artistic epiphany was the discovery

of the work of Mondrian. It happened, unfortunately, via a big book, the only one available in French at the time on the artist, by the critic Michel Seuphor, a friend of Mondrian's in the 1930s and a champion of his work. The book was heavily illustrated, and I was stunned by the images, mostly black-and-white, when I tripped over it in a Toulouse bookstore. It was way too expensive for my pocketbook, so I began an ultimately victorious half-year-long campaign to persuade my grandparents to accept it as my choice for the present they were planning to give me for my (Huguenot) confirmation.[14] I devoured this book, gulping down Seuphor's account as if it were gospel: I was enormously impressed by his portrait of the artist as a kind of hermit saint, who lived alone in his immaculate studio, solely and uncompromisingly dedicated to his art, an art that was meant to be as "pure" as possible. I even wrote to Seuphor and went to meet him several times, as happy to hear his testimony as the old man was to deliver it to a fawning youth.

My rather misplaced admiration for Seuphor was dented a bit by his public position against the students in May 1968 (he signed a petition in support of de Gaulle, which was published in *Le Monde*), and I stopped visiting him; but the real *coup de grâce* came from Lygia Clark, whom I met during the early fall of 1968. In the course of our very first discussion—and there would be many more, especially after I came to live in Paris—she told me that my view of Mondrian was completely wrong ("my" view was a paraphrase of Seuphor's, of course, for whom the Dutch artist was the king of what he called "peinture construite"). *Au contraire*, Clark told me, "Mondrian is all about destruction." This was baffling, to say the least, all the more since I had yet to see a single work by Mondrian (none entered French public collections until 1978, two years after the opening of the Centre Pompidou). As it happened, for once the timing was right: A retrospective of the artist was due to open a few months later in Paris, and I would be able to test the pros and cons of the conflicting takes on his painting.

I did not see the show with Clark, but I certainly tried to see it with her "destruction" motto in mind. It was hard work. It took me a long time, for example, to realize that in his very first Neoplastic painting, from 1920 (now at the Stedeljik Museum in Amsterdam), Mondrian had managed to place a square at the center: How did he make this very conspicuous, centered figure so inconspicuous?[15] After this first "discovery," things came more easily. I was impressed in particular by the strategies Mondrian used to undo geometric identities, to invalidate the distinction between line and plane, for example (something that was on Clark's mind, I'm sure). Another thing that puzzled me, and which I did not quite know what to make of at the time, was the varied textures of these paintings. Especially after Mondrian stopped using different shades of whitish gray or grayish white within the same painting, in the early 1930s, the white planes were rarely painted in an identical manner: The final layer of brushstrokes would be vertical in one

white rectangle and horizontal in an adjacent one. Much later, after having seen many more of Mondrian's works but also after having encountered the paintings of the American artist Robert Ryman, I understood the function of the Dutch artist's very subtle play with texture in his white planes: It was in order for the light to strike those planes differently, so that they would not coalesce into a single surface perceived as empty, neutral ground.

At the time, though, I was unaware of the many statements Mondrian had made against construction, geometry, order—the most famous being perhaps "I think the destructive element is too much neglected in art."[16] Nor did I know that Mondrian had been fascinated with the Dada movement—for several months he even signed his letters "Piet Dada." That not-so-monkish side of him was utterly hidden by Seuphor—the only hint of it in his tome is in his horrified comments about the artist's love of hot jazz and dancing. In any case, what I saw at the exhibition through Clark's eyes, so to speak, had been enough to convince me not only that Seuphor's reading was extremely reductive but that I would need to spend years investigating Mondrian's oeuvre, which I did.[17]

## II. Musings

Let me now return, after this long autobiographical digression, to Robert Klein and why certain of his texts so struck me when I stumbled upon them (in so doing I remain in the autobiographical mode, but indirectly). The long excerpt provided above comes from the last in a series of remarkable texts, most published in the 1960s, in which he deals with modern and contemporary art. They have attracted surprisingly little attention—as far as I know, the only serious tribute to them, by the French art critic Catherine Millet, was published only in 2017, fifty years after Klein's death![18] Millet's take is polemical; she zeroes in not on the issue of historicization but on what she deems Klein's foresight with regard to the current artistic situation.[19] I do not necessarily disagree with her, but in emphasizing two of his obsessions—the very '60s attacks against the "work of art" (both its material existence and its concept) and the predictable disappearance of critics along with that of criteria of judgment—she runs the risk of transforming the writer into some kind of Cassandra. I believe, like Millet, that today's situation is dire, and by all means worse than when Klein was writing, with hordes of tourists running through exhibitions just to get a selfie in front of a work of art, and museums evermore in the hands of a new brand of trustee—the collector/speculator—whose collections are in turn shaped by "art advisers," among many other ills. Klein certainly diagnosed a crisis in his own time, but one should not ignore his skeptical conviction that crises are cyclical.

Witness the opening sentences of the very first text that bears in passing on contemporary art, an essay titled "On the Signification of the Synthesis of the Arts," published in 1952 in *La Revue d'Esthétique* (and unfortunately

not anthologized in *La forme et l'intelligible*). It begins: "A persistent desire, or more exactly a periodic one, leads artists and the public to dream about a universal art, one that would use all means and address all senses at once. But either as attempts to gather into a single work arts that are usually kept separate, or to expand a single art so that it comprehends and says all, those endeavors almost always end up in failure."[20] Or take another, much shorter essay, also not anthologized, titled "Death of Art or Death of the Work of Art?," published as the last response to a questionnaire on "l'art informel" launched by the magazine *Preuves* in February 1964.[21] The editors had obviously sent Klein some of the responses, which are almost all pure drivel—the champion of sentimental goo on "the sacred" was the poet Yves Bonnefoy. Klein alludes to these responses here and there, making fun of their rant on the "cosmic" or their metaphors of ecstasy. But once again he begins his essay by calmly remarking that the crisis lamented by his colleagues is a cyclical phenomenon:

> More than once in history, the artists and their public thought that art had run its course [*était arrivé au bout de son rouleau*] or, which is the same thing, had reached the "summit of its perfection." Of course, what was at stake was nothing else than the exhaustion of a rather limited number of problems and sooner or later one would discover that the pursuit of this or that (constructive or destructive) task went hand in hand, in the work of those who searched, with the formulation of other styles and questions. So, let's start with the idea that what is happening today is of the same nature and that, since we do not know yet which criteria are being developed, we should ask: what is actually dying in the current "death of art," and what is left intact?[22]

Before I come back to the issue that first struck me in Klein's writing—that of the position of a work in a historical/chronological sequence as aesthetic criterion—I would like to point to what I would call the gnomic tone often taken by his prose. Reading him, one is from time to time, and always unexpectedly, confronted with a dense sentence that is almost aphoristic—a strange pronouncement that certainly makes me "sit up and take notice," as much as Clark's enigmatic riddles did when I heard them. One never knows up front what to make of these Delphic statements, but they linger in one's memory. I can't resist offering a few samples—each of them having a correlation with art practices at the time of Klein's writing, even when he was not explicitly referring to them.

From "Synthesis of the Arts" (1952): "Nothing proves the specifically aesthetic character of the participatory emotion"; or this: "The marvelous [*le féérique*] is the most elastic of all aesthetic modes."[23]

From "Notes on the End of the Image" (1962): "Everything placed in a museum becomes ipso facto its own parody, put there to eternalize a gesture

from then on empty or untenable. But the metabasis [*sic*] is so complete that one has to be a boor to see that it is comic. All intentionally new art is a parody of the preceding to the exact extent to which it makes use of it; and all art that has outlived its time becomes self-parody."[24]

From "Modern Painting and Phenomenology" (also 1962): "The slow agony of reference began well before the disappearance of the figure: perhaps after the discovery of perspective, which assigned a fixed point of view to the spectator and thus transformed the work of art into a 'subjective' experience."[25]

From the response to the *Preuves* questionnaire (1964): "Hysteria is, or at least should be, banned from the Informel."[26] Or this, from the conclusion of the same short text: "Current attempts, whose radicalism is extraordinary—but so many have been over the course of five centuries—contribute above all to bring to light the fundamental but hidden antithesis we unwittingly utter each time we combine these words: 'work of art.'"[27]

This last sibylline bit brings me back to Klein's recurrent preoccupation with what he called the "eclipse of the work of art." We should not ignore the fact that the word *eclipse* connotes a cyclical return: Eclipses are only temporary, after all. Klein himself of course leaves this possibility open, but not without some disquiet. A few paragraphs down from the long passage I excerpted at the outset, the text concludes thus: "Can one imagine a state of affairs in which art could dispense with works of art? Or can one imagine works of art that would not be incarnations of values and congealed experience? Before we can be sure that the eclipse of the work of art is only an eclipse, we must be able to rule out a priori these two eventualities."[28] One wonders what he would have thought of the famous *Erased de Kooning* (dated 1953) or the equally famous *Portrait of Iris Clerc* (dated 1961), both made by Robert Rauschenberg, an artist he mentions favorably in his "eclipse" essay.

Even though Klein could eventually allude ironically to the "ludicrous contradiction evident, for instance, when an artist signs, preserves, exhibits and sells an object which he has just stamped on or lacerated with rage,"[29] he took the iconoclastic tendencies he was witnessing in the art of his time seriously. In a page he discarded from the draft of "Modern Painting and Phenomenology," he notes that "the avant-garde is both indefensible and unassailable. For though the philistines attempt to ridicule it, they can invent nothing other than what the artists themselves have already said, done, or proposed themselves. The authors of the once famous farce of Master Boronali have long been outdone, and their parody seems shy and laboriously bourgeois next to what their targets are doing. Furthermore, they would be taken today for inventors of a new *tachisme*."[30]

But let's go back to the major argument of the "eclipse": We are witnessing a shift, according to Klein, from what he calls the "absolute artistic value" of the individual work (which is never clearly defined) to a historical "value

of position." This is a leitmotif of his thoughts on contemporary art. One can already read this in his 1962 "Notes on the End of the Image":

> Contemporary masters, as has been observed, work by series and 'periods'; it has also been noted that it is no longer possible to judge a painting or sculpture without knowing who made it and in what spirit. Each important master 'adds' his mark, defines his 'contribution'—to what? To what can only be the movement of art as a whole, toward its progressive clarification; [ . . . ] it is this movement that gives meaning and eventually relative value to any invention or discovery, to the new gestures of each artist or school. By this historical bias [*par ce biais de l'historisation*] criticism recovers some advantages it lost at the level of the art work itself.[31]

I could multiply the quotations in kind: Such reflections are to be found in all the texts from the '60s that I mentioned. For Klein, the recourse to "historicization" is an illusory Band-Aid masking the fact that critics have been forced by the art of their time to abandon their prerogatives: Being unable, or not yet able, at least, to compare these new works against a preconceived ideal—which is what their activity barely amounts to for Klein—critics cling to history as a life jacket. Occasionally Klein seems to concur with Leo Steinberg's critique of the idea that the task of the artist is one of problem-solving (in this notion, defended in both historicist and essentialist terms by Clement Greenberg and his followers, Steinberg diagnoses a bureaucratic perversion of aesthetics by a corporate and puritanical model).[32] More often than not, however, he tacitly adheres to the typically modernist conception of the evolution of art as a progressive and continuous march toward the pure definition of its own self. Historicization might be just a Band-Aid, but it will do *faute de mieux*. The conclusion of his brilliant 1963 essay "Modern Painting and Phenomenology" ends with these words: "One might suggest that modern art, which seems to be done with art works in the classic sense, has nevertheless been building, over the last fifty years, an enormous and magnificent cathedral unfolding in time."[33]

The paradox is that this cathedral was in the process of becoming a ruin at the moment these lines were written, that this phantasmagoric construction is precisely what was under attack—much more so than the "work of art" per se—and on this point, especially in hindsight, one cannot but side with Steinberg, whose perspicacious denunciation of the modernist canon, or rather mode of canonization, is quasi contemporary with the "eclipse" essay.[34] Klein's blindness on this account is puzzling, given his extraordinary insight elsewhere. But, in fact, it is rooted (it seems to me) precisely in his privileging the role of historicization as criterion in his cultural diagnosis

of the period—or, more specifically, in his taking for granted the traditional definition of historical time as linear, in taking only "solar time," as Georges Kubler would phrase it, into consideration. To my knowledge, Klein never mentions Kubler's *Shapes of Time*, which appeared in 1962, so one can reasonably assume he did not read it. If he had, it would have helped him appreciate that several historical sequences can cohabit, that contemporaneity is not necessarily synchrony, and that paradigmatic/synchronic series are just as important as syntagmatic/diachronic sequences.[35] It might have also led him to revisit his phenomenological belief that there could be, or could have ever been, something like the appreciation of the work of art per se, "as such," without any external consideration, a mode of "pure" aesthetic contemplation subsequently replaced by the historicist attitude of the connoisseur. (In contrast to his predecessor the aesthete—who for Klein is a disappearing species—the connoisseur, in making an aesthetic judgment, analyzes, and, at least mentally, serializes, compares, and thus contextualizes works.)

I mentioned in passing that reading Klein early on had the paradoxical effect of gearing my interest toward the issue of pseudomorphism—in fact, I now realize how often the question "what would Klein have thought of this?" functioned as fuel for my various scholarly pursuits. Pseudomorphism is something that Kubler also investigates, as it challenges our historicist impulse and spotlights on the issue of the "intention" that lies behind a work of art, a topos that often returns in Klein's prose, sometimes rather ambiguously. And what about works of art that are not produced with any intention to fit into a series, works that insist, rather, on their contextless-ness? I was somewhat surprised to see no mention of Art Brut in Klein's writings, given the promi-nence of the debates around it at the time of his writing, his friendly relationship with Damisch (then a major interlocutor and advocate of Jean Dubuffet), etc.[36] Maybe he had concluded, again with remarkable insight, that the category of "bruteness" was simply not tenable and doubted the very possibility of a total lack of contact with "artistic culture" on which this utopian category was based.[37]

To conclude—or rather to end, as in my mind there can never be anything conclusive about Klein—I would like briefly to examine one of the few specific historical mini-sequences he examines in detail, or at least one that seems to have obsessed him, since he alludes to it in all his essays dealing with contem-porary art. It has to do with the use of chance, which he consistently saw as one of the most efficient weapons in the war against "the work of art" launched by modern artists. Paying insufficient attention to Dada, in my view, which he deemed purely suicidal, he identified three ages of chance in modern art: 1) Surrealism—no real chance there actually, notes Klein, since the unconscious was put forth as the "transcendental subject" and "desire" was cast as the true

author of the work; 2) "Informel art" or "*tachisme*" (the French equivalent of Abstract Expressionism), which he rather unfortunately read through the concept of "Action Painting," advanced by Harold Rosenberg, as "preserved" or "canned" trance; and 3) a then very recent cybernetic trend (here he referred mostly to the kinetic art machines that were invading European galleries around 1965 and were intended as a direct critique of the Informel movement). He also mentioned happenings, Pop art, the mass production of the Fluxus group, the work of the Nouveaux Realistes group (notably Daniel Spoerri), etc., as participating in a vast anti-intentional and particularly anti-expressionist wave. He was, in short, amazingly au courant with regard to the artistic practices of his time, even occasionally sporting the connoisseur's hat (there is a rather comical passage in the "eclipse" essay, in which, almost immediately after having stressed once again the disappearance of criteria of judgment, he proposes various verdicts, deeming Roy Lichtenstein "a downright aesthete—and a superior one" and Larry Rivers "an academic").[38]

His chart of the use of chance in twentieth-century art is quite expert (but for the glaring omission of John Cage), although we know now that accident played a far lesser role in the productions of "Informel art" than what was thought at the time (for example, we know now, in great part thanks to the work of conservators and their close look at Pollock's technique, that this artist exerted a lot of control over the way his paint dripped onto the surface of his canvases). The one regret one might have is that in brushing off and disdaining information theory—one of his *bêtes noir*—he deprived himself of a useful tool for dealing with the cybernetic version that obviously intrigued him. As in the case with Kubler, examining all of what Klein has to say about chance, I wondered what would have happened if he had read (or rather taken into consideration, since he very well might have read it) Umberto Eco's *The Open Work,* mentioned earlier, in which information theory functions as the main theoretical model. My guess is that, although remaining resolutely skeptical, he would probably have been less inclined to see chance as pure negativity, as precipitating the ending of the work of art. I would have liked to throw at him a painting called *Seine*, produced in 1951 by Ellsworth Kelly through what engineers call a "modified random technique," and hear what he would say. Such a dialogue can only be a posthumous one, but it is one of the things that keep me working.

1.  Aside from the scholars already mentioned, the participants were William Fash, Anke te Heesen, Sachiko Kusukawa, Maria Loh, Laura Otis, Winfried Menninghaus, Greg Radick, and Avinoam Shalem.

2.  "*Ce pelé, ce galeux*" might be better translated as "the villain of the play." The phrase is taken from the opening of a famous verse by Jean de la Fontaine ("*ce pelé, ce galeux, d'où venait tout leur mal*") from his fable "The Animals Sick of the Plague." The tale is a denunciation of abuses of justice, in which a donkey is condemned to death by a grotesque tribunal that accuses him of having brought the plague.

3.  Robert Klein, "The Eclipse of the Work of Art," in *Form and Meaning: Writings on the Renaissance and Modern Art,* trans. Madeline Jay and Leon Wieseltier (New York: Viking, 1979), 180–82.

4.  I still remember my enthusiastic approbation when reading in 1974 this note passed by Jean Paulhan to the painter André Lhote during a meeting of the Conseil des Musées Nationaux (dealing with acquisitions): "It is not useful to have the same thing twice. Lhote makes Bazaine useless, Bazaine makes Manessier absolutely useless." Quoted in the exhibition catalogue *Jean Paulhan à travers ses peintres* (Paris: Grand Palais, 1974), 59.

5.  On this issue, see my essay "The Semiology of Cubism," in *Picasso and Braque: A Symposium* (New York: Museum of Modern Art, 1992), 169–208.

6.  For my take on pseudomorphism, see Yve-Alain Bois, "On the Uses and Abuses of Look-alikes," *October* 154 (Fall 2015): 127–49, and "François Morellet/Sol LeWitt: A Case Study," *October* 157 (Summer 2016): 161–80.

7.  Paris: Gallimard, 1970. From the twenty-five essays of this anthology, thirteen were selected and published in English (see above, note 3). The English title of the book is very flat, and I doubt it would have similarly caught my attention.

8.  It is while I was preparing the present talk that I realized my memory of the film was completely inaccurate. The film in question, *Prélude à la gloire,* by Georges Lacombe, from 1949, recounts the early career of a musical prodigy, Roberto Benzi, played by himself, who began conducting orchestras as a child (he was thirteen when the movie came out). He quickly rose to international fame, but—as I remembered it—this phenomenal success had taken its toll and his fall as a young adult (alcohol, drugs, whatever) had been brutal. There is nothing of the sort in the film, which only describes Benzi's ascent. Furthermore, Benzi never fell—on the contrary, he continued to thrive as a conductor (see his website: http://www.robertobenzi. com/english/biographie.html). I have no explanation for why I had so distorted the film's synopsis.

9.  On *Robho*, see "J.C. or the Critic" in this volume, 79–102. The first issue of the journal was published in 1967 and the last, its no. 5–6, in 1971. It is in this final issue that the photographs of my work appeared.

10.  W. Jackson Bate, *Burden of the Past and the English Poet* (Cambridge, MA: Harvard University Press, 1970), 3–4.

11.  Eco's book, which was published in Italy in 1962 and appeared in France as *L'oeuvre ouverte* in 1965, is the first book on aesthetics that I read. Unfortunately, it is not inscribed, perhaps because it was bought for me by my father. I remember who had suggested reading it: Paul Ricoeur, who was an acquaintance of my father and whom I had gone to visit, asking for guidance, before my exchange-student year in America. My correspondence with Walther is published in *Dialogues,* the catalogue of his 2017 exhibition at Reina Sofia (Madrid), 55–111.

12. The course was on Romanesque architecture, in which Toulouse and its region is so rich.

13. On this early childhood experience, see "Better Late Than Never," in this volume, 223–32.

14. I still have the book. My grandparents' dedication is dated May 7, 1967.

15. This prestidigitator's trick does not work in reproduction. The painting in question is *Composition with Yellow, Red, Black, Blue, and Gray,* no. B114 of Robert Welsh and Joop Joosten's *Piet Mondrian Catalogue Raisonné* (New York: Abrams, 1996).

16. James Johnson Sweeney, "An Interview with Mondrian" (1943), reprinted in *The New Art—The New Life: The Collected Writings of Piet Mondrian,* ed. Harry Holtzman and Martin S. James (Boston: G.K. Hall, 1986), 357.

17. This investigation would eventually result in the retrospective of the artist I co-curated at the National Gallery of Art in Washington in 1994–95, with stops at the Gemeentemuseum in The Hague and the Museum of Modern Art in New York. On this venture, see "Why Do Exhibitions" in this volume, 209–21. I should add that Lygia Clark was similarly instrumental with regard to my interest in the history of axonometric projection. Not only were some of her early works, responding to Josef Albers's *Structural Constellations,* axonometric, but she puzzled me by another of her oracular pronouncements according to which "Albers was a real Surrealist, much more Surrealist than Dalí!" I'm still working on that riddle.

Finally, to briefly close this chapter on formative encounters, I'd like to refer to another artist, the French painter Christian Bonnefoi, who also helped me to reformulate my views on Mondrian. It was not as radical a shift as that initiated by my dialogue with Clark, partly because we were of the same generation: In fact, I met him in Damisch's seminar, and he became very much part of the group of friends with and for whom the journal *Macula* was published. Bonnefoi's painterly process was very elaborate—it involved a kind of braiding that disturbed the indexical relationship between temporal and spatial succession. To say it very summarily: In the works he was doing at the time, whatever looked as if it had been painted materially on top of another mark had in fact been painted first (this is described at greater length in my 1979 text "The Future Anterior: On a Canvas by Christian Bonnefoi," recently reprinted in *Journal of Contemporary Painting* 5, no. 1 (2019): 49–57. In any event, Bonnefoi was most interested in pictorial processes and particularly concerned by what he called the "surface's depth." He was extremely eloquent, and it was a pleasure to see exhibitions with him—he would always point to technical details you had missed and show their relevance to the overall economy of the work. Needless to say, we discussed Ryman a lot. Even though I don't think we spoke much of Mondrian per se, it is thanks to Bonnefoi, no doubt, that I became more and more interested in the Dutch artist's process. Not only that, but it is Bonnefoi's concept of the surface's depth (and his own braiding practice) that led me to pay close attention to Mondrian's third-to-last painting, *New York City,* of 1943, and its unfinished variants, all of which were presented in the 1994–95 retrospective (and of course discussed at length in the catalogue). In them, as might be guessed by now, I saw Mondrian's last destructive act: that of surface as entity. See also my 1985 essay on *New York City* in *Painting as Model* (Cambridge, MA: MIT Press, 1990), 157–83.

18. "Robert Klein et l'art contemporain," *La Nouvelle Revue Française* 624 (May 2017): 72–84.

19. Reading Millet's essay, discovered by pure chance two or three days

before I was to give my second talk at I Tatti—and thus as most of it was already written—reminded me that I had also made a polemical use of Klein in a text devoted to the trashbin conception of history (as reservoir from which to pick whatever one wants) that was enacted by various trends of what was then called "postmodernism." See Klein, "Historisation ou intention: Le retour d'un vieux débat" in *Les Cahiers du Musée National d'Art Moderne* 22 (December 1987): 57–69.

20. Klein, "Sur la signification de la synthèse des arts," *Revue d'Esthétique* 5 (1952): 298.

21. I wonder if Klein would have participated had he known that this journal was financed by the CIA under the cover of the International Association for Cultural Freedom. This was revealed soon after his death.

22. Klein, "Mort de l'art ou mort de l'oeuvre," *Preuves* 156 (February 1964): 29. Echoes of these lines, I realize now, can be found in my musings about the periodically announced "death of painting" in the essay "The Task of Mourning," reprinted in *Painting as Model*, 229–44.

23. Klein, "Sur la signification de la synthèse des arts," 308.

24. Translated in *Form and Meaning*, 171. The unknown word "metabasis" is the literal translation of *métabase,* which is similarly unknown in French. It is quite possibly a typo (for *métastase*). It already appeared in the original publication of this essay in *Archivio di Filosofia* 1/2 (1962), 124, and was reprinted as such in *La forme et l'intelligible*, 376.

25. Klein, *Form and Meaning,* 185.

26. Klein, "Mort de l'art ou mort de l'oeuvre," 30.

27. Ibid.

28. Klein, *Form and Meaning,* 183.

29. Ibid.,

30. My thanks to Jérémie Koering for having shared with me (and all the participants of the Klein symposium) the unpublished manuscripts left by the writer. As for the now forgotten Boronali, I quote the perfect summary offered on the website of the Museum of Hoaxes (hoaxes.org): "The painting 'Sunset over the Adriatic' won praise from critics when it was displayed at the Salon des Indépendants in Paris in March 1910. It was said to be the work of J. R. Boronali, proponent of a new school of painting called 'excessivism.' One collector offered to buy the work for 400 francs. But after a few days the truth was revealed. Boronali was actually a donkey named Lolo who had 'painted' by having a brush tied to his tail. The stunt was dreamed up by art critic Roland Dorgelès as a way to play a joke on his Impressionist painter friends."

31. Klein, *Form and Meaning,* 174.

32. Steinberg's scathing critique of and contempt for what he calls the conception of "the artist as engineer" is pervasive in "Other Criteria," where it is presented as a corollary of the linear conception of history embraced by Greenberg. See Leo Steinberg, *Other Criteria: Confrontations with Twentieth-Century Art* (New York: Oxford University Press, 1972), 55–91.

33. Klein, *Form and Meaning,* 199.

34. Steinberg's text was published in 1972 but it was given as a lecture at the Museum of Modern Art in March 1968.

35. After I uttered these words at the second I Tatti symposium, Jérémie Koering, one of its co-organizers, confirmed that there was no mention of Kubler in Klein's published or unpublished texts. But he also informed me that Klein had been made aware by André Chastel, with whom he

collaborated on several projects, of lesser-known aspects of Henri Focillon's work pertaining to asynchronic contemporaneities and to the stratification of historical time. (Kubler was in many ways indebted to Focillon, whose *La vie des formes* he translated into English.) In 1961, Chastel gave Klein a book manuscript of his to read titled "Histoire de l'art: culture et sciences humaines," which remains unpublished. In it Chastel quotes from the explicitly anti-Hegelian foreword of Focillon's *Moyen Âge: Survivances et réveils, études d'art et d'histoire* ("For us history is like a piling up of geological strata in which abrupt faults or 'canyons' suddenly reveal to the traveler simultaneousness within duration" [11]), as well as from its extraordinary first essay on prehistory and medieval art: "We firmly believe that facts, in the history of art, are not grouped in time as a monotonous sequence, as a rosary of identical beads that are only differentiated by the unequal length of the intervals between them." [30]). Focillon's collection of essays was edited by himself but published posthumously in 1945 (Montréal: Valiquette).

36.  On Damisch's long engagement with Dubuffet, see the cluster of his writings on the artist, as well as the correspondence between the two men edited by Sophie Berrebi, and various critical essays, published in *October* 154 (Fall 2015).

37.  On Dubuffet's fateful quest for a totally "brute" art, and his eventual renunciation, see Hal Foster, "Jean Dubuffet and His Brutes," in *Brutal Aesthetics* (Princeton, NJ: Princeton University Press, 2020), 25–69.

38.  Klein, *Form and Meaning,* 180.

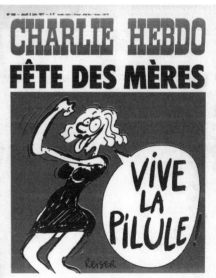

Jean-Marc Reiser, various covers of the journal *Charlie Hebdo*, all 1970s.

# Taken Liberties

*Like the piece on the French daily newspaper* Libération, *this short text on the weekly* Charlie Hebdo *casts a retrospective look at a publication that had been essential to me during my formative years. Those two journals are indelibly linked in my memory of the 1970s, and it is not by chance that—after the terrible terrorist attack in January 2015 that left eight of its editors dead, four badly wounded, and its quarters sealed as a crime scene—the tragically reduced* Charlie *team took temporary refuge in the offices of* Libération. *This piece was written in the heat of the moment, weeks before the asinine, if not frankly repulsive, public letter co-signed by many writers I admire in protest against the Freedom of Expression Award bestowed on* Charlie Hebdo *by PEN America.*

*Writing impulsively entails risks for someone not accustomed to the hurried tempo of journalism, particularly if one solely relies on memory for the occasion (as I had). In April 2022, I was made aware of a significant mistake in my text by the widow of Jean-Marc Reiser, Michèle Reiser, whom I met through my friend the writer Arthur Dreyfus. I thought for a moment that I ought to rewrite the erroneous section of my text, but in the end I decided against it, for thus revised it would no longer adequately convey the heat of the moment. (More often than not, dishes lose much of their flavor when reheated.) So, as in the case of my short eulogy of Ellsworth Kelly, I am using the occasion of this contextualizing introduction to correct my blunder.*

*In the text I ponder the reasons why I stopped reading* Charlie Hebdo *soon after moving to the US, noting that whenever I picked it up during occasional stays back in France, I found it progressively less engaging and eventually stopped paying attention to it. While part of this is true, the premise is wrong:* Charlie Hebdo *had ceased publication in December 1981, two years before I moved to America, and, with the exception of one single farewell issue in 1982, it resumed publication, with a somewhat different editorial team, only in 1992. This is to say that the estrangement I described and wondered about did occur, but after a ten-year gap. There are mitigating circumstances for this memory lapse, in that a number of the collaborators of the original journal remained onboard (including several of its most celebrated caricaturists), and the layout remained identical. This is not to deny that* Charlie Hebdo *redux was different in tone from its first incarnation (in fact, unlike that of the journal I had loved,*

*the life of* Charlie *from 1992 on was marred by a series of internal conflicts that alienated many of its readers), yet one thing did not change whatsoever, and on this my piece did not err: The journal remained indefatigably anti-religious and fundamentally anti-racist.*

•

The thing I found perhaps most absurd in the aftermath of the *Charlie Hebdo* massacre was to see comments, particularly in the American press, presenting the journal as racist and Islamophobic. *Charlie Hebdo*, racist? Only people who had never even leafed through the publication, much less read it, could possibly have had such an idea, unless the journal had dramatically changed since the years of my youth. Indeed, it is rather for its militant, absolutely constant anti-racism that I remember *Charlie* best. One of the most notorious characters invented by the cartoonist Cabu (Jean Cabut) was the repulsive *beauf,* a racist, xenophobic, misogynist, intolerant, and ignorant moron whose politics were closer to those of Jean-Marie Le Pen's National Front (one of *Charlie*'s pet targets from its inception) than to any other. As for the specific charge of Islamophobia, it didn't square any better with my memory of the journal. Thankfully, other doubters equipped with better tallying skills than I decided to look into this: A statistical analysis of *Charlie Hebdo*'s content over the past ten years, particularly that of its front page, was published in *Le Monde* on February 25, 2015. It reveals not only that the publication was actually less obsessed with religion than is generally supposed, with only seven percent of its front pages devoted to the subject, but also that the topic of Islam makes up less than a fifth of even these covers. [Addition 2022: This excellent and very detailed article in *Le Monde,* penned by two sociologists, Céline Goffette and Jean-François Mignot, and entitled "Non, 'Charlie Hebdo' n'est pas obsédé par l'Islam," is quoted (with link provided to it) by Andrew Solomon and Suzanne Nossel, president and executive director respectively of PEN American Center, in the op-ed piece they published in the *New York Times* in defense of the award on May 1, 2015. In passing they note that "the leading French anti-racism organization, SOS Racisme, has called *Charlie Hebdo* 'the greatest anti-racist weekly in this country.'"] In fact, when *Charlie* attacks religion—its contributors are particularly exercised by fundamentalism (of all stripes) and the hypocrisy of the clergy—Catholicism is most often the butt of its satire. To wit, I still remember the back page of the issue from June 24, 1974, following the death of Cardinal Daniélou, one of the most conservative and extreme opponents of contraception and the legalization of abortion, who suffered a fatal heart attack in the lodgings of a prostitute: twenty-four merciless cartoons, in grid formation, by the journal's star draftsmen—notably Georges Wolinski and Cabu, the two most famous victims of the lunatic jihadists in January's murderous raid.

*Charlie Hebdo* was the journal of my student years, a banner of the French left (together with *Libération,* whose golden age was the 1970s). I only realized later, after I emigrated to the US in 1983, how indebted I was to *Charlie*'s team, not only for its political progressiveness but for my knowledge of the history of cartoons and comic strips. A little background is needed here: In February 1969, the editors of the satiric publication *Hara-Kiri* launched a monthly journal, *Charlie Mensuel,* which would be exclusively devoted to comic strips, publishing not only recent works by young authors but also great classics, particularly American ones, as well as serious articles on the history of the medium. The cover of the first issue featured Snoopy on the roof of his doghouse, even though Charles M. Schulz's creatures were far better behaved than most of those welcomed in the journal. (If *Calvin and Hobbes* had then existed, its anarchism would surely have secured it a place of honor in *Charlie*'s pages.) Year after year, *Charlie Mensuel* presented Krazy Kat, Dick Tracy, Popeye—but also Little Nemo and many other characters—to a French audience, elevating the whole tradition of the medium to the status of a serious art and literary form and transforming its readers into seasoned connoisseurs. The directorship of the journal, which rotated often, was always taken up by one or another cartoonist from *Hara-Kiri* (Wolinski became editor-in-chief within a year, followed by Willem and Nikita Mandryka), and all the regular contributors to that magazine (Jean-Marc Reiser and Cabu in particular) also published their work in *Charlie Mensuel.* (I particularly remember a great satiric story by Willem on the art market.) In November 1970, a little more than a year after the creation of *Charlie Mensuel, Hara-Kiri* was, in effect, closed down by the French government (for a stinging mockery of Charles de Gaulle's death that was, apparently, too hard to swallow).

*Charlie Hebdo*'s inaugural issue would appear a week later, produced by the same team of editorialists and cartoonists, with the motto *"L'Hebdo Hara-Kiri* is dead. Read *Charlie Hebdo,* the journal that profits from the misfortune of others!" Needless to say, between the two *Charlie*s, the monthly and the weekly, the traffic was constant (and when an important dossier about a classic cartoonist was published in *Charlie Mensuel,* its little brother made sure to properly advertise it). In short: It would have been nearly impossible for a young French leftist of my generation to have ignored the existence of George Herriman (*Krazy Kat*), Chester Gould (*Dick Tracy*), or Winsor McCay (*Little Nemo*), whose works were, thanks to the efforts of Wolinksi and his pals, picked up by PhD students of semiotics or sociology for the topics of their dissertations. I was utterly dumbfounded when, after moving to the States and arriving at Johns Hopkins University in Baltimore, I found out that no one there had ever heard of any of these brilliant inventors (just as no one had ever heard of the 1941 film *Hellzapoppin',* a cult classic in France ever since it was first shown after the

Liberation). Things have obviously changed a lot on that score during the past thirty years, but thanks to *Charlie* (both *Mensuel* and *Hebdo*), the French public was, for once, ahead of the curve.

I continued, for a while, to pick up *Charlie Hebdo* occasionally when traveling back to France, but more and more jokes were lost on me. Indeed, this was another question that *Le Monde*'s statistics helped me to answer, a question I had pondered after hearing the horrific news—namely, why had I gradually stopped reading *Charlie Hebdo* soon after leaving France? The fact is: If the journal's cartoonists and editorialists are obsessed with anything, it is with French politics, the day-to-day material provided to them by the lies and tribulations of French politicians, of which it is hard to keep abreast from afar (not to mention the fact that American politicians provide us with more than our fair share of idiotic pronouncements and ludicrous behavior). Political satire is local as well as time-bound—it rings flat with expats, and it quickly fades.

Furthermore, the death in 1983 of Reiser, the cartoonist I most enjoyed and whom I think a graphic genius, had coincided with my departure for America. All in all, the journal no longer felt so relevant to me, and eventually I let it go by the wayside. Had my taste changed? Was the cultural stuffiness of the States (the "political correctness" and the rampant puritanism) having a subliminal impact on me? Perhaps. I remember having two distinct thoughts about *Charlie Hebdo* on arriving here. The first was that such a journal could not exist in the US, which I see as a nation of fundamentalists. (To wit: It is the sheer *placement* of a comma in the Second Amendment that guarantees the right of the people to bear arms—and ensures that, as the writer David Vann recently declared in *Le Monde,* America is the greatest nursery of killers; *"Les Etats-Unis fabriquent des tueurs"* [The United States manufactures killers] was the title given to his interview, which was illustrated with a large color photograph of a young boy seen from the front, closing one eye and aiming his gun, with his father right behind, guiding his kid's insecure hand.) Following President Georges Pompidou's death from a rare cancer, *Charlie Hebdo*'s cover presented a cartoon representing his face bloated by his cortisone treatment, barred by a red X and bearing the caption *"Plus jamais ça"* (Never again). When de Gaulle died, the offending cover of *Hara-Kiri Hebdo,* from whose ashes *Charlie* was born, was entirely filled by a black-bordered notice stating *"Bal tragique à Colombey—1 mort"* (Tragic ball in colombey—1 casualty), which referred both to the horrendous fire in a nightclub the week before, in which many people had died, and to the tiny village where de Gaulle had been spending his retirement years. Can one possibly imagine an American journal, not an underground zine with a confidential readership, producing something similar the week after Reagan died, let alone after Kennedy was shot? The only thing that comes close is John Waters's forty-five-minute film *Eat Your Makeup*, in which Divine plays Jackie

Kennedy for a scene reenacting the assassination—but the film dates from 1968, five years after the event, and furthermore, perhaps not coincidentally, it remains among the few works by Waters that have not been commercially distributed.

At the *"Je suis Charlie"* mass demonstration in Paris on January 11, 2015, there was something grotesque about the spectacle of international heads of state, many of them authoritarian rulers who imprison political opponents and journalists at home, joining arms with French politicians whom *Charlie* had relentlessly lampooned over the years. This so repulsed several friends of mine that, though fully supporting the cause, they stayed home. Had I been there, I probably would still have gone, for my visceral revulsion over the murders eclipsed my distaste for the gross political manipulation. I would have gone as a matter of principle, as almost two million people did, even though I have not read *Charlie Hebdo* in decades and am by no means certain that I would still identify with it as a reader. The principle in question was, of course, freedom of expression and a defense of the long tradition of satire that goes with it; but in the particular circumstances of the butchery, marching in support of this principle included a paean to the journal's formidable endurance in the face of continuing threats (countless lawsuits, a firebombing in 2011 in response to one issue's mock renaming of the publication as *"Charia Hebdo,"* on whose front cover the prophet is caricatured as warning: *"100 coups de fouet, si vous n'êtes pas morts de rire"* [A hundred lashes if you are not laughing your head off]). There was a plea in this paean: Never again.

First published in *Artforum* 53, no. 8 (April 2015): 224–27. The title was coined by the journal's editor.

Jack Shear, *Ellsworth Kelly, Venice Beach,* 1994.

# Ellsworth Kelly, In Memoriam

*Given the importance that Ellsworth Kelly gradually assumed in my life since the day we met, and the number of essays I have devoted to his work, it would have felt odd if he did not appear at all in this book. Most of the texts I have published about him, however, are either better suited to more traditionally academic volumes (such as that on noncomposition in twentieth-century art, to which I allude in the introduction) or require extensive illustrations. Then, of course, there are the hundreds of notices, some rather extensive, I've prepared for the catalogue raisonné of his paintings, reliefs, and sculpture that I am currently writing.*

*As a rule, I have refrained from personal allusions in my scholarly essays on Kelly, but I do not restrict myself in this way whenever I am asked to lecture about his work, especially to a general audience. Given that some of these presentations are available online, I shall allow myself to quote the very beginning of one of them almost verbatim and then use this occasion to correct a factual error that I have innocently repeated many times:*[1]

Ellsworth Kelly is one of the very first artists whose work I liked. Perhaps he was second, just after Piet Mondrian. One of the things I asked Kelly after we finally met and became friends was why he had not answered a fan letter that I had written to him in my teens. He remembered the letter. He had received it at a time when he felt isolated, bypassed by a new generation of artists, and he had been struck by the fact that it came from a French teenager living in the middle of nowhere. Of course, he has responded to it! He thought he might even have kept it. Since Kelly is a demon archivist, he found the darn letter, and he gave me a copy of it. Reading it was humbling. First, because I realized I had misdated it in my memory, placing it three years too early—I thought I had sent it from France while in fact it was sent from a farm in Pennsylvania where I was living as an exchange student. My mistake was probably due to the fact that the main event described in the letter, my initial encounter with his works, at a show of his lithographs at the Galerie Adrien Maeght in Paris, dated from even earlier (1965). Second, because it was sheer adolescent drivel. At the time of the letter, Kelly was for me the purest representative of pure abstraction, whatever that is supposed to be.

This interpretation was in fact reinforced by a groundbreaking essay on the artist's French years, written by John Coplans, then chief editor of *Artforum*. It was one of the first things I read when I arrived in America as an exchange student in the summer of 1969. Coplans, in this excellent article, had said nothing of the "figurative" origin of the many works he was describing (and publishing for the first time). So, I was utterly dumbfounded when I read the expanded, or rather rewritten, version of this text in the monograph he published only two years later, in 1971. I felt literally betrayed (by Coplans certainly, but even more so by the artist himself) when I read about the "real" sources of the pictures that had been reproduced in the journal and that I had greatly admired. Too many art historians were always ready to deny the existence of abstraction, reading abstract paintings as if they were little rebuses one could simply decode just as the iconologist decodes the "hidden, textual meaning" of a Renaissance painting. I found it devastating that an artist whom I had always deemed a champion of abstraction would unabashedly admit that the three horizontal bands of a multi-panel painting in fact "referred" to the colors of fields seen from a train (*Train Landscape*, 1952–53), that the black lines on a folded screen were the "rendition" of the cast shadows of a railing on a metallic stairway (*La Combe II*, 1950–51), or that his first masterpiece, earlier known as *Construction—Relief in White, Grey and White*, was now to be rebaptized *Window, Museum of Modern Art, Paris* (1949), since indeed it was the most exact duplicate, in reduced size, of one of the windows of the old, pre-Centre Pompidou, Musée National d'Art Moderne.

Feeling betrayed, I sulked for a while, like teenagers do, and then moved on to other things, forgetting about Kelly's high treason, but also not paying as much attention to his work as I should have for many years. Then, suddenly, while I was teaching at Johns Hopkins University in Baltimore, I was plunged back into Kelly-land when visiting the touring retrospective exhibition of his drawings organized by Diane Upright, which came to the Baltimore Museum of Art in 1988. It is then that I really discovered Kelly's early graphic production. My teenage militancy about "pure abstraction" had vanished long ago (I had become an art historian in the meantime, and I knew by then that this was a very inept notion). Seeing the drawings, and thus being offered a glimpse at the process of formation of the paintings, I realized that the "figurative" source of many of the French pictures did not amount to a stylization or distillation of a spectacle seen in the world. I did not understand exactly why this was so, but I was determined to find out.

In late 1989, I was asked to write an essay for the catalogue of the exhibition of Kelly's French years (1948–54) at the National Gallery of Art in Washington and the Galeries du Jeu de Paume in Paris—an invitation I immediately accepted.

This was soon followed by a first visit to Kelly's studio in Spencertown (upstate New York), and then many others, and it is during the yearlong, intermittent discussions we conducted on his Parisian works that I gradually came to understand the function of the "figurative" origin of many of the French paintings and reliefs—how it had nothing to do with representation but rather with a noncompositional system, which I call the "transfer," and, in turn, how this relates to other noncompositional strategies in his work of this period. In short, I was finally able to absolve Ellsworth from the "high crimes and misdemeanors" I had been accusing him of as a teenage prosecutor. The intellectual, visual, and affective pleasure I took in granting this absolution was only the beginning of a wonderful friendship.

*The lecture from which I've excerpted this anecdote goes on to examine various noncompositional strategies in Kelly's work during his years in France (1948–54). My account of these strategies is recurrent in most of my writing on Kelly and here is not the place to rehearse it again, but this is the place to amend the initial anecdote. For, contrary to what I believed for years, Kelly had replied to my teenage letter! I had written to him that the following weekend I might be able to come to New York City (from Hanover, PA), and in response he jotted a few words on a postcard (one of his plant drawings) saying that he would not be in the city at that particular time but inviting me to call him next time I would be coming. Of course, he could not have any idea of how extraordinarily difficult it was for me to convince my American host family to permit me to travel to New York (which they probably regarded as Babylon), or of the trouble my (real and not-English-speaking) parents had to go through to persuade them to let me go, not to mention the bureaucratic mountain I had to climb with the organization supervising my student exchange.[2] I have a hard time understanding how I could have forgotten about this postcard. It is possible that I received it only after my return from the city, or that I did not dare to call, given how little freedom I had in my host family and how embarrassed I would have been to admit my state of dependence. Whatever the case, the fact is that I completely repressed Kelly's response . . . until I stumbled upon it.[3] I almost called Kelly on the spot to tell him about it (I had been working with him in Spencertown just a few days before)—but then, remembering that he was hosting friends that night, I abstained. The next day I felt it would be silly to bother him with such a peccadillo. He died less than two weeks later, and, sadly, I never was able to share the story with him.*

*I read the remarks that follow on the occasion of the memorial staged at the Museum of Modern Art on January 31, 2016, a little more than a month after Kelly's death on December 27, 2015, and they appeared in a special section dedicated to the artist in the April 2016 issue of* Artforum.[4]

My first thought when I got the news of Ellsworth Kelly's death was that the world had suddenly gone dimmer. I could no longer expect the gush of joy that always engulfed me when discovering his most recent works in Spencertown, New York. But while it is true that he is no longer here to surprise us with utterly new twists and turns in his practice—which became ever more playful as he grew older—I soon realized that I had been wrong to think that way. For the work remains, and it remains as a rock of optimism no matter how grim the world becomes around us. It is to this constant freshness that I would like to pay tribute.

Those of us who knew him well often heard Ellsworth lamenting about this or that, but his art always contradicted whatever gloomy mood he might be in. His work was, and will forever be, upbeat, and he himself was invariably upbeat when hard at work. Self-doubt very rarely troubled him, even though he was his own harshest critic. He could be hilariously funny, and he was quite a storyteller, but he kept irony at bay from his work. He had no distance from it. He was perhaps the last happy modernist.

I have often wondered about Ellsworth's consistent passion and energy—especially during the last years of his life, when his health was failing. Obsession was part of it, to be sure—and he was more obsessed with his own work than any other artist I have met—but that is not enough. A remark that Matisse made a few months before his death helped me understand where this was coming from: "The artist . . . has to look at everything as though he were seeing it for the first time: He has to look at life as he did when he was a child."[5] In many ways, I think that's what Ellsworth achieved.

He was very fond of recalling childhood memories—and his memory was spectacular. One of the events he liked most to recollect happened when he was trick-or-treating with a group of friends. Approaching a house at night, he had marveled at the shapes and colors that he could see from afar, framed by a window, in a brightly lit room—only to discover, on moving closer and peeking through the window, that the interior in question was utterly banal, that nothing there could justify his interest. Any other child would have shrugged this off, but Ellsworth insisted (no doubt as his cohort was impatiently waving him back) on returning to the same exact spot where that initial magic encounter had sparked, so that he could verify it, so to speak.

"Finding the exact spot" could be the motto for how Ellsworth's vision operated. I think it explains, in large part, his extraordinary capacity to return to his past works as an endless cornucopia: to take a collage he had made twenty, thirty, even sixty years earlier and then realize it in painting—but without any editing or adaptation, changing nothing except the size and the medium. That

first spot, in other words, remained exactly right. He had no control over the spot itself—he was just immensely open to catching sight of it, eyes wide open. He had no theoretical compass, no blinders of any sort. Paradoxically, for someone who always sought to expunge subjectivity from his work, his only guide was his intuition. He never knew why he was attracted to such-and-such a shape, why the particular curve of this particular shadow so struck him that he had to record it at once with whatever instrument on whatever support he had at hand, why he immediately perceived this piece of folded cardboard found in the street as fodder for his art. And when he was starting from scratch, as he did more often than one might think, he did not know why it felt absolutely necessary for him to trim, by just one degree, the radius of an ample, generous curve with a ten-foot span. He had no control over the spot, but he had full confidence in his visual radar, in the exactitude of what his radar let him see. As anyone who ever watched him install an exhibition could testify, he had what we could call "perfect visual pitch": He could eyeball in a split second the slightest discrepancy between what he had meticulously planned and what impatient art handlers or curators had made of his instructions.

Ellsworth often remarked that his visual accuracy was enhanced early on by his bird-watching in the New Jersey countryside (he alluded to it again this past December, marveling at photographs of a colorful painted bunting that had made a rare appearance in Brooklyn's Prospect Park).[6] And indeed, the skills required for bird-watching include an attention not only to the bird but to everything around it, to the ground as much as to the figure. Visiting an exhibition with Ellsworth was a lesson in perception: He was always pointing to details one would not otherwise notice, to interstitial spaces between figures, or to the juxtaposition of two color planes in a marginal area of a canvas. He would then inevitably relate those discoveries to his own work, past or recent. I vividly remember a visit to an exhibition of van Gogh's portraits at the Museum of Fine Arts, Boston, during which he kept signaling shapes or color chords in the Dutch painter's works and noting how much they recalled some of his own—to the point that I felt compelled to joke that if one could be sure of anything, it was that van Gogh had not copied him.

But if Ellsworth's visual proficiency allowed him to discern hidden similarities, it was even more attuned toward detecting minute differences—as I found out many times when, having compared two of his works that seemed to me very close morphologically, I was gently rebuked for not having identified their essential dissimilarity. God, for him, was indeed in the details.

I was fortunate to be able to discuss with Ellsworth, at great length, the genesis of many of his works. He was particularly voluble when speaking of his French years, in part, perhaps, because there were things he did not need to spell out with a French native, but above all because he knew how important

135

his stay in France at the beginning of his career had been in his formation—this is where and when he had discovered and developed the noncompositional strategies (what I have classified as chance, the transfer, grid, monochrome, and silhouette) that would sustain his life's work. He bore no grudge against the French for not having been any faster than the Americans in welcoming his work; and he enjoyed, late in life, the belated accolades he received from overseas. The only reproach he kept making against my compatriots concerned vichyssoise, the cold soup of leeks, potatoes, and crème fraîche, which he was convinced he had invented. I don't think I managed to persuade him to the contrary.

This was the least of Ellsworth's extremely strong core beliefs. He stuck to his guns all his life, never belonging to any group, never compromising, always proud of his singularity. Despite the experience of a certain solitude that this implies, he had many friends. And he was a generous friend, whom I'll miss dearly.

First published in *Artforum* 54, no. 8 (April 2016), 192–94.

1. The lecture in question was given to the Friends of the Institute for Advanced Study, Princeton, on October 30, 2013. Significant excerpts of the talk, entitled "Ellsworth Kelly's Dream of Impersonality," were published in the Fall 2013 issue of *The Institute Letter* and are available on the IAS website at https://www.ias.edu/video/friends/2013/1030-YveAlainBois.

2. The date I gave to Kelly was February 20–22, 1970. In my mind I stayed longer—but I was so impressed by this first stay in New York that my memory probably amplified its duration. In any event, my correspondence with Mathias Goeritz, whom I met then, and with Sibyl Moholy-Nagy (who generously paid for my Greyhound bus ticket and arranged for me to stay in the room of one of her students), shows that this was indeed the unforgettable weekend when I discovered New York. I did return once again that year, in April (17–20), but that time it was with my parents, who had come from France to visit me for (or rather at the time of) my birthday, and, thanks to their chaperoning, there was no problem getting away from Hanover for that second trip.

3. The amusing circumstance is that, while trying to pinpoint the date of my two stays in New York in early 1970, I found the postcard, mysteriously misfiled with much later letters from Meyer Schapiro. I was curious about the date, because I had agreed that my correspondence with Franz Erhard Walther, which began shortly before I met him in New York (during my April trip), be published, and I wanted whatever critical apparatus the editor had engineered to be accurate. This correspondence is reproduced in facsimile in *Franz Erhard Walther: Dialogues* (Madrid: Museo Nacional Centro de Arte Reina Sofia, 2017), 57–111.

4. Other speakers at the MoMA event were Emily Rauh Pulitzer, Frank Stella, and Jack Shear, as well as people from the host institution—Glenn D. Lowry, Agnes Gund, Ronald S. Lauder, and Ann Temkin. The latter also contributed to the tribute published in *Artforum*, alongside Richard Serra, Terry Winters, Mary Heilmann, and Molly Warnock (who offered a wonderfully generous review of the first volume of my catalogue raisonné, which had appeared in May 2015).

5. "Looking at Life with the Eyes of a Child" (1953), reprinted in *Matisse on Art*, ed. Jack Flam (Berkeley: University of California Press, 1995), 218.

6. My allusion to the painted bunting spotted in Brooklyn specifically refers to a downtime moment during one of our sessions of hard work. Kelly, of course, knew everything about the bird, while I had just learned of its existence in the press, which was then full of it: Its coming as far north as New York had created quite a commotion among birdwatchers, their cheers mixed with worries about what this meant with regard to global warming.

Christophe Verfaille, *Untitled,* April–July 1991.
Acrylic on wood, 13 7/8 × 14 5/8 inches.

# When Lacquer Screen Meets Blotting Paper

*I met Christophe Verfaille in 1967, at a summer camp in the College Cévenol of Chambon-sur-Lignon. We were both teenagers and adamant we would become* artistes-peintres, *as one said at the time. He was the student of J. P. Maillot, a pupil of André Lhote (Lhote was a mediocre artist but a very interesting critic who directed his own art school). Verfaille's professor had him copy Romanesque frescoes. As for my own (soon aborted) pictorial practice: I thought of myself then as a "geometric abstract painter" (ridiculously preten-tious, but true!). Needless to say, we had fierce discussions about the future of painting during this monthlong vacation—we disagreed about everything, but we became very dear friends, each convinced that the other would soon come to his senses and switch sides. After that summer, we saw each other irregularly, sometimes losing contact for long periods but sooner or later renewing our connection with excitement and joy. I often visited him in the various extremely modest studios he occupied (the first time he was still living with his mother in her cramped apartment, in a dreadful high-rise building in one of Paris's "satellite" cities hastily created in the 1960s). By then I had given up painting and it was he who had become a "geometric abstract painter" (he had "come to his senses," after all—as had I, in my own way!). My visits became less frequent when I moved to the United States in 1983, but whenever I could, I was always delighted to spend a day with him looking at his newest batch of paintings and debating as ever about the possible future of that medium. In 1996, I wrote the text of the leaflet accompanying his exhibition at the Galerie Alessandro Vivas in Paris (which, alas, did not bring him the recognition he deserved). I had not seen him for a couple of years, for reasons that have nothing to do with any lack of fidelity in my friendship, nor with any lessening of my interest in his work, when he contacted me out of the blue in January 2010, sending me an email (the first I'd received from him—he had long been a Luddite of sorts) to which was attached, by way of a greeting card for the New Year, the scan of a small crayon drawing that reminded me of those made by Barnett Newman before* Onement I. *We resumed our correspondence, and I soon learned that his life had taken a tragic turn. Not only had his mother died from complications after surgery but his diabetic condition had dramatically worsened. He was now spending three long and exhausting days a week in a hospital for dialysis and was desperately awaiting a kidney transplant. Despite all his miseries, he remained passionate*

*about his work (he was at his studio when not at the hospital or teaching art in
a nonprofit organization dealing with disturbed kids from the Paris suburbs).
Our conversations never stopped for long from then on, and I visited him every
time I came to Paris. His end was particularly tragic: He had finally received
the kidney transplant he had so long awaited (the last time I saw him was just
after the operation, around Christmas 2010), but even though the graft had
been successful, his whole organism was so feeble after years of illness that it
collapsed after a few months of steady decline. He died on July 18, 2011. He
was fifty-eight years old.*

•

I am staring at a small painting on plywood that Christophe Verfaille gave me
long ago. Every time I look at it, which happens daily as I pass by it on the way
to my desk, I am bewildered, captivated. "How did he do it? How did he obtain
such a surface, so smooth and yet so matte? Where do these strange colors come
from? And from where, these faint ghost shapes?" Anyone who sees this work at
my place inevitably asks such questions. I know some of the answers. That is: I
know how he did it, materially speaking. But being in the know does not in any
way lessen the bewilderment nor decrease the captivation. I am forever captive,
drawn to this surface that is so hard and yet so soft, so gentle, so inviting.

The first striking thing about Verfaille's best paintings is the total absence of
texture. Smooth is an understatement: Their surface is polished. One thinks of
Formica, and the artist did not mind the comparison when I submitted it to him
(the whitish web that emerges here and there, particularly in the smallest pieces
on ultra-thin plywood, reminds me of cheap kitchen tables and countertops
from the late 50s or early 60s). Another immediate association, in a nobler
vein, is with lacquer. Neither Formica nor lacquer is a convincing descriptor,
however, since both are almost inevitably (albeit in varying degrees) linked to
sheen in our minds. Most of Verfaille's paintings are *intensely* dull—though a
glossy color plane could occasionally land on the top paint layer, contrasting
with everything else on the panel (even more rarely, he substituted glitter dust
to mere paint gloss on such top-layer intruders). Matteness is antithetical to
smoothness in our everyday perception. Language is poor in combining the two
semes: Is there even an adjective that could mean both polished (or burnished,
or buffed) and dull? Sleekness is always mirror-like in our mind.[1]

But though far from perfect, the Formica and lacquer associations have
some truth to them. In fact, even though this does not conform to the concept
one has of lacquer (as glossy), Verfaille did use lacquer paint, among other
kinds (he preferred acrylic for his small formats).[2] One quickly senses that
the color planes that populate Verfaille's paintings, even if of a light hue, owe
their peculiar elusiveness to the numerous underlayers that activate them from

beneath. In other words, he embraced lacquer for its enigmatic chromatic quality that is a function of the number of superimposed layers involved in its making (and, when using acrylic, he treated it as if it were lacquer). The accretion of razor-thin strata coalesces in a color-matter effect. One cannot, either visually or intellectually, dissociate the material support from the color that seems frozen within it—and the best-quality Formica could give this impression of an indivisible slab, all of a piece, colored in its thin mass. The indefinable colors and absorptive effect of certain very opaque planes come from what one could call a depth without substance. The absorptive appearance is paradoxical, for these surfaces are anything but sponge-like (they are fragile and vulnerable to scratches but would not soak up liquid): What they soak up is our gaze. A comparison with another medium, perhaps, could get us closer to pinpointing the specificity of Verfaille's almost immaterial materiality: photography—and indeed, formally at least (minus the color), some of his paintings look a bit like the abstract photograms (or camera-less photographs) that László Moholy-Nagy produced at the Dessau Bauhaus during the 20s. As in those, perfectly clear-cut geometric planes are interrupted by others, blurred, wraithlike, that seem to be approaching from far away or receding in the distance; and as in photography in general, the image is without material substance: It never appears to be *on the top* of the material support but embedded *within* its skin.[3]

But if this last comparison is useful, even though it is just as approximate as the others, it is for what it reveals by contrast. If anything is blurry in a photograph while everything else is in focus, it is usually because it moved during the exposure. And this connection of blur and movement is so ingrained in our visual culture that we are prompted to mentally infer motion in a photogram, even if we know that any lack of focus in such images is due to objects that were not evenly flattened on the photographic paper as it was exposed. But for the rare exceptions of long takes (something that fascinated Moholy-Nagy as well), photography implies speed—while even the most casual glance at a Verfaille painting is enough to assess that it was not born in a flash.

The artist was not secretive about his process: He would gesso his plywood panel, then paint a geometric colored plane over it, let it dry, paint another, overlapping the first or not, let it dry again, repeating this operation multiple times until he had forgotten whatever shapes and colors were buried beyond the surface of his top paint layer, sandwiched between all the independent coats he had applied. Then he would sand the whole thing, letting some vestigial traces of well-buried strata come forth. If dissatisfied with the outlook, he would embark on a new campaign of paint applications—this could go on ad infinitum. In any event, it took him a very long time to finish a painting, or rather to accept it as finished, to let it go—up to ten years, as the dates that he stamped on the back of his panels attest. (On the verso of the painting I own, stamps indicate

that it was started in April 1991 and thought completed in July of that year—an exceptionally short span; but then it was taken up again and last stamped in March 1995.)[4]

I imagine that quite a lot of painters have used sanding during the past fifty years or so—more precisely since the invention of acrylic, whose inert surface many felt they had to scour in order to squeeze some liveliness out of it (little did they suspect, alas, the degree to which this practice was a health hazard). Verfaille was introduced to the technique by Martin Barré, whom he greatly admired and saw as a role model (as did so many young French artists of his generation). Barré took to sanding when searching for means to obtain a fresco-like, almost rupestrian look. Verfaille did not have such muralist desires: Sanding for him was a way to recover past strata but also to compress temporality, an ancient layer back up to the surface and thus perturb the last one applied from underneath. But there is another way in which he learned from Barré: As with the varied systems used by the older artist in his work, Verfaille's anamnestic method introduced a voluntary relinquishment of control, given that there is no way, even if he had wanted to, that he could have memorized the formal configuration of each geological stratum that he had piled up on his wooden support.

This voluntary loss of mastery, combined in Verfaille's work with an urge to erase any autographic gesture through mechanical sanding, is part and parcel of what I have often labeled the noncompositional impulse in twentieth-century art. This impulse is coeval with the recurrent myth of the last painting—they appeared at the same time (with Malevich) and periodically returned in tandem. It is not the place here to inventory the artists who tried to obliterate any trace of their presence by avoiding all subjective compositional strategy, eliminating the hierarchical opposition between figure and ground, or letting chance, set systems, material processes, and other objective factors supersede their own agency. Even a thick volume would not suffice.

Let us just point to one paradox: Though Verfaille was determined to efface his own self (not only all traces of his handicraft, but also a good part of his own authority over his material), his noncomposed works are often very similar, morphologically speaking, to highly composed ones—one thinks of Liubov Popova's *Painterly Architectonic* series of around 1918, for example (a few years before she enlisted, along with Rodchenko, Ioganson, the Stenberg brothers, Medunetzky, and other Soviet Constructivists, in a hard-line combat against composition). In fact, this resemblance of something that was deliberately conceived as an assault against composition with historical exemplars of . . . composition narrows the genealogical search. The family tree is no longer that extensive.

There are no doubt other branches, but the most pertinent consist in the work produced by Ellsworth Kelly during his French years (1949–54). From

the mid-80s to the last year of his life—when between long and depressing sojourns in hospitals he was too weak to paint and sand and devoted himself to drawing[5]—Verfaille faced in painting the very issue that had puzzled Kelly around 1950 when he broke with the post-Cubist rhetoric of abstraction of the time by merely transferring onto his canvases found patterns copied from flat items on which he had zoomed in the world at large (the repetitive motif of a Japanese stencil for a textile design, the shadow of a balustrade on a metallic stair, the rhythm of open and closed windows on the facade of an apartment building, etc.). Kelly's problem, which must have, to a point, confronted any abstract painter in search of noncompositional means besides the modular grid or the monochrome, was to prevent his noncompositional transfers from looking like abstract compositions pure and simple; to make sure, for example, that a relief minutely replicating the disposition of flagstones in the courtyard of the American Hospital in Neuilly would not be seen as a poor imitation of a Georges Vantongerloo painting from the early 20s.[6]

But if Verfaille's work reopens the long modernist tradition of the noncompositional (and in doing so signals that the obstacles blocking the road to the advent of the mythical "last painting" might not be removed anytime soon, if they are removable at all), it is not the main reason why I find it so compelling. Another genealogical search that it calls for is far more specific, since it relates to the peculiar color-matter effect mentioned above as a direct consequence of his sanding technique. I have not yet found a name for this effect, and it is easier to say what it is not (purely optical) than what it is. All I can venture about this effect is that it is due to a perturbation in our sensory input. It is present when the color-matter titillates our sense of touch (inducing in us a caressing desire), of taste (we want to lick), or of smell. Those senses are not summoned *in place of* that of sight but *along* with it, upsetting our visual mastery by a synesthetic overflow of sensory data.

I find this color-matter that Verfaille's work resuscitates—going backwards in the chronology—in Brice Marden's wax paintings of the 60s, which were similarly produced by an accumulation of underlayers (let us note in passing that most commentators insisted at the time on the indeterminate character of their color, and that one of them spoke of his desire to smell such paintings).[7] I also locate it in Ad Reinhardt's so-called "black" paintings, as little textured and as matte as Verfaille's; in thirty or so canvases that Georges Braque painted shortly after World War I, when he felt free at last from Picasso breathing down his neck and allowed himself to take advantage, without guilt, of his formidable painterly skills (the composition in these still-lifes is not particularly noteworthy, but the color-matter effect generated by a strange mixture of oil paint, water-based paint, turpentine, and other still unidentified liquids, the whole sauce occasionally applied on a sandy ground looks as delicious as that produced by

143

chocolate icing); I detect it even more in the small interior scenes that Vuillard painted in tempera during the 1890s, and of which André Gide used to say that they made him think of murmur because they force the beholder to come very close and decelerate his or her gaze; finally (and I doubt it would be possible to go back much further in history, since this color-matter effect is incompatible with the glazes and varnishes that were constitutive of studio practice up to that time), I catch it in several of Courbet's pictures of waves, walls of water foaming under a thunderous yet stony sky.

In all these examples (at least if some idiotic, market-motivated application of varnish has not irremediably disfigured the paintings), we are dealing with a superlative matteness, a deep, dense matteness—but whose depth and density are not accessible to eyesight alone.

Each time the work of a painter forces me as a historian to summon an unusual ancestry, I feel grateful. In impelling me to explore anew the whole pictorial tradition from which it sprang and to map within it a territory that had up to then gone unnoticed, such works suggest that there might be many other overlooked fields of the kind, still fallow but waiting to be tilled. I am thus grateful to Verfaille's painting for having spurred this invocation of artists of the past, uncovering for me what their extremely diverse production has in common. Combining matteness and smoothness, he invented unlikely objects: Paintings that are at once thick and thin, deep and flat, at once lacquer screen and blotting paper.

First published in *Christophe Verfaille* (Cologne: Galerie Buchholz, 2014), 4–11.[8]

1. I wonder what Verfaille would have thought of Gerhard Richter's recent super-slick "paintings" (in fact digital prints under a layer of glossy Lucite). Would he have approved of Richter's labeling them paintings? Savored the irony? Would he have seen them as a last attack on painting (an assault against which, then, he would have seen his own work as a protest)? Or would he on the contrary have interpreted them as one more strategy invented by Richter to delay the demise, announced so many times, of painting as a medium? I am certain that, on account of several conversations we had about Richter's work in general, these "paintings" would not have left him indifferent. On these works, see Benjamin Buchloh's essay in the catalogue of their exhibition in Paris at the Galerie Marian Goodman (September 23–November 3, 2011) and Paul Galvez's review in *Artforum* (January 2012).

2. My thanks to Jean-Paul Douthe for this technical information, which Verfaille never disclosed to me. In fact, he never corrected me when I implied, in the 1996 essay mentioned above (note 1), that his paintings were not made with lacquer paint. Bernard Joubert, another close friend of Verfaille's, and himself a painter, confirmed that he used both lacquer paint and acrylic (the latter notably from the brands Liquidex and Golden).

3. I should note that this color-matter effect (and the coalescence of painterly layers into an indivisible concretion) is an attribute of Verfaille's paintings alone. Perhaps as a kind of personal antidote (just as Barnett Newman made very skinny paintings to ward himself off the seduction of large color planes), Verfaille made numerous small collages (in which, by their very nature, materiality is underscored). In the last decade of his life, he also produced flimsy sculptural assemblages of very light refuse material (plastic yogurt jars, medicine packets, etc.). He started making them around 2000 (the letter he sent me along with a photograph of one of them

dates from Christmas of 2004, yet Jean-Paul Douthe, who witnessed Verfaille's development much more assiduously than I, thinks that some might date from 1999). Alas, he packed them disassembled during the move to his last studio, after which he found himself too sick to configure them again. Fortunately some had been photographed and might possibly be reassembled.

4. In parallel to his panel paintings, Verfaille made a lot of small drawings (on paper but also on black, opaque portions of X-rays that he scratched, or on dark fabric). These drawings consist of white lines that divide the whole field into irregular, loosely geometric parcels. They seem to have been made very quickly (as rapidly as the painted panels are made slowly), almost in an automatic fashion. Did they function for the artist as a starting point, as a sketch for the first paint layer of his panels, or for several consecutive layers? They are usually grouped by size and material support (taped together on boards, stapled in sketchbooks).

5. Among his last works are diary-like small sketches in color crayons or pastel, which he mounted, grid-like, on large sheets of cardboard. Some of them are clearly landscapes and were done at Mont Saint Père, close to Chateau-Thierry (his last residence). In a letter he wrote to me in the fall of 2010, he describes the sessions of "plein air painting" he finally allowed himself to have during the summer between long stays at the hospital, regretting that he had for so long refused himself that "innocent" pleasure (he writes "peindre sur nature," but the works in question are all on paper and are not painted). This letter is handwritten, barely decipherable.

6. On this particular anecdote, and on Kelly's early work in general, see my essays "Ellsworth Kelly in France: Anti-Composition in Its Many Guises," in *Ellsworth Kelly: The Years in France, 1948–1954* (Washington, D.C.: National Gallery of Art), 9–36; and "Kelly's

*Trouvailles*: Findings in France," in
*Ellsworth Kelly: The Early Drawings,*
*1948–1955* (Cambridge, MA: Harvard
University Art Museums, 1999), 10–35.

7.    See Douglas Crimp, "New York Letter,"
*Art International* 17, no. 6 (Summer
1973): 89. I should add that Verfaille was
particularly interested in Marden's as well
as Reinhardt's art and that we had several
discussions about their work. Needless to
say, as with Marden's wax canvases and
Reinhardt's "ultimate paintings," photog-
raphy is incapable of capturing the peculiar
matteness of his sanded panels.

8.    As has become common, the catalogue
was printed after the close of the show
(which was held from October 12 to
November 30, 2013) and contains views of
its installation.

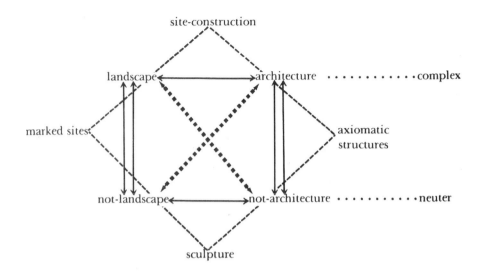

Rosalind Krauss, Klein diagram from
"Sculpture in the Expanded Field," 1979.

# Not [on] Diagrams

*The following text was my contribution to a symposium at Princeton University organized jointly by the School of Architecture and the Department of Art and Archaeology in 2007 to mark the passage of approximately three decades since the publication of Rosalind Krauss's seminal essay "Sculpture in the Expanded Field" in the journal* October *in 1979.[1] The occasion was both festive and studious, including many friends, colleagues, and former students of Rosalind's, united in their admiration for "Sculpture in the Expanded Field" but also in their willingness to underscore some of its limitations, as they sought to contextualize the essay historically.*

*The proceedings of the symposium were published in an extended form (with relevant archival documents as well as the responses to a questionnaire sent to artists and historians of art and architecture) under the title* Retracing the Expanded Field: Encounters between Art and Architecture. *This elegant volume, edited by Spyros Papapetros and Julian Rose, appeared in 2014, and the title under which my presentation appeared in the volume—"Not [on] Diagrams"—was given by the editors. (Note: For a brief account of my first encounter with Rosalind Krauss, who has been an important interlocutor for many decades, see my preface to "The Sculptural Opaque" on page 315 of this volume.)*

·

I have to confess that I am not good with diagrams. You might think it odd for someone whose formation was structuralism, but actually it was Barthes's pre-structuralism—in *Critique et vérité*, for example—and what we're now used to calling his "post-structuralism"—in *S/Z* and his subsequent books—that were my bread and butter as a student. My lack of taste for diagrams is not of a theoretical nature; it has nothing to do with the critique that their structuralist use often receives. I am perfectly aware of the flaws of diagrams: their pretense at universality, their effortless conjuring of images of totalities. But I can also appreciate, even if I can't experience it myself, their heuristic quality. My reluctance is not ideological; it is more the result of a personal incapacity: that of distinguishing right from left. Not at the visual level (I shall never confuse, say, the left and right sides of the *Demoiselles d'Avignon*), but at the semantic level. Anyone with whom I drive in a car finds out very quickly that my response to the

command "turn left" or "turn right" is random and that the indication "turn here," accompanied by a clear hand motion, is the best way to secure the desired effect. This incapacity has to do with bodily and neuronal short circuits; I was born left-handed, so I was told, and this genetic "defect" was "corrected" during my early childhood in colonial Algeria. In any case, I can't deal with diagrams, for the same reason I can't easily use a computer mouse or a mirror to put a tie on.

Yet I remember specifically the intellectual pleasure Rosalind's essay gave me when I read it while writing a review of *Passages in Modern Sculpture*. This pleasure was principally in reading the synthetic diagrammatization of the sculptural field as a counterbalance to the teleological impulse of *Passages*. In *Passages*, you might recall, the entire history of modern sculpture was written as an unfolding narrative that began with Rodin and inevitably ended with Minimalism and so-called "Post-Minimalism." I didn't fundamentally disagree with this narrative (unlike Benjamin Buchloh, perhaps), nor did I fail to recognize its militant impetus. After all, Rosalind was then the leading critic of Minimalism, and I saluted her decision to write the history of modern sculpture from her contemporary vantage point. But it was elating to recognize that tele-ology, although a very efficient tool of persuasion, could give way to its contrary, or to a taxonomic mode of explanation that, by its very nature, admitted the viability of diverse and sometimes divergent positions.

Of course, like many readers, I recognized that Rosalind's diagrammati-zation could be subjected to the same criticism as any structuralist operation: its reliance on binary oppositions; its necessary closure of the field it constructs in order to articulate it; its apotropaic frenzy of arrows that seek to mask its non-dialectical stasis. Just as with Lévi-Strauss's work, I was more attentive to what this diagrammatization was producing, and to what it allowed Rosalind to perform. And the first thing that struck me was that it dispensed with the authorial position, or with the artist as bound by his or her own system. It is not only that her categories are porous, but, as she writes explicitly, "it is easy to see that many of the artists in question have found themselves occupying, successively, different places within the expanded field."[2] Today, it might be hard to understand why this "mapping" was so enlightening, although the current acritical state of the art world, the global "anything goes" as sanctioned by the market and the museums, tends to indicate that things have not changed that much. The catchword "pluralism" is no longer in favor, but the general equivalence and neutrality it advocates are everywhere pervasive.

Debunking the authorial position, thus, was in direct response to the critical defeatism of the time, and to a critical position that was content to give up intelligibility for some kind of soft anti-intellectual "eclecticism." Yet this debunking had its roots in Rosalind's long practice as a formidable analyst of an artwork's formal characteristics. In particular, her "formalism" allowed a

programmatic bypassing of the traditional category of style. (This was actually rather unusual within formalist ranks, for the habit was to compensate for the loss of authorship with a personification of style as a historical agent: Wölfflin's "history of art without names" is populated by a battery of styles each busy sublating the other.) In this respect, I saw the "Expanded Field" essay as a theoretical justification of the formidable couplings Rosalind proposed in *Passages* (the most famous being Brancusi and Duchamp, but also Boccioni and Hildebrand, Gabo and Ibram Lassaw, Arp and Giacometti). Forsaking the category of style made it possible for Rosalind to look into Surrealist sculpture (something which, because it is stylistically so diverse, had not been thought of as having a core identity and thus was not deemed worthy of including in the modernist canon). Of course, "Sculpture in the Expanded Field" went further than that. It could also be seen, methodologically, as the polemical counterpart of the "Notes on the Index" from a year or so earlier, which unequivocally proposed the photographic model as the common denominator of a whole range of art practices in the 1970s.[3] What was striking in both essays was the redistribution of cards that they proposed—a redistribution that revealed underlying similarities and recurrences, and related practices thought to be utterly diverse. This was in the grand tradition of structuralism, no doubt about that: One thought of Propp and his laundry list of the mandatory properties of the fairy tale, but even more of Barthes's unlikely trio of Sade, Fourier, and Loyola.[4]

But there was also something else that struck me, particularly since, as I said, I read "Sculpture in the Expanded Field" as I was reviewing *Passages*. This was the relative absence of value judgment and of polemics (the only villains, briefly mentioned at the beginning of both this text and "Notes on the Index," are the happy bozos exalting "pluralism"). Everyone familiar with Rosalind's work knows how "agon" plays an important role in her discourse. *Passages* certainly partook of that agonistic tendency, even if the essays upon which it was based were stripped of their most virulent polemics. In particular, I'm thinking of the chapter on Brancusi, based on an *Artforum* review of the show curated by Sidney Geist at the Guggenheim. Rosalind popped the balloon of the catalogue's cheap Neoplatonic prose and, in a very disrespectful manner that was resented by many, proposed the idea that Brancusi's statements were useless and that his best account of his sculptures was through his photographs.[5] Another example is the pages on Anthony Caro, based on an *Art in America* review of the show curated by Bill Rubin at MoMA. Here too, the polemic but not the stance was elided. I could give many other examples.[6] By comparison, both "Sculpture in the Expanded Field" and "Notes on the Index" were remarkably inclusive; in these essays, Rosalind named several artists whom she "could not possibly like." I was sure of this and she confirmed it when I asked. She named them not as foils in a polemic but as pawns occupying a position on a chessboard.

It is actually the metaphor of the chessboard that made me grasp the theoretical input of the "Expanded Field" essay; for, at the time, Hubert Damisch was elaborating his strategic model of history. I have written extensively about this, so I don't want to repeat myself. Let me just say briefly how Damisch was led to chess as a heuristic tool, which I think is relevant here. It has to do with the claim, as common then as today, that painting is dead. According to Damisch, the question raised by this model with regard to the modernist myth "becomes one of the status that ought to be assigned to the *match* 'painting,' as one *sees* it being played at a given moment in particular circumstances, in its relation to the *game* of the same name."[7] In other words, the end of a match does not mean the end of a game. With regard to the game called "painting," I think the match currently played by Gursky, Jeff Wall, and others is indeed proof that it is not dead, even if the painter's brush is now a mouse and his palette a digital program. Damisch's strategic model had a clear anthropological origin: Its direct source was Lévi-Strauss's *The Way of the Masks*. Even though I did not find any thread of this in Rosalind's essay, this metaphor linked their respective work and helped me see that both writers were pointing to the potentiality of repetition and recurrence in a historical field that was valued, on the contrary, especially in avant-garde circles, for its constant motion forward. It did so—and this is the most surprising—while fighting the specter of historicism. Of course, the long-duration idea was perhaps not the message Rosalind wanted to convey at the time; the apparition of the category of "postmodernism" in the text contradicts that particular reading. Yet in retrospect, and in view of today's amazing repeat of "pluralist" overcrowding, it is most relevant.

First published as "Not [on] Diagrams," in *Retracing the Expanded Field: Encounters between Art and Architecture*, ed. Spyros Papapetros and Julian Rose (Cambridge, MA: MIT Press, 2014).

1.   The essay was reprinted in Rosalind Krauss, *The Originality of the Avant-Garde and Other Modernist Myths* (Cambridge, MA: MIT Press, 1985), 276–95.

2. Krauss, "Sculpture in the Expanded Field," 148.

3. The essay was first published in 1977 in the journal *October*. It is reprinted in *The Originality of the Avant-Garde*, 196–219.

4.   Vladimir Propp, *Morphology of the Folktale*, trans. Laurence Scott (Bloomington: Indiana University, 1958). Roland Barthes, *Sade, Fourier, Loyola*, trans. Richard Miller (Baltimore: Johns Hopkins University Press, 1997).

5.   For more on the Duchamp/ Brancusi chapter of *Passages,* see my "The Sculptural Opaque" in this volume, 315–45. The exhibition to which I allude is *Constantin Brancusi, 1876–1957: A Retrospective Exhibition*, curated by Sidney Geist, New York, Solomon R. Guggenheim Museum; Philadelphia, Museum of Art; Chicago, The Art Institute, August–October 1969. Rosalind's review was published as "Brancusi and the Myth of the Ideal Form," *Artforum,* January 1970, 35–39.

6.   For more on this, see once more "The Sculptural Opaque" in this volume, 315–45.

7.   Hubert Damisch, *Fenêtre jaune cadmium, ou, les dessous de la peinture* (Paris: Éditions du Seuil, 1984), 170. On Damisch and chess theory, see Damisch, "The Duchamp Defense," trans. Rosalind Krauss, *October* 10 (Fall 1979): 5–28; Damisch, "L'échiquier et la forme 'Tableau,'" Conference Proceedings (University Park, PA: Pennsylvania State University Press, 1989). I discussed Damisch's chess model in the chapter "Painting as Model" in *Painting as Model* (Cambridge, MA: MIT Press, 1990),

245–57. See also my review of "Moves," the exhibition curated by Damisch at Museum Boijmans van Beuningen on the theme of chess and card games, in this volume, 364–67.

Hubert Damisch giving a seminar on perspective, ca. 1990.
Photo: Teri Wehn-Damisch.

# Tough Love

When the editors of the *Oxford Art Journal* asked me to speak about Hubert Damisch, they told me I should feel free "to concentrate on whatever issues have been important for [my] own work." Easy enough, I thought, but then, when trying to come to terms with the assignment, I realized what I knew in theory but had never quite experienced so vividly—that the debt to one's mentor can never be ascertained. Not only because one's intellectual horizon is by necessity a blind spot, but because it is multilayered, acting without our control from the multiple recesses of our memory. Where does indebtedness start? Can it be circumscribed in any sense? What, exactly, does one learn? Is one's formation evolving according to the organic rhythm of plant life—first a seed, then young shoots, then branches sprawling in many directions, some cut short to allow others to thicken? If so, what is the nature of the seed? How is it implanted? In what soil?

I have, in fact, already written several times about the importance of Hubert's work, not only for my own but for the field of art history at large— most notably in a review of his *Fenêtre jaune cadmium* whose title, "Painting as Model," became the title of the volume of essays in which it was reprinted, something that was clearly intended as an homage and was generally read as such. Not wanting to repeat myself, I began reading, or re-reading, the books that Hubert has published since the last work I had reviewed of his (the cata- logue of the exhibition *Moves*, which he curated for the Museum Boijmans van Beuningen, Rotterdam, in 1997).[1] I found new grist for my mill, of course, but this did not happen the way I had expected.

I had previously outlined four models at work in Hubert's lifelong endeavor: first, the *perceptive* model he built against Sartre with the help of Merleau-Ponty; secondly, the *technical* model, which I could also call epistemologic-haptic, by which he rebelled against the modernist canon of opticality; thirdly, the *symbolic* model, transformed from Cassirer via the Russian Formalists into a mapping of the dynamic interrelations between the various series usually grouped, in Marxist parlance, under the label of ideological superstructure (art, science, religion, philosophy, and so on); and finally the *strategic* model, by which he got rid of the potential gridlock in which a strictly structuralist approach could have led him. I find these models furiously competing in the recent books, with perhaps a slight advantage given

to the perceptive and strategic ones (I am speaking of *Skyline: La ville Narcisse*, 1996, which appeared earlier than the point in time I had chosen for a start, but which I read later; *Un souvenir d'enfance par Piero della Francesca*, 1997; *L'amour m'expose*, 2001; *La Dénivelée*, 2001; and, finally, *La peinture en écharpe*, also from 2001). I also discovered that a certain loosening up of the rules of his game had allowed Hubert to take into account several traditions of *Kunstwissenschaft* that he had to exclude earlier on in order to assert the specific field of his inquiry—just as Saussure, say, had to ignore what had been the main concern of his scholarly activity, the genealogy of Indo-European languages, in order to found his structural linguistics. One of these traditions, which makes a surprising return in Hubert's recent work (although this shift had already begun with *Le jugement de Pâris*, 1992), is iconology. Needless to say, it is iconology with a twist, informed both by the Russian Formalists' notion of theme as device and by Jacques Derrida's practice of dissemination. This particular turn reminded me strongly of Roland Barthes's final acceptance of biography as literary (or more exactly, "romanesque") material in his 1971 book *Sade, Fourier, Loyola*, in spite of his longtime admiration for Proust's polemics against Sainte-Beuve and his own combat against the old Sorbonne after the scandal that erupted over the publication of his *Sur Racine* in 1963.

Musing about the similarity of the two moves—and the common strategy upon which they rested, the right to store up or to come back to obsolete and discarded models if your object has developed a resistance to newer ones, to transform them, and put them to new use—I was suddenly struck by the importance of the autobiographical in Hubert's recent prose, wondering if the last model he had put to the test was not indeed that of Barthes's notion of the biographeme, and if so, what I could learn from this. Or, to put it otherwise: What does one learn from the autobiographical stance? My immediate answer is: a mode of address, a way to summon, to capture, one's addressee—not an insignificant lesson for anyone, like most of us, who has become, for better or worse, a teacher.

It is not that this mode of interpellation of the reader is necessarily more powerful than any other, but in Hubert's work it is particularly effective in that it is combined with another tactic that he has been using ever since he started writing. In an interview with him that I published long ago—this was on the occasion of the publication of *Ruptures cultures* in 1976—he told me that he liked to *phagocyter* his readers, a French verb meaning "to destroy by phagocytosis," to swallow your prey up and slowly digest it. We were talking about his particular syntax, these long, digressive sentences that curl upon themselves to the point that, when the final period of the text is reached, we feel compelled to go back into the forest and rewind the argument in order to make sure we have not overlooked anything or prematurely discarded a key element

as an aside.[2] But curiously, I did not question Hubert about what seems to me now, in retrospect—and this became ever clearer to me when navigating the last books—the necessary condition, or corollary, of his method of phagocytosis: his abrupt *introïts*, the way in which, at the beginning of each of his texts, either short or book-length, he places the reader, without warning, "before a thicket in winter," to speak like Joseph Koerner about Caspar David Friedrich's *Trees and Bushes in the Snow* of 1828.[3] I am referring here to Koerner's first sentence in his book on Friedrich because it is, to my knowledge, the first occurrence in an art-historical book written in English of such a violent entry without any pre-amble. There was no introduction of any sort, no preface, no acknowledgment: You were literally plunged into the thicket of the text, kicked into the swimming pool by some authority figure who thinks that tough love is the best pedagogy and that one learns how to swim by swimming. Well, this "tough love" approach is at the heart of Hubert's summons: Almost all of his works begin with this kind of Zen stroke that numbs you for a brief moment before it puts you in motion and forces you to resist the slow process of digestion to which you will inevitably succumb.

Given that I had been similarly struck by the very first sentence of Hubert's first book, the 1972 *Theorie du nuage*, which reads, "Soit, à Parme, les coupoles peintes à fresque par le Corrège,"[4] I wonder why I did not connect this peculiar mode of attack with his phagocyting scheme—in retrospect it seems to me that the Proustian example, which I knew very well, should have made the link immediately apparent to me (the abrupt though deceivably ingenuous "Longtemps, je me suis couché de bonne heure," followed by the most lethal and fantastic enterprise of literary phagocytosis that ever was). Perhaps I had become too close to Hubert by that time, so that the "tough love" strategy was no longer producing the desired effect? Perhaps I was in danger of becoming immune to it and thus, perhaps, of becoming a clone? Hubert, I now recall, had sensed something of this. The interview in question was published just as I had stopped going to his seminar, at his request. Remembering his own difficult cohabitation with Pierre Francastel at the École Pratique des Hautes Études and the years it took him to feel free from this towering presence, fearing that I would not be able to fly on my own if I continued to soak in his teaching and learn by capillarity, deciding that the moment had come to put me to the test, he suddenly weaned me off the weekly fix of his seminar. This last Zen stroke, perfectly symmetrical to that by which he had plunged me into his universe of discourse, text after text, was particularly harsh. I even thought at the time that it was cruel, while in fact there was nothing more generous, as I came to under-stand over the years from my own pedagogical experience. Among other things, this unexpected and blunt weaning had the immediate effect of precipitating the launch of the journal *Macula* by Jean Clay and myself—a venture that Hubert

greatly encouraged by offering to us several essays, including in 1979 the very first draft of what would eight years later become *The Origin of Perspective*, but also a venture from which he resolutely kept at a distance even though it was and remained to the end a pure offspring of his seminar. That too was generous on his part, to let us shape his legacy as we saw fit, without any censure, for anyone who would dust off these old issues today would immediately perceive in their pages—particularly in the opening editorial—a childlike desire to seduce the master who could easily have used the journal as his own personal mouthpiece if he had wanted to.

Now I notice that I have myself gradually moved into autobiographical territory. Perhaps this is inevitable on such occasions, but commemoration is not exactly my intent. Rather, I would like to dwell upon what I learned directly from Hubert's teaching, or rather how I learned it—because it is on a par, albeit less well known, with what everyone else can learn from his writings. Indeed, in rereading his work I realized that what I called summons, or mode of address, could be termed the pedagogical model. The autobiographical passages that follow are meant to illustrate how this model functions.

I met Hubert in the fall of 1971, shortly after I came to Paris in order to study with Roland Barthes—in fact it was at Barthes's urging that I went to audit Hubert's seminar. It might seem strange, but I did not know who he was at the time. I had completely abandoned any dream of studying art history—I had tried twice, and both times it had been disastrous. The first was in Toulouse, when, still a high-school student, I had attended the first two lectures of a course on Romanesque architecture at the university; the second was during my first year as a college student, in Pau, where my parents had moved while I was away as an exchange student in the United States during the year that followed my baccalauréat. The class in Toulouse had been a grotesque caricature, but I knew enough about the topic to blame the inanity of the old instructor for its failure to engage me in any way, and I had fled without hesitation. The Pau debacle was much more serious—it was the only art-historical course offered then, and the instructor was young and aggressive. Her stance was staunchly conservative, and she was attacking everything that had begun to interest me—I remember in particular a diatribe against Wölfflin! If she had spilled her venom against Hubert it is probable that I would have rushed to read whatever one could find of his publications, and that my growing contempt for our discipline would not have resulted in what I thought to be, at the end of that fateful year, a definitive farewell. But she did not, and I had to endure the tedium of her class on British art—I am sorry to say that to this day I have not been able to look at a Hogarth or a Gainsborough without having to struggle to overcome the revulsion instantly brought back by the memory of this early lecture course. I left France so long ago that I cannot speak with any authority on the current situation of art

history in that country, but I can certainly say that, in my youth it was catastrophic. Hubert's seminar was the only place where the discipline had not been reduced to antiquarian philately.

I had no idea of this and was skeptical of Barthes's advice, upon my arrival in Paris, to go and have a taste of this seminar—even a little reluctant. I had spent the summer mourning the loss of art history as a potential field for me and felt confident that my choice of semiology, as Barthes's discipline was still called then, was right. I shall never forget the first session of Hubert's seminar that I attended, the first of the academic year. The medium-sized rented room on the rue de Varenne was packed with about thirty people surrounding a huge table and soon filled with smoke. Hubert spoke nonstop at top speed, with the sonic background of thirty pens furiously scratching paper; the whole session lasted two hours if I remember correctly. Later in the term, the rhythm became less frantic, the sessions expanding to three hours with a fifteen-minute break, and the second half often devoted to discussions or, eventually, presentations by participants. But the vivid impression of being in the midst of some intellectual fireworks, sparkling with ideas never left me during the four or five years I was in regular attendance.

The 1971–72 seminar was devoted to the Bauhaus. I had seen in Paris in 1969 the big traveling exhibition celebrating the fiftieth anniversary of the German institution; I had read its catalogue as well as everything else on the topic that was available in French at the time, which was not much (anyone who has not lived through these years can have no idea of the paucity of information that was then at our disposal); I had also read several books in English, bought during my exchange student year in the United States. In short, I felt I had a fairly good knowledge of the subject—my attitude that day when I first joined the seminar could even be called a bit blasé. What else was there to learn on *das Bauhaus* and its failed utopia? This is when the thicket hit me right in the face.

During the first five minutes or so, Hubert calmly raised ontological issues—what was the Bauhaus? A movement? A school? An academy? An Ideological State Apparatus (after all, it was called Staatliches Bauhaus)? An avant-garde group forced to reflect upon its social insertion?

But then he immediately plunged into some of the facets he wanted most to examine—what exactly was the theoretical contribution of the Bauhaus? Was it a new pedagogy? Did it signal a new understanding of the interrelation between two "series," the technological and the artistic? Did it mark a return of the Wagnerian *Gesamtkunstwerk*? Was its main purpose an abolition of the division of labor in the artistic sphere? And what was its relevance today? Was it fair to subsume all of its efforts under the category of "design," as was often done? Questions followed questions. None was answered directly—this was, after

all, an introduction to a whole year's worth of seminar—but in relation to each question, Hubert offered a glimpse of what he had in mind by alluding to a text, a work of art, a debate that exemplified the particular issue. In rapid succession, I learned that Karl Marx had discussed the possibility afforded by machines of producing geometric forms; that in Russia the quarrel between the Proletkult and Trotsky over the notion of cultural heritage could be viewed as the counterproof of the first Bauhaus's propositions on this topic; that Bertolt Brecht's conception of abstraction was a direct response to the Bauhaus's programmatic functionalism, all of which was completely new to me.

Then there was a change of rhythm: This half-hour salvo was followed by a patient reading, and obstinate refutation, point by point, of an article on the Bauhaus that had recently been published by the critic and poet Marcelin Pleynet—similarly punctuated by digressions.[5] One of Pleynet's slogans about art's "relative autonomy" led to a discussion of one of modernism's inherent paradoxes, that its claims of medium specificity historically coincided with the dissolution of all specificities—Hubert concluding that one can never analyze one phenomenon without analyzing the other because they were dialectically linked. (The Russian situation was once again brought to the fore—this time with a long excursion into Lissitzky's 1922 Berlin lecture, a brilliant text that would often be called upon throughout the year. But the gradual ossification of Clement Greenberg's art criticism was also alluded to as resulting from his failure, despite his early "Trotskyism," to grasp the dialectic in question—this is when I heard for the first time about Richard Wollheim's *Art and Its Objects*.)

Pleynet's text steered Hubert back to the Bauhaus per se, but the issue of specificity was not abandoned; instead it was teased in relation to the Bauhaus pedagogy, particularly to the *Vorkurs*, the preliminary course. Did this represent a desire to find the "common root" of all the arts? And, if so, did this imply an ideology of the *tabula rasa*? Was the historical context of phenomenology relevant (given the contemporaneity of Husserl's work)? Was there an anthropological dimension in the fascination of the Bauhaus, most conspicuous after Josef Albers took charge of the *Vorkurs*, for optical illusions? Was the dream of a universal visual language, or a kind of visual esperanto, necessarily doomed? And if so, should we condemn a priori the artistic productions it engendered? At this point there was another digression, this time on Le Corbusier, whose work was then being attacked from various quarters as representing the paragon of an aggressively imperialist, almost fascist, conception of modernist architecture. (Needless to say, Hubert came to Corbusier's defense, pointing to the contradiction between his discourse and his built architecture, and he paradoxically brought in Venturi's *Complexity and Contradiction in Architecture* to this purpose, a book I had never heard of before, while chiding a similarly unheard-of Manfredo Tafuri for some violent anti-Corbusier diatribe.) The

dissection of Pleynet's article was pursued to the end, with many other asides and many other references, always given with bibliographic exactitude and briefly discussed for the benefit of ignoramuses like me.

I was utterly knocked out by the end of the session—I felt out of breath but at the same time strangely elated. True, I had been humbled when finding out how little prepared, contrary to my proud assumptions, I had been for this class. But Hubert's formidable erudition, his constant invocation, at every possible turn, of the most diverse sources in order to elucidate this or that point, was never castrating. He had not shamed my ignorance; instead he had shown me how information or theory could be put into circulation, how independent fields of knowledge can rub against one another, and how new ideas emerge from such a friction. Furthermore, each of his multiple digressions had a prolonged echo. I found myself pursuing several paths of inquiry onto which he had only opened a window, not only looking up that reference to Marx or Brecht or buying Venturi's book (or, alas, finding that Tafuri's text was not available in any other language than Italian) but wandering on my own. Hubert's swimming-pool pedagogy was working miracles: For several days, after I had recovered from the hurricane of that first seminar, I was percolating with ideas, drunk with excitement. (Of course, I checked my notes in order to write down the account I have just given of "my" first session—an event that happened more than thirty years ago, after all—but in so doing I was amazed to find out how little I had forgotten.)

I immediately realized that if I wanted to benefit fully from Hubert's way of teaching, I had to devise a new mode of hearing; I had to open simultaneously two receptors in myself, one for the main line of the argument, the other for all the asides that were constantly branching out and competing for my attention. I conjured up the trick of taking notes in two columns, leaving a wide margin where I could scribble not only all the references given by Hubert during his multiple digressions but also, in some kind of personal shorthand, the many free associations it sparked in me.

Until then, the only pedagogical models I had ever encountered were the one I had left in disgust—the old university one, where the professor, as in Toulouse or Pau, delivers a series of facts ex-cathedra—and that of Roland Barthes, which was conceived as a slow apprenticeship.[6] Barthes was never interested in transmitting knowledge, but he would never have kicked any of his students into the swimming pool either. He had no desire to be a father (I have to admit that I saw him much more as a motherly figure). He was the one who was struggling in the pool; all we had to do was watch. What he wanted, what he did in fact to perfection, was to show us how to write by writing in front of us. Every single Barthes seminar that I attended resulted in a published text, often a full book (including *Roland Barthes*): Reading the "final product," his students could measure all that had been purged and how he had, starting

from a messy heap, patiently constructed a beautiful architecture. His writing and his pedagogy were a form of asceticism. Not Hubert's, as I had instantly discovered. Maybe this difference has to do with the fact that they were half a generation apart? Whatever the case, both pedagogical practices were supremely generous, but with opposite means: Barthes told us how to pare down one's inquiry to a couple of essential issues, Hubert to navigate an endless labyrinth, to stray without getting lost. No intellectual formation, I can say today, could have been more ideal than working under the protection of these two perfectly complementary guides.

For all their differences, they had much in common. The same enemies, the same structuralist past with which they had to cope (we were at the very beginning of what has been called "post-structuralism"), the same capacity to actualize their inquiry, to make it relevant *hic et nunc*, to show how their own interests, their own researches, connected to ours (whatever those might be), to vividly relate general, theoretical issues to the present. I had the immense fortune to gauge this shared commitment as they each gave a seminar about what could be called the history of semiology (in the case of Hubert, of course, it was the "semiology of art"). The two seminars were not simultaneous—Barthes's was at the same time as Hubert's Bauhaus course, while Hubert's semiological journey was scheduled for the following year, which was most probably a godsend, as the material in that latter class was much more diverse and vast than that in the former.

The curiosity of Barthes's students had been immensely aroused by the announcement of a course on the history of semiology: In this period of intellectual turmoil marked by a general Oedipal desire to kill the structuralist model, they expected from him something to ease their understanding of the shift underway from A (structuralism) to B (so-called post-structuralism). They anticipated a chronological summary. Such a narrative, after an in-depth presentation of Saussure's and Charles Sanders Peirce's concepts, would have discussed the work of the Russian Formalist school of literary criticism, then, after Roman Jakobson had left Russia, of the Prague Linguistic Circle grouped around him; then of French structuralism; and finally, in conclusion, it would have dealt with Julia Kristeva's "sémiotique" and Jacques Derrida's deconstruction, in *Of Grammatology*, of structural linguistics as governed by the same "logocentrism" that had fashioned Western metaphysics ever since Plato.

Barthes's auditors got the package they had hoped for, but not without a major surprise. Instead of beginning with Saussure, as logic would have dictated, Barthes initiated his survey with a three-session examination of the ideological critique proposed, from the 1920s on, by Bertolt Brecht.

Although Barthes, no less than his peers, had succumbed to the dream of scientific objectivity when the structuralist movement was at its peak, he now

implicitly advocated a subjective approach. No longer interested in mapping a discipline, he endeavored instead to tell the story of his own semiological adventure, which had started with his discovery of Brecht's writings. Coming from a writer whose assault on biographism had led to scandal, this was unsettling, but there was a strategic motive as well in this Brechtian beginning, a motive that becomes apparent when one turns to the essay in which Barthes had discussed Saussure for the first time, "Myth Today," the postscript to the collection of sociological vignettes dating from 1954–56 and collected under the title *Mythologies* (1957).[7]

In "Myth Today," to which he only briefly alluded at some point in his first seminar session, Barthes had tentatively posited what would become key structuralist axioms: Signs are organized into sets of oppositions that shape their signification, independently of what the signs in question refer to; every human activity partakes of at least one system of signs (generally several at once) whose rules can be tracked down, and, as a producer of signs, man is forever condemned to signification, unable to flee the "prison-house of language," to use Fredric Jameson's apt phrase. Nothing that man utters is ever insignificant— even saying "nothing" carries a meaning (or rather multiple meanings, changing according to the context, which is itself structured).

Choosing in 1971 to present these axioms as derived from Brecht (rather than from Saussure, as he had done in 1957), Barthes was pointing to the historical link between modernism and the awareness that language is a structure of signs. In his numerous theoretical statements, Brecht had always attacked the myth of the transparency of language that governed the practice of theater, defined as a cathartic enterprise ever since Aristotle; the self-reflective, anti-illusionistic montage-like devices interrupting the flow of his plays had always aimed at aborting the possible identification of the spectator with any character and, as he phrased it, at producing an effect of "distanciation" or "estrangement."

The first example Barthes commented on at great length in his 1971–72 seminar was a text in which the German writer patiently analyzed the 1934 Christmas speeches of two Nazi leaders (Hermann Goering and Rudolf Hess). What struck Barthes was Brecht's extreme attention to the form of the Nazi texts, which he had followed word for word in order to elaborate his counter-discourse: "The destruction of monstrous discourse is here conducted according to an erotic technique," noted Barthes.[8] Advancing in slow motion, Brecht had been able to pinpoint the oratorical efficacy of these speeches in the seamless flow of their rhetoric: the smoke-screen with which Goering and Hess masked their faulty logic and mountain of lies was the mellifluous continuity of their language, which functioned like a robust, gooey adhesive. Barthes's Brecht, in short, was a formalist, eager to demonstrate that language was not just a neutral vehicle made to transparently convey concepts directly from mind to mind, but

that it had a materiality of its own and that this materiality was always charged with significations. He was a formalist in spite of himself, even if he had resented the label and spent a good deal of time and energy throwing it back as an insult in Lukács's face.

I shall spare you more reminiscences about this seminar, during which many such "deconstructive" inversions were proposed (the most spectacular, perhaps, being the presentation of Saussure himself—some of whose "anagrams" had just been published by Jean Starobinski—as the gravedigger of structuralism), and I shall instead switch to Hubert's exploration of the semiological adventure.

The initial stroke was less exotic than that of Barthes—in fact, the first session was devoted to photography, and the first text Hubert ploughed through was Barthes's famous 1961 essay on the photographic message, written during the heyday of structuralism.[9] However, Hubert immediately challenged it by way of Walter Benjamin's "A Short History of Photography," which was very little known at the time and which was invoked as a critique of Barthes's lack of concern for the technical apparatus in his early essay. This was followed by several excursus into Frege's theory of reference, in refutation of Barthes's ill-conceived (and certainly "un-Brechtian") notion of a "message without a code." By the second session, however, Hubert made two jumps just as unexpected for me as Barthes's pointing to Brecht as the first semiologist. He posited the two experiments by which Brunelleschi had theorized perspective, and which he would analyze at great length later on, as an attempt to "evacuate" the real by encoding it (thus as one of the first conscious inventions of a semiological "simulacrum"), and he presented Panofsky's iconology as the suppression or repression of the structuralism of Panofsky's early (German) texts.

I could go on and on about this yearlong seminar, during which the main focus was to test the logocentric assumption, best formulated by Émile Benveniste, that only language had the capacity to interpret other semiological systems. This is the year when *Theorie du nuage* appeared, and one of the greatest benefits of the seminar for me was that it highlighted the most important methodological aspect of the book: that a structured system can only be "proven" through a central exception—that it is what cannot be taken into account by a system, framed by it, that explains it and at the same time makes it possible for it to survive. (The cloud cannot be drawn in perspective and because of that it played a major role, despite its apparent marginality, both in the invention of perspective, and in the historical development of Western post-Renaissance painting. It is in a way what made the monocular system sustainable.) Throughout that year's seminar, we were constantly invited to find out what, in each system of thought or mode of visuality we were discussing, was playing the role of the cloud.

We explored the production of recent Soviet semiology and compared the analysis of Russian icons proposed by the Tartu group to the ideas formulated fifty years earlier by the Russian Formalists and by Nikolai Tarabukin; we read Marcel Mauss as well as Peirce (I particularly remember the session during which we grappled with the obscure notion of the "hypo-icon," which Hubert most creatively linked with Freud's concept of regression in the *Traumdeutung*), Cesare Ripa, Meyer Schapiro, Freud, Albers, Wittgenstein, Jakobson, and many others, always wondering what to make of Cézanne's question about "the truth in painting" (that was several years before Derrida's famous essay).

Once again, the course was a continuous feast, with Hubert bringing every week new grist for our mill (his appetite was voracious, but without our noticing it he had gradually trained all of us listeners to be able to cope with such Gargantuan portions). While Barthes's narrative had started with Brecht and then flashed back to Saussure, whence it had proceeded in a steady fashion up to Kristeva and Derrida and their effect on his own work, Hubert's course had cast a much wider net while never losing sight of its central question course—that of the fundamental difference between an image and a text. In his seminar, Barthes had gently taken us by the hand and guided our movements across the discipline of semiology, gently paving the way for us, eliminating various roadblocks of which we were not even aware, a seductive pied-piper method that characterizes for me his best writing. Hubert, by contrast, had shown us how to use roadblocks, how to rebound from them—and, contrary to what one might expect, he was by far the most Socratic of the two. In rereading for this occasion the *Macula* editorial I mentioned earlier, where all the main articulations of Hubert's course are laid out in the interrogative mode, I recognized that in the process of being digested by phagocytosis, I had also learned how to digest theoretical discourse, or, to use the Marxist phrase that encapsulates best for me Hubert's lifelong enterprise, how to put it to the test and increase its use-value.

First published in *Oxford Art Journal* 28, no. (2005): 247–55.

1. My review appeared in the December 1997 issue of *Artforum*. I had also reviewed his *L'origine de la perspective* (1987) in the *Journal of Art*, to which I regularly contributed during the brief period when Barbara Rose was its editor-in-chief. Both of these texts are included in the Appendix, 361–67.

2. [Addition 2021] As I was preparing this lecture, I could not find the issue of the French monthly *Art Press* where this interview had appeared in November 1976, and although my quotation from memory is accurate, there was a certain ambiguity in Damisch's formulation that I had forgotten: It is not only the reader he wants to "phagocyter" but the whole culture his work addresses. The interview has been reprinted in 2013 in a collection for which I wrote the preface, *Les grands entretiens d'artpress: Hubert Damisch* (Paris: IMEC/artpress), 15–21.

3. Joseph Leo Koerner, *Caspar David Friedrich and the Subject of Landscape* (New Haven: Yale University Press, 1990), 5. The exact sentence is "You are placed before a thicket in winter."

4. This line ends with a colon and is followed by two captions giving precise references to the frescoes in question. It is translated by Janet Lloyd as "Corregio's frescos in the cupolas of Parma:" (*A Theory of /Cloud/: Towards a History of Painting* [Stanford, CA: Stanford University Press, 2002], 1). Perfectly accurate, but in eliding the initial "Soit," this rendition blunts somewhat the violence of the book's beginning. "Soit" is the way a mathematician sets the parameters of a problem to solve—something like "Given . . ."

5. Pleynet's essay originally appeared in 1971. It is translated into English as "The Bauhaus and Its Teaching" in *Painting and System*, trans. Sima N. Godfrey (Chicago: Chicago University Press, 1984).

6. [Addition 2021] For a more detailed account of Barthes's pedagogy, see "Writer, Artisan, Narrator" in this volume, 303–12.

7. Roland Barthes, *Mythologies* (1957), trans. Richard Howard and Annette Lavers (New York: Hill and Wang, 2012).

8. [Addition 2021] This sentence is quoted from the essay that resulted (four years later!) from Barthes's session on Brecht at the beginning of his 1971–72 seminar. Published in 1975 in the special issue on Brecht of a journal edited by one of my peers in the seminar, it was translated by Richard Howard as "Brecht and Discourse: A Contribution to the Study of Discursivity," in *The Rustle of Language* (Berkeley: University of California Press, 1986). The temporal gap between oral presentation and publication was unusual, but reading the text, I was reassured to find that Barthes's eloquence had not lost much of its edge in the final written form. I was somewhat sorry to find that the sentence that had mesmerized me when I heard it—*Brecht secoue le nappé de la logosphère*—had been somewhat diluted, but the gist of it was still there. The main difference between the reader of the text and the listener of the seminar/lecture was that the latter had been provided with a handout of the Brecht text analyzed by Barthes, in which the German writer annotates a speech by Rudolf Hess.

9. Roland Barthes, "The Photographic Message," trans. Stephen Heath, *Image-Music-Text* (New York: Hill and Wang, 1977).

« Rien n'est jamais
un document de culture sans être en même temps
un document de barbarie. »
Walter Benjamin (*Fuchs collectionneur*)

# macula

PEINTURE ET PHILOSOPHIE I

*Meyer Schapiro, Jacques Derrida*
Heidegger et les souliers de Van Gogh.

*Walter Benjamin*
Eduard Fuchs, collectionneur et historien.

*Jean Louis Schefer* L'entretien suspendu.

*Lawrence Gowing* Le système de la couleur
chez Cézanne.

*Kasimir Malevitch* Lénine.

*DOSSIER* RYMAN.

# 3/4

VISITE AUX ATELIERS
Le réalisme poussé à sa dernière limite.

# The Right Touch

*Jacques Derrida died on October 9, 2004. The following remarks were read on December 6, 2004, at a memorial event organized by the Humanities Center of Harvard University.*

•

This is the first time I have taken part in a memorial of this sort.[1] Thus far my hesitation has always been stronger than my desire to pay tribute. But there are two reasons why I have now managed to bypass this constitutive reluctance.

The first is that while such a reluctance was long shared by Jacques Derrida himself, he lifted it, painfully and hesitantly, but lifted it nevertheless, as he analyzed its multifarious motives in his first piece of obituary prose ("The Deaths of Roland Barthes") and in all the posthumous homages he was driven to write, down to the last published one, pronounced at the burial of Maurice Blanchot a year and a half ago.[2] After one reads Derrida's numerous "adieux" to friends and colleagues, none of the fears one might have in taking up the role of memorialist are dissipated—quite the contrary—but at least we know that there is no way out and that whatever we say will necessarily fall into one or the other of the identificatory booby traps he has so unremittingly disclosed.

The second reason why I summoned the courage to speak is that I felt some public event should send a message of protest against the revolting obituary of Derrida published in the *New York Times* on October 10, 2004.[3] In today's pervasive anti-intellectual, anti-academic, and xenophobic climate in this country, I think it is our duty to salute a thinker whose entire oeuvre militated against the forces that set the conditions of possibility of such a climate.

At the risk of falling into identificatory trap number one (that by which the phrase "the great man and I" is surreptitiously transformed into "I and the great man"), I shall dwell on my encounters with Jacques Derrida, mostly because they had a determining effect on my professional choice. I had been lucky enough to be exposed to his writing while in high school—the first text of his that I read was one of his first on Antonin Artaud, "La parole soufflée" (reprinted in *Writing and Difference*). It was daunting, but with the help of a professor of philosophy who was kind enough to hold a private tutorial for several students frustrated by the regular curriculum, I did not give up.[4] Other

difficult texts followed, and I quickly realized that they helped each other in my mind, that it was all right not to understand everything at once, and that there were thresholds of understanding that one could pass, one after the other, incrementally and perhaps irreversibly so.

By the time I came to Paris to study with Roland Barthes, I was ready to tackle *Of Grammatology*. This book was the most complex I had ever read—it took me a good three months to swallow it. It did not change my determination not to become a philosopher. But in its powerful critique of logocentrism, including that of Barthes's reversal of Saussure's characterization of linguistics as part of semiology, this book became an ally. I had wanted above all to study art history. But because this discipline was utterly mediocre in France at that time, and I am sorry to say that it has not changed much, I had opted for Barthes's semiology, soon to grasp that its main motto, "Il n'y a de sens que nommé" (there is no meaning that is unnamed), was also that of a particular branch of art history, called iconology, against which I would spend the rest of my life struggling.

Perhaps under the pressure of what I saw as two irreconcilable systems of thought, I literally collapsed. (I would realize only a bit later that Barthes himself had already left the semiological territory he had helped to chart and that he was not fundamentally in disagreement with Derrida—even if he still believed, and would until the end of his life, in Émile Benveniste's statement according to which language is the only system of signification that is able to interpret other systems.) But I was not that clever or well informed in 1972, and after reading in a binge the three books by Derrida that appeared that year (*Dissemination*, *Margins of Philosophy*, and *Positions*), I fell into a deep depression. What I did not know was that Derrida was in a pretty bad state too. The reason was the almost complete silence that surrounded the publication of the three books I mentioned. They were quite simply boycotted by the French intelligentsia. The only reviews to appear were, quite hilariously in hindsight, in the communist press. Coming out of my slumber one morning, I wrote him a postcard saying something like: "Do not worry about the silence; people, particularly young people, do read your work." He responded immediately— and I will always remember his phrase: "Votre lettre me touche, et elle touche juste" (your letter touches me, and it touches right on)—and he asked me to call him up. During my first visit, with his usual generosity, he took a gamble and, in order to pull me out of my depressive state, commissioned an essay from me, vowing to have it published in the journal *Critique*—which is what eventually happened. One could say that the topic of the essay was a kind of compromise— it concerned Matisse's texts on art, which had just appeared, and not directly his art itself—but I knew, after having passed this test, that I could, if I wanted to, become an art historian.[5]

Thanks to Derrida's encouragements—but also to Hubert Damisch's and of course to Barthes's—I started co-editing a journal (or rather a kind of yearly almanac whose fourth and last issue had circa three hundred pages!). It is to this "journal," called *Macula*, that Derrida offered in 1978 his famous essay "Restitutions de la vérité en pointure" (rendered in English as "Restitutions of the Truth in Pointing," which does not come close to translating the pun of the French title between *pointure*—the size of a shoe—and *peinture*). I would have quite a few amusing anecdotes to tell about the origin of this text and the various problems encountered around its publication, but all that I currently want to mention is that, at the time, the essay was for me a disappointment. Not only did it not perform what I expected it would and had nothing to do with the scathing critique of Heidegger's text Derrida had offered in his seminar on "The Origin of the Work of Art," which I had attended, but it also seemed to me to be suffering from the same malady that affects all French philosophers, except perhaps Merleau-Ponty, when they write about art—which I would call a certain blindness to the specificity of art, a certain tendency to consider the work of art as an illustration, as a document rather than a monument.[6]

Of course, I should have known better and not considered this brilliant piece of writing as having anything to do with art per se, or art criticism, and read it, as I had done for Derrida's even more brilliant text on Kant's aesthetics ("The Parergon"), as a philosophical tract. But I had some excuse for my misprision, which is that, like many French literati before him, Derrida was then beginning to indulge in the belletristic exercise of the exhibition catalogue, and his artistic taste was then, I am afraid to say, at the mercy of his ignorance. Like many, many before him, he had been seduced by the work of artists whose works were illustrative and in many ways made to seduce, with a few clever devices, writers like him. The same was also beginning to hold true in the field of architectural criticism, into which he intervened as well (to devastating effect, particularly in this country, given the fickle voracity of architects and their eagerness to consume theory as ornament).

As I had started *Macula* with the firm desire to combat the dilettantism of the belletristic genre, it is not hard to understand why I was disappointed, particularly because I had always considered Derrida, no matter how odd it might seem to many, a model of earnestness—and one has to remember his critique of Michel Foucault's *Madness and Civilization* to grasp why this could be so, for in this critique, which he reiterated in the obituary of his former professor, Derrida had chided Foucault for his nonchalance with regard to the canon and stressed the necessity, before attempting to "deconstruct" anything, to learn its codes by heart. In short, reading the various texts on art and architecture that Derrida was prone to publish in the late 1970s and early '80s, I felt that he was not doing what he had advocated and so superbly done when dealing with

Saussurean linguistics or with psychoanalysis (and also with modern poetry and fiction): He had not really paid attention to pictorial and architectural codes, and even less to their history.

I drifted away somewhat. I kept reading Derrida's work, but not as assiduously as in the past—until, about fifteen years ago, I stumbled upon a particular problem in my work as an art historian—and it might not be by chance that this was concerning Matisse once more. It would not be the place here to deal with the issue at stake, concerning Matisse's invention of his color system and its main law—according to which "one square centimeter of any blue is not as blue as a square meter of the same blue"—via a new understanding of drawing.[7] But what was important for me to discover was that, as in the case of Freud's or Marx's, Derrida's texts on art were not necessarily the most operative, the most precious, for the field of art history or even of art criticism. Just as we learn a lot more about several artistic devices in Freud's book on jokes or the sixth chapter of the *Traumdeutung* than in, say, his text on Leonardo, I realized what I had known long ago but had forgotten or even repressed: that one learns a lot more about how to approach modern painting and architecture in Derrida's texts on Plato, Mallarmé, or Nietzsche than in his essays on Gérard Titus-Carmel or Peter Eisenman. This was the happiest reconciliation of sorts, one that has helped my work for more than a decade.[8] My encounters with Derrida have stopped being live for just as long—they have been mostly textual since I left France in 1983. But ever since that feverish eureka surrounding the Matisse conundrum, these encounters have always touched me, and touched right on.

First published in *Grey Room* 20 (Summer 2005): 90–94.

1.  Marjorie Garber chaired the event; the other speakers were Tom Conley, Alice Jardine, Christine McDonald, and David Rodowick.

2.  [Addition 2021] These texts are all gathered in Jacques Derrida, *The Work of Mourning* (Chicago: University of Chicago Press, 2001).

3.  [Addition 2021] Upon reading the obituary, I immediately sent a letter to the *Times'* editor. It was not published, unsurprisingly given its incendiary beginning, but it circulated widely online (and is included in the appendix in this volume, 369–70). Then Sam Weber and Kenneth Reinhard also wrote a (much better-pitched) letter to the *Times* that was co-signed by more than four hundred academics, including myself, and was eventually published (after some emendations).

4.  [Addition 2021] The professor of philosophy in question was Raymonde Hébraud-Carasco, whom I had befriended during the remarkable events of May 1968 (during which at my high school in Toulouse, students, rather than sitting idly at home, "occupied" their classrooms and discussed the work of political authors such as Marx, Trotsky, and Franz Fanon with enthusiastic faculty most generous of their time). Raymonde was very close to Gérard Granel, a specialist of Husserl who taught at the University of Toulouse, and she would play an important role in the creation of the journal *Macula* (*Hors-cadre Eisenstein,* her 1979 book on the Soviet filmmaker, would be the first issued under the Macula label). In 1978, she began making experimental/documentary films, several of them dedicated to the Tarahumaras, whose rites she had discovered in Mexico while retracing the footsteps of Antonin Artaud. (See http://raymonde.carasco.online.fr.Hébraud-Carasco died in 2009.)

5.  [Addition 2021] The essay in question is the first I wrote on Matisse. Entitled "Légendes de Matisse," it proposed a fragmentary reading of the artist's *Écrits et propos sur l'art* that had just been edited by Dominique Fourcade (whom I met on the occasion). Writing the essay did help me come out of my spleen, all the more since Derrida (much too leniently) approved of it, as did Jean Piel, the director of *Critique,* whom I also met then. But Piel had the (excellent) idea of asking his brother-in-law, the painter André Masson, to write down his memories of Matisse, and soon began to elaborate the project of a special issue on the artist to which Fourcade, Jean-Claude Lebensztejn, and Pierre Schneider were to contribute. A good year passed between my handing in of the manuscript and its publication in the May 1974 issue of *Critique,* and by then I was already beginning to be aware of its many flaws.

6.  If l remember correctly, it is only after his seminar that Derrida became aware of the essay by Meyer Schapiro on Heidegger and Van Gogh's shoes (Schapiro had sent me a copy, which I passed on to Derrida when urging him to "write down" and publish his dissection of Heidegger's essay). To my surprise, Derrida decided to devote much of his energy to Schapiro's essay, resulting in what seemed to me overkill. Upon receiving Derrida's "Restitutions," my co-editor Jean Clay and I felt that in all fairness we needed to publish a translation of Schapiro's text as well—which led us to a complicated diplomatic dance between two writers we equally but differently admired and who were basically engaged in a dialogue of the deaf. Somewhat reluctantly, Schapiro agreed to let us publish his text, but he did not take Derrida's deconstructive reading very lightly. In "Further Notes on Heidegger and van Gogh," the afterthought he wrote in 1994 and published that year in the fourth volume of his *Collected Papers* (*Theory and Philosophy of Art: Style, Artist, and Society* [New York: Georges Braziller]), he chose to ignore it altogether. For more on this whole sad episode, see C. Oliver O'Donnell, *Meyer Schapiro's Critical*

*Debates: Art Through a Modern American Mind* (University Park, PA: Pennsylvania University Press, 2019), chapter 7.

7.   See my essay "Matisse and 'Arche-drawing,'" in *Painting as Model* (Cambridge, MA: MIT Press, 1990). Derrida's model of deconstruction as a "double science" (first overturn a hierarchical opposition, then dispel its binarism by the introduction of a new concept) is particularly examined in relation to Matisse on pages 60–63.

8.   I should also say that, to his credit, Derrida attempted seriously to perfect his artistic education during the period I was less attentive to his work. Even though he still tended to treat works of art as documents in his *Mémoires d'aveugle*, which functioned as the catalogue of an exhibition he curated at the Louvre in 1990, a lot of homework went into it—an initiation of sorts, without which, for example, he would not have been so receptive to the painting of Simon Hantaï a decade later.

Fabrizio Perozzi, *Papiers peints #29,* 2003.
Oil on paper, 26 × 19 inches.

# From Near as From Afar

*I met Fabrizio Perozzi in late 1977 or early 1978. At the time, he was studying with the formidable Polish graphic designer Roman Cieslewicz at Penninghen, a reputable school located in the building of the old Académie Julian. For his diploma's final requirement, Perozzi was planning to design a set of posters (in the form of painted panels) on the life and work of Kazimir Malevich and had been told by a friend in common that I would be a good source of information on the subject (I had recently finished a dissertation on Malevich's and Lissitzky's conceptions of space). We immediately bonded on the topic and soon found we shared many other interests as well: We were both compulsive readers of Walter Benjamin and great admirers of Cy Twombly, for example. Fabrizio's cultural tastes were extraordinarily broad, and he introduced me to many films, writers, and recordings of early and Baroque music, among other things. But it was with regard to Italian Renaissance and Baroque painting that I learned the most from him. (I was already hooked on Pontormo when we met, but he passed on to me his love for the multifaceted Lorenzo Lotto.) We visited many exhibitions together, most memorably, perhaps, in 1978, the Parisian venue of William Rubin's phenomenal* Cézanne: The Late Years. *After several years of intense dialogue, the vicissitudes of life pulled us apart, and, when I moved to the US, we lost touch. He reached out to me again in 1991, just as I was about to move from Baltimore, where I had taught for eight years, to Cambridge. He had relocated to Montréal from Paris. While I was not too surprised to learn that he had left a successful career in book design to devote himself to the practice of painting, I was quite astonished to see, when I went to visit him, what he had been working on. His painting was not only figurative and based on photographs but crafted with Old Master techniques: quite some distance, I thought, from the love of Malevich's Suprematism and Twombly's graffiti! In fact, encountering Fabrizio's painting practice made me realize how much I was still (unconsciously) adhering to the essentialist, historicist dogma of modernism— the unfolding of art since Manet as a continuous series of irreversible ruptures, an article of faith I thought I had already definitively abandoned. It was by looking closely at his works that I began to understand the logic of some of his formal and technical choices. In order to impress on the beholder the effect he wanted to elicit (and force him or her to come close to the picture plane), Fabrizio not only had to paint myopic close-ups of figurative scenes, images that*

*were manifestly cropped, but also to counterintuitively demand from his traditional medium (oil paint and its transparent glazes) that it manifests the quality of its antithesis (the opaque matteness of tempera). An attention to techniques and materials had always been paramount in my approach to any painting (indeed, it is this which I suspect precipitates the accusation of "formalism" routinely hurled at me), but my interest in them had been considerably heightened by the study of Ad Reinhardt's procedures into which I had plunged and was trying to fathom (especially those of his late "black" canvases) at the very moment Fabrizio reached back out to me.[1] Reinhardt's "ultimate paintings," as he called them, test the limit of our perceptive capabilities and in doing so prompt us to register and savor the faintest of nuances in value or chroma. In trying to understand "how he did it," was I returning to the old "art for art's sake" creed? I came across Fabrizio's painting, particularly his oils on paper, at the right moment. It definitively freed me of any guilt when putting on, when need be, the ancient cloak of the persnickety connoisseur.*

·

To meet Fabrizio Perozzi's work where it implores us to meet it, one would have to forget the pools of ink spilled on Walter Benjamin's pointed definition of aura as the "unique apparition of a distance, however near it may be."[2] For we are dealing with the near and the far in what he calls his *Papiers peints*—the far as near, but mostly the near as far, and the to-and-fro between the two. The paradox of this painting is that its serenity rests upon this fundamental dynamism.

These works say "come hither" in various, distinct ways. The most immediate way, essential as always, pertains to their materiality. First, let us note the modest proportions of these *Papiers peints* (approximately 66 by 48 cm, or around 26 by 19 in.), which remain identical throughout the series (or at least are perceived as such; fabricated artisanally, the sheets of gray paper have irregular borders and therefore, strictly speaking, the format varies slightly from one to the next). Seemingly utterly disconnected from the famous "apocalyptic wallpaper" that constituted, for Harold Rosenberg, Jackson Pollock's great allover skeins, these works share with them an embrace of the paratactic.[3] Being aligned amongst its kin, each of his *Papiers peints* beseeches us all the more violently, declares itself all the more jealously as worthy of examination; each sheet begs us to choose—but the injunction is feigned, it exists only to engender our reluctance and to make us realize that to choose is somewhat beside the point. I'm thinking of Barnett Newman's *Cantos*, of Matisse's *Themes and Variations*; ideally, the ensemble would remain whole, maintaining the contingency of an unbound album we could leaf through and rearrange at our leisure. Between the book and the picture, Perozzi's *Papiers peints* compel intimacy.

The weft of this luxurious handmade paper, of an incontestable sensuousness, also works to invite us near. A striation of thin threads animates the surface of these sheets only if seen close up—the only way, in fact, to appreciate the incommensurability of two grids on which the artist capitalizes, that of the traditional squaring method by which he transposed onto the gray page the photographic source (since each of these paintings "reproduces" a photograph) and that of the "laid" grid integrated in the paper's surface through the manufacture process. Given the laid surface, the absence of pictorial texture is all the more flagrant—the pigment is applied dry, rubbed, as if the paintbrush were crushed. Because of the visual play, one might say that there is an ideal distance from which to observe these works, a vantage point before or beyond which one of the two parameters (pictorial smoothness, grain of paper) will dominate and the vibratory tension their opposition generates will dissipate. It is this ideal distance that Perozzi gently invites us to sense. Not so easy to achieve! For precedents I can only think of Georges Seurat, who invited his viewers to step back from his drawings so the digitization carried out by the weft of his sheets and their activation by his Conté crayon would be reabsorbed in an illusionist image, or of Agnes Martin, whose penciled grids on canvas, from which the fog dissipates as soon as we peer closely enough to discern the lines that make up their configuration, lines whose irregularity is due solely to the roughness of the cloth.[4] With Seurat as with Martin, the exclusory nature of the alternative was self-evident (the whole or the part, the image or the surface, the far or the near), and the passage from one to the other instant and dramatic. Perozzi's wager is to dwell in this threshold and to pressure us, without violence, to remain in a state of precarious suspension between either term. Hence the importance not only of the size of these sheets but of the internal scale of the images as well, a scale I would characterize as *tactile* and determined by a vision at arm's length (the depth of field, if depth there is, is indicated only by the positioning of a mirror in either the foreground or the middle distance). No need to lose one's control of the visual field and to ignore the image in order to perceive the grain (as is the case with Martin's large canvases); no need to step back in order to rediscover the image, as one does with Seurat.

The third invitation to this gentle myopia is the work's lack of sheen, its *matteness*. Those works are oils on paper; yet the medium which binds the pigment seems altogether absent. No greasy halo oozing on the gray margin of the paper; and very little luster. It is as though Perozzi forced this most unctuous of mediums, oil paint, to transform itself into powder (into pastel), but without the slightest connotation of dryness. The technique is paradoxical, since working with oil typically means relying on the subliminal effect of layering and on variations of texture and viscosity. Such subtle and ancestral geology has no place here: On the one hand the paper absorbs nothing (everything remains

on the surface); on the other, it tolerates almost no reworking. Why then paint in oil? Why not opt for distemper, for example, the medium through which Édouard Vuillard at his best (in the 1890s) obtained the most matted and most absorbent surfaces? Two reasons: Distemper (paint made with glue) presupposes flatness and requires quick work, as it dries very fast (Vuillard learned this while working in the theater, a domain in which alacrity is an asset, as is matteness: to rapidly build sets that would absorb the spotlight's blinding rays, that's all that was asked of him).[5] But Perozzi wants both to retain modeling and to work with paints that dry slowly, allowing him to mix and blend the colors on the surface of the paper itself. He seeks to obtain the same effect that Vuillard produces in us, an indolent deceleration of the gaze, but by completely different pictorial means. He seeks the dull matteness of blotting paper but not its opacity, the thin transparency of glazes without their sheen. And to better ensnare us, he persists in representing luminous reflections, reflecting surfaces—he multiplies shimmering effects through the most antithetical means possible.

These material injunctions to intimacy (small size, grainy paper, absorbing matteness) would have little or no effect were they not linked to Perozzi's figural and formal strategies (and vice versa). I have already alluded to the internal scale in the *Papiers peints* that determines an ideal distance from which to look at them. The mirror, I noted, is the device through which Perozzi draws near the faraway: It is there, very near, where we can decipher its dirtiness, the lacunae of its silvering, the bevel of its edges, and at the same time it lets us peep at an off screen reality that frequently comes to dominate the image. Often the allusion is a deliberate tease (and Perozzi takes pleasure in reinforcing the eroticism of the unseen, transforming us into frustrated voyeurs): A length of jeans, a shoulder, nude legs, hair, fragments caught in some corner of the mirror allude to bodies outside the frame and beyond the field of vision. More often still, this eroticism of such "off-screen" passages concerns the space itself; the defamiliarizing mysteries of catoptrics empty this stage of its inhabitants, whose return we are left to imagine.

Rarely is the mirror positioned frontally. Yet paradoxically it is when the mirror seems to be facing forward that it is at its most troubling, because in that instant we no longer know where to place ourselves, where to look—we must obey two contradictory commands, to approach *and* to distance ourselves so as not to disrupt by our unreflected presence what we have come to call a "reality effect." Perhaps this is the source of the worrisome strangeness of *Number 1*, despite its dazzling light; of *Number 7*, in which the blue bottom half, so motionless when juxtaposed with the reflected draperies, cuts the composition like a cleaver; and, finally, of *Number 29* with its inverted Malevich fragment. But there is something more troubling still: what I would call the mirror effect, brought about by its serial quality, through which the nearing of the faraway

transmutes into its opposite. Looking at some of these truncated images, we read them as though they were reflected, we seek the slightest clue that might betray the action of the mirror—for example, in *Number 11* (blue sleeve), *Number 27* (pairs of legs), and *Number 28* (pair of semicircular stretchers decked out in ridiculous tutus, whose loose canvas fringes their backs). There is no reason to suppose, a priori, that these compositions are framed and inverted by a mirror whose presence should remain miraculously invisible; and yet, deprived of any sure signs, we fall back paradoxically on the most unstable of hypotheses that we have learned to cope with in the previous images. The reality effect is no longer a lure, since it has become an effect of irreality.

Perozzi employs other means to render this distancing of the nearest palpable, to signify perhaps that the near as well as the far, the dyad forming his central theme, is equally inaccessible. We will have noticed that the world described is the circumscribed one of the artist's studio (his own, that of a sculptor friend), and we rediscover the same accessories from one *Papier peint* to the next. Amongst the accessories, the least conspicuous is without a doubt a tarnished pane of glass that he interjects between himself and the objects he depicts; from it, we perceive only the stains or the reflections it captures, more incomprehensible still than the imperfections of the mirror. Belonging to this distancing pane, in *Number 31*, is the orange stain and the blurred shapes that are superimposed on the drapery unfolded above a pearly snuffbox; we redis-cover the same stains, suspended, seen from afar, in *Number 25*, accompanied by reflections, in the lower-right corner of the image, about which we ask ourselves whether they truly belong to the same plane. Without fanfare, Perozzi feigns to comply with the entire pictorial tradition of the Renaissance, while at the same time playfully perverting it. In the Albertian conception of painting—the clearest theoretical conception of a "reality effect" sought in mimetic aesthetics—the plane of the painting is as transparent as glass. Perozzi reveals this idealized window for what it is, a studio trick: Not only does he place it obliquely with relation to the picture plane but he sullies it. Come closer, examine my stains, they are no less real, no less unreal, than that snuffbox or that rectangular spark of light, the blinding reflection of a sunlit window in a pocket mirror, the paintings say.

I come finally to the most obvious—you will forgive me for broaching this topic so late, albeit consciously—the connections between Perozzi's work and other uses of photography in painting. Rather than strive to situate this work on a continuum that would begin with Eugène Delacroix and wind its way to Gerhard Richter and beyond, I prefer to address the question from the artist's signature dialectic play of distances. The few deliberately blurred images Perozzi produces are the most obviously photographic in his work: the nudes in *Numbers 5* and *10*, the view of the artist's studio in *Number 15* (in which we

Fabrizio Perozzi, *Papiers peints #10,* 2003.
Oil on paper, 26 × 19 inches.

recognize the enigmatic objects if only for having seen them clearly in *Numbers 14, 16,* and *17*), and the figure relegated to the shadows by a great luminous slash in *Number 30*. No human eye could pinpoint so distinctly the vagueness of such contours—we read these views immediately as focuses on photographic blurriness (just as *Numbers 9* or *12*, very *Neue Sachlichkeit* in appearance, are nothing more than focuses on sharpness).

Standing before the blurry *Papiers peints* as before the ultra-sharp ones, we must concede that our eye adjusts too quickly, that we can never pause and take stock of what we actually see: Our generic visual field is average, never too blurry, never too clear, and every good ophthalmologist knows that his or her primary obligation, when determining the best eyewear for our failing vision, is to retrieve that middle ground that escapes us. The impossibility of the ultra-sharp had been the gambit of hyperrealism (whose relationship with photography was simple: It sought only to demonstrate the degree to which it was vacating reality). For diametrically opposed reasons, this impossibility is also a preoccupation of today's creators of action or epic science-fiction films (like *The Matrix*) who feel compelled to insert imperfections into their digital images to give them some plausibility. Dealing with the blur is more complex. If it is true, as Chuck Close has somewhere stated, that it is photography that has rendered the fuzzy visible, has stabilized it for us, nothing is more difficult than to accomplish this in painting. As for Richter, he thinks this is an impossibility: "Pictures are never blurred. . . . Since paintings are not made for purposes of comparison with reality, they cannot be blurred, or imprecise, or different (different from what?). How can, say, paint on canvas be blurred?"[6] The only way, as Richter has so forcefully shown, is to operate a series of short circuits between the blurry, the near, and the faraway. For Richter, the distance and the proximity brought forth in the blurry concerns itself mostly with history; the before-yesterday of Nazism, the yesterday of the Baader-Meinhof group, the today of a bucolic countryside that is fast disappearing. I would say that Perozzi's melancholy is more phenomenological: His *Papiers peints* summon our bodies (come closer, please!) and then, having done this, cast us away forever.

Translated by Tim Gauthier.
First published in *Fabrizio Perozzi* (Montréal: Galerie Art Mûr, 2004), 101–03.

Fabrizio Perozzi, *Papiers peints #25,* 2003.
Oil on paper, 26 × 19 inches.

1.  Trying to figure out how Reinhardt obtained the inimitable velvety surface of his "black" paintings had been frustrating. In 1989–90, I accompanied William Rubin on the many visits to collections, public and private, that he made in the preparation of the Ad Reinhardt retrospective he was jointly curating with Richard Koshalek (at the Museum of Modern Art, New York, in 1991 and the Museum of Contemporary Art, Los Angeles, in 1991–92), for the catalogue of which I would write the sole essay. Deeply intrigued by Reinhardt's technique, I questioned conservators, friends of the artist, witnesses, anyone who could have some information, and I got no response, as if the painter had a secret that he had jealously brought with him to his grave. (I did not discuss the matter in the catalogue, having nothing to munch on.)

Nearly two decades later, I was utterly dumbfounded by a document shared with me by Carol Stringari, who was preparing a small but remarkable exhibition at the Solomon R. Guggenheim Museum about the particularly difficult problems conservators have to deal with in treating a Reinhardt "black" painting. It was a 1962 letter to Alfred Barr, kept in MoMA's archives (!!) and of which Rubin had obviously not been cognizant, in which Reinhardt gives a very detailed recipe for obtaining his singular surfaces. The letter is published by Stringari in the catalogue of her show (*Imageless: The Scientific Study and Experimental Treatment of an Ad Reinhardt Black Painting* [New York: Solomon R. Guggenheim Museum, 2008] 22). I commented on it in "Black Trek, Backtrack," published in the same catalogue (11–17).

2.  Walter Benjamin, "The Work of Art in the Age of Its Technological Reproductibility," in *Selected Writings: Volume 4, 1938–1940*, ed. Howard Eiland and Michael W. Jennings (Cambridge, MA: Harvard University Press, 2003), 255.

3.  [Addition 2021] The connection to Pollock is lost in translation: *Papier peint* is French for "wallpaper," and Perozzi was well aware of both Rosenberg's quip and the derogatory connotations of this expression when applied to a painting.

4.  On this aspect of Seurat's drawings, see my review of the extraordinary exhibition curated by Jodi Hauptman at the Museum of Modern Art, New York, in 2007–08: "Georges Seurat: The Drawings," *Artforum*, April 2008, 359–60. On the changing perception of Martin's grids according to the distance of the beholder, see Rosalind Krauss, "Agnes Martin: The /Cloud/" (1993), reprinted in *Bachelors* (Cambridge, MA: MIT Press, 1999), 75–89.

5.  On this point, see the excellent thesis by Nancy Forgione, *Édouard Vuillard in the 1890s: Intimism, Theater and Decoration* (Baltimore: Johns Hopkins University, 1992), esp. 205–06.

6.  Gerhard Richter, "Interview with Rolf Schön" (1972), reprinted in *Writings 1961–2007* (New York: D.A.P., 2009), 60.

# PEINTURE

## Lygia, l'art hors des enceintes

*A la Biennale de Venise, 1968.*

« *N* OUS *sommes des propo-
seurs : nous sommes le
moule, à vous de souffler
dedans le sens de notre existence.*

*Nous sommes des proposeurs : no-
tre proposition est le dialogue. Seuls,
nous n'existons pas, nous sommes à
votre merci.*

*Nous sommes des proposeurs : nous
avons enterré « l'œuvre d'art » en
tant que telle et nous vous sollicitons
pour que la pensée vive par votre ac-
tion. »*

« *Nous sommes des proposeurs... »*
C'est Lygia Clark qui parle, la grande
artiste brésilienne. Née en 1920, elle
a vécu deux ans à Paris, où elle fut
l'élève de Fernand Léger. Revenue au
Brésil, elle s'intéresse beaucoup aux tra-
vaux de Mondrian. Comme beaucoup,
elle commence à faire de l'abstrac-
tion géométrique. Mais, dès le début,
son œuvre apparaît comme la contes-
tation logique et permanente de toute
convention artistique. C'est d'abord le
cadre qui disparaît : la forme n'est dès
lors limitée que par une très fine ligne
blanche à l'extrême bord du tableau,
elle veut s'échapper... Puis c'est la no-
tion de plan qui est contestée dans les
tableaux-pliages à trois dimensions,
avec la ligne-charnière.

C'est ensuite une guerre contre la
forme : Lygia Clark se lance, de 1960
à 1964 dans toute une série de recher-
ches qu'elle nomme « bêtes » à cause,
dit-elle, « *de leur caractère fondamen-
talement organique* ». Des plaques de
métal unies par des charnières et qui
demandent la manipulation du specta-
teur : ainsi romps-tu avec la mono-
tonie habituelle et, comme le dit Jean
Clay (rédacteur de « *Robho* ») (1),
un vrai dialogue s'instaure, dialogue
parce que la « *bête* » ne fait jamais
exactement ce que tu veux : à chacun
de tes gestes correspond tout un jeu de
mouvements organiques. Malgré l'op-
position de la « *bête* », tu es libre

avec l'œuvre. « *C'est toi qui mainte-
nant donne expression à ma pensée
pour en tirer l'expérience vitale que tu
veux* », nous confie Lygia Clark.

Après cette mort de la forme fixe,
une autre contestation : celle
de l'œuvre elle-même. Ainsi le « *che-
minant* », qui consiste à découper jus-
qu'au bout un ruban de Moebus sans
jamais repasser au même endroit : l'acte
de découper est la seule œuvre artis-
tique, et puis pourquoi garder le résul-
tat de l'expérience ? On peut recom-
mencer ! comme la vie...

La dernière bataille de Lygia Clark :
contre l'art intellectuel, elle propose
l'art *sensoriel*. Des vêtements empê-
chant certains mouvements nécessaires,
des œuvres en plastique-eau-et-coquil-
lages qu'il faut palper, écraser, cha-
touiller, écouter, rire..., des cagoules,
des masques gonflés d'air glacé... tout
un ensemble de nouvelles propositions
ludiques qui nous dépaysent vers des
régions jamais explorées jusqu'ici.
Saura-t-elle ébranler nos conformismes,
cette guérilla culturelle née en Améri-
que latine (avec toute la vitalité de ses
peuples jeunes), saura-t-elle mettre
l'art dans la rue ?

Ainsi sont les grands visionnaires,
qui ne se lassent pas d'inventer des
moyens nouveaux. Courrez voir les
belles machines de Lygia Clark. Dans
son rire brésilien, elle vous dira :
« *Nous sommes des proposeurs ; nous
ne vous proposons ni le passé ni le
devenir, mais le maintenant.* »

Yve-Alain **BOIS**

(1) Une des premières revues à défen-
dre les recherches artistiques vraiment
contemporaines. Adresse : 55, avenue du
Maine, Paris. Un voisin, quoi !

# Some Latin Americans in Paris

*This essay was written for the publication accompanying an exhibition of selected works from the Patricia Phelps de Cisneros Collection at Harvard University's Fogg Art Museum in 2001. Specific allusions to the exhibition— for example, references to a particular work in the show or figure in the catalogue—have been deleted here for clarity.*

•

The following notes are shamelessly impressionistic—subjective even—as they largely draw on my memories of early encounters with several Latin American artists in Paris. In short, this is no grand synthesis—the time is not yet ripe for that, at least on my part—but rather something more like an autobiographical fragment. It was a time, in the late 1960s, when postcolonialism was still a nascent concept, even though the issues it frames had already become pressing. That so many geometric abstract artists from Latin America should live in Paris then did not strike me as peculiar at the time, perhaps because I did not yet know that New York had "stolen the idea of modern art," to use Serge Guilbaut's catchphrase.[1]

The disintegration of the French colonial empire was patent (although the Algerian War had ended in 1962, its wounds were far from healed), but I was not thinking then in terms of center and periphery. I enjoyed listening to Jesús Rafael Soto play the guitar in Carlos Cruz-Diez's studio (and certainly appreciated the exoticism of the situation), but if the abundant colony of Latin American artists appealed to me more than any other group in Paris, it was mostly for its great openness and easy sociability as well as for its infinite patience with my immodest youth (though I would not have phrased it that way at the time). A man like Sergio Camargo, a sophisticated sculptor whom I remember as a kind of benevolent aristocrat, had no qualms about discussing Lygia Clark with me for hours, and Carmelo Arden Quin was always ready to reminisce about the early activities of the Argentinian Madi group or to show me one of his transformable books.

But if I was drawn more to them than to their French counterparts, I certainly did not categorize these artists as "Latin American." I met them along with artists from various countries who participated in the short-lived venture of kinetic art, which had as its hub the Galerie Denise René. Although

some of them continued to develop—for example, the French artist François Morellet—many disappeared from view along with kineticism itself, which quickly degenerated under the pressure of the art market. The story of the rapid degradation of this trend will have to be written one day. For now we need to realize that the baby should not have been thrown out with the bathwater: The early works of Soto, particularly those from the late 1950s and early 60s that combine a look typical of the French informel school—heavy impasto, assertive brushwork—with the parallel striations to which he owes his trademark moiré effect, strike me as being as powerful as what Lucio Fontana, say, or Robert Rauschenberg were doing at the same time. And one indeed feels that the tide of neglect is now beginning to recede.[2]

The Latin American artists I met in Paris had no great desire to be cast as Latinos or Latinas, but they did share an essential condition that greatly impinged on their work—that of transculturalism. As such, their early experience is particularly resonant in our present decentralized, multicultural world. Two concepts are helpful in trying to understand their situation.

The first is that of "creative misreading," a phrase coined by the literary critic Harold Bloom in his 1973 book *The Anxiety of Influence*.[3] Utterly dissatisfied with the traditional notion of influence as it was used by academic literary history, Bloom elaborated a model of filiation based on the notion that whenever one artist is "influenced" in any interesting way by another, in reality the latecomer is actively misreading the earlier work—that a cardinal and deliberate "error" of interpretation underpins the relationship of any strong poet to the work of his or her predecessors. According to Bloom, this primary (and willful) misunderstanding of past rivals is the precondition for the poet's greatness and eventual liberation from what Bloom calls the "anxiety of influence"—the fear of being derivative, of being flooded by a strong predecessor. Bloom's main issue is that of legacy, of the painful coming to terms with the recent past, but his model can nevertheless be quite useful when applied to the relationship between the symbolic authority of a center and what is felt as a situation of periphery. We will see that the reaction of the Neoconcretist group in Brazil, and Lygia Clark in particular, to the Bauhaus heritage represented by both Max Bill and Josef Albers was one of misprision, or willful, creative misreading.

The second concept, directly related to the first, is that of *foreignness*. In a review of the 1908 Salon des Indépendants, the French poet Guillaume Apollinaire reveals that foreignness has long been interwoven with the history of modernism and the formation of its ever-changing canon. Apollinaire addressed the fact that the Art Nouveau illustrator and painter Felix Vallotton was highly esteemed in Germany while in France nobody seemed to care for his work:

People in France are too wary of foreign taste. Yet foreign taste could at least give an indication. It should be admitted that a foreigner who is outside the Parisian coteries and free of the influence of critics, who are often submissive and rarely disinterested, will be naturally drawn to the most important works, works whose beauty appears to him to be the newest and the least debatable. Above all the foreigner freely seeks out those paintings whose meaning [*enseignement*: literally, teaching] appears to him to be the most elevated and the most revealing. He seeks out what he does not have in his own country and reserves his warmest glances for works of the highest originality.[4]

Now, in order to unpack this statement, it is necessary to consider the context.

First: for a French artist in 1908 to be appreciated in Germany was the kiss of death. Apollinaire's remark was in fact a jab at the Symbolist writer Octave Mirbeau, who had mocked Vallotton's high reputation on the other side of the Rhine (the French defeat in 1870 at the hands of the Germans was still on everyone's mind, and resentment would only escalate to and through World War I; Cubism, of which Apollinaire was soon to become the most eloquent supporter, would be criticized as *art boche*, a slang term for German art—and even discussed in parliament as something deliberately anti-nationalist).

Second: Apollinaire's statement takes on a particularly ironic flavor here when one remembers that Vallotton was not French but Swiss (even though he lived in Paris). In many ways his situation was similar to those of Gego, German-born but working in Venezuela; Mathias Goeritz, also German-born and working in Mexico; Mira Schendel, Swiss-born but working in Brazil; and the Brazilian artists Lygia Clark (who lived in voluntary exile in Paris from 1968 to 1976) and Hélio Oiticica (similarly exiled in New York between 1970 and 1978). Of all these artists, however, the Vallotton medal has to go to Goeritz, who was profoundly detested, as he was proud to remark, by the official Mexican artists of the period, such as the muralists Alfredo Siqueiros and Diego Rivera.

The derogatory term *art boche* and the foreignness of Vallotton are particulars that one needs to keep in mind while reading Apollinaire's statement. But this short paragraph also highlights an important phenomenon: that of the freedom with which the stranger can look at a complex cultural system without having to fully know or understand the rules of its game, a freedom that often enables the foreigner to pick and choose what is most vibrant (and most controversial) in a given culture. Within Apollinaire's lifetime, a perfect example would soon be provided by the Russian collector Sergei Shchukin, who began collecting Matisse and Picasso around 1908 and who brought back from each of his Paris trips the freshest and most important works by these painters (at least those that had not been snatched by the American expatriates Gertrude and Leo Stein, with whom he soon entered into a frantic competition). The story

of the Russian collection is well known: It is thanks to Shchukin's inspired picks that the Russian avant-garde artists were exposed to the best examples of *art boche*—to the masterpieces of Cubist art that remained utterly unavailable to the French public for at least a generation (especially since Picasso and Braque did not exhibit in the Salons). The result: Russia produced Malevich, Tatlin, and Constructivism, while France, whose audience had to contend with second-rate imitations of Picasso and Braque, would not be able to come up with any truly innovative abstract art until after World War II. Only then would French artists finally be able to understand Cubism and thus to creatively misunderstand it—that is, to reject it.

The comparison is not perfect, of course, but many artists I shall be evoking are akin not only to Vallotton (as exiles) but also to both Shchukin (in that they chose what to inherit and what to canonize) and Malevich and the Constructivists (in that they ran away with this newly defined canon and radically transformed it).

●

But enough generalities. Let us now switch, as promised, to the autobiographical mode—not because I have any particular attraction to the genre, but because I simply cannot disentangle my thoughts about two artists and their particular "anxiety of influence" from my personal interaction with them. One is Lygia Clark; the other is Mathias Goeritz. I met them long before my intellectual and artistic tastes were fully formed—in fact, they played a major role in my education and especially in my awareness of modern art in Latin America. I have encountered many artists in my life, but only those two ever functioned for me as mentors. I met them both through a journal called *Robho*, which was published in Paris in the late 60s (the title is an acronym; no one knows what it stands for). It was one of those little avant-garde magazines that quickly disappear, and it was edited by Jean Clay, a man who had considerable clout at the time as an art critic. Years later, Jean and I would found a much more serious and ponderous journal called *Macula* (this one did not last very long either), but when I first bumped into Jean I was a teenager.

Here is the whole anecdote, given as a little period piece: It was 1967, and I was in the French equivalent of tenth grade. I was living in the beautiful city of Toulouse in the southwest of France and would come to Paris whenever I had earned enough money from various small jobs to pay for the train ride—schoolchildren have a lot of small vacations in France. I don't quite know how I had gotten this idea, but I wanted to become an artist, and I spent all my time dreaming about my next trip to Paris, where I would visit as many galleries and museums as possible. I would stay at my uncle and aunt's place, but they would only see me at dinner, after which I would collapse, having run around

all day. Then there was a break in this routine: I was invited to an evening party celebrating the opening of a group show in the new branch of the Galerie Denise René on the Left Bank, Boulevard Saint Germain, to be precise, right next to the gallery of Alexandre Lolas (representing Magritte and Fontana)—and my uncle agreed to let me go, provided that Jean Clay, whom he knew slightly, would be there to chaperone me. My uncle drove me to the gallery while I crossed my fingers in the car: Jean greeted me, and as the youngest kid on the block I was immediately welcomed by a whole roster of artists. Jean became a friend and I learned a great deal from him (he also put me to work instantly: I sold dozens of *Robho* issues in my provincial high school).[5] It was Jean who first told me about Lygia Clark and showed me photographs of her work. He also gave me some of her texts to read, which he had had translated in anticipation of a special dossier on her in his journal (this would only come out in late 1968). I was so intrigued by this body of work that it prompted me to publish my very first article—a short (and, as can be imagined, very jejune) essay on Lygia that appeared in the March 1968 issue of a Huguenot weekly called *Réforme*, my father being a Protestant minister. (I apologize for using only Lygia's first name from here on, as this familiar mode of address for someone I knew so well comes most naturally to me.)

The year 1968, remember, was a tumultuous one in France. High-school kids were just as politically involved as college students, and I thought, as did everyone else of my generation, that we were going to change the world. There was of course much talk about the possibility of a "revolutionary art," but thanks to the little I already knew about Lygia's phenomenological conception of art, I could not accept the idea of an *engagé* art that left the beholder in a state of passive consumption. Political art, in order to be efficient, had to allow for a different role; I knew this much, but did not quite know where to go from there. My own attempts—some later published by Jean Clay in *Robho* with the quite undeserved encouragement of Lygia—did not satisfy me.

It was after the rather dramatic summer of 1968, very shortly after Russia's intervention in Czechoslovakia, that I first met Lygia—in the studio apartment she had just obtained in the Cité des arts, in a hideous building on the banks of the Seine where the city of Paris lodges foreign artists, in keeping with France's pre–World War II dream of Paris as the center of the art world.[6] She had just returned from the Venice Biennale, where she had represented Brazil with a major retrospective of her work that included early things but also her various *Máscaras sensoriais* (Sensorial masks) and *Roupa-corpo-roupa* (Clothing-body-clothing) outfits of 1967, as well as the large installation/environment *A casa é o corpo* (The house is the body).[7] The studio was filled with boxes of all sizes, and Lygia was visibly depressed (apart from having to process a retrospective, always somewhat traumatic for a mid-career artist, she had been thoroughly

disgusted by the hype of the Biennale. On top of that, she had just learned of the death of her ex-husband). She had agreed to receive me thanks to both Jean Clay's and Camargo's kind words, and because she knew that I was in Paris only in passing and would not pester her long.

As she began showing me her things—letting me touch them, handle them, inhabit them under her guidance—I witnessed a kind of transfiguration. I literally saw her dark melancholy vanish, and I always thought, in retrospect, that our friendship was sealed during this long afternoon: By pure chance, being there at the right moment, I had helped her ditch her depression.

First there were the few things scattered on the tables—pebbles connected with small rubber bands tied together, one or two pebbles at each end. Lygia showed me how to use those precarious assemblies: You pull a pebble or a group of pebbles toward you and, at a given moment, always unpredictable, the mass at the other end of the elastic will follow, either in a jump, as if moved by a spring, or dragging feebly like a slug. It was the interaction between different forces that moved her—your own pulling, the extensibility of the elastic, and the weight of the pebbles—and the fact that the resulting immeasurable act cannot fail to be perceived as a phenomenological metaphor for the relationship of your body with others in the world.

Then she began to unpack the boxes and hand me older things. One of the "objects" I remember most vividly was her 1966 *Diálogo de mãos* (Dialogue of hands), which she had devised with her soul mate, Hélio Oiticica. This work, or rather "proposition," as she was already calling her works, consists of almost nothing, like many of her pieces—that is, it really is nothing if you do not use it: Materially, it consists of a little Möbius strip made of an elastic medical bandage.[8] Each of our right hands passed through one loop of the Möbius strip in opposite directions, and by joining our hands or releasing them we experienced the resistance of matter (for our gestures were restricted by the limited elasticity of the cloth). If the "dialogue" is continued long enough, the visual and tactile sensations seem to part company and a moment comes when the impression is born that the hands are dancing by themselves, separated from the body. This moment can be extremely perturbing, almost hallucinatory.

At that point of my visit, Lygia began to reminisce about the beginnings of the Neo-concrete movement in Brazil, and the deliberate attack she had plotted with Oiticica (whom I was never to meet) against geometric abstraction, the tradition in which both had been trained.[9] She revealed to me the importance of Max Bill to Brazilian art in the early 50s, especially after his retrospective at the Museu de Arte Moderna of São Paulo in 1950, followed by his being awarded the international sculpture prize of the first Bienal of São Paulo in 1951: Eenthusiasts of Bill's "Concrete Art" (as he called his production in which everything had to be planned by arithmetic calculations) suddenly flooded the

tiny Brazilian art world, which until then had been rather resistant to modern art. She gently led me to understand that her 1966 *Dialogue*, this tiny piece of bandage that did not look like much, in fact represented the conclusion of a long battle against Bill's type of art. For the Möbius strip had been one of the favorite geometric figures of the Swiss artist, who had planted its polished granite image in several sculpture gardens around the world. Bill had frozen the Möbius strip into an icon of the autonomy of the modernist art object; Lygia transformed it into the support for an experiment aimed at abolishing any idea of definite, closed identity. With *Dialogue*, a "sculptural" object is no longer sacred as autonomous and formally perfect, but rather the falsely symmetrical dialoguing hands become, as it were, autonomous performers.

Needless to say, we talked a lot about abstract art that afternoon (notably about Mondrian, my first love in art—and what she told me then definitively terminated my adolescent reading of his art, standard at the time, as a kind of Neoplatonic paean to pure form). I learned a lot about Lygia's past involvement with geometric abstraction, enough to understand that it was her foreignness to the European tradition of abstract art that had allowed her to creatively misread it. Many details were filled in later through other conversations and with the help of the *Robho* dossier mentioned above. Since what follows are historical events that I only heard of long after they occurred, I will for a moment abandon the guise of the autobiographer.

•

Returning to Brazil in 1952 from a year in Paris (where she had studied with Fernand Léger), Lygia quickly assimilated Bill's rationalist catechism and soon began to destroy it from within. Noting that Bill often borrowed his forms from topology, she resolved to go beyond his purely iconographic appeal to this scientific field. Her first mature paintings (1954) were jigsaw puzzles (often in wood) in which she endeavored to give a positive role to the black interstices (empty joints) between the color blocks and to transform the frame into a pictorial element. As she insisted at the time, her goal was to undo the empty/full, inside/outside oppositions upon which planar geometry and rationalism are based.

Discovering in 1957 the isometric positive/negative reversals of Josef Albers's *Structural Constellations* (which she thought much more surrealist than any work by Dalí and his peers), she understood that she needed to call the fixedness of the ground into question if she wanted her lines to function other than graphically. During this Albersian exploration she enhanced the jigsaw aspect of her pictures, now nearly all on wood, by a pervasive recourse to modularity: The ambiguous spaces, engendered by the sheer juxtaposition of independent planar units, were to prompt a ludic response from the beholder, to initiate (and frustrate—because the units are in fact immobile) a desire to rearrange the planes in another combination.

But even though the "ground" was no more—that is, even though she was no longer painting on a surface conceived as a neutral recipient but, rather, building the very surface out of painted blocks—Lygia grew dissatisfied with what she saw as her reliance on "drawing" in these works.

Her next step was a series of pictures (or, rather, wood reliefs) in which a square mechanically painted in a matte black is bordered on one or several of its sides (and sometimes bilaterally divided) by a recessed white line that functions more like a hinge than a frame. She had managed to illusionistically torque the plane, an accomplishment she verified in a tondo called *Ovo linear* (Linear egg), 1958, a black disk bordered by an interrupted white line. Because the white line laterally dissolves into the surrounding white wall, we refrain from the gestaltist habit of closing the circle, and the black area tends to visually shift in depth with the line, one area receding while the other seems to protrude toward us. It is this perceptual to and fro, conceived as the "death of the plane" (her words), that propelled Lygia to publicly secede from Bill's school and to found Neoconcretismo, with several younger artists, in March 1959.

The other major figure besides Lygia to emerge from this movement, her friend and alter ego Hélio Oiticica, rallied to the cause only after the publication of the group's manifesto, penned by the poet and critic Ferreira Gullar (this text was entirely based on Lygia's reinterpretation of the tradition of geometric abstraction through the lens of the phenomenology of perception, quoting Maurice Merleau-Ponty's philosophical work, which she had recently discovered and which would remain a lifelong interest). The publication of the "Neo-concrete Manifesto" coincided with Lygia's elaboration of a series of reliefs called *Casulo* (Cocoon) and *Contra-relevo* (Counter-relief, in homage to Tatlin), dating from 1958–59, in which she translated the perceptual instability of her preceding works into the real, phenomenal space of our senses (Oiticica soon proposed his own version, which he called *Relevo espacial* [Spatial relief]). Each *Casulo* is made of a single rectangular sheet of metal partially cut and folded (but not cut out—nothing is deleted or added) so that its frontal proportion, whatever its projection in space, is always a square (hiding, so to speak, an interior space that the beholder discovers when stepping aside—suddenly, in a flash that can be quite vertiginous, as if the ground had collapsed under one's feet). The fold engenders the fantasy of unfolding and of the plane as a compression of volume, an idea developed further in the *Counter-reliefs*, where void is sandwiched between layers of black or white boards. Unfortunately, the impact of these works is almost impossible to convey in photographs.

That the plane has a volume and that this volume can be opened up (like a cocoon) is at the core of Lygia's most celebrated works, the *Bichos* (Critters) of 1960–64, freestanding structures made of hinged metal plates that one can manipulate to give the sculpture various shapes (stored, a *Bicho* is perfectly flat).

The articulation and disposition of the metal plates determine a set of possibilities that are often unforeseeable ("When I'm asked how many movements the *Bicho* can execute," Lygia wrote, "I reply: 'I don't know, you don't know, but the *Bicho* knows'").[10] In these first participatory works, Lygia transposed her topological investigations (concerning the possible abolition of the reverse side of a plane) into the mode of relations between subject and object: neither is passive or entirely free. The *Bicho* is conceived as an organism that reacts, with its own laws and limitations, to the movements of whoever manipulates it to modify its configuration. Often it requires certain gestures or unexpectedly turns itself inside out like a glove: The dialogue between *Bicho* and "beholder" is at times exhilarating, at times frustrating, but it always undermines the notion that one could ever be in control of the other.

Along with the black-and-white paintings of the late 1950s, the *Bichos* are in appearance Lygia's most exhibitable and most photogenic works, but one should not be deceived: Their riches remain inaccessible to anyone not engaged in combat with them. Shown as passive objects on a pedestal, they look like any other abstract geometric sculpture. Lygia, needless to say, always had to insist that people be able to manipulate them whenever they were exhibited, and it is in part the incapacity of museums and galleries to provide such a tactile apprehension of these works that drew her away from such institutions.

She temporarily sought a solution to this dilemma by devising several pieces as models for a transformable architecture—something she had already investigated a few years before (1960) in a very Miesian model in wood and Plexiglas, *Construa você mesmo o seu espaço a viver* (Build the space where you live), which she always kept in her studio, next to her *Abrigo poetico* (Poetic shelter) (1964).[11] I often dreamed of the vistas that the rotating "walls" and "ceilings" of this shelter would have engendered had it been built—slices of light, cuts of space: something close to Matta-Clark's collapsing of the section and elevation in his last works, perhaps, but in perpetual slow motion. Yet Lygia was perfectly aware of the dire situation of architecture at the time and knew that her anti-monumentality was not fitting the agenda; Oscar Niemeyer's Brasília was. In fact, she probably would have recoiled at the prospect of having anything built at all: Architecture remained for her somewhat of a conceptual exercise, which does not mean that she did not take it seriously. The *Abrigo poetico*, for example, evolved from studies in which she exploited the suppleness of paper in order to explore the properties of the topological transformations of a continuum. She recorded these studies, as well as many other experiments (or exercises?) that lay at the basis of most of her early works, in a carefully designed foldout book, *Livro-obra* (Book-work), that she proudly showed me during my first visit and that became one of my favorite delights among the many that followed.[12]

As a result of the way in which her *Bichos* were too easily transformed into art objects and thus consumed visually, she invented the *Caminhando* (poorly translatable as "Trailing," "Walking along"), which in 1964 marked both her definitive farewell to geometric art and the beginning of a trend in her work (and in that of Oiticica) that one could characterize as the progressive disappearance of the art object as such. The *Caminhando* returned one more time to Bill's infatuation with the morphological wonders of the Möbius strip, but rather than being an object, it is conceived as an experience that has to be lived through. First, you have to make a Möbius strip out of paper, and then follow Lygia's do-it-yourself instructions:

> Take a pair of scissors, stick one point into the surface and cut continuously along the length of the strip. Take care not to converge with the preexisting cut—which would cause the band to separate into two pieces. When you have gone the circuit of the strip, it's up to you whether to cut to the left or to the right of the cut you've already made. The idea of choice is key. The unique meaning of this experience is in the act of doing it. The work is your act alone. To the extent that you cut the strip, it refines and redoubles itself into interlacings. At the end the path is so narrow that you can't open it further. It's the end of the trail.[13]

What's left—a pile of paper spaghetti on the floor—is ready for the wastebasket: "There is a single type of duration: the act. The act is that which produces the *Caminhando*. There is nothing before, nothing after," writes Lygia,[14] adding in retrospect that it was essential "that you not attempt to know—as you were cutting—what you were going to cut after nor what you had already cut." And then: "Even if this proposition isn't considered a work of art, and if one remains skeptical about what it implies, we still need to undertake it."[15]

Three aspects are important here and recur in Lygia's subsequent work. She spells them out dramatically in her extraordinary texts, which often bear overtones of what we could call a secular mysticism (for one of her goals in inventing "rituals without myths," as she often called her propositions, was to undermine any notion of the sacred).

There is, first, an overbearing insistence on the irreducibility of the now (Lygia would sometimes call this "the immanence of the instant," drawing on Gaston Bachelard's writings, which helped her to understand what she had accomplished).[16] The *Caminhando* is a modest device whose foremost function is to awaken the cutter to this precious temporal content of which our gestures have been deprived by mechanization. The underlining of choice sounds like an existentialist version of Cartesian free will, but the philosophy Clark was closest to is pre-Socratic: Freedom is for her a function of transience.

Second, the personal, intimate nature of the experience itself implies both a deflation of the artist's authority and a new mode of communication (she would write in 1969, at the very moment when her propositions began to involve several participants: "My communication cannot be made through *a priori* spectacles, group manifestations like in the others, but it is such a biological, cellular experience that it is only communicable also through an organic and cellular manner. From one to two, to three or more, but something always comes out of the other, and it is an extremely intimate communication from pore to pore, from hair to hair, from sweat to sweat").[17]

Finally, and perhaps most strikingly evidenced in Lygia's personal diaries and notes, there is a marked contrast between the simplicity of the gestures involved and their phantasmic charge (the concept of the act embodied in the *Caminhando*, for example, unleashed in her a cosmological dream of generalized fusion: "I perceive the whole of the world as a single, global rhythm that stretches from Mozart to the footwork of a soccer game on the beach").[18] It is important to realize, however, that Lygia never offers the free associations that spun out from her own experiencing of one of her propositions as anything like its "official" meaning: On the rare occasions when she published these verbal images, it was only as examples of the type of effect on oneself (liberating fantasies) that the proposition can have once set in motion—it was to indicate that if a proposition did not have any exchange value, it had a use value.

From the *Caminhando* a whole series of works in copper, steel, or rubber followed, called *Trepantes* (Grubs) for their capacity to be hung anywhere, on any objects, on trees, or simply thrown on the floor.[19] The most interesting of these, the *Obras moles* (Soft works), are made of black industrial rubber and anticipate by a few years the development of what would be called Antiform in the United States (when hung on the wall, they resemble a 1967 *Felt Tangle* by Robert Morris). But this was a direction in which she could not continue for very long; by then Lygia knew too well the human propensity to willingly accept our role as passive beholders. The experience of the *Caminhando* had been a breakthrough that made any art object look suspicious: She stopped cutting up *Trepantes* within a year, and after a long crisis began to assemble the pebbles and elastic soft-structures I mentioned at the beginning. From then on, she and Oiticica would develop a complex interactive practice that would steer clear not only of any consideration of the object per se but also of any notion of theatricality (no performance, even in the "propositions" that involved multiple "participants"—to use the words that replaced *object* and *beholder*, respectively, in their numerous texts). Even more important, the very concept of the artist would gradually become irrelevant as Lygia's "art" would become a kind of therapy or social work. Needless to say, this later period of Lygia's practice was even less suitable for museums or art galleries (to her delight and pride). But

although it belongs to a different world than that of the earlier Neo-concrete works, her late development casts a potent light on these seemingly inert objects—and it is exactly in these terms that she staged a retrospective of her career for me during our first encounter, to which I shall now return.

•

One of the propositions I remember best from that inaugural afternoon is *Pedra e ar* (Stone and air) (1966). She placed in my hand a small transparent plastic bag that she had just blown up and sealed with a rubber band. It was hot with her breath (the plastic was very thin). She placed a pebble on one of its corners, which balanced precariously and sank into the corner of the bag. It hung there, nearly fell, but even the slightest change in the pressure of my hands caused it to rise again like a floating bob. I felt as though I was clumsily helping a very delicate animal to give birth (this feeling was certainly enhanced by my having just performed on myself the "caesarian" section prescribed by one of the uncomfortable latex jumpsuits of her *Roupa-corpo-roupa* (clothingbody-clothing) series, *Cesariana* [1967]). The contrast between the nothingness of the prop and the intensity of my perception while playing yo-yo/peek-a-boo (mildly reenacting the famous *fort/da* play described by Freud in his account of children's sexuality), this gap between the simplicity of the actual gesture and the kind of generic memory of the body it awoke in me, is something that I never forgot. It is as if a prehuman body had been brought back from an archaic bank of sensations stored somewhere in my species memory, as if Lygia's work were countering Darwin's evolution. There is the tactile aspect: The skin of the hand, redoubled by the plastic skin that molds it, becomes a kind of autonomous organ. Then there is the dissonant visual aspect: the stone's movement of protention/retention (which Lygia specifically related to Albers's *Structural Constellations*), the plastic bag's swelling or deflation, its corner's pointedness or curvaceousness—all this clearly referring to the sexual act but without one's being able at any moment to assign a specific role (or gender) to any of the elements.[20]

The next "proposition" I was handed was *Respire comigo* (Breathe with me), whose prop is a simple rubber tube used by underwater divers for breathing. I quote Lygia here: "You join the two ends of the tube together and place your thumb over the joint. As you stretch the tube next to your ear, you're perturbed by a suffocating sound of breathing. The first time I did it, the consciousness of my breathing obsessed me for several stifling hours."[21] As Guy Brett notes, we have "the sensation of taking out our own lung and working it like any other object"—which can be either terrifying or inspiring.[22]

I did not perceive the terrifying implications at the time. I was hooked, so to speak. Lygia became the most important part of my "support group" as a teenager, and I saw her on each of my trips to Paris during the following

academic year. Then, after high-school graduation, I came to the United States as an exchange student for a year, and we began a correspondence that lasted until I came to live in Paris in the fall of 1971—after which it stopped for the simple reason that I saw her almost every day until she returned to Brazil in 1976 (for one thing, her psychoanalyst lived just a block away from my tiny student den). By the time I got to Paris she had moved into a larger apartment/studio in a similarly hideous building close to the Porte de Vanves—a gathering place for every Brazilian artist, singer, or filmmaker passing through Paris (there were many, especially during the years of the military dictatorship). The musician-composer Caetano Veloso, who was then living in exile in London, never failed to show up if he was on tour in the French capital (he commemorated one of his visits with a song—"If You Hold a Stone"—composed in homage to *Pedra e ar*).[23] There were also many regulars (particularly on Sunday evenings, when we would ritually watch the "cineclub" feature on TV, often after having gorged on a *feijoada* I would have helped Lygia prepare): Camargo before he returned to Brazil, Mario Pedrosa and his wife Mary, who came to live in Paris after Pinochet's coup in Chile. But not only Brazilians gathered at Lygia's. The Filipino artist David Medalla would occasionally pop up, as would Guy Brett; as her earliest supporters in Europe, both were always welcome.[24] (Medalla had first exhibited Lygia's work in 1965 at the Signals Gallery in London, which he co-directed for a while and whose journal devoted an extremely well-illustrated special issue to her;[25] Brett was a lifelong devotee of both Lygia's and Medalla's, as well as of Hélio Oiticica: In 1969 he organized Oiticica's first European exhibition at the Whitechapel Gallery in London, for which the environment *Eden* was conceived.)[26] I have many memories from this period, but I have to cut the story short, and the last anecdote I will allow myself about Lygia will help me to introduce Mathias Goeritz.

I said earlier that I met him through *Robho*. In fact, I came into contact with him via mail, after having read a dossier about his work in the journal. The initial spread of this dossier (published in the same issue as that devoted to Lygia) was striking: On the left page was an article listing elements of Goeritz's work and aesthetic attitude in two columns, the "for" and "against" sides balancing each other; on the right, filling the huge page, was a stunning photograph of the towers of *Satellite City* that he co-authored with the architect Luis Barragán in 1957, for me one of the handful of truly successful public sculptures of the twentieth century.[27] Many aspects of Goeritz's early work were revealed in this article—the quasi-Minimalist sculptures he created for the experimental museum El Eco in 1953, his involvement with Concrete poetry, and his collaboration with Barragán. I was very impressed.

I must have written to him shortly after arriving in Hanover, Pennsylvania, as an exchange student (just in time for the Moon landing, which I watched on

TV without understanding a word being said), because that's where the first letter he sent me is addressed, dating from July 27, 1969. After that he would be the most faithful correspondent, maintaining a weekly exchange with his unknown admirer and answering my tireless questions about his past without any sign of fatigue or irritation (I would only meet this tower of a man in February 1970 in New York, during my first, unforgettable trip to that city). I must have asked him what he thought about Lygia's work in one of my first letters (particularly because a photograph of him handling a *Bicho* had been published by *Robho*), for here is what he replied on August 25: "The work of Lygia Clark—I like it A LOT. Unfortunately, I do not know her personally. Since you tell me that you see a connection between her work and mine, I can only say that I feel it's a real honor. I love this woman but I do not know why. She is searching much more deeply than all the others, including myself." A month later, probably as I had passed on the information to Lygia, she replied to me: "I do love the work of Mathias Goeritz! I'm delighted that he likes what I do as well." I began to feel like a matchmaker and must have continued probing one artist about the other. On January 19, 1970, I received this extraordinary letter from Goeritz:

> You ask me a question (which is not at all indiscreet): why have I never contacted Lygia Clark. The answer is simple: as she is a very great <u>artist</u>—and to my mind one of <u>the most</u> remarkable women artists ever, even when taking into consideration all the past centuries—I'd like to KNOW her before writing to her. I've seen photographs and I'd probably fall in love with her. Such an extraordinary woman frightens me. In general I believe, unfortunately, in the "superiority of women." So with a woman that talented, I feel like a midget. When I was your age, I met Käthe Kollwitz, who made an enormous impression on me. She was then about 70 years old or more. That was in Hitler's Germany. And I assure you that the image of this woman never left me. It was not what I was looking for in art, but her monstrously human quality won me over. Now, with Lygia C., this is an even more complex case. I was told she is a very sweet woman [*une femme très douce*: on that count, Goeritz was quite mistaken]. I think I know more about her than you think I do, and all I know is <u>extraordinary</u>.

More letters followed in which Goeritz explained to me not only who Kollwitz was but also why it was probably better that he and Lygia never meet. For some reason, however, the real encounter between these two surrogate parents of mine was a voyeuristic fantasy I cherished for quite a while. A few years later, during one of Goeritz's stopovers in Paris, I brought him to Lygia's place. I suppose I had secretly hoped not only that Goeritz would fall in love but that it would be reciprocated; yet to my amazement both were terrified, and the evening was one of the very few during which I saw either of them embarrassed.

It was a total flop that deeply puzzled me and remained a major event in my sentimental education.

Now, by the time of this nonevent—around 1974 or 1975—the Mathias Goeritz whose work I had admired enormously was no more. I had no interest in his recent development; the last work of his that I appreciated—and only in photographs that he had sent me—was his *Via Lactea* (Milky Way) (1968–69), made of slices of toppled star-sectioned columns dispersed around a pond onto which they reflected. He knew of my criticism, and to my amazement he would always agree with it (even when it was harsh). In letter after letter—for this remained our common mode of communication for a decade—he would deprecate his own work. I always protested when this self-criticism concerned his early production, and I suppose he liked my faithfulness. But he was not fishing for compliments: he had arrived at this attitude fairly early on and maintained it with any interlocutor. In the early letter I mentioned, before telling me for the first time of his admiration for Lygia's work, he discussed other artists, probably at my urging—for example Brancusi, whom he liked (while Lygia did not). But the passage ended this way:

> All these are artists who are making limited experiments, though rather beautiful. All this—my own work included—is not too important. We are all trying to get out of ART FOR ART'S SAKE. We all do our little thing, not always successfully. But since the basis of contemporary art is vanity—ambition [. . .]—the idea of success became all too important. I'm not trying to destroy myself, I'm just trying to be HONEST. I could make an effort to deceive you, but why? I prefer not to deceive myself. I am not a pessimist, quite the contrary, but I refuse to be too idiotic. Rivera, Siqueiros, etc.—their work is of an impressive hideousness. But at least they wanted to "say" something. The works of Tamayo are neither ugly nor hideous, but terribly boring, and I wonder if I do not prefer, in the end, the works of the precursors of a kind of political POP ART. Siqueiros and company hate me, but I feel a certain sympathy for these people, especially now that everybody badmouths their work. They are quite "underdeveloped" (as far as their taste is concerned), but that's precisely their strength.

I received myriad letters of this sort—but one should not think that Goeritz used this candid tone only with young and inexperienced correspondents like me. Read, for example, his letter to the architect Pedro Friedeberg, which was published in English—with Goeritz's benediction—in the first monograph on his work, in 1963:

> During all of my ambitious life I haven't invented anything. This is unfortunately not false modesty but an honest conviction. My ideas, considered by you

"avant-garde" or modern, are generally more than one hundred years old (I myself through ignorance didn't realize it until much later). There is only a change of focus, and this is due to the difference of medium, location, and time. My work is poor, unimportant. My painting has been first a reflection and later on, a sickly offspring of the German expressionists, of Klee and the others. My sculpture is a confusing mixture of various influences, among them pre-Columbian art and the art of superior sculptors like Arp, Barlach or the Dada Max (Ernst). My *Towers*? You know very well they are a dubious interpretation of the towers of Bologna. The *Complexes* are almost a copy of the forms of African [artists], and the *Clouages* already existed even in Picasso's work, whom I detest. My present work? Malevich, the genius, has said and done everything better. After admitting all this, the only thing left for me to do is to continue trying to serve, spiritually and materially, so that my entire life should not be a complete failure.[28]

Here Goeritz is clearly unfair to his early work. The 1958 *Complejos ambulantes* (Walking complexes), for example, which are reproduced and described in the same book as "thin horizontal wooden pieces, sometimes more than twenty feet long, encrusted with big rusty nails," deserve much higher praise. Though the connection of these works with African art remains somewhat obscure to me, I am still deeply impressed by the way they crawl on the floor, making the much later production of Arte Povera look like designer stuff. The same is true for the *Messages* of 1959, sheets of iron pierced by hundreds of nails (he calls them *Clouages* in the letter just quoted).[29] When I asked him about the very similar reliefs Günther Uecker made several years later, Goeritz replied that when he met Uecker he realized how different his approach was: "For him it's a matter of form," he wrote, "for me, as you'll understand when you meet me, it's a kind of masochism: it is into me that I am driving these nails." It is also from this kind of religious imagery that Goeritz's *Mensajes metacromáticos* [Metachromatic messages] evolved in 1959–60, for they functioned almost like icons reflecting light (it is undoubtedly to these plain wood panels uniformly covered with gold leaf that the allusion to Malevich refers). In short, Goeritz's masochistic mysticism, which I saw then as a form of courage, is nothing but a reminder of the perils that haunt those who do not come to terms with their "anxiety of influence"—an anxiety that is spelled out in every word of his letter to Friedeberg. Unlike Lygia, whose foreignness helped her overcome this anxiety and radically transform an intimidating past tradition, Goeritz remained overburdened, never fully acquiescing to his German heritage in order to fully disentangle himself from the stuffy, politically overdetermined Mexican situation.

Although Goeritz claimed that geographic displacement had been the major instrument of his fame, he suffered more than any other artist from a kind of

national identity crisis—and from the arrogance and chauvinism of a Western art world already largely dominated by New York.[30]

Lygia was at the other end of the spectrum. Because, at least after the Venice Biennale, she resolutely disengaged her activity from any market economy (there is no big risk that the *Caminhando*, for example, will ever end up at Christie's) and retained only limited contacts with the art world, she did not feel burdened by her illustrious predecessors (they simply did not belong to the same sphere). Her voluntary exile was not merely geographic: She had left the traditional land of art in order to propose another model of aesthetic communication—she preferred the word *sensorial*, but, as I reminded her during one of our daily lunches, the Greek word *aisthesis* means "sensation."

First published in *Geometric Abstraction: Latin American Art from the Patricia Phelps de Cisneros Collection* (Cambridge, MA: Harvard University Art Museums, 2001), 77–103.

1.   Serge Guilbaut, *How New York Stole the Idea of Modern Art: Abstract Expressionism, Freedom, and the Cold War* (Chicago: University of Chicago Press, 1983). As I recall it, the French art world was completely oblivious to what was happening on the other side of the Atlantic—American art was almost entirely absent from the walls of galleries and museums. An exception such as the exhibition *The Art of the Real*, in which a French audience discovered Minimalism, was met with total incomprehension. It is true that it was poorly timed, occurring in November–December 1968, at the height of anti-US sentiment.

2.   While Guy Brett's little book *Kinetic Art* (London, New York: Studio-Vista, Rienhold Book Corporation, 1968) had long dissociated its topic from the disco-like bedazzlement offered by Op art, it had unfortunately appeared too late for anyone to notice—by then the whole of kineticism had already been discarded as kitsch. But the wide success of the exhibition he mounted in Barcelona (Museu d'Art Contemporani) and London (Hayward Gallery), *Force Fields: Phases of the Kinetic*, demonstrates that it is high time to reopen the files. Brett's early book was already proposing a story of kinetic art different from that which had been popularized by exhibitions such as *The Responsive Eye*. Bridget Riley and Victor Vasarely were not even mentioned in this study, whose heroes were, above all, Lygia Clark, Hélio Oiticica, and David Medalla (along with Jesús Rafael Soto, Pol Bury, Sergio Camargo, Gianni Colombo, Liliane Lijn, Mira Schendel, Takis, and Jean Tinguely). The same cast of characters— with several additions, such as Gego—is to be found in the catalogue of *Force Fields*, which contains an important essay by Brett, "The Century of Kinesthesia." For more on this exhibition, see "Angels with Guns" in this volume, 17–77.

3.   Harold Bloom, *The Anxiety of Influence: A Theory of Poetry* (New York: Oxford University Press, 1973).

4.   Guillaume Apollinaire, "Le Salon des Indépendants," 1908, in *Apollinaire on Art: Essays and Reviews, 1902–1918*, ed. L.-C. Breunig, trans. Susan Suleiman (New York: Viking Press, 1972), 445.

5.   On Jean Clay's activity as a critic, as well as his role in my formation and our long friendship, see "J.C. or the Critic" in this volume, 79–102.

6.   I have already recalled this first encounter, in a more detailed fashion, in my presentation of Lygia Clark's texts in *October* 69 (Summer 1994): 85–88.

7.   The full title of this piece is *A casa é o corpo. Penetração, ovulação, germinação, expulsão* (The house is the body. Penetration, ovulation, germination, expulsion).

8.   [Addition 2021] One day, I suppose as she was clearing her Paris studio-apartment before her definitive return to Brazil, Lygia gave me the piece of elastic bandage she had sawn into a Möbius strip and used to enact her "dialogue of hands" with various visitors, as she had done with me that afternoon. It is somewhere in my mess, but the last time I saw it it had completely lost its elasticity and was totally flattened, looking like a sad, twisted suspender. She also gave me the rubber tube of *Respire comigo*, described further down, which has aged slightly better. For her these were just props, not art objects.

9.   Ronaldo Brito's 1975 account of the birth of the Neo-concrete movement, written in 1975 but only published in 1985, remains unequaled. It has been translated into English as "Neo-concretism, Apex and Rupture of the Brazilian Constructive Project," *October* 161 (Summer 2017): 89–142.

10.  Lygia Clark, "1960: The Beasts," *October* 69 (Summer 1994): 97. The English translation of Clark's texts in this issue of *October* was colored by previous translations into French, in which *Bicho* was rendered as "Bête" (this is also the way Lygia called these works when speaking to French interlocutors, and this is the word I remember her using). Often, *Bicho* has been translated into English as "animal." However, in MoMA's 2014 retrospective catalogue of Clark's work, it is translated as "critter," which seems better to me.

11.  Now at the Museum of Modern Art, New York.

12.  The original *Livro-obra* dates from 1964. Recapitulating Lygia's production up to that point, it offers theoretical comments and "do-it-yourself" mock-ups of her early reliefs and paintings. Though it was conceived from the beginning as a proto-type destined to be published, publication did not occur until 1983 (one copy for each letter of the alphabet) and in a modified form (two-sided foldout) augmented with later texts. Many of the figures consist of geometrical cutouts that the reader is invited to manipulate.

The most stunning example is the (seemingly) three-layer black disk illustrating these directions: "The plane surface is a human invention. I sensed its precariousness when I carried out this experiment: I took two equal circles, placed them one above the other, and cut them from the center to the edge. Then, with a strip of tape, I joined one cut edge of the upper circle to the opposite edge of the lower circle. Then, holding firmly the loose edge of the upper circle, I folded the loose edge of the top circle underneath itself, moving it in a circular motion until it passed through the first circle and the two circles formed new planes, one above the other. What's curious is that the circles never left the plane during the experiment."

13.  Lygia Clark, "1964: Trailings," *October* 69 (Summer 1994): 99.

14.  Ibid.

15.  Lygia Clark, "1965: Concerning the Magic of the Object," *October* 69 (Summer 1994): 101–02.

16.  A fragment of Bachelard's *Intuition of the Instant* was translated in the special issue of *Signals* (no. 7) devoted to Lygia that appeared in April–May 1965 (see note 25 below)—that is, before the reprint of Bachelard's now-famous 1932 text, which appeared in 1966. It might well be the editor of *Signals*, David Medalla, who introduced this text to Lygia and thus initiated her into his work. Medalla had met Bachelard a few years before and was familiar with his work. On this point, see Medalla's memoir, "Signals," in Rasheed Araeen, *The Other Story: Afro-Asian Artists in Post-war Britain* (London: South Bank Centre, 1989), 115. See also Purissima Benitez-Johannot, "A Narrative of Differentiation: Medalla from the Sixties to the Eighties," in *The Life and Art of David Medalla*, ed. Purissima Benitez-Johannot (Quezon City, the Philippines: Vibal Foundation, 2012), 42–43.

17.  Lygia Clark, letter to Mario Pedrosa, May 22, 1969, in *Lygia Clark* (Barcelona: Fundació Antoni Tàpies, 1997), 250. The cryptic phrase "like in the others" undoubtedly refers to performances, happenings, and other types of events with which her work was often associated by critics, wrongly so, in her mind, in that they involve spectators.

18.  Lygia Clark, "1965: About the Act," *October* 69 (Summer 1994): 103.

19.  In the MoMA catalogue mentioned in note 10, *Trepante* is translated as "climber," while in every previous publication it had always been rendered as "grub." "Climber" is undoubtedly the literal translation, but the uplifting, ascending connotation it

conveys seems to me entirely at odds with Lygia's invasive, parasitic ribbons. There is something disquieting about them, which "grub" connotes well.

20. The pan-sexualism of Lygia's works, even of her earlier ones, was not lost on her first defenders. I quote from an essay written in January 1967 by David Medalla and published in the *Robho* dossier (unfortunately, I have to retranslate from the French): "Mario Pedrosa compared some of Lygia's articulated constructions to a vagina, a comparison that seems forced if one only takes into account the visible shapes of these constructions. But Pedrosa's comparison makes perfect sense if one thinks of the movements of Lygia's construction and relates them to the opening/closing movements of a vagina. The first time I touched a work made with rubber by Lygia Clark, I was struck by its resemblance to the foreskin of an uncircumcised penis. Lygia's rubber sculpture resembles, for me, the foreskin of an uncircumcised penis—not for its form, or its size, but due to its elasticity and reversibility, its wonderful aptitude to develop and to fold onto itself as it is touched by the participant." Medalla, "Participe présent: l'art de Lygia Clark," *Robho*, no. 4 (1969). Pedrosa's essay, "The Significance of Lygia Clark," was published in the special issue of *Signals* devoted to the artist (April–May 1965): 8–9.

21. Lygia Clark, "L'art, c'est le corps," in *Preuves* 13 (1973): 142.

22. Guy Brett, "Lygia Clark: The Borderline Between Art and Life," *Third Text* 1 (Fall 1987): 84.

23. [Addition 2021] Veloso's visits happened mostly in 1969–71, before I came to live in Paris, so I never met him. He had become very close to Oiticica in London, but also to various members of the vast family of Miguel Arraes who were living in Paris, and whom I met very often at Lygia's

place (Arraes himself, Lygia's great love, was living in exile in Algiers—his rare sojourns in Paris were the only times when she abstained from any social life). For the singer's version of the *Pedra e ar* anecdote, see Caetano Veloso, *Tropical Truth: A Story of Music and Revolution in Brazil* (New York: Knopf, 2002), 53.

24. [Addition 2021] Here I must improve my wording, which is somewhat imprecise. As in the case of Veloso, I never saw Medalla in Lygia's studio, for the simple reason that by the time I came to live in Paris he had not only left the city but also been banned from her place forever. Lygia admired his work as much as he did hers, and she told me both of his numerous visits and of the reason for his banishment: Without asking her permission, he had named her as a legal guarantor on the lease of the boat, moored on the Seine embankment, in which he was living for a while (and where I met him for the first time in 1970 or 1971), a fact she discovered with horror when a bailiff rang her bell and sternly asked her for unpaid dues. She never stopped expressing her admiration for his work and gratitude for his early support, but she never forgave him for going AWOL and having left her to deal with the French bureaucracy.

25. There were also special issues on other Latin American artists: Soto, Camargo, Alejandro Otero, and Cruz-Diez, all in connection with one-man shows held at the Signals Gallery. The entire run of *Signals* (ten issues that appeared from August 1964 to March 1966) has been excellently reprinted by the Institute of International Visual Arts (London, 1995).

26. The show would have been held in 1967 at the Signals Gallery, which abruptly closed shortly before it was scheduled, in the middle of an exhibition of Mira Schendel. (On these circumstances, see "Angels with Guns" in this volume, 17–77. This text is devoted to Guy Brett's lifelong activity as a critic and to our sustained

dialogue.) A detailed account of the extraordinary Oiticica exhibition, which the artist called "The Whitechapel Experiment," is provided in Brett and Luciano Figueiredo, eds., *Oiticica in London* (London: Tate Publishing, 2007).

27. I am far from being alone in this belief. I recall a conversation with Richard Serra, following my review of the installation of his own *ClaraClara* in the Tuileries Garden, where I had alluded to Goeritz's *Towers* ("The Meteorite in the Garden," *Art in America* [Summer 1984]). Serra expressed his delight at having his piece compared to *Satellite City.*

28. Quoted in Olivia Zúñiga, *Mathias Goeritz* (Mexico City: Editorial Intercontinental, 1963), 47.

29. I have always wondered why the original title of these works was the English *Messages.* In her recent book *Mathias Goeritz: Modernist Art and Architecture in Cold War Mexico* (New Haven: Yale University Press, 2018), Jennifer Josten provides the explanation: "After showing four of the *Sudarios* in Mexico City, Goeritz retitled the series *Messages.* He did so in English because he had made them, first and foremost, for export to New York for his second solo show at Carstairs Gallery, in March 1960" (169).

30. He was greatly affected, for example, by the attack against him with which Gregory Battcock begins his introduction to his *Minimal Art: A Critical Anthology* (New York: Dutton, 1968), 19–20. Some of Battcock's claims were far from being unfounded (notably that Goeritz's mystical manifesto against Tinguely's famously self-destructive *Homage to New York* of 1960 was reactionary), but the tone was unnecessarily offensive.

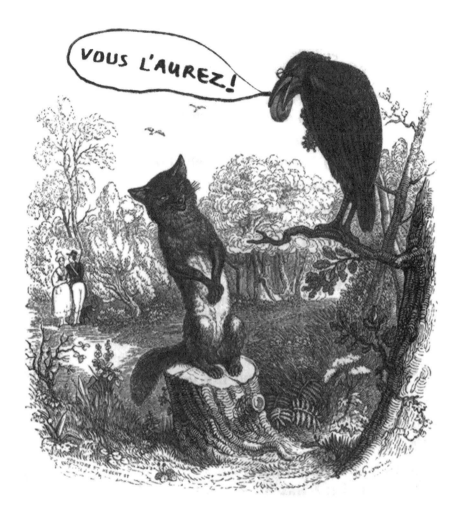

J. J. Grandville's 1838 illustration of Jean de La Fontaine's "The Crow and the Fox," annotated by the author, in imitation of a fax, now lost, that he received from a collector he was soliciting for a loan.

# Why Do Exhibitions?

*The following is the text of my contribution to a symposium entitled "À quoi servent les expositions?" (What is the use of exhibitions?) that took place in the Musée du Louvre on March 22, 2000. The majority of the other contributors either directed museums or worked for institutions in charge of organizing exhibitions, so it was not surprising to me that my opening salvo was not very well received.*

•

I shall begin with a statement that is most likely too abrupt—at any rate, deliberately provocative: There are too many exhibitions. More precisely, there are too many exhibitions designed merely to occupy space and time. I shall not go into details of the financial and logistical machinery that obliges every museum, forced at first by strict necessity to set up temporary exhibition spaces, to then fill those spaces constantly. Temporary exhibitions must follow, one after another, like radio or television programs—the offerings ought to be varied, but the essential element is continuity. Hence the increasing number of what I shall call filler exhibitions. No silence or pause can be allowed in what, already in 1944, Theodor Adorno and Max Horkheimer were referring to as the culture industry. Sociologists will have no doubt much to teach us about the current superabundance that mimics that of the supermarkets, transforming the viewer into a hurried consumer.

It is not my habit to play Cassandra, and I should not think of complaining about the situation, quite recent as it is, if it were not for the fact that this excess brings with it a danger that seems to me to be rather real: the constantly growing circulation of works of art. Whatever one might hear, works of art are not designed to take plane flights several times a year and to be subjected to the physical assaults of the crushing crowds of museumgoers who give them only a quick glance as they listen to their audio guides. Happily, the sheer pro-liferation of requests for loans obliges those who are responsible for the works of art—*a fortiori* if the latter are important—to think twice before responding favorably to a request. Indeed, constantly harassed, they must often choose between several concurrent demands. Every exhibition curator who is at least a little experienced knows very well how much more difficult the task is today than it was only ten years ago, and that direct competition with counterparts

in other museums is inevitable. This state of competition, deriving from the market economy, has today reached a point close to saturation. This may be a good thing.

In any event, it seems to me that we are moving toward a split of the genre "museum exhibition" into two subcategories: the exhibition-as-spectacle, where the content as such matters less and less (a pure affair of marketing), and the exhibition-as-research that aims to further knowledge, either by bringing to light materials up to now unexplored or by proposing a new interpretation of the objects shown. Given the increasing difficulties that I have just mentioned, and the fact that potential lenders must themselves be increasingly circumspect if they wish to preserve anything on their own walls, there is reason to hope that the exhibition-as-research will prevail and replace the exhibition-as-spectacle that seems to be dominant today. But this is perhaps rather too elitist a scenario, and it could well be that what I see as the ideal exhibition, one that satisfies the needs of both research and entertainment, will emerge victorious from the current plethora.

That exhibitions might (and, as I understand it, must) speak on two levels at the same time—one intentionally popular, and the other sophisticated—is a fact that I became convinced of some twenty years ago as I was admiring the show organized by my friend Bruno Reichlin, in a small cultural center in Lugano, on the villas that Le Corbusier built in the 1920s and 30s. Nothing is more difficult than presenting the work of an architect—the technical difficulty inherent in the reading of plans is immediately off-putting for anyone who is not a specialist. Starting from this known fact, Reichlin decided to include a great many archi-tectural models, whose miniature, doll's house aspect make a nostalgic appeal to our childish sense of play. Alongside the many drawings through which any specialist would be able to examine at leisure the evolution of Le Corbusier's thought for each of the ten or fifteen villas under consideration, Reichlin had set up a series of models, five or six for each villa, the sequence of which made clear the progressive changes undertaken during the evolution of the project (here a displaced wall, there a window shifted). It was immediately apparent, even from a cursory comparison, how the architect had moved from A (his first conception) to Z (the completion of the project). It was an exhibition that you could see in half an hour, moving quickly, but you could also take three hours or more, and Reichlin was betting that a good number of museumgoers would get hooked and follow all of the details. He was not mistaken: The exhibition attracted large crowds, and their approach to the material was more studious than swift. The most remarkable thing was that there were no constraints. The viewer who saw the exhibition on the run did not feel at all excluded, and this was in large part due to the fact that there was a strict minimum of wall texts. The curator's "discourse" was almost entirely articulated in visual terms. For my

part, I took away the best introduction ever to Le Corbusier's thinking, and also the conviction that an exhibition must be, or at least should try to be, art history without words.[1]

At least this is what I have tried to do with the exhibitions that I have organized or co-organized these past years.

•

Among these, the first exhibition I will discuss is the Piet Mondrian retrospective I curated with Angelica Rudenstine and Joop Joosten.[2] Contrary to what one might think, since it was a retrospective (a type of exhibition tacitly based on the idea of an exhaustive and "objective" presentation), the choice of works was determined by a very distinct criterion. That is, our selection was designed to correct two errors that were widespread in the literature and backed up by the preceding retrospective exhibitions. We wanted, through our selection, to unseat two major false ideas about Mondrian's art. That we did not succeed entirely is perhaps true because the myths persist, but I think we made some progress in the right direction.

The first of these false ideas concerns the part played in Mondrian's art by what one might call the Symbolist sentiment, and in particular by Theosophy. There can be no doubt that this was a determining factor during what Mondrian called his "transition period" (1908–11), the time when he was rapidly discovering all of modern art at once, from Monet to Matisse and Picasso by way of Van Gogh and Cézanne. At this time, it was Theosophy that allowed him to assimilate and organize a great many new artistic ideas; indeed, it kept him from panicking. It still played an important role during the period (1912–17) that took him from Cubism to abstraction. However, through this period, Theosophy diminished noticeably in importance for Mondrian and was gradually replaced by a more dynamic system of thought, namely, Hegel's dialectics. This led him, toward the end of 1920, to achieve his own stylistic system that he called Neoplasticism. From that point on, Theosophy disappears almost entirely from his concerns (he refers to it only twice in his voluminous writings, and both times to criticize it as being out of date). The same is true for the polar opposition of masculine and feminine, also part and parcel of the same Symbolist-Theosophical baggage. The last significant text on that subject dates from 1918. Therefore, it would be if not dishonest at least quite wrong to try at all costs to read Mondrian's Neoplastic canvases as kinds of diagrams that one could decode with the help of Madame Blavatsky's overblown breviary. As we saw it, to speak of Mondrian's Neoplastic works in this way was to be blind to what made them particularly modern and to transform them into simple illustrations, whilst the artist, once he had moved to abstraction, was in fact radically opposed to the very idea of illustration.

As we looked at the previous retrospective exhibitions and their attendant critical receptions, we noticed that one painting in particular dominated all of the reviews. This was *Evolution*, from 1911, one of the very rare paintings by Mondrian (rare even during his Symbolist phase) that had an explicitly Symbolist theme. The painting preceded, by a few months, Mondrian's discovery of Cubism. But "dominated" is too weak a term—article upon article did nothing but go over the main theme of this blockbuster (the most reproduced work in the newspapers) and then project this schema shamelessly onto the rest of Mondrian's career. There were good reasons for this, despite the mediocrity of the work and the rather cheap mysticism that runs through it: It is the largest painting that Mondrian ever produced, and the one with the greatest saturation of color. Its physical presence alone is enough to overwhelm any other paintings placed alongside it on a wall, especially those by Mondrian himself, which are generally much more modest in size. So we decided not to show it, and I must say we had the artist on our side in the matter: It is at the very exhibition where he showed *Evolution* that he discovered Cubism, a discovery that made him instantly realize that he had chosen the wrong path and vow to never again attempt to translate an esoteric program into pictorial terms. So as not exactly to engage in trickery, we did show Mondrian's *Red Mill*, a painting from the same period but in which the Theosophical symbolism is more discreet.

Our choice was seen as censorship, and it occasioned fierce attacks from those critics who were bent on repeating long-assimilated clichés; however, they remained a minority. The same minority of critics were upset with us also for having shown a rather draconian selection of the so-called early Mondrian (up to 1907). There again, we had the painter on our side since he freely confessed that what he called his "naturalist" period had been very static and entirely based upon a pre-Impressionist aesthetic. Our desire was to show Mondrian's modernity, and so we stressed the serial aspect of his production dating from before his conversion to modern art and to its glorification of color. But the rigor of our choice was based upon a very precise principle: If Mondrian had died in 1907 at the age of thirty-six, then he would today only be known to specialists of Dutch art and regarded as a talented follower of the Hague School, itself a pale copy of the Barbizon School. Again, in 1907 even, as Picasso was working on the *Demoiselles d'Avignon*, Mondrian was producing works that could have been painted around 1850 by a contemporary of Théodore Rousseau or Camille Corot.

We decided to pass quickly over this early period and to focus through a few key works on Mondrian's development as an abstract painter, i.e., on what happened during his "transition period" when he was absorbing both Post-Impressionism and Fauvism, and then on his very personal interpretation of Cubism (1912–14). Finally, we sought to bring out the very linear evolution that took him to Neoplasticism, and here we included almost all of his paintings

from 1915 to 1920, along with a large selection of preparatory drawings. We supplied the attentive museumgoer with all of the means necessary for entry, step by step, into the very new territory that Mondrian had discovered. Here once more, we were proceeding from an idea the artist himself followed, since he was a staunch evolutionist for whom each work marked a step of progress onward from its predecessor, superseding it and making it redundant. (This, by the way, is the reason why he was always against the very idea of retrospective exhibitions.)

The other serious critical error that we wished our exhibition to correct, and that had been repeated in all of the preceding retrospective exhibitions and monographs on the artist, was that Mondrian had essentially slept through the 1930s, only to "reawaken" after his arrival in New York and during the last four years of his life. The beginnings of Neoplasticism had always been well documented—and we went over the top by showing no fewer than twenty-three paintings from his first Neoplastic season of 1920–22—but his very rapid, and for us remarkable, evolution from the beginning of the 1930s had only ever received a summary treatment. The resulting impression was that it was only through the discovery of American skyscrapers and the neon signs of Times Square that the painter had become suddenly galvanized enough to produce such masterpieces as *Broadway Boogie Woogie* and *Victory Boogie Woogie*.

In the first place, we wanted to point out that Neoplasticism had been, from the very beginning, a much more supple system than was generally thought (alongside the great classic and superbly balanced canvases of 1921, we hung three paintings from the same period that demonstrated an evident desire to explore a certain compositional disequilibrium).[3] But we wanted above all to show that at a certain point in time Mondrian changed course. After that point, it was no longer for him a question of a mere (and occasional) disequilibrium but rather of the self-destruction of his own system through a growing dynamism. Our first task was to locate the point of departure for this second phase of Mondrian's Neoplasticism. It occurred after a moment of grace, a sort of apogee. Between 1929 and 1932, Mondrian produced a series of canvases based on a single formal schema (something that is much rarer in his work than is generally understood), and we managed to secure the quasi-totality of this series for our show, which, for brevity's sake, I shall call the "classic" series.[4]

Because it is a good story, I shall go into the assiduous campaign of seduction I led in order to obtain *Composition no. II* (1930) for the exhibition (a painting also called *Composition with Blue and Yellow*). This is a fascinating work in that it almost totally inverts the color arrangement of the first canvas in the series that dates from the preceding year. The fortunate owner of the painting—who was at first furious with me for even knowing that he had the painting in his possession and had forbidden me to ever come close to his house—finally relented when

he saw the (color) reproductions of its sibling paintings that I had brought along with me at the time of the visit he had reluctantly granted in the end. I recall fondly the moment when he told me that he had no good reason to believe that, if he allowed himself to lend the painting, it would come back to him in better shape. Since he was thinking in these terms, I said to myself, it must mean that the exhibition is at least a possibility for him. I was right. After several visits and a voluminous correspondence, I received by fax a copy of Granville's illustration of La Fontaine's "The Crow and the Fox" on which this collector, so lovingly attached to his painting, had traced a speech bubble coming out of the mouth of the crow, with the words "You shall have it."

Once we had safely secured this classic series, it remained for us to show its "destruction" through the introduction of what Mondrian called the "double line." In the first painting where this happens, *Composition B, with Double Line and Yellow and Gray,* from 1932 (PMCR B231), the interval separating the two lines is of the same thickness as the black line that they cross. However, starting with the following two canvases, *Composition with Double Line and Yellow* (PMCR B237) and *Composition with Double Line and Yellow and Blue* (PMCR B238), both from 1932, it becomes clear that the double line will very quickly, as the artist wrote, "grow larger, heading toward the plane," and it is this ontological ambiguity that was to undermine his system. Since there was no longer a fundamental difference between line and plane, why should the line not be colored? This was the point that Mondrian reached in 1933 with the famous *Lozenge Composition with Four Yellow Lines* of the Gemeentemuseum (PMCR B241)—although he was to let this possibility lie fallow until his arrival in New York.

The "classic" type was to function for two years as a solid platform on which Mondrian was to test out the effectiveness of his sabotage. In a painting that is today lost (he displayed this work proudly in his studio alongside the canvas with yellow lines), he doubled all of the lines (*Composition with Double Lines and Yellow,* 1934 [PMCR B242]), then in subsequent works he tripled, quadrupled them, or else, moving in an opposite direction, he made his double line into a full-fledged plane. In the last canvas of this series (which, alas, was unavailable to us), *Composition with Yellow* (PMCR B264) of 1936, the very idea of the double line gave way to what he called a "plurality of lines," whose function, as he put it, was to destroy the plane.

I shall not pursue this demonstration any further. It seems to me quite clear that this new dynamism, this sort of visual pulsation, with which Mondrian strove to animate his paintings intensified during the 1930s and reached its culmination in the visual exuberance of his New York period. There were, of course, changes along the way, and Mondrian has left us a clear account of the transition by retouching a dozen or so paintings that he had completed in Europe,

adding to them a number of tiny colored dashes.[5] But after an examination of his evolution through the 1930s (entirely neglected up to the time of our exhibition), the attentive viewer was much less likely to believe the myth of a Mondrian crying out "Eureka!" in Times Square.

·

The second exhibition that I shall mention was of an entirely different nature since it was a themed exhibition (although this is not exactly the right word, because for us it was more a question of procedure rather than of thematic content). This is an exhibition that I co-organized with Rosalind Krauss, entitled *L'informe: mode d'emploi* (*Formless: A User's Guide*).[6] Instead of giving the general outline of the show, I shall focus on certain points in it.

The first procedure we examined we called for simplicity's sake "horizontality" (although it would have been clearer, but less elegant, to have called it "horizontalization"). "Horizontality" was placed under the sign of Jackson Pollock, or rather of the interpretation of Pollock that a number of artists had proposed from the middle of the 1950s on, against the dominant—and on the way to being almost official—reading that was Clement Greenberg's. These artists began from the recognition that the formalist interpretation of Pollock had taken no account of two crucial facts, 1) that the artist worked on the ground, and 2) that he did not himself actually paint, but rather allowed the force of gravity to delineate the complex networks of his "drippings." The move from the customary vertical plane of easel painting to the horizontal working surface of the barn floor, and the importance accorded to gravity in the making of the work (not to mention that the painter almost never touched the canvas, the brush being no longer, for him, the prolongation of his arm), had struck these artists as constituting a radical transformation in the practice of painting. Pollock himself had made this perfectly clear, in particular, with *Full Fathom Five* (1947), one of his very first "drippings," through the way in which he allowed all sorts of materials (cigarette butts, paint tube tops, thumbtacks, keys, etc.) to accumulate as if his canvas were a sort of junk drawer into which he was emptying his pockets.

The first space in the exhibition was a small room in which the visitor came immediately upon one of Andy Warhol's *Dance Diagrams* (this particular one from 1962), which was exhibited horizontally on the floor just as Warhol himself had arranged it at the time of his first retrospective. *Full Fathom Five* was also in view, as well as *Glue Pour*, a 1965 sequence of photographs by Robert Smithson, and a painting that the Japanese artist Kazuo Shiraga had done with his feet in 1957. As you can see, chronology was not an absolutely determining factor here. The essential idea was that all of these works were expressly created in response to, and in a certain sense as a tribute to, Jackson Pollock.

The second, very large room presented further examples of "horizontality," notably with Robert Morris's *Felt Tangle* (1967), a work that displays very clearly the function of gravity in its formal appearance, and also Warhol's huge and magnificent *Oxidation* from 1978 (another tribute, but also a parody in that, in order to create it, Warhol had asked his friends to urinate on a canvas covered with copper-based paint). But it was perhaps the third room that had the most to say: It was completely dominated by the reconstruction of Morris's *Threadwaste* (1968), an immense jumble of textile fibers, pieces of copper tubing, felt, and mirrors, that was laid out entirely on the floor. Once they entered the room, the viewers could see, inviting them from across the other end of the room, a small canvas by Pollock whose color combination echoed precisely Morris's accumulation. So that no one would remain fixated on this simple formal affinity, we had also positioned from floor to ceiling a sagging *Fried Egg* by Claes Oldenburg (1966), along with a series of "liquid" words painted by Ed Ruscha in 1969, spreading out in *trompe l'oeil* like pools of vomit (a preview of the final section of the exhibition that was devoted to entropy). The extreme stylistic and thematic diversity of all of these works was designed to underline their single point in common—the move from a vertical register, which had for several centuries guaranteed the superior status accorded to painting, to a horizontal register, inferior and, by extension, prosaic.

The second grouping of works in this exhibition made a similar structural argument. This arrangement was built around another form of deliberate debasement that we called, borrowing directly from Georges Bataille's vocabulary, "base materialism." The first gallery devoted to this "procedure" included works all characterized by a certain insistence on their materiality, or at least on the idea of matter as something raw, inarticulate, even fecal. Certainly, this was not matter as it was seen by the Enlightenment philosophers, but rather the much less noble mud that fascinates very young children. In the middle of the room there were three sculptures by Lucio Fontana, including his phenomenal *Ceramica spaziale* (*Spatial Ceramic*) of 1949, a cube that seemed to have fallen out of the world of pure geometry and to have sunk into a universe of viscous gesticulations. But the main draw of this room was surely the juxtaposition of Jean Dubuffet's *Messe de terre* (*Rite of the Earth*)—one of his "Matériologies" dating from 1959–60—with a Fontana canvas from the same period, a very large *Combustione plastica* (*Plastic Combustion*) by Alberto Burri from 1964, and a twice-as-large black polyptych by Robert Rauschenberg from 1951.

Here, I must tell a story about this juxtaposition because, like the tale of the Mondrian and the La Fontaine fable, it was for me an exercise in perseverance. The Dubuffet and the Burri were immediately available to us because they belonged to the Musée National d'Art Moderne, and Rauschenberg, by some miracle, had agreed to lend his polyptych (now at SFMOMA), but we had not

been able to secure the loan of the ochre painting by Fontana that, out of all of this artist's production, seemed to us best able to stand up against such imposing works as Burri's burnt plastic and Rauschenberg's tarred newspaper, works that so forcefully handled the same conjunction of attraction and repulsion that Fontana was after. The Musée d'Art Moderne did have in its collection a work of the same type, with the same crumpled surface (strongly reminiscent of the disgusting skin that forms on heated [non-homogenized] milk when it cools); however, this piece did not completely satisfy us. There were several reasons for this: Firstly, the work was divided into two colored areas, and this introduced an element of confusion (paradoxically of "form") into Fontana's visual discourse, the latter being based upon the marriage of taste and distaste; secondly, the piece was square and quite small. We had tried and failed to obtain the ochre painting, in part because we had never succeeded in contacting the owner directly. Just as we were about to work on the installation, I learned the name of the happy custodian of the canvas and I wrote to him immediately describing to him the company in which the work would find itself if he were to consent to lend it for our exhibition. I explained to him that its horizontal format, rather rare in Fontana, as well as its size, made the piece particularly propitious for the installation that we had in mind, and that the presence of the piece in this context would go a long way toward dissipating the cliché of the Italian painter as almost exclusively a creator of slashed canvases and as the inventor of increasingly elegant forms of iconoclasm. I concluded my letter to this collector by pointing out that if he were to visit the exhibition and to see another painting in its stead, then he would probably feel as if he were faced with a usurper, and he would experience some regret. My argument carried the day.

Finally, I'll move on to the following room in the show, devoted to what we considered another figure of "base materialism," namely debasement by means of kitsch. I shall be very brief, because I hope that the preceding examples will have brought out clearly enough the organizing principle of this exhibition. Let us say, to sum up, that we had been very struck by Jean Fautrier's interest in "bad taste," explicitly stated in several letters and other manuscripts, as a strategy for breaking away from the tradition of the fine arts, and from the fine art of painting in particular. Our section on base materialism was arranged as a dance: with Fautrier, Piero Manzoni, Fontana, Rauschenberg, and Warhol all holding hands around a piece by Oldenburg, a pile of plastic green beans (cut in the manner typical of the American frozen food industry). Of course, it was not our intention to make kitsch the only sphere of meaning in which to place Fautrier's work; however, quite simply, we wanted to point out that it was perhaps a good idea to dislodge it from the existentialist discourse in which it was encased.[7] I am giving most of my attention to Fautrier here because his work allowed us to show in the best possible way what we understood by procedure—a procedure

of debasement that-in our way, which in our view was faithful to the artist-we wanted to emulate. We wished to exhibit debasement itself as a principle, by lowering (or, you might say, by declassifying) a work whose bad taste had been deliberately passed over—such was our wager.

<div align="center">•</div>

Rather than carrying on with this tour of the *Formless* exhibition, I should finally like to make a brief allusion to the exhibition *Matisse and Picasso* that I organized for the Kimbell Museum of Art (Fort Worth, Texas) in its superb Louis Kahn building.[8] This time, I shall not go into any detail about the exhibition's main idea—it was quite simply to show the extent of the dialogue between the two artists after 1930. This date was chosen for purely practical reasons since it would have been impossible for me to secure the loans necessary for an examination of the preceding period, beginning with Matisse's *Bonheur de vivre* at the Barnes Foundation, and therefore permanently off-limits to borrow. But it remained quite possible to make a virtue out of necessity because, if the exchange between Matisse and Picasso had been very well explored for the years 1906–17, the literature dealing with the reprise of their dialogue after 1930 was almost nonexistent, except for Françoise Gilot's extremely valuable recollections of her life with Picasso during nearly a decade.

I should like now, in a few words, to point out the rewards for an art historian that come from organizing an exhibition.

First of all, there is the discovery of works that one might not have known existed—objects that come up unexpectedly. From the very beginning of my work on this exhibition, I wanted the last part of it to be a coda showing the works that Picasso created in tribute to Matisse during the two years that followed the latter's death. Among other things, I wanted a high point of the exhibition's conclusion to be four paintings from the two *L'atelier à La Californie* (The Studio at La Californie) series that Picasso painted in 1955–56. As I see it, these canvases are a direct response, after a delay of eight years, to the series of Interiors that Matisse painted at Vence in 1947–48. I wanted to have two vertical and two horizontal canvases. After I had discovered that one of the two vertical pieces I had selected was unfortunately unavailable, I received an offer by way of consolation: an even better piece that I had thought lost and that became for me one of the jewels of the exhibition. This was *L'Atelier à La Californie* of April 2, 1956, and I was able to hang it in such a way that the visitor could see, at the same time and in the distance, Matisse's *Intérieur au rideau égyptien* (*Interior with Egyptian Curtain*), one of the best Vence Interiors.

The second source of discoveries is the installation itself. I had at the outset wanted to juxtapose two sculptures: Matisse's *La serpentine* (a work that dates

from 1909 but that Picasso was to see for the first time in 1930) and a *Baigneuse allongée* (*Reclining Bather*) by Picasso from 1931. The formal similarity between these works was all the more valuable in that it made clear the fundamental difference between them in terms of underlying principle. Matisse thinks volume in continuity; he takes the bones out of his figure in order to create a line that closes itself into a loop. Picasso, on the other hand, works the clay as if he were making a Cubist collage. As if it were a game of Tinkertoy, he combines separate parts (this is very clear in the preparatory drawings for the *Baigneuse allongée*). When we opened the packing cases, I was amazed to see that the two works (one vertical, the other horizontal) were of exactly the same size, and so much so that one might have thought, at a cursory glance, that Picasso had quite simply toppled *La serpentine* to the ground.

Finally, I would like to mention those discoveries that are made "too late," once the exhibition has been hung and the die already cast. The first major painting in the exhibition was Picasso's *Grand nu au fauteuil rouge* (*Large Nude on a Red Armchair*), dating from 1929. This was a caricature of the odalisques that Matisse had painted in the 1920s. It dominated the back wall of the small room with which the exhibition began. It was only well after the hanging was finished, when it was no longer possible to make any changes, that I noticed that by hanging it on another wall of the same room I could have arranged things so that the visitors would see this painting once again as they were leaving the exhibition, or rather that they would rediscover it while seeing at the same time the very last canvas in the show (not visible previously), another woman seated in an armchair (*Woman in a Rocking Chair* of 1956, now in the Art Gallery of New South Wales, Sydney), Picasso's final tribute to Matisse. From caricature to admiring tenderness—that would have made the story I wanted to tell come full-circle.

I very much regretted missing the boat on that one; however, it made me appreciate all the more the direct contact I was able to have with the works, allowing me to experience the immense joy brought about by this unforeseen comparison. This is the real reason, I believe, why art historians like to organize exhibitions so much, and it is why, despite all of the concomitant trials and tribulations, I shall continue to do so.

Translated by Nicholas Huckle.

First published as "L'exposition dans la pratique de l'historien d'art," in *Art Press*, Special issue *Oublier l'exposition* (Fall 2000): 49–53. The title was given by the journal's editors.

1.   The exhibition *Le Corbusier: La ricerca paziente*, curated by Reichlin and Sergio Pagnamenta, was held in the Villa Malpensata, under the auspices of the City of Lugano and the Gruppo Ticino of the Federazione Architetti Svizzeri, from September 6 to November 16, 1980. Reichlin used the same device (of several models illustrating the evolution in the project of a single building by Le Corbusier) in an exhibition I curated with him and Jean-Paul Rayon, *De Stijl et l'architecture en France*, at the Institut Français d'Architecture, Paris (November 4–December 20, 1985).

2.   *Piet Mondrian: 1872–1944*, National Gallery of Art, Washington, June 11–September 4, 1995; traveled to Haags Gemeentemuseum, The Hague, December 17, 1994–April 30, 1995; and Museum of Modern Art, New York, October 1, 1995–January 23, 1996. Even though the first venue of this exhibition was the Gemeentemuseum and it ended at MoMA in New York, it was launched by the National Gallery of Art in Washington. Neither MoMA nor the Gemeentemuseum contributed to the selection process.

3.   *Composition with Blue, Red, Yellow and Black* (no. 100 of the exhibition catalogue), *Composition with Blue, Yellow, Black* (no. 101), and *Composition with Large Red Plane, Gray-Blue, Yellow, Black, and White* (no. 102), all three works from 1922. These works are, respectively, numbered B142, B145, and B144 in the *Piet Mondrian Catalogue Raisonné*, the second volume of which, dedicated to the works of 1911–44, was established by Joop Joosten (New York: Abrams, 1996). Hereafter PMCR.

4.   Six works from the series were included in the show. From 1929: *Composition no. II and Composition with Yellow and Blue* (no. 122/PMCR B215); from 1930: *Composition with Yellow* (no. 127/PMCR B221) and *Composition no. II; Composition with Blue and Yellow* (no. 129/PMCR B225); from 1932: *Composition A; Composition with Red and Blue* (no. 132/PMCR B230), *Composition C; Composition with Gray and Red* (no. 133/PMCR B232), and *Composition with Yellow and Blue* (no. 134/PMCR B234). Two works were not included: *Composition no. I with Red and Blue* (PMCR B227) and *Composition no. II with Yellow and Blue* (PMCR B228), both from 1931.

5.   This extraordinary series of "trans-atlantic" canvases, all of which have a double date, was the subject of an exhibition, organized by Harry Cooper and Ron Spronk, held in 2001 at the Busch-Reisinger Museum, Harvard University Art Museums, and the Dallas Museum of Art. Born from the close collaboration between a museum curator and a conservator, this is a typical example of an exhibition that advances research.

6.   *L'informe: Mode d'emploi*, Centre Georges Pompidou, Paris, May 22–August 26, 1996. An English translation of the book that functioned as the catalogue of this exhibition was published as Yve-Alain Bois and Rosalind Krauss, *Formless: A User's Guide* (New York: Zone Books, 1997).

7.   [Addition 2021] Fautrier began his "Hostages" series in 1943 while he was hiding from the Gestapo in a psychiatric asylum outside Paris, and after hearing the sounds of the torture and summary execution, in the surrounding woods, of civilians randomly picked by the German authorities in retaliation for acts of sabotage by the Resistance. The exhibition of these heavily impastoed paintings, in the immediate postwar Paris, was immensely successful, thanks in great part to the preface of the catalogue by André Malraux, brimming with his usual bombast. Neither he nor Jean Paulhan, his fellow hero of the Resistance and steadfast defender of Fautrier, could make sense of the stark

contrast between the title of these works or others such as *The Gunned-Down, The Flayed,* and *Oradour-sur-Glane* (the name of a village where the Nazis burned alive hundreds of women and children who had taken refuge in a church) and their saccharine color chords. They resolved to pathos, setting the tone for the subsequent literature on the artist. Only the poet Francis Ponge, noting that these paintings were "part rose petal, part Camembert spread," understood Fautrier's kitsch as a strategy of defilement. For more on this, see "Kitsch" in Bois and Krauss, *Formless: A User's Guide,* 117–24, and Yve-Alain Bois, "The Falling Trapeze," in *Jean Fautrier*, ed. Curtis L. Carter and Karen K. Butler (New Haven: Yale University Press, 2002), 57–61.

8.  *Matisse and Picasso: A Gentle Rivalry*, Kimbell Art Museum, Fort Worth, January 31–May 9, 1999.

Replica of Constantin Brancusi's studio, Musée National d'Art Moderne, Paris
(avenue du Président Wilson), 1962. The visitor's view was limited as one
could not enter this space, which was roped off. One could only bend over and
peep through the little door with a wooden frame visible at right.
Photo: Centre Pompidou, MNAM-CCI, Service des Collections.

# Better Late than Never

*I had been asked by Bernard Blistène to write a history of the Musée National d'Art Moderne for the catalogue of the exhibition* Rendezvous: Masterpieces from the Centre Georges Pompidou and the Guggenheim Museums *that he was co-curating from Paris with Lisa Dennison in New York. I immediately responded that, should I feel up to the task (I didn't, although I agreed someone should do it), there was no way I could do this properly within the deadline that had been mentioned, and, more crucially, without having ready access to the necessary archives, as I was based in the US. Instead, I proposed to write something more personal: I would touch upon the history of the museum, but the driving argument (that the current state of its collection had nothing in common with what it had been until the mid-1970s) would be based on my own, rather unflattering, experience. To my surprise this proposal was approved without any qualms, and the text was published in the massive catalogue of the exhibition, which opened at the Guggenheim on October 16, 1998.*

•

There is some disagreement about when I made my first visit to the Musée National d'Art Moderne (MNAM). My mother thinks I was five. But given how sharply I remember certain features of the event, I find this doubtful. Perhaps I made up a composite memory, blending that visit with a later one? In my mind, the encounter took place in 1961 or 1962, shortly before I entered the *lycée*. We lived in a small southern town and once a year came to Paris to see my grandparents and to shop in the department stores. My brother and I weren't too happy about the shopping part of the trip, and to placate us, my mother would take us to the museums. Not art museums—we were undoubtedly deemed too young—but the Muséum National d'Histoire Naturelle, the Musée de l'Homme, the Palais de la Découverte . . . one by one these great repositories of knowledge, and many others, were meticulously attended. Assiduous, we would often beg for a second visit. On our second trip to the Musée de la Marine, we unex-pectedly found its doors closed. We were already quite familiar with the other non-art museums in the area, so for some reason my mother resolved to stroll down the street to MNAM (the Musée Guimet might have been another choice, and I often wonder if I would have become a historian of Khmer or Chinese art if chance had led us there instead).

Perhaps, after all, it is my second visit to MNAM that I recall, for in this memory I am alone with my mother—we are the perfect Proustian couple. My younger brother probably complained, and my mother would have agreed to return with me the next day. What I do remember with absolute precision is my exhilaration in front of: the little roped-off room in the museum's basement, which was supposedly a reconstruction of Constantin Brancusi's studio (until its transfer to the Centre Georges Pompidou, I'd return to this room, as if on a pilgrimage, each time I'd visit the museum); a huge allover canvas by Jean-Paul Riopelle; the large Matisse cut-out *The Sorrow of the King* (1952), which then greeted visitors on the landing of a monumental staircase; the Léger room; and a small painting, saturated with ultramarine and punctuated by spots of yellow and orange, by Gustave Singier (no doubt its title, *La nuit de Noel* [1950], played a major role in the strong impression the work made on me).[1]

It amuses me in retrospect to notice how much these youthful choices reflected the nature of MNAM's collection at the time. Its strongest element was the bequest from an artist (Brancusi's studio), and it was, indeed, large gifts of this kind, engineered by the director, Jean Cassou, after World War II and inaugurated by Pablo Picasso's offering of eleven paintings in 1945, that then constituted the highlights of the museum's collection. The Léger ensemble, the cumulative result of many generous donations over the years (there were few purchases at this point), testified to the importance of a handful of benefactors without whom the historical part of the collection would have been a disgrace. Securing the Matisse cutout had been very difficult, involving a struggle between Georges Salles, director of Musées de France, and Cassou, on the one hand, and the state bureaucracy, on the other; and only the support of the artist himself finally made the purchase possible. (On the whole, Henri Matisse was very poorly represented—the bulk of the museum's holdings being the seven paintings bought directly from the artist, in 1945, only nine years before his death. My childish eyes had selected a work from the end of his career, but it might have been otherwise if stronger works from the 1905–17 period had been on display.)[2]

The Singier and the Riopelle had been bought by the state in 1951 and 1960, respectively, and were immediately allocated to MNAM. The Singier was typical: During the 1950s and throughout the 1960s, the French state's purchase of twentieth-century art was almost entirely geared toward the production of what was then called the "Nouvelle École de Paris," even though it was not so "new," as most of its practitioners had come to maturity during World War II. The large Riopelle (*Chevreuse*, 1954) was much more unexpected. But, upon reflection, it fits the chauvinistic sentiment that pervaded the French art administration at the time. The painter, though Canadian, was fully assimilated (he had been living in France since 1947 and his strongest supporter was

Georges Duthuit, Matisse's son-in-law). He had participated in the famous exhibition *Véhémences confrontées* (at the Galerie Nina Dausset in Paris in March 1951), where he had aligned himself with the French artists in the competitive comparison with Jackson Pollock and Willem de Kooning. True, the allover conception of his work was quite foreign to the landscapist half-baked abstraction of his Informel colleagues, and it had much more to do with Abstract Expressionism, especially in scale. But purchasing Riopelle's canvas had provided the administration with a good alibi: Why buy Pollock when one could obtain the "same thing" at home for less than half the price (the first Pollock did not enter the collection until 1972)? I don't want to sound unfair to Riopelle—his canvas was, and remains, impressive. But the politics that presided over its acquisition had little to do with the painting's intrinsic quality. (Many works purchased at the same time are today as embarrassing as the Singier—airport, or rather hotel, art, basically—and are now mostly confined to storage.) The structure of the institution was such then that the acquisition of a work of any importance either constituted a statistical miracle or represented the isolated victory of a persistent curator.

The seed of my interest in modern art was sowed during those early visits, although it remained dormant until my early teens, when I educated myself as best I could through the art books in my high school library. It is then that I began to realize the huge gaps in the collection of the Musée National d'Art Moderne, which I now visited alone very regularly, taking the overnight train to Paris as often as I could afford it. Seeing today what has become a spectacular collection, it may be difficult to understand how bad things were, and moreover for how long they remained so: It was only in 1974 (yes, 1974!) that the curators of MNAM were at last given the means to institute a concerted acquisitions policy. For what they have managed to accomplish in the twenty-five years since 1974, helped by the invention of the *dation* (a remittance of artworks in lieu of inheritance taxes) in 1968, they must be commended. During the visits of my teen years, I was particularly shocked at the absence of any work by Piet Mondrian, who had lived in Paris for more than twenty years, and whom I had discovered through Michel Seuphor's monograph. Seuphor, whom I met in 1966, fueled my anger when he told me that the donation of a Neoplastic painting had been personally nixed by André Malraux, the minister of culture. According to Seuphor, Malraux had said: "Moi vivant, ça jamais!" The Caillebotte affair all over again, I thought.[3] The first Mondrian, the purchase of which Dominique Bozo fought for mightily, did not enter the collection until 1975. I was also immensely frustrated at the lack of Dadaist works, and the absence of anything American. As Bozo notes, in 1961, the collection included only a single work by an American artist, Alexander Calder (and he lived in France half the year), although, from 1947 on, the museum had acquired

1,000 paintings and 300 sculptures).[4] Basically, nothing had changed since my childhood visit—only now I was better informed, and thus disappointed. The collection was still centered on the great masters (Braque, Léger, Matisse, Picasso, etc.), yet it contained few key works by them since the purchases were made so late (prices had become prohibitive), and the walls of the museum kept filling up with canvases by the now very old-looking Nouvelle École de Paris.

The year immediately after high school, 1969–70, which I spent in the United States as an exchange student, perfected my disillusion. Visiting the galleries of the Museum of Modern Art (MoMA), New York (where I also saw Frank Stella's big retrospective in 1970), and the architecture of the Solomon R. Guggenheim Museum, New York, so opposed to that of the pompous neoclassical Palais de Tokyo, made me ashamed of my country (even if, politically—to my great astonishment, as not long before I'd been on the barricades—I felt obliged to defend Charles de Gaulle's anti-American position regarding the Vietnam War). I remember having to return to the Guggenheim several times in order to see its permanent collection, which was often whisked away to make room for temporary exhibitions. It was a fabulous time to be in America for anyone fascinated with contemporary art. Post-Minimalism and Conceptual art were at their height; the gallery scene was buoyant, with the museums trying their best to keep up. Going back to France, after such a cure, was painful. But now I wanted to understand why everything seemed so stale. In particular, I wanted to know why Paris, the birthplace of so many of this century's important works of art, had no museum that could compare with either MoMA or the Guggenheim. Why was MNAM so tragically lethargic and antiquated?

I was not yet trained as a historian, had no archival skills, and the responses to my queries—mainly from artists, but also from a few critics, who had long thought the situation hopeless—were biased by politics. The right-wing government was prima facie detested by most of the intelligentsia; and museum curators, thought guilty by association, were deemed its accomplices. I too jumped on the bandwagon, not able to recognize the paradox that, at that very moment, Georges Pompidou, who became president of France in 1969, was beginning to free MNAM from its straitjacket. Only much later, when I read Jeanne Laurent's extraordinary book *Arts et pouvoirs en France de 1793 à 1981: Histoire d'une démission artistique*, was I able to fully understand the situation and how it had arisen.[5] Although her major argument was against the Académie des Beaux-Arts, which still had a powerful hold on the French cultural bureaucracy (it would only begin to lose it after the election of François Mitterand to the French presidency in 1981), Laurent examined in detail the circumstances behind the disastrous arts policy of the French government from the French Revolution on. And, to my surprise, she completely exonerated the museum's successive directors and curators of responsibility for the blatant inadequacies of

MNAM's holdings (she is perhaps a bit too diligent in that regard, but she had a case to make).[6]

I peruse the checklist of *Rendezvous: Masterpieces from the Centre Georges Pompidou and the Guggenheim Museums*, concentrating on the works that will be exhibited in the main galleries. Interestingly, one of the effects of this parallel crash course in the history of Modernism is to make the two collections—that of the Musée National d'Art Moderne and that of the Guggenheim—look oddly similar. I wonder, for a moment, whether the moral of the tale is that, in the end, there is no fundamental difference between the state museum and the capitalist, private, entrepreneurial foundation since the results they attain are the same.

Such a conclusion, however, would ignore a major historical factor inherent in the tale—the labor performed over time by works on display in a public collection. For it is not the same thing to have seen a great early Kandinsky or a classic Neoplastic Mondrian in the 1930s, as New York museum goers could have done on a permanent basis, and to be exposed to such works forty years later. Writing about the French government's lamentable auctioning, between 1921 and 1923, of about 1,500 works confiscated from the stock of the Kahnweiler Gallery as "enemy property" during World War I, and about Cassou's and Salles's damage-control efforts after World War II, Laurent notes that this act of deliberate sabotage prevented the French public from seeing any masterpieces of Cubism until 1947: "Such a delay is irreparable. What would have been living nourishment in 1919 belongs, in 1947, to the class of archaeological treasures."[7]

The Musée National d'Art Moderne was created in 1945 (it officially opened in 1947), but the idea for such an entity had been in formation over a period of more than ten years. As early as 1934, a plan had been conceived to merge two collections: that of the Musée du Luxembourg, or "Musée des Artistes Vivants," which had been created in 1818, and that of the Musée des Ecoles Étrangères Contemporaines at the Jeu de Paume, created in 1922 (but not opened until 1932). The Musée du Luxembourg had long been the stronghold of the Académie des Beaux-Arts, and in her book Laurent exposes in detail how scrupulously its curator, the conservative Léonce Bénédite, followed the orders of Paul Léon, director of the Beaux-Arts administration, who had declared a war against modern art.[8] The museum at the Jeu de Paume, however, had an independent budget, with funding from other sources, such as the Ministry of Foreign Affairs, and it quickly became a bastion of emancipation from the very powerful yet underground domination of the Académie des Beaux-Arts. The museum's curator, André Dezarrois, was sensitive to modern art and began to assemble a modest collection. It is thanks to him, for example, that the first Picasso, *Portrait of Gustave Coquiot* (1901), acquired by gift, entered the national collections. He also hosted a series of remarkable exhibitions.[9]

The two institutions could not have been more antipodal, and it is an understatement to say that the Académie des Beaux-Arts was opposed to the merger. But thanks to the Front Populaire government's support for the principle of a museum of modern art, the Académie failed to abort the plan (although it managed to impose a conservative architect for the Palais de Tokyo, which was built in 1937). The Académie received a further blow in 1938, when Cassou was appointed assistant curator at the Musée du Luxembourg, with the mission of supervising work on the Palais de Tokyo, which had been so poorly built that it needed major reconstruction before it could house a permanent collection.

The Vichy government interrupted Cassou's work (he was sacked), and he did not really get started until 1945, with the full support of his superior Salles, who was himself a collector of modern art (MNAM's great *Portrait of a Young Girl* [1914] by Picasso was a personal bequest from him). For two years, the two men, as heroes of the Resistance, were unstoppable. (The Académie des Beaux-Arts, momentarily silenced for having been too ostentatiously collaborationist during the war, had to toe the line.) Managing to obtain special credits for the occasion, Cassou and Salles launched an acquisitions campaign, supplemented by donations they judiciously secured through the old technique of "I'll buy four, you give me one." The results were stupendous: seven Matisses (among them the 1941 *Still Life with a Magnolia*), five Braques, two Brancusis, two Bonnards, a 1915 Gris, several works given by Joan Miró, etc. The ball was rolling. Unfortunately, it soon stopped. Once the special funds had been exhausted, there was nothing to be done except go the bureaucratic route, with predictable and disappointing results. Not until the end of 1974 was MNAM detached from the overall Direction des Musées de France and, at last, given an autonomous acquisitions budget by the government. Until then, if one excludes bequests, gifts, and the first *dations*, acquisitions were entirely dependent on the caprices of two external committees. The first, the Conseil artistique des musées nationaux, was involved almost exclusively with the work of dead artists. Although the director of MNAM (or a curator) regularly took part in the committee's meetings and had the support of Salles, the competition for funds involved all the national museums. It is not difficult to guess, given the conservatism of the profession in those years, where the votes would go if the purchase of a Mondrian, say, was weighed against that of a Boucher. The second committee, which dealt with living artists, was the Direction des arts plastiques (later rebaptized the Direction des arts et des lettres). Most of its members were uninformed bureaucrats easily manipulated by the Académie, whose power had been reinforced, in 1959, by Malraux, contrary to his legend as a "revolutionary."[10] MNAM had no direct say whatsoever in the workings of this second committee, and had to be extremely discreet when applying diplomatic pressure, in order to avoid a backlash.

Despite such unfavorable conditions, Cassou and his team were able to secure important donations during the 1950s and early 1960s, but these very successes prompted a different kind of opposition: Why buy, reasoned the state, what we can get for free? In 1965, a frustrated Cassou resigned, soon followed by his brilliant second, Maurice Besset, the only curator at that time well informed in the international development of art. Besset was not replaced, and another curator, Bernard Dorival, whose views were ultranationalist, if not racist, and whose taste was utterly provincial, became director of MNAM.[11] His tenure represents the darkest years of the museum and its acquisitions policy: Not a single work was bought for MNAM by the Conseil artistique des musées nationaux, and only a handful were purchased by the other committee.

It was only after the political seism of May 1968 that the situation began to change. At the end of that year, Jean Leymarie replaced Dorival as the head of MNAM and was given the means to assemble a new team of curators, including Bozo and Isabelle Monod-Fontaine, both well-versed in the history of twentieth-century art. Concurrently, however, the Centre National d'Art Contemporain was created as an organ wholly independent from MNAM, with the mission of exhibiting and purchasing contemporary work. While this entity allowed for the circumvention of some bureaucratic red tape,[12] it left MNAM even more insulated from current art, which was now entirely outside the museum's mandate. MNAM took a more aggressive stance in order to secure donations and purchases from the two committees (for example, during this period, it acquired Matisse's four *Backs* [1909–30], its first Pollock [*Silver over Black, White, Yellow, and Red*, 1948] and Gorky [*Landscape Table*, 1945], but that was all it could do).

The departure of Malraux (with the election of President Pompidou, who was known to be deeply interested in twentieth-century art) encouraged Leymarie and his team to press their case: Compared to the collections of many of its European counterparts, not to mention those of museums in the United States, MNAM's was a collection of holes, a situation that might have been avoided had it been granted both financial autonomy and full independence from the politically appointed bureaucracy.

Georges Pompidou launched the idea of the center bearing his name in October 1970. It took four years to meet the conditions for the necessary aggiornamento. In 1974, Pontus Hulten, who could not be accused of French chauvinism, was appointed head of the museum, with the mission of preparing its transfer to the huge building being erected on the Plateau Beaubourg. At this juncture, MNAM was finally granted the autonomy it had been requesting since 1945, and it immediately began buying aggressively: Many Dadaist, Surrealist, abstract (including Abstract Expressionist), and Pop works entered the collection during these interim years, before the 1977 inauguration of the

Centre Georges Pompidou. Hulten also urged the creation of a department of photography, which was established in 1975,[13] and a department of video, which was created in 1976.[14] Starting almost from scratch, these two departments have managed to acquire impressive holdings over the intervening years.

With the election of President Mitterand in 1981, MNAM saw its acquisition budget doubled and, with the help of the *dation* system and the numerous donations engineered by Bozo, who was director from 1982 to 1986, many crucial gaps in its historical holdings were filled. (For example, *Luxe, calme et volupté* [1904–05]; *French Window at Collioure* [September–October 1914]; *Portrait of Greta Prozor* [late 1916,]; and *Auguste Pellerin II* [1917], four important pre-Nice works by Matisse, were added to the collection during this period.) At the same time, conscious of its poverty in this regard, MNAM made a real effort to acquire many works of contemporary American art, while not forgetting its French and European counterparts. The year 1982 also saw the creation of the newest department in the museum, the cinema department, which, in record time, has amassed a vast collection of experimental films, from the heyday of Dada to the underground movies of the 1960s and beyond.[15]

Finally, if belatedly, institutional apparatuses were now fully in place to ensure a steady increase in the museum's collection. The exhibition *Manifeste, 30 ans de création en perspective, 1960–1990*, hastily organized in 1992 at Bozo's request, revealed to the public the amplitude of the acquisitions made during the previous decade. Simultaneously, Bozo, then president of the Centre Georges Pompidou as a whole, decided that the Centre de Création Industrielle, responsible for the collections of architecture and design and until then independent from MNAM, should become a department of the museum.

It had taken almost a half-century for the Musée National d'Art Moderne to develop the means of housing a truly multimedia collection and to be worthy of its name. The damage resulting from the delay in the formation of the collection of twentieth-century art, denounced by Laurent in her book, has not, however, been repaired. It cannot be. But perhaps, if the museum continues its good work, new generations of kids brought to the museum by their mothers will not notice its effects.

First published in Bernard Blistène and Lisa Dennison, *Rendezvous: Masterpieces from the Centre Georges Pompidou and the Guggenheim Museums* (New York: Guggenheim Museum Publications, 1998), 41–47.

1.  [Addition 2021] Advice to parents: Childhood encounters with a work of art can leave indelible traces. When I wrote the present essay, I had not seen the Singier painting since that early visit to the museum, nor a reproduction of it, but I remembered it so well that when I wrote about it to Isabelle Monod-Fontaine in order to get its title and the exact name of the artist (I was hesitating between Singier and Alfred Manessier), my description was so precise that she was immediately able to identify the work. As for the Riopelle, I saw it again at the occasion of the retrospective of his work at the Centre Georges Pompidou (October 1–November 16, 1981), held at the same time and on the same floor as a Robert Ryman exhibition for the catalogue of which I had written the lead essay. It was visible from afar, and I recognized it instantly.

2.  From those years, there were only *Le Luxe I* (summer 1907) and *The Painter in His Studio* (1916), both bought from the artist in 1945, as well as *L'algérienne* (1909). These are fine paintings, but far from giving a sense of Matisse at his best. The great *Interior with a Goldfish Bowl* of 1914 came to the museum only in 1965 (as a bequest), several years after my visit.

3.  In 1894, Gustave Caillebotte made a bequest of his collection of sixty-nine Impressionist works to the French state. The administration tried to turn down the bequest, but, after an uproar, was forced to accept part of it. In the end, twenty-nine works were refused.

4.  Dominique Bozo, preface, *La collection du Musée national d'art moderne* (Paris: Éditions du Centre Georges Pompidou, 1987), 18.

5.  Jeanne Laurent, *Arts et pouvoirs en France de 1793 à 1981: Histoire d'une démission artistique* (Saint-Étienne: Centre interdisciplinaire d'études et de recherches sur l'expression contemporaine, 1982).

6.  Bozo, who was passionate about raising the quality of the Musée National d'Art Moderne's collection, was very fond of Laurent's study, to which he pays due homage in his preface to *La collection du Musée national d'art moderne*, featuring highlights from the museum's collection. Bozo is no more tender than Laurent toward the administrative system that had engendered the situation he was so instrumental in overturning.

7.  Laurent, *Arts et pouvoirs*, 134. In fact, the real date is not 1947 but 1952, the year of André Lefevre's donation.

8.  As Laurent shows, Léon was fully responsible for, among other disasters, the Kahnweiler sales of 1921–23. In flooding the market with more than 1,500 works by, among others, Braque, Juan Gris, Léger, and Picasso, Léon's purpose was to devaluate Cubism. His plan failed: Prices did not plummet, though they were much lower than prewar levels. Many fortunate buyers—for example, Raoul La Roche—later gave some of their purchases to MNAM. But a footnote in Laurent's text is quite telling: "Braque's *Man with a Guitar* (1914), bought for 9,000,000 francs by the Musée National d'Art Moderne in 1981, was sold for 2,400 francs at the first Kahnweiler sale, on June 13, 1921" (which, if my calculations are correct, is approximately a thousand times less in constant value, adjusted for inflation) (ibid., 121).

9.  The exhibition *Origines et développement de l'art international indépendant*, mounted on the occasion of the 1937 *Exposition internationale*, Paris, was a notable survey of the history of art from 1900. Striking in its inclusiveness and refusal of national criteria, it included works by, among others, Brancusi, Giorgio de Chirico, Max Ernst, Julio Gonzalez, Paul Klee, Joan Miró, and Mondrian, as well as Picasso's *Ma Jolie* (1911) and Matisse's *Moroccans* (1916), both now in the collection of the Museum of Modern Art, New York, and Wassily Kandinsky's

*With the Black Arc* (1912), bequeathed to MNAM by the artist's widow in 1976. The French public would have to wait until 1960 and *Les sources du XXe siècle: Les arts en Europe de 1884 à 1914*, the landmark exhibition organized by Cassou at MNAM (but, crucially, with financial support from the Conseil de l'Europe, that is, independent of the French bureaucracy), to again see such an accumulation of key historic works.

10. As soon as he arrived in power, Malraux appointed an academician, Jacques Jaujard, to head the Direction des arts et des lettres. On Malraux's action, see Laurent, *Arts et pouvoirs*, 158–64. Laurent describes Malraux's policy toward MNAM as one of deliberate asphyxia.

11. Dorival's nationalist views are endlessly expounded in his three-volume *Les étapes de la peinture française contemporaine* (Paris: Gallimard, 1946), as well as in numerous articles. This quotation dates from May 1945, a time when one would have expected any proponent of the racial theory of art to keep his own counsel: "Here the Slavs and the Spaniards, Juan Gris and Picasso above all, whose works unite Zurbaran's tension and the pure-bred nervousness of Velasquez with the schematic and dry elegance of the Islamic art at Cordoue. There the Frenchmen, more faithful to the real, such as Lhote and La Fresnaye, or to the 'beautiful handiwork,' such as Villon and Delaunay, exquisite colorists, or Léger, flawless practitioner. Between the two groups, Braque, too much Picasso's friend not to be seduced by the abstract refinements of this Oriental, and too French not to share with Villon and La Fresnaye their taste for an art all in nuances" ("Le Cubisme," *Les Nouvelles Littéraires*, May 31, 1945).

I owe this reference to Gerte Utley, whom I thank for having made her PhD dissertation available ("Picasso and the 'Parti de la Renaissance Française': The Artist as a Communist, 1944–1953."

New York University, Institute of Fine Arts, 1997). As Utley shows, this type of discourse, notably the portrayal of Picasso as an "Oriental," was pervasive in contemporary right-wing journals. See also the book that came out of her dissertation, *Picasso: The Communist Years* (New Haven: Yale University Press, 2000), 92ff.

12. The Centre National d'Art Contemporain's purchases, which also included historical works, among them a large de Kooning drawing (*Woman*, 1951) and a Rothko canvas (*Dark over Brown, No. 14*, 1963), were eventually merged with MNAM's collection with the creation of the Centre Georges Pompidou.

13. See Alain Sayag, ed., *Photographies 1905–1948: Collection de photographies du Musée national d'art moderne* (Paris: Éditions du Centre Georges Pompidou, 1996). With the exception of Brancusi's photographs of his works, which were part of the artist's bequest to the French state in 1957, MNAM owned only two photographs as late as 1975.

14. See Christine Van Assche, ed., *Vidéo et après: La collection vidéo du Musée national d'art modern* (Paris: Éditions du Centre Georges Pompidou, 1992).

15. See Jean-Michel Bouhours, ed., *L'art du mouvement: Collection cinématographique du Musée national d'art moderne* (Paris: Éditions du Centre Georges Pompidou, 1996).

Christian Bonnefoi, *Babel,* 1979.
Acrylic and graphite on tarlatan, 39 3/8 × 51 3/16 inches.

# The Pin

*I met Christian Bonnefoi in Hubert Damisch's seminar at the École des Hautes Études en Sciences Sociales, which I began attending in the fall of 1971. As far as I recall, we did not encounter each other at the very beginning of the academic year, and it may have been through Martine Deborne—Christian's first wife, like me a student of Roland Barthes—that I was made aware of his presence in the group. (Martine was a brilliant literary scholar who died tragically young; I greatly admired her, but we were not particularly close, and I do not remember seeing her in Christian's modest apartment for graduate students in the Résidence Universitaire d'Antony when he invited me there and showed me his first paintings and collages.)*

*At the time, Christian was a full-time art historian, writing a dissertation on the modernist architect Robert Mallet-Stevens, which he finished in 1974 but, alas, never published. This extraordinary piece of work, advised by Jean Laude, then the only full professor sympathetic to modern art in any Parisian university, was rich in rigorous descriptions and novel analyses. By the time Jean Clay joined Damisch's seminar at my urging, I had become a good friend of Christian's, and the three of us took up the habit of going to a café immediately after the end of each seminar session to continue to debate all that had just been discussed.[1]*

*This went on until 1976, when we stopped attending the seminar and Jean and I launched* Macula, *a short-lived journal (with four issues annually) that we edited until 1979. It had become clear that we could not indefinitely hold onto the privilege of attending Damisch's seminar while a growing number of students, quite a few of them international, were envying our spots and banging at the door; but we had become addicted to our post-session colloquies. Jean and I had often toyed with the idea of starting a journal, and Christian's enthusiasm at this prospect was pivotal in our decision to do so. By then he had resolutely switched from art history to painting and was already preparing a solo exhibition, but the originality of his take on artists whose work we knew well (from historical figures like Piet Mondrian and Josef Albers to contemporaries such as Robert Grosvenor, Martin Barré, and Robert Ryman) was astounding, and it would have been natural for him to have joined us as an editor.*

*I do not remember why this did not happen. Maybe he preferred to remain on the sidelines, especially since we were committed to supporting his art practice, or perhaps he realized that editing a journal entailed an enormous*

*amount of labor that would distract him from his studio work. Whatever the case, his voice, directly or not, was very present in the journal to which he regularly contributed, culminating in the last issue with a dense thirty-page interview of him by Jean and me as well as an essay of my own (an essay that, in retrospect, I find too much of a period piece, with its convoluted prose, to include in the present volume, preferring instead this shorter, slightly later text, less affected by Gongorism).*

*Christian remained a close friend even after I left France for the United States in 1983. We meet each other, here or there, almost every time we find ourselves on the same side of the Atlantic, and I try to keep abreast of his production, both in writing and in painting. Over the years, he has been crucial to the development of many ideas I have articulated about painting—particularly concerning Mondrian and Ryman—but also concerning sculpture and architecture.*

●

It is in a 1978 essay on Robert Ryman that Christian Bonnefoi alluded for the first time to the pins one can see in some of Picasso's Cubist *papiers collés*, and since then he seems to have been haunted by them. In almost every one of his texts he pinpointed them, so to speak (and this is more than just a pun). To pinpoint Picasso's pin—this should have been the art historians' or critics' task. The Spanish artist himself, pedagogue-like, relentlessly suggested its importance: Isolated as it is in the geometric center of *Musical Score and Guitar*, one of the very first of his *papiers collés* (1912, Daix 520, Musée National d'Art Moderne, Paris), the pin is too obvious to miss; impossible too not to see the dozen or so pins seaming *Bar Table with Guitar* of 1913 (Daix 601, private collection, Saint Louis).[2] Picasso adds pins to the point where they can't be ignored. In some of these "pasted papers" (without paste), he even stresses the opposition between the pinned-up fragments and those that are drawn (*Céret Landscape*, 1913, Daix 612, Musée Picasso, Paris). But when someone did finally notice his pins, more often than not it was to ascribe them to some kind of bohemian rush, to some kind of poetic "anything goes" when it comes to handicraft and technical matters: As late as 1933, Brassaï tells us, Picasso had to "really insist" that the pushpins of his collage for the cover of the first issue of *Minotaure* "also appear" in the reproduction (one can well imagine Albert Skira, the young publisher of this luxury journal, balking at the prosaic look of the thumbtacks).[3] Until Bonnefoi, no one, to my knowledge, had hinted at what is at stake in Picasso's basting stitches:[4]

Picasso's pin "collages" dissociate the preconceived unity of the surface. To a syntagmatic division of the surface (according to the lateral and extensive

236

mode of space), they oppose a paradigmatic division, that of one layer on another (intensive mode in the direction of thickness: Mondrian).[5]

In the cubist collages, the main issue was not to perpetuate the figurative tradition by the invention of a new technique which would be more visual, but to affirm that the surface is not and had never been a background, a certainty, a place of evidence: that it can be divided in itself, and is thus open.[6]

What Bonnefoi discovered in Picasso's pin was the possibility of a new relationship to history. On the one hand, the pin pinpoints the essentialist naiveté of a certain modernist discourse (Greenberg's, of course, but long before him that of Malevich, of the "classical" Mondrian [1921–32], and of all those who conceived the surface of the canvas as the ahistorical zero degree of painting); on the other hand, the historicist theory in which this essentialism was grounded is itself defeated and a new genealogy—monumental and fragmentary—can emerge: no more "inevitable evolution" of the art of painting toward its end, conceived as a return to its origin (the absolute unveiling of the zero degree as the future and final horizon of painting, the steadfast conquest of flatness from Manet to Stella), but rather a sifting of the pictorial tradition from the standpoint of the pin, and partial appeals to nonpictorial practices. On the pictorial side, we have the granular relief of Seurat's drawings and of Josef Albers's Masonite boards; the transparent veils of Louis Hayet; the cast shadows of László Moholy-Nagy; the adhesive tapes of the late Mondrian; all of Ryman, etc. On the extra-pictorial side, we have the projected screen of the architect Robert Mallet-Stevens; a film sequence by Marcel L'Herbier; the space inside the double membrane constituting Brunelleschi's dome in Florence; Louis Kahn turning columns inside out, like gloves.[7]

The standpoint of the pin is slightly Borgesian: Surfaces have a thickness, it says. Contrary to what Saussure seemed to think (but his secret passion for anagrams shows that he had doubts about such a surface economy), there is a space between the recto and the verso. After Picasso's intuition, Mondrian would further explore just such a space in his last works (for Mondrian, it was a question of destroying the surface's entity so as, paradoxically, to prevent its optical hollowing out—something he had found no way to avoid in his classical neoplastic canvases); then, although slightly less so, it was Pollock's turn to pursue the search with his drippings.[8] But I'd like to insist here on what I'd call the "expanded" standpoint of the pin (and which Bonnefoi calls "the division of division"), for it is there, it seems to me, that we find the focus of his pictorial energy during the last fifteen years.

To sum up: The standpoint of the pin is that of a division of the surface in its thickness (material depth); it involves a lamellar stratification. Now, the division

of the surface has been a major stumbling block for modernism. A satisfying solution was found (a positivist one), but it has consisted in positing the system as achieved once it is coiled back onto its beginning (modernism divided the surface into surfaces). A way of motivating the arbitrariness which underlies all composition had to be discovered (by composition I mean the rhetorical and hierarchical division of the pictorial surface into parts that has been in use since the codification of the Renaissance). The modernist solution was to abolish composition either by suppressing division per se (the monochrome) or by adjusting this division so that it became an index of the surface in question (modular grid; symmetry; deductive structure; adequation of figure and field). With these various solutions, the system "easel-painting" finally became self-reliant, closed off; henceforth, only two possibilities were available: either the repetition and lateral extension of these formal structures (in the series) or the pure and simple relinquishment of the pictorial surface per se and switching to object-making (the monochrome painting, inasmuch as it is a readymade, facilitates this process): Such a paradigm delimits the field of the modernist tradition that led to Minimalism. In contrast, Bonnefoi's work does not try to escape the closed-off system of easel-painting; rather, it tries to defer its closure, to delay it ad infinitum. To abolish the division of the surface, Bonnefoi divides it in its thickness. His canvas becomes a kind of napoleon cake, his practice that of Scheherazade or Penelope:

> If the surface or the edge of the canvas appear objectively and inevitably as limits beyond which there is nothing or something altogether different (this "something else" would be the nickname of the current avant-garde), it is precisely there that the iconoclastic operation has to take place, and not in the more or less successful composition within these limits.[9]

> The idea of exceeding the work's boundaries internally, linked to a problematics of the symbolic and of temporality, is opposed to exceeding these boundaries externally, which is linked essentially to a problematics of the object and of space (proposed by Minimalism and the subsequent avant-gardes).

> The idea of a perpendicular extension in the plane replaces one of lateral and successive extension, which was the basis of the avant-garde principle of seriality.[10]

I have written elsewhere on the mode of temporality implied in Bonnefoi's paintings of the *Babel* series, a mode that is a direct function of the standpoint of the pin,[11] and Georges Didi-Huberman similarly insists on this issue in his beautiful essay on the painter.[12] As for what Bonnefoi calls the symbolic, it is

related to what I said above about history: The "expanded" standpoint of the pin sideswipes the whole institution of painting, all the painter's gestures, all his processes, that is, everything that constitutes the symbolic order of painting (the tradition, the Law). This standpoint could be defined as a formalist device (in the sense of the Russian Formalists and of *ostranenie*), a device meant to de-automatize: The standpoint of the pins seeks to denaturalize everything, from the simplest to the most complex, and to restore everything to history as malleable material. But the main goal of this kind of intensified formalism is to counter any formula, to prevent any stasis.

> The division is for me a recurrent operation that takes hold of all the material and historical givens, from the origin of the act of painting to the painter himself, the painter who can no longer envisage a direct relationship to his canvas, a gesture that would simply apply some paint. The division goes even as far as dissociating the gesture itself.[13]

Faithful to Ryman, whose lesson he has understood perhaps better than anyone else in France, Bonnefoi is primarily concerned with the status of the pictorial gesture. But while even with Ryman an indexical relationship remains established between the gesture and its trace on the canvas (the relationship is endlessly stretched, the casual link thinned out, but the thread never quite cut), Bonnefoi seeks to divide the gesture in depth, in the same manner that he had divided (the division of) the surface. He tries to multiply the productive agency of the gesture, to dig an unbridgeable gap between its origin (the body of the artist in motion) and its result (the brushstroke on the canvas). Whatever the mode, and there have been many variations over the years, the *Babel* paintings are conceived as delayed action, in at least two stages. This would not be new in itself, if these (at least) two stages were subsumed in a unitary synthesis: With one proviso, the principle of the *Babel* canvases is similar to that of Pollock's drippings. On the one hand, Pollock also articulates his paintings in depth (he actually fails as a painter when this articulation in depth is lacking, when he simply divides his surface into surfaces); on the other hand, his inter-lacings are conceived atomically: The movement producing any given dripped line on the canvas is *temporally* independent from the one producing a neigh-boring or anterior line in another color, since the layers of various color are each painted one at a time—which does not preclude the possibility of having several layers of the same color (first the black dripping, for example, then white, then blue, then silver, then maybe again the black, etc.). But (that is the proviso) this temporal independence is held in check by the painter's control over the color division of his canvas, both in its surface and thickness: I put the silver drip here or there because it will contrast or harmonize with a given black or a blue that I

might have already dripped here or there. In other words, the temporal gap (the division of the gesture) is abolished in the great final synthesis, and by the same token the division in depth is canceled out, flattened. What remains is the spatial unity of the all-over. Despite the fact that he wanted not to know what he was doing while he was actually painting (or so he said), Pollock could not fail to know—as Albers shrewdly noted when, in the photographs of the East Hampton studio, he pointed out the ladder on which the painter climbed to assess the overall effect of such and such a drip on his canvas spread out on the floor.[14] Pollock could not fail to know, that is, to see, what he was doing.

Bonnefoi learned a lot from Pollock (although he never talked much about him). He started with this blind spot in the dripping process: The standpoint of the pin is not enough to abolish the composition if it is not expanded to the other pictorial instances (if one does not go beyond the opposition between surface and depth). Bonnefoi's conclusion is that to elude this blind spot, one has to blind oneself, and it is as a blind man that he carried out his *Babel* canvases. Through all kinds of procedures, the painter prevents himself from seeing what he is doing when he is doing it: Impossible to know in advance if this blue trace will be alongside, above, or under this black or white or silver trace. All he knows is that there will be color traces, and he will have the privilege of being his first spectator (a bit like a potter discovering with pain or delight the chemical caprices of enamels when he empties out his kiln).

Yet Bonnefoi does not indulge any more than the potter in a cult of lack of control: I do not think that the painter, in his capacity as his first spectator, renounces the privilege of discarding a painting that "does not work." The process, while it is partly conceptual, is above all intended to open up the system of easel-painting: not to surpass it, but to render it infinite. One could even say that it is in the gap between this productive blindness and the perception of the spectator that Bonnefoi's fundamental question lies: How can one show the invisibility constituted by the division of the division? Even when it is not expanded, the standpoint of the pin is not easily accessible—the lack of attention given to Picasso's pin bears witness to this. Needless to say, Bonnefoi's all-encompassing needlework is almost imperceptible. It is also almost impossible to theorize, to demonstrate, and above all to translate in formal terms (very early on, Bonnefoi noted that the stylistic effects of his work—here "gestural," there "geometric"—had no relationship whatsoever with what he was pursuing). Hence perhaps the somewhat esoteric nature of the painter's declarations, his idiosyncratic use of certain words borrowed or rather misappropriated from the language of mysticism. I would say that his painting is conceived as a gamble: What Bonnefoi does is to work within a gap while knowing perfectly well that the actual perception of this gap would mean the end of his enterprise. The whole status of seeing in painting is suspended or

rather divided in itself: a painting that would not make us see but rather think the infinite division of its "material and historical" givens, a painting that would help us pinpoint its technical—that is, conceptual—data.

First published in *Bonnefoi: La stratégie du tableau/The Strategy of the Picture* (Madrid: Galerie Alfredo Melgar, 1992), 14–17.

The Pin

1.  For a description of Damisch's seminar and the kind of afterthoughts its ebullience elicited among its participants, see "Tough Love" in this volume, 155–66.

2.  Daix is an abbreviation for Pierre Daix and Joan Rosselet, *Picasso: The Cubist Years 1907–1916, A Catalogue Raisonné of the Paintings and Related Works* (London: Thames and Hudson, 1979).

3.  See Brassaï, *Conversations with Picasso*, trans. Jane Marie Todd (Chicago: Chicago University Press, 1999), 9. For what concerns me here, the pin and the pushpin (or thumbtack) are far from identical (the couture connotation—above/under, basting, weaving: all that fascinated Bonnefoi in the pin—disappears with the pushpin). But when one considers the heterogeneous violence they entailed (an industrial object entering the realm of art) and the kind of censorship which was the fate of such heterogeneity (the fact that nobody seems to have noted these pins in Picasso's "collages"), the two objects are similar, the pushpin being even more "proletarian" than the pin (the fat pushing thumb being set against the fine fingers of the tailor).

4.  As this essay was going to press, Christine Poggi sent me the manuscript of her forthcoming book, *In Defiance of Painting: Cubism, Futurism, and the Invention of Collage* (New Haven: Yale University Press, 1993). On pages 10–11 of the published version, she notes that Picasso's pins are like an answer to Braque's famous trompe-l'oeil nail in *Violin and Pitcher* of 1909–10 (Kunstmuseum, Basel), a trompe-l'oeil whose function was, by contrast, to affirm the planarity of the picture plane, according to the classical interpretation provided by Clement Greenberg. Braque's device was illusionistic (a studio trick), while Picasso's pin does the same job without any recourse to illusion. Because of its non-illusionism, the pin opens onto the negation of the surface as an entity.

5.  Christian Bonnefoi, "Notes on Collage," November 1990 (unpublished).

6.  Christian Bonnefoi, "Communication pour le séminaire," *Sfr* 1 (special issue on Bonnefoi) (October 1990): 7.

7.  Most of these examples are provided by Bonnefoi in full-page illustrated inserts added to "Sur l'apparition du visible," a long interview with Jean Clay and myself in *Macula* 5/6 (1979): 194–228; reprinted in Christian Bonnefoi, Écrits *sur l'art* (Brussels: La Part de l'Œil, 1997), 159–217. On Albers, see Bonnefoi, "La fonction Albers," *Macula* 2 (1977): 88–92; reprinted in *Écrits sur l'art*, 51–58. On Ryman, see Bonnefoi, "À propos de la destruction de l'entité de surface," *Macula* 3/4 (1978): 163–66; reprinted in *Écrits sur l'art*, 109–14.
    [Addition 2021] Concerning the least well-known items to which Bonnefoi alludes: Louis Hayet was a Neo-Impressionist whose paintings on muslin were placed on varying "backgrounds of solid primary hues which would show through the weave of the thin material," to quote Robert Herbert in the catalogue of the exhibition *Neo-Impressionism* that he curated at the Guggenheim Museum in 1968 (p. 63), a book which Clay brought to Bonnefoi's attention. The allusion to Mallet-Stevens refers to his *Pavillon de l'électricité* at the World's Fair of 1937 (in Paris), whose curved facade was dominated by a gigantic white plane onto which, at night, bright light was projected. The film by Marcel d'Herbier that had struck Bonnefoi (for its ghostly sequence of shadows moving on a ceiling in parallel to the action of the main characters) is *L'Argent* (Money), from 1928.

8.  See my essay "Mondrian: New York City," in. *Painting as Model* (Cambridge, MA: MIT Press, 1990), 157–83. On Pollock, see Jean Clay, "Pollock, Mondrian, Seurat: La profondeur plate," in Hans

Namuth, *L'atelier de Pollock*, 2nd ed. (Paris: Macula, 1982), unpaginated.

9. Christian Bonnefoi, "Communication pour le séminaire," 9.

10. Ibid., 11.

11. See Yve-Alain Bois, "Le futur antérieur," *Macula* 5/6 (1979): 229–33; reprinted in Bonnefoi, *Écrits sur l'art*, 257–65.
[Addition 2021] The process used by Bonnefoi in the works of this series, as well as many that followed, is complex, but the most important point is that a patch of paint that appears to have been applied last or a gesture that appears to be the last mark (because they are materially on top of the others) is in fact the very first, chronologically speaking. I quote from this early essay: "The painter covers a sheet of plastic mounted on a stretcher with white or gray paint. He then invades this smooth and monochromatic surface with charcoal scribbling. Then, covering this expanse with a piece of tarlatan fabric (akin to cheese-cloth), he draws broad gestures or patches with a paintbrush soaked with glue that penetrates the fabric and adheres it in drying to the film of pigment on the plastic. Next, pulling up his transparent (or rather open weave) canvas—as one would peel off a fresco in order to display it in a museum or to restore it—the artist removes *all at once* all the glued surfaces, detaching the pigment from its original support (the plastic sheet) and imprinting these areas [which I then called 'atoms' because they are discrete and indivisible] on the underside of the tarlatan. [ . . . ] After having been raised by the glue, that which was formerly on the back of the canvas finds itself inscribed on its front, without having carried out any reversal: a stencil created in a reverse manner. The operation is repeated several times, with a possible re-covering (partial or total) of the plastic sheet between each turn, until the fabric is saturated with the atoms. But during the operation, once the tarlatan is resting on the smooth sheet of plastic (clear of paint in the areas where it has been lifted by the glue), the artist cannot predict the visual effect that his second gluing will produce on the canvas: at this point, the field of inscription is *always already saturated* by what one sees in transparency through the tarlatan. Indeed, supposing that the voids left on the plastic by that which was removed by the glued tarlatan are not filled up again with a new coat of pigment, this openness will be concealed from the painter by the transfer—more or less exact—of the two surfaces, one over the other (the positive imprint adjusts itself to the negative imprint): the 'false tears' visible on the finished canvas are the result of an 'incorrect' registration, a fortuitous circumstance due to inevitable fluctuations in the tension of the fabric."

12. See also Georges Didi-Huberman, "Éloge du Diaphane," *Artistes* 21 (1984); reprinted in Didi-Huberman, *Phasmes: Essais sur l'apparition* (Paris: Les Éditions de Minuit, 1998), 99–112.

13. Christian Bonnefoi, in Yve-Alain Bois, "A propos du 'double bind': Trois questions à Christian Bonnefoi," *Critique* 408 (May 1981): 551; reprinted in Bonnefoi, *Écrits sur l'art*, 231–39.

14. See Jacqueline Barnitz, "Taped Interview with Josef Albers," *Art Voices* (Winter 1965).

The Pin

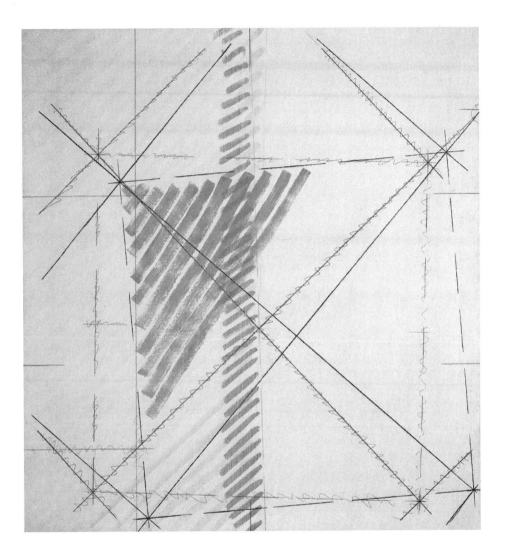

Martin Barré, *75 - 76 - E - 123 × 116*, 1975–1976.
Acrylic and pencil on canvas, 19 3/16 × 18 inches.

# Incompletion

*I met Martin Barré through Lygia Clark, who dragged me to his exhibition of paintings held at the Galerie Daniel Templon in Paris in the spring of 1973. The only thing I knew about him at that time was that he had made two "Conceptual art" shows in the same gallery some years prior. I had not seen these earlier exhibitions but knew of them, as Jean Clay had shown me photos while he was preparing a long essay on "bourgeois art" published in 1971 in the journal he was editing,* Robho.[1] *For the first of these exhibitions, in 1969, Barré had photographed details of the gallery interior (a wall corner, a spotlight, a heating pipe, etc.) and hung prints, approximately sized at a 1:1 scale, next to what they depicted. For the second, in 1970, he hung photographic enlargements of calendar pages on the gallery walls, one for each day of the duration of the show. As I was just coming back from a year spent in the United States, where I had been exposed to quite a number of similar experiments investigating the indexical sign, my response to what Jean showed me had been blasé. I had no idea that Barré had been a painter for some fifteen years prior to these "conceptual" forays, and quite a reputable one at that, just as I had no idea that he had recently "returned" to painting, after a hiatus of three years, when Lygia forcefully chaperoned me to his 1973 show.*

*My reluctance to go see it was unremarkable: If was bored by Conceptual art, I saw a retreat to painting as a step backward. Painting was then considered moribund in avant-garde quarters, and everything that had excited me in contemporary art during the previous five years had nothing to do with it. Indeed, Lygia herself had been essential in my move away from painting (hadn't she called for the "end of the object"—thus of the "art object," and thus of painting?). My shock upon entering the Templon gallery was unforgettable: Here was a clear affirmation not only that painting was not dead but that it could be again a medium of thought, as it had been for Mondrian or Malevich, my heroes at the time (and, I would soon discover, the artists that had been most important in Barré's formation).*

*Our friendship began as we met at Lygia's for dinner a week or so after my unforeseen wonderment (a dinner during which I discovered that Barré's wife, Michèle, and I were born in the same city—Constantine, Algeria). From then on, I met Barré regularly and attentively followed his production, never missing any of his solo exhibitions (one per series) until I definitively left France for the US*

*in 1983. In 1993, I published a monograph on his work, which I translated into English in 2008. Although there have been multiple exhibition catalogues dedicated to Barré's art—including the excellent one produced for his retrospective at the Centre Georges Pompidou in 2021, an exhibition that, alas, COVID-19 closed less than two weeks after it opened—my old book, to this day, remains the only one on the artist.*

*Martin was not voluble (though he could be hilarious when occasionally making fun of the art world), but everything he said about painting—his but also that of his peers or of the past—made a profound impression on me. He died in July 1993 at age sixty-nine.[2]*

•

The verb "to incomplete" does not exist.
—Martin Barré

As a kid I stamped my foot (with rage? Impatience?) whenever my father served his favorite riddle to one of my friends coming for a sleepover. Where did the stumper come from? The poetry of Charles Cros? The memory of some hazing he had to suffer in his youth? A Dadaist pamphlet? A hidden repository of family sadism? I was required to remain absolutely silent through the ordeal of my friend, and nothing was more painful for me than having to witness the jubilation of the tormentor and the frustration of the tormented when the "solution" was finally uttered. Frustration is actually too weak a term. It was, rather, the feeling of having been betrayed that had assailed me when I had been subjected, at age seven or so, to this paternal test. For reasons unknown to me (colonialism? The customary xenophobia of jokes? A jab at Napoleon?), the conundrum was defined as "Corsican" and pronounced with the relevant accent. Roughly translated, it goes like this: "It's green; it has feathers; it goes cock-a-doodle-doo: What is it?" Answer: "A herring!" And the explanations, after the inevitable protestations: "It's green—because it is; it has feathers, because I stuck them into it; it goes cock-a-doodle-doo, so that you would not solve the riddle too fast."

At first, it would seem that my irritation as a child came from the fact that the wording of the riddle did not respect the rules of the genre. It only offered one of the parameters that could lead to the solution (and not a very secure one at that: Is it really *green*, a herring?)[3] and was further weakened, in the most arbitrary fashion, by its inclusion in a sequence of most confusing . . . red herrings. As such, the riddle flaunted nothing else than sheer abuse of power. Yet, examining the situation closer, I do not think that my feeling of betrayal was based solely on injustice (why would the momentary victory of my father and his little experiment irritate me so much each time?). It was due, rather, to

the impression of a general collapse of logic. Without being aware of it, I was reading a radical critique of authority in the riddle, seeing it as a version of Aesop's fable of the Wolf and the Lamb. If deductions and inductions were that fragile, then the whole adult way of thinking could not but crumble. Had I painfully reached the "age of reason" only to be told that this reason was nothing but a house of cards? The lesson was a bit hard to take—not least because it was taught too early on.

But today, in front of Martin Barré's painting, I feel at last capable of hearing it. The foot-stamping is replaced by gratitude. I am grateful to him for having repeated my father's deconstructive move in his work but with much more tact—tact with which he transformed an act of sabotage into pleasure and helped me leave the domain of childhood without nostalgia. The enigmas of Barré's painting ricochet endlessly, but ultimately what they abolish is the illusion the beholder or the critic might fleetingly entertain of ever being able to have the last word.

Martin Barré's work is serial, the most rigorously serial possible. The ordinal nature of the work, which Robert Klein claimed was one of the fundamental characteristics of modern art,[4] has perhaps never been as thoroughly demonstrated as in his painting, and perhaps never as effectively as in the 1977–78 series, known as the "Indissociable."[5] Such a claim has several implications, some concerning the history of painting, others the specificity of Barré's work in general, others still that of his recent work.

Since Monet, the series has served as one of the most efficient reflexive strategies of modern art: Considered to be a means of analysis, it has on each occasion allowed for the elimination of certain parameters in order to emphasize a fundamental pictorial constituent (apotheosis of light as the essential referent for Monet; elimination of compositional problems in favor of color alone in the work of Josef Albers and Ad Reinhardt or of the constitution of the field for Morris Louis and Frank Stella, etc.).

Martin Barré, who has always worked on several paintings simultaneously, was led to the series when trying to resolve a preliminary issue: "A painting is essentially a flat surface covered with colors assembled in a certain order" (Maurice Denis); so be it, but each time this surface is of a specific format. To ignore this, as Władysław Strzemiński pointed out long ago, would be to adhere to or to return inevitably to the projective aesthetic of representation, which modern art as a whole has aimed to eradicate. If the overall ambition of modernist painting, its reflexivity, was to eliminate the arbitrary, to motivate that which, in the absence of the mimetic link connecting what is represented to what represents it, was in danger of having no other ground than the artist's subjectivity, the issue of the format (the proportions and size of the canvas) appears as an unavoidable threshold of analysis.[6]

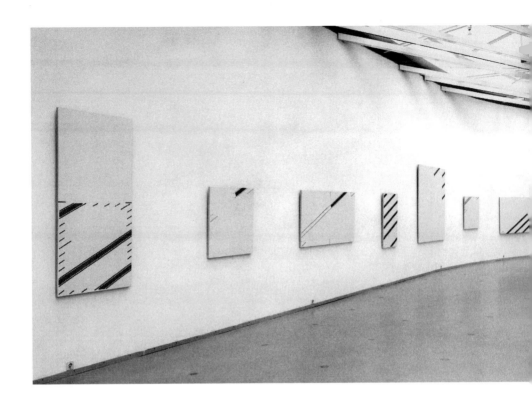

Martin Barré, *The Indissociable*, 1977–1978.
Installation view of a single work in fourteen parts,
Musée d'Art Moderne de la Ville de Paris, 1979.

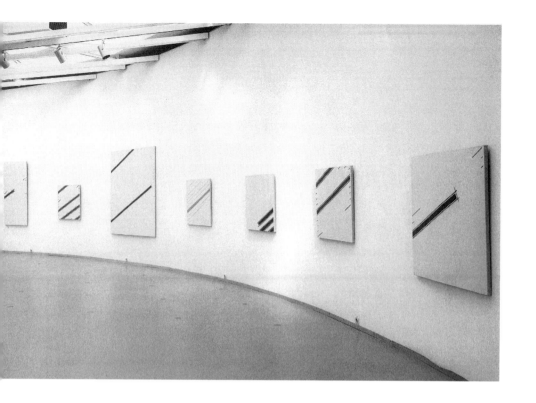

Barré's response was initially a pure refusal of the institution (in the form of the standard formats commercially available, which he calls the "*marché-avant*" [translatable into something like "the front-market," as one speaks of the "front matter" of a book, or "the anterior-market"]): From the onset of the 1960s, he emphasized the singularity of his formats by including their dimensions in the title of his paintings. Then, in 1967, serialization intervenes de facto with the geometrical justification of the format when he decides that the stretchers of his canvases will be constructed according to the proportional ratio of the Golden Section—a format he will stick to until 1975. Nevertheless, this repetition of the format still hardly plays a role in the creation of the paintings themselves: The "zebra" paintings or the "arrow" paintings only constitute series because for each one of them the same mode of production presides over its creation (spray for the "zebras" or spray plus stencil for the "arrows"). But this means of production doesn't involve the series in itself because the paintings are created independently of each other. In 1972–1973 the grid was used to connect multiple paintings: With the introduction of this macro-structure, which turns each work into the fragment of a larger ensemble, the centrifugal impulse implicit in Barré's work since the beginning of the 1960s constitutes from this point on the link between the different members of the series. But the two instances of serialization (format, grid) still function in parallel. In four consecutive series (73-74, 74-75, 75-76, 76-77), we witness a progressive merging of these two components: markings of inscription (referring back to the general grid of the series) and markings of construction (determining the formats, visible on the canvases themselves starting in 1974–75) become little by little more isomorphic (and sometimes even isochromatic) yet without ever overlapping (except negatively in the series 76-77, in which a blank square of identical dimensions and in orthogonal position ends up in each of the sixteen canvases of the series, irrespective of its size). Yet discerning this isomorphism is far from being essential to your apprehension of the works—this is what distinguishes Barré's painting from that of Strzemiński as well from any modular production.[7] In fact, the obliqueness of the overall grid and the diversity of the slant from one painting to the next prevent the isomorphism in question, most often, from even being perceived. You can, by means of geometric graphs, try to break up the series and identify the unique relationship that exists in each canvas between the out-of-sync structuring systems (general grid, formats), but even with the help of the most feverish mnemonics, you will never be able to ensure that your gaze, once it is confronted with the paintings, does not throw all this cabalistic knowledge to the wayside. Even their serial hanging, one after another, does nothing more than signal to you that such calculations took place: You see that there were rules, you understand that the family resemblance between the canvases is not fortuitous, but you can never read them as anything but simply compossible fragments.

The serial mode is, above all, what allowed Martin Barré to rein in the compositional arbitrariness of the tradition from which he came (the "post-Cubist" academic abstraction of 1950s French painting)—those little manipulations mocked by Stella with a touch of chauvinism (he called it "relational painting": "The basis of their whole idea is balance. You do something in one corner and you balance it with something in the other corner").[8] As Jean Clay has so aptly shown (referring to Saussure's anagrams or to the "third meaning" of Barthes's photograms), the series for Barré was the means to make a condition that is essential to any picture—that is, its fragmentary nature—visible.[9] In the words of the artist:

> Not only should a painting refer back to another (also present in the exhibition) but also to those that are no longer there; that we saw on another occasion and that left "traces" (of their traces!) in the memory of the viewer. I want each "fragment" to refer back to the whole: to Martin Barré's painting but also to that of others; to paintings made during my time, that is, created by artists whose search is close to mine—and perhaps as well to searches, over several centuries, for solutions that our era rediscovers while developing them in a manner that other societies did not allow.[10]

The series necessarily transforms each canvas into a question regarding the metonymic functioning of every painting, summons all our memory, prevents a purely contemplative attitude. The fragment is also a stimulant, a trigger for plural readings. The fragment, more directly than all the programmatic discourses, simultaneously problematizes the relationship to contemporary pictorial production ("paintings made during my time") and to tradition (at a time when Parisian discourse was saturated with the bellowing of the avant-garde, Barré was among the few saying that Franz Hals, Vermeer, or Pompei interpellated him to the same extent as Picasso or Mondrian).

None of all this has been abandoned in Martin Barré's recent work. Yet something has changed with the *Indissociable* series. First and foremost, on a technical level, as all the commentators have observed, we go from a logic based on the stratification of layers (the metaphor of the palimpsest could not be more appropriate) to a logic of extension. It is not that laterality was previously absent from Barré's art; quite the contrary, the assertion of the fragmentary nature of the work was founded on the violence with which his canvases framed (as does a photographer) a grid that seemed to extend beyond the canvas itself. But in abandoning geology, and in acting as though the paintings of the *Indissociable* series, wholly superimposable, as Jean Clay reminds us, were the result of a peeling back of the various thin layers constituting a single painting that never existed, Barré introduces a new mode of completion in his work—or rather of incompletion.

As with the series, the question of the end, of completion, was a recurring theme in modernist thought: From Cézanne's empty patches of canvas to the kind of Penelope's labor by which *Victory Boogie Woogie* was made and unmade to the discussions of the American Abstract Expressionists at Studio 35, there are countless anxious signs that something essential has always played out in the dilemma of ending, and the few interviews granted by Barré (a reserved painter if ever there was one) confirm it. Nothing is more logical: The question of the end, the question at the end, is the same as that of the beginning, that of the reining in of the arbitrary conceived as the historical vocation of modernism. Yet despite the fact that everything about the series suggested it would bring a definitive response to the question of completion—indeed, the series' particularity was to state in advance the parameters taken into account as well as the fact that they are limited—it turned out to be a poor inducer of ending: If we exclude the obsession of a Sol Lewitt desperately trying to exhibit the exhaustiveness of his *122 Variations of Incomplete Open Cubes* (an ironic commentary on the inanity of the desire to complete), the various serial attempts always show the statistical infinity to which every engendering structure leads, as soon as a variable, even if only one, enters into consideration (think again of Albers's *Homage to the Square*).

It is with the *Indissociable* series that Martin Barré takes up this infinity of the code, not as the mere sign of the fragmentary nature of any painting but that which the mode of serial production must show: It is there that both the modernist dream of a lasting elimination of the arbitrary and that of the motivated end are deconstructed (a dream that the completion of the painting would necessarily lead, once all the problems are resolved without remainder, to the end of painting as practice). Up to that point, we might recall, Barré's compositional focus had been entirely directed toward the progressive isomorphism of two networks, the one ruling over the formats and the other the net in which all the canvases of a series are caught. But the gap—the slippage of one network over the other, a gap that was never the same—did not seek to produce anything other than the impression that the paintings belonging to the same series belonged to an organized but imperceptible set of geometrical regulations. The question of completion had remained untouched by the serial practice: It was the responsibility of geology—the other mode of organization governing the paintings—to address the issue and to show that it could never be resolved.[11] With the *Indissociable* series and the abandonment of the palimpsest, the two regulating systems are superimposed (the slant of the oblique markings, everywhere the same, is determined by the diagonal of a horizontal rectangle made of the sum of two adjacent squares, a diagonal that is nowhere drawn as such in the series). From this point forward the markings of the two superimposed systems constitute, along with color, the only compositional parameters. And

color is reduced to its most simple expression: Rather than the infinite variations of saturation and value specific to the previous (geological) system, in which a various number of coats of white would constantly deny color its own identity, this series makes use of five very clear hues of gray, green, blue, red, and yellow. This simple account of the distribution of colors—a "first dispersal," notes Jean Clay—shows how the reduction of the parameters immediately leads to an interrogation concerning the infinity of the code (why three bands of color here? Four there? Two elsewhere?). It all happens as if, in the *Indissociable* series, Barré had decided to expose the very core of his previous series: By dramatically reducing the number of variables, by providing the viewer with the possibility to reconstruct for him- or herself the system by which his paintings were generated, Barré not only produces the recognition of a mere family resemblance but the keen awareness of what the series *omits* in the actualization of the system. In restricting the number of plastic components, Barré (almost against all his previous pictorial production) tells us to what extent chance, or choice, constitutes the horizon of every serialization: The infinity of the code was not perceptible in the previous series because they involved too many unregulated elements (it's impossible to discern how choices were made in such an ocean of possibilities). With the *Indissociable* series we are able to elucidate both the rule and what escapes it, to measure the performance in light of competence (to speak the tongue of transformational linguistics), since all the pictorial elements (format, color, inscription), minimalized to an extreme, are dealt with by a simplified code.

It is not a coincidence that the matter of completion, or incompletion, appeared with intensified acuity alongside a series immediately conceived of as inseparable (the fourteen paintings of the *Indissociable* series are one single work, a sort of vast polyptych whose hanging is immutable and set according to the generative code particular to the series). The polyptych structure was not new to Barré (we find it in his oeuvre well before his serial work), but dealing with a *finite* number of physically independent easel paintings *as if* the whole set were a polyptych led him to transform the function of the fragmentation and the signification of incompleteness: Painting and series are henceforth the signifier of one another. The painting no longer refers back to the series like a simple fragment among so many other possible ones; it is one of the indispensable units for the constitution of the series as a form, setting forth the code as it reveals each time one of its essential aspects. Inversely, the series is no longer merely the frame of reference, the context that informs the painting. It is the structure that defines, through difference, the singularity of each canvas, just as, in Latin declension, *rosa* is opposed to *rosarum* or to *rosis*. In fact, the difference between paintings changes in nature with the *Indissociable* series: In the previous series, this difference was often huge but too loose

to be meaningful (the geological process being indefinite); it was neutral, or *unmarked*, to borrow a term from structural linguistics. Here this difference is not less pronounced, but it is marked, part and parcel of a tight network of oppositions. If Martin Barré now seeks out maximum difference, it is, much more than previously, to show the breadth of the code, its range of possibilities, and to make of each painting a unicum capable of signaling on its own if not the code in all its potentiality, then at least its generative principle. Through a strange dialectic of which only Barré holds the secret, it is at the very moment when the series appears as an ensemble exhausting the traditional structure of the individual painting that this structure emerges strengthened from the assault. As he notes, "Seriality does not aim to produce paintings that are nearly similar but to produce paintings that are the most different from each other as possible, and what matters is the painting. Seriality is the means to produce them. It is not so much the paintings that make the series as the series that makes the paintings."[12] Hence the absence of repetition (redundancy is excluded: Each painting counts in the enunciation of the code); hence as well the exceptions, that is, the "cock-a-doodle-doo" of the fable.

Let us sum up. From the *Indissociable* series onward, the parameters of the code are set forth in simple terms—one could even say simpler and simpler terms (and the simpler they are, the more extensive is the code's potentiality). Yet the *Indissociable* series carries one exception (and almost all subsequent series will do the same): The code forbade two paintings of identical format or color to be hung next to each other, but the numeric incompatibility of these two parameters (seven different formats for fourteen paintings, six of them being of an identical format and the colors distributed as such: three paintings with gray bands, three with green, four with blue, two with yellow, and two with red) made such an installation impossible. In the first hang of the series, the artist defied his own interdiction; three paintings of the same format were hung next to one another (small "yellow," "blue," and "gray" squares).[13] Barré occasionally speaks about these exceptions but only incidentally, in passing; he notes that he "breaks the rules of the game when painting calls for it," and how such and such a subversion determines the invention of the code that presides over the next series. It is obvious that these exceptions are not more essential to him than the strict obedience to a system that he obeys in most of his canvases. Yet they have an heuristic value (it is always an exception that shows a rule, indicates its limit; it is always heresy that defines the institution): The fact that they are possible, and perceived as such, indicates both that the serial practice has been sufficiently mastered for the imponderable to become one of its ostensible features, and that all the modernist positivism (the removal of the arbitrary) is nothing more than wishful thinking (historically necessary, to be sure, but wishful all the same). There is humor in Barré's impiety: For the pure

pleasure of investigation, we wear ourselves out trying to reconstruct the code, to detect its mode of declension in a given painting, and the exception knocks "everything" down, but we find out that this "everything" was far from being just that—we had only forgotten (as the riddle goes) the feathers of the herring.

Is this to say that, in the end, Martin Barré could not care less about the concept of series? Not at all. First, in order to destroy, to deconstruct, an order, it is necessary to have been able to invent it or rather to determine its specificity. Next, the series as a form after the *Indissociable* series has gradually become in his work not only a generative process but a mode of being inherent to each painting (if I were to rewrite this article, I would limit myself to individual paintings, so as to show the paradox). We might note that with the series 79 B the centrifugal (oblique) markings disappear from Barré's painting: It is no longer necessary to mark the fragmentation by means of various acts of atectonic violence. Anyone who sees a painting by Barré, even in isolation, knows at once that it refers to a larger ensemble (dashes or dots that henceforth gauge the canvases, functioning as spatial coordinates and anchorage points, immediately summon the whole of the space and intimate the possibility of other configurations grafted onto the same system). Potentiality is no longer emphasized in a dynamic mode (which always contains, according to Strzemiński, a trace of illusionism), and, more importantly, it is the very notion of form that has changed. Form is no longer given positively as *morphé*, as figure (triangle, quadrilateral, bar), but as a structure of elimination/inclusion, as differential negation. One final point will underscore this change: In the 82–84 series, colors are distributed by zones of allocation (the rectangular surface of each canvas is divided into four zones delimited by the diagonals: red on the left quadrant, yellow on the right, green on the bottom, blue on the top). There are several exceptions to this code, but the most striking is that not one of the eighteen canvases of this series makes use of the "blue zone." From the virginal whiteness of the upper zone of these canvases you necessarily conclude that the system exceeds its performance. Each painting designates in itself an opening, a gap—the lack that the code draws there. The reliance of the system is only tested on you so that you measure its essential incompletion.

Translated by Philip Armstrong and Jennifer Branlat.

First published as "L'inachèvement," in *Martin Barré* (Nantes: Musée des Beaux Arts; Tourcoing: Musée des Beaux Arts; Nice: Galerie des Ponchettes et Galerie d'Art Contemporain, 1989), 71–80.

1. For further discussion of Clay, see "J.C. or the Critic" in this volume, 79–102.

2. He had felt faint at the opening of his retrospective (on February 16, 1993), for which he had conceived an extraordinary installation (of the kind he called "accrochage chahuté" [upset hanging]) in the Galeries du Jeu de Paume, together with the architect of the museum's renovation, Antoine Stinco. It was not uncommon for him to be indisposed at one of his openings, but this time the malaise had a deadly cause: Soon thereafter, he was diagnosed with a lung cancer that had metastasized to the brain, and he had less than five months to live. I was in Brazil when I got the sad news of his passing. Not able to attend in person, I sent a brief eulogy to be read at his funeral.

3. In the Armenian version of this same riddle, as recounted by Roman Jakobson in his savage critique of the notion of realism, the herring is green because "it was painted green" (see "Realism in Art" in Roman Jakobson, *Language in Literature*, ed. Krystyna Pomorska and Stephen Rudy [Cambridge, MA: Harvard University Press, 1987], 25–26.)

4. Robert Klein, "Notes on the End of the Image," trans. Madeline Jay and Leon Wieseltier, in *Form and Meaning: Essays on the Renaissance and Modern Art* (Princeton: Princeton University Press, 1979), 174.

5. [Addition 2021] In the original publication of this essay, it was called the "Renault Series," owing to the fact that it had been commissioned by the automobile company. While its official title is "77–78," the artist preferred "the Indissociable," which is the designation I will use here.

6. For the brief history that follows, I am entirely indebted to the analysis offered by Jean Clay in the appendix of his essay "L'oeil onglé," *Macula* 2 (1977): 79–80, and in "La peinture en séton," in *Martin Barré* (Paris: Arc, 1979), 12–13.

7. See my essay "Strzemiński and Kobro: In Search of Motivation" in *Painting as Model* (Cambridge, MA: MIT Press, 1990), 123–55.

8. Bruce Glaser, "Questions to Stella and Judd," in *Minimal Art*, ed. Gregory Battcock (New York: Dutton, 1968), 149. Is it necessary to point out that Stella's post-1970 work constitutes the complete negation of his former positions: His exhumation, in *Working Space*, of the most academic part of Kandinsky's work (the "biomorphic abstraction" of his Parisian period) only confirms this new version of a "return to order."

9. Clay, "La peinture en séton," 15–16. Barthes: "The still, then, is the fragment of a second text *whose existence never exceeds the fragment*; film and still find themselves in a palimpsest relationship without it being possible to say that one is *on top of* the other or that one is *extracted* from the other." ("The Third Meaning," reprinted in *A Barthes Reader*, ed. Susan Sontag [New York: Hill and Wang, 1982], 332). Clay: "Even more than in the anagram, since here all the units are equally active and able to engender new syntagms, an insubordination with regard to the whole (to the film already there) can be observed; the photogram is no more an extract of the film than the painting in Barré's work is an extract of a general framework. In both cases, the fragments are the network's *material*; the general framework is deduced and produced there."

10. Cited in Christian Bonnefoi, "Entretien avec Martin Barré," reprinted in Christian Bonnefoi, *Écrits sur l'art* (Brussels: La Part de l'Oeil, 1997), 39–49.

11. "All the interventions (grid, hatchings, whitewashes) of this process that could be called cyclical are not aimed at the end of the process but at the appearance of a '*moment*' that I decide to privilege, to show, to deliver to the gaze [*donner à voir*], in other words, to 'summon' [*faire venir*], to

'sieze'—the moment when the painting *appears*, 'reveals' itself. . . . Technically, it would be possible to continue indefinitely (obviously not if that ends up being three meters thick) but that would be of no interest—since no *end* exists (in the sense of a finished painting—that's it, it's finished!)—this process knows no 'end.'" Bonnefoi, "Entretien avec Martin Barré," 45–46.

12. See the interview with Catherine Millet in *Art Press* 96 (October 1985): 14.

13. [Addition 2021] At this point in the original publication of this essay, I briefly alluded to such exceptions in two other series (79 and 82–84), allusions that could only be intelligible (at best) with corresponding illustrations. The passage was digressive and has, therefore, been omitted here.

The *Indissociable* series has, so far, been shown only twice. First, at the 1979 retrospective of the artist (Musée d'Art Moderne de la Ville de Paris), and second, after Barré's death, during his retrospective at the Musée National d'Art Moderne, Centre Pompidou, Paris (but in a room outside the exhibition proper), in 2020. It was then on view for less than two weeks, as the museum closed altogether for several months because of the COVID-19 pandemic.

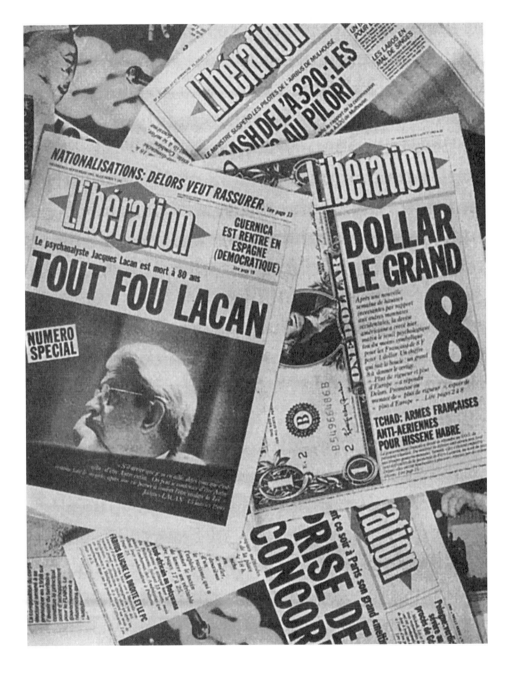

Various front pages of *Libération* during the early 1980s.
Photo: Thomas Hollier-Larousse.

# French Lib

*Denis Hollier is someone I have always admired. Indeed, his unrivaled 1974
study of Georges Bataille,* Against Architecture, *was the main inspiration
behind the exhibition* L'informe, mode d'emploi *(*Formless: A User's Guide*)
that I co-curated with Rosalind Krauss at the Centre Georges Pompidou in 1996.
Thus, when he asked if I wanted to contribute to the massive collective volume* A
New History of French Literature *he was editing for Harvard University Press, I
was both flattered and embarrassed: I am no literary scholar; how could I even
think of partaking of such an enterprise, with a list of sought-after contributors
sounding like the "Who's Who" of French studies in the US? But I had read
a good number of texts by and about Sergei Tretyakov in the 1970s while in
France (where he was much better known than in America, as were the very
diverse productions of the Soviet avant-garde of the 1920s more generally), and
it suddenly occurred to me that something approaching the kind of documentary
writing he advocated under the name of "factography" had been attempted
by the daily newspaper* Libération *in the first ten years of its existence. While
by the time of my writing the journal had lost a lot of its impact, it had been
essential to the intellectual formation of my generation, and I thought it would
be amusing to convey some of its intractable irreverence in a thick tome
dedicated (for the most part) to canonical figures of French Lit.*

*This is a period piece, written in 1989 about the heyday of a journal that had
come out in 1973 and had been so successful that it had threatened to knock the
arch-venerable* Le Monde *off its pedestal but was now in crisis and no longer
thriving—and* Le Monde, *having learned a few lessons from its competitor
and loosened its own stuffy (and often pedantic) style, was slowly regaining its
first-place status in the heart of the left-leaning intelligentsia.* Libé *went through
many crises over the next decades, some with a better outcome than others, and
the situation I describe no longer corresponds to what it is today, when it has
regained much of its early punch and "factographic" mode.*

•

When Jean-Paul Sartre held a press conference on January 4, 1973, to
announce the founding of the newspaper *Libération*, no one believed it would
last more than a few months. The first issue was launched on April 18 (after
five trial runs) despite the sort of administrative, financial, and ideological

turmoil that seemed to promise an early demise. But for about fifteen years *Libération* constituted one of the most exhilarating experiences of the French press since the mythical days of the 1944 . . . liberation. With a circulation that skyrocketed in a decade from 10,000 to over 200,000 copies daily, it could hardly have been more successful.

*Libération*'s impact on French journalism has indeed been considerable. Acknowledging a strong debt to the American press, it was the first Parisian "news journal" (as distinct from a "journal of opinion") to crudely tell it like it is. No fudging of the facts, and no moralizing: "We will call a murder an 'accident' only if such is the case," proclaimed the manifesto distributed at the press conference. As a result, although *Libération* is a chronic defendant in numerous lawsuits, its boldness has forced even an established but declining newspaper such as *Le Monde* into a more "with-it" stance.

*Libé* has become an adjective. There are Libé prices (moderate) and there is a Libé style. Applied to a person, *style Libé* first of all indicates a regular reader of the newspaper: high-school student, prisoner, immigrant worker, or—increasingly—yuppie, left-wing but undogmatic, slightly anarchist but not paranoid, interested in alternative issues, open to all kinds of social and cultural experience, "in" without excessive snobbery, and, most important, feeling part of a politico-affective community as a result of being a reader. Applied to language, *style Libé* indicates a tone that is sometimes abrasive but always humorous, sometimes flaky but always cheeky. This tone is an attempt to create a formula of the spoken/written to intercept the conflicting signals of an accelerating world. In a country whose media have been characterized chiefly by linguistic primness (if one leaves aside the satirical paper *Le Canard Enchaîné*), *Libération*'s combination of dadaist laughter with "just-the-facts-ma'am" inquiries, of passionate lyricism with keen political analyses, of generosity with total disrespect, breathed fresh air into a stuffy environment. More than its ideological content, which is not at all homogenous, although it has increasingly tended to become so, it is this irreverent tone that engages its readers' complicity.

May 1968 opened a Pandora's box of language; poetry was in the streets— as the cliché had it. And it is true that people did begin to talk to each other, that political slogans were transformed into surrealist verse ("Under the paving stones, the beach"; "Be realistic, ask for the impossible"). But the harsh political restoration that followed, under President Georges Pompidou's "Louis-Philippe" style of administration, dealt a severe blow to the hopes raised by the outburst of May. With its monopoly over radio and television, its control of the national news agency (Agence France-Presse), its alliance with press magnate Robert Hersant (today's French William Randolph Hearst), and the transformation of its police into a paramilitary force, the growing authoritarianism of the state forced the leftist groups that had led the May revolt to organize more or less

clandestinely. Mostly doomed to bankruptcy or to outright censorship, many newspapers went underground. Those that lasted the longest were the products of the most coherent sector of the French left (which was otherwise divided to the point of caricature), the Maoists, often called *Mao-spontex* for their insertion of libertarian spontaneity into the teachings of the Chinese Red Sun. Like many other revolutionaries of the time, they spoke a formulaic, wooden idiom. But they were cleverer. To circumvent the recurrent bans, they sought out the protection of Sartre as director. Though as a writer he was rather foreign to their rhetoric, Sartre was fascinated by their desire to break down the capitalist division between manual and intellectual labor (many of them went to work in factories, including Serge July, the current director of *Libération*).

The political arena was not the only one in turmoil. Social groups stressing their *différence* began to organize: the MLF (Mouvement de Libération de la Femme), the French women's liberation; the FHAR (Front Homosexuel d'Action Révolutionnaire), the first large gay organization (aligned on Maoist positions!); Michel Foucault's GIP (Groupe Information Prisons), established to collect testimony from jail inmates. In this time of dissent there was a dream of direct democracy: Against the authoritarianism of the state, let us save the free speech of May 1968; let the people speak to the people. Foucault's dictum "No one has the right to speak for anyone else" was a kind of motto.

The cacophony was extreme. Leftists were more divided than ever. Delusive triumphalism alternated with nihilistic depression. But one single event suddenly realigned the various fronts: Not only all leftist groups but the whole intelligentsia and the whole journalistic profession united in protest against the official cover-up of an incident of police brutality against a freelance journalist [Alain Jaubert]. A group of Maoist militants called for the creation of a free news agency, on the model of the American Liberation News Service, existing since 1968 in the United States. The Agence de Presse Libération (APL) was founded on June 18, 1971, a date carefully chosen for its Gaullist connotations (on June 18, 1940, the birthdate of the Resistance against the Nazis, de Gaulle broadcast his address from London calling on the people to refuse Pétain's surrender to Germany). The beginnings were modest, the technological apparatus that of the urban guerrilla. The first texts had all the symptoms of the "infantile illness of leftism," as Lenin would have said. The news proffered by APL's bulletin caused little stir. But another official cover-up, in February 1972, brought the agency to the fore. APL released a series of photographs displaying, step by step, the cold-blooded assassination of a young worker [Pierre Overney] by a member of the private security force of the governmen-owned company Renault; overnight, APL became a respected source of information concerning all censored issues. Yet it retained its collective and amateurish character. None of its editors was a trained

journalist, and none had a special field of interest. The news was gleaned from multiple contacts established by the Maoist organization, fact-checked, and anonymously published.

In the fall of 1972, APL drafted its plan for a popular newspaper, to be called *Libération*, with Sartre as its godfather. Controlled by its readers, devoid of advertising, resistant to the hierarchy of a differential salary scale and the division of labor, it was to—and did—uncover and publish repressed issues, to be in tune with its time, constantly to take the pulse of the "population." The Maoists astutely realized that their only chance of success was to function on a broad political platform. They built an ecumenical team around the motto "information must come from the people and return to the people." Amid grotesque internal strife, they initiated a promotional campaign with the support of Michel Foucault and a few other intellectuals. Committees were formed all over France. While their primary functions were fundraising and organizing the newspaper's distribution, they were also supposed to institutionalize the readers' control over the editorial board, a role they never fulfilled.

The first issues of *Libération*, published during the presidential campaign of 1973, were far from impressive, the journal being in the grip of unremitting conflict. Again, it was to be saved by events. Protesting against the liquidation of their clockmaking company, the workers of Lip, in Besançon, having confiscated both the products and the means of production, set up a cooperative to manufacture and distribute watches. This move, upsetting all the rules of organized trade unions and all the prescriptions of political analysts, became a social symbol that marked the end of traditional leftism in France. Very much on the scene at Lip, *Libération* was welcomed by a festive working class, conscious of its pioneering role and using language reminiscent of May 1968 and of the Popular Front of the 1930s. This support rejuvenated the newspaper and overshadowed the ideological battles within the Paris bureau. A page of the newspaper was offered daily to the workers, who used it with a devastating sense of humor. Through the events of Lip, *Libération* found its tone. Internal political differences remained, but the idea of a "direct contact with reality" prevailed. Thinking of this, Sartre later said, "*Libération* is part of my oeuvre."

Having survived many crises, duly reported in its own columns, in 1982 *Libération* finally adopted the customary practices of an institutionalized press—advertising, a hierarchical scale of salaries, a traditional division of labor, the introduction of external capital. Although it was in a way the beginning of its end, *Libé* did not abandon its freedom of language, publicizing on a large scale, especially in its pun-laden headlines, a type of mordant irony indebted to the broadsheets of the 1920s avant-garde. Two anticlerical issues devoted to the pope's trips to France—one in 1980 printed on incense-scented paper; the second, in 1987, sporting the headline "Pope Show"—provide good samples of

this tone. Indeed, it was set from the very first issue, in 1973: Speaking about the failed launching of two French satellites, *Libération* splashed, "Castor et Pollux: Plouf! [Splash!]." The most memorable example of this peculiar humor remains the front-page obituary of Jacques Lacan, the French psychoanalyst famous for having introduced outrageous puns into the most abstruse matters: "Tout fou Lacan," a pun on *tout fou* (totally mad) and *tout fout le camp* (everything scrams).

Like all other newspapers, *Libération* has a few great writers (Serge July's Machiavellian and epic analyses of French politics are unequaled in France), but it is its general stenographic wit that distinguishes its pages. Despite the increasing specialization of its collaborators, *Libération* treasured a kind of editorial anarchism until its last major transformation, in 1987. Thus a review of Kafka's letters might be written by a specialist in rock music, or a tennis match might be reported with a passionate commentary by Serge Daney, a veteran of *Cahiers du Cinéma* whose film columns are the gem of the paper; sprinkled throughout were the NDLC (*note de la claviste*), by which the typesetters, like so many wry kamikaze pilots, buzzed the columns with strange parenthetical interjections. The wish to be true to one's experience remained pervasive, but it had changed sides, moving from the call-to-the-readers of the early years to the highly subjective idiom of the journalists. Thus the Lebanese conflict leading to the Sabra and Shatila massacres was covered by a native of Beirut whose hymn to his city was greeted as a magisterial piece of lyrical prose. The force of the newspaper lay not in its frequent scoops—the publication of names and addresses of Central Intelligence Agency operatives in France; the uncovering of a document proving that during the 1968 crisis the government had planned to round up political dissidents in a stadium; the conduct of an exclusive interview with Norodom Sihanouk—but in its presentation of firsthand testimony of all aspects of daily life and current experience.

Two features enhanced this aspect of the paper and were innovations in France: a weekly supplement of free personal ads (terminated when it began to resemble Krafft-Ebing's encyclopedia of sexual "perversions"); and a daily page of letters to the editor, which became both a sociological monument and the catalyst of a new literary genre. Published as a "collective novel" in 1983 under the title *La vie tu parles* (an untranslatable phrase that means something like "life live" or "life? No kidding!"), a chronological and anonymous selection of these letters provides the most polyphonic and dialogic accounts of a decade.[1] Full of anger à la Céline or elegiac happiness, of dreary repression or merry exhibitionism, the letters represent a kind of grid of all the events of French social experience as they affect individual lives and, at the same time, the purest of *Libération* as a literary undertaking, its marginal center, as it were.

Today the newspaper is endangered by its own success and a certain drift away from its principles under the spell of a growing fascination with high-tech modernization and the frenetic hype of fashion. In 1987 *Libération* moved its headquarters and adopted the newest computerized printing techniques, and each member of the staff was assigned a special field of interest: It was claiming publicly that it had stopped being the ugly duckling. But at the same time, it lost its peculiar character, and its readership began to decline: Puns started to look stale, its audacity of tone artificial. In finally taking up the standards of the established press, *Libération* had ceased to define a community of readers; its heyday is obviously over. For more than a decade, however, it remained the only voice able to give a live account of the evolution of what one could call French civilization.

First published in *A New History of French Literature*, ed. Denis Hollier (Cambridge, MA: Harvard University Press, 1989), 1040–45.

1.  [Addition 2021] Imprecision of language here: The selection itself is not anonymous, but the letters are printed one after the other without any signatory name. The book was prefaced by Serge July, who was the chief editor of *Libération* until 2006, but, faithful to the journal's anti-hierarchical stance, the book was edited (160 letters were selected out of 10,000) by Françoise Fillinger, who had been in charge of *le courrier des lecteurs* over the years, aided by two proof correctors. One of them was my close friend Bruno Montels, a Concrete poet whom I had met during my year (1969–70) as an exchange student in the United States (he was part of the same exchange program). Bruno died prematurely on July 27, 2000. Among many things, I owe to him my early immersion into the world of Mallarmé—we spent hours dissecting *Un coup de dès.* When I left definitively for the US in 1983, I gave him my small collection of books of Concrete poetry, a movement I had been acquainted with during my teens (a vague but hilarious memory is that of a weekend spent at the country house of Julien Blaine, around 1968, during which I participated in the elaboration of the "manifesto of bipointillisme" with a whole band of writers from different countries, Alain Arias Misson among them; the manifesto was signed ":"). *La vie tu parles* was one of the first books published by P.O.L., the publishing house founded in 1983 by Paul Otchakovsky-Laurens, which quickly became the most searching literary press in France, the equivalent for the last four decades of what Jérome Lindon's Éditions de Minuit had been before for almost just as long.

i10

AMSTERDAM 1927

| | |
|---|---|
| KANDINSKY | BEHNE |
| TOLSTOI | BIROEKOFF |
| FILM | TER BRAAK |
| UTOPIE | BLOCH |
| SYNTHETISCHE KUNST | KANDINSKY |
| NIEUWE PHILOSOPHIE | DE LIGT |
| GEEST EN TECHNIEK | MOHOLY-NAGY |
| MODERNE STAD | MONDRIAAN |
| ARCHITECTUUR | OUD |
| MUZIEK | PIJPER |
| ARCHITECTUUR | VAN RAVESTEYN |
| TROTSKY | ROLAND HOLST |
| REPRODUCTIES | |

I/1

First issue of *i10*, January 1927.

# The Lesson of *i10*

*I met Arthur Lehning—the formidable scholar of anarchism, editor of Mikhail
Bakunin's collected writings, and director of the short-lived avant-garde
journal* i10*—in early 1980 while I was an "attaché de recherche" at the Centre
National de la Recherche Scientifique spending the academic year in Holland
doing research on Piet Mondrian and De Stijl. I had been introduced to him
by the architecture historian Thomas A. P. Van Leeuwen, who, with his wife
Hoedel, did all he could to cheer me up during the winter months in Amsterdam,
which I remember as particularly gloomy. For a break from long hours sitting
in libraries, I had endeavored to visit and interview all of Mondrian's surviving
friends and acquaintances, with the plan to anthologize their various testimo-
nies, alongside those already published and the scant interviews the painter
himself granted the Dutch press in the 1920s. Though I never deliberately
abandoned this project, it eventually lost steam. My encounter with Lehning,
however, developed into a close friendship that lasted until his death in 2000 (at
age 101) and led to the only published trace of my interrupted research:* Arthur
Lehning en Mondriaan: Hun vriendschap en correspondentie *(Arthur Lehning
and Mondrian: Their friendship and correspondence), a book that appeared (in
Dutch only) under my name in 1984.[1] It consists of a narrative based on hours
of interviews, which I (ghost)wrote in Lehning's voice, about his relationship
with the artist from the time of his first visit to the famous studio of the Rue du
Départ in 1925 to their last meeting in London at the end of 1938, as well as all
the surviving letters that he had received from Mondrian and the reprint of the
texts that the artist had published in* i10*. Unfortunately, the letters sent during
the two-year period of* i10*'s run are lost (along with the journal's archives),
but enough are extant from before and after this hiatus to give a sense of the
artist's interest in Lehning's political views, as well as of Lehning's admiration
for the painter's art. While Mondrian worked for several years on a book
manuscript on "art and society," he would send Lehning passages concerning
"true" socialism that were directly inspired by, and occasionally even a pure
paraphrase of, his friend's anarchist pamphlets, asking him to vet them. As for
Lehning, he bought a painting by Mondrian in 1929, one of the few possessions
he managed to bring with him as a refugee in wartime London, and which I had
the constant pleasure of viewing on the wall of his book-filled apartment during
our many sessions of work together.*

*The following essay was written for the catalogue of "*i10 *et son époque"*
*(*i10 *and its time), an exhibition held at the Institut Néerlandais in Paris in 1989.*

•

Lucia Moholy had no idea how right she was when she said, after spotting the
table of contents of the first issue of *i10*, how it made her think of what the Tenth
International might become, so much did the presence in one place of so eminent
and heterogeneous a group of authors strike her as an extraordinary feat.[2] What
other review, in effect, at the end of the 1920s, could begin publication with a
constellation of articles signed not only by Wassily Kandinsky, Mondrian, J. J. P.
Oud, and László Moholy-Nagy, but also Ernst Bloch, Bart de Ligt, and Henriëtte
Roland Holst? What other review could announce forthcoming issues with
articles on architecture by Mart Stam, Victor Bourgeois, and Szymon Syrkus, as
well as including critical analysis of the situation in Stalin's Russia, the current
state of American socialism, Mussolini's Fascism, and the experiment of a
socialist community in Llano, Louisiana? Certainly, a whole host of small avant-
garde reviews had already tried to break down the barriers between genres, and to
build a bridge, as was said at the time, between art and life—indeed, that had been
an entire project since the birth of Dada, De Stijl, and so many other movements
born during the First World War or in its immediate aftermath. However, despite
owing much to these predecessors, *i10* remains absolutely one of a kind.

In order to specify its uniqueness, I shall compare *i10* with two other
journals: *L'Esprit Nouveau*, edited by Amédée Ozenfant and Charles-Édouard
Jeanneret (a.k.a. Le Corbusier), and Theo van Doesburg's *De Stijl*. I have
three reasons for making these particular comparisons: Architecture figured
prominently in all of these; each of the periodicals sought to internationalize
its intellectual debates; and their relative historical contemporaneity. Indeed,
*i10* appeared on the scene just two years after *L'Esprit Nouveau* had ceased
publication (for the same financial reasons that would eventually lead to *i10*'s
own demise along with that of a number of other small avant-garde publica-
tions) and at a point when *De Stijl* was almost moribund.[3] In a certain sense at
least, it looks very much as if *i10* was designed to pick up where these reviews
left off. Oud's presence on its editorial board indicates a desire to defend a line
in architecture that was considered, rightly or wrongly, as more advanced than
that of Le Corbusier, and the collaboration of almost all of the former members
of *De Stijl* (all of whom had quarreled with the difficult Van Doesburg, rebelling
against his abusive authority) shows quite clearly that *i10* sought to benefit from
the experience of the most important branch of Dutch modernism, and to reunite
its major figures after they had lost their common forum.

Let us begin with *L'Esprit Nouveau*. Starting with the fourth issue, by
which point Ozenfant and Jeanneret's takeover of control was complete, the

subtitle *Revue internationale d'esthétique* (International review of aesthetics) was replaced by *Revue internationale illustrée de l'activité contemporaine* (International illustrated review of contemporary affairs), and the following were added to the list of topics that it claimed to cover: "pure and applied sciences [ . . . ], urban planning, philosophy, sociology, economics, moral and political sciences." As with *i10*, the desire to inform on a wide range of contemporary life was made clear in the editorial of the very first issue, and it became clearer with the appearance of this expanded program. And yet, if one looks closely, there is a dramatic difference between the two magazines. In fact, for all fields outside of architecture and urban planning, Le Corbusier's magazine advocated for what was called at the time (following Jean Cocteau) the "return to order," in reaction to the "extravagances" of Dadaism and Cubism. On the one hand, the pictorial aesthetic they proposed is that of a tamed, academic Cubism—not only Purism but also the work of Georges Braque and Juan Gris in the 1920s, Jacques Lipchitz, Jean Metzinger, Victor Servranckx, Gino Severini, and Ivan Puni. (Cocteau himself was asked to contribute, which he did with an article in the third issue on an artist as conservative as Roger de la Fresnaye.) On the other hand, the editors were consolidating an essentially French tradition, and were here entirely within the line of a return to neoclassicism (such as was carried out by a Paul Valéry, or even a Igor Stravinsky, and by Henri Matisse and Pablo Picasso at the time), despite their avowed intention to open themselves up internationally. The enormous number of articles devoted to the masters of this tradition such as Paul Cézanne, Georges Seurat, and also Camille Corot, J. A. D. Ingres, and Le Nain (going back even to Nicolas Poussin) all tended in that direction. The ridiculous diatribe, signed by Ozenfant and Jeanneret, against De Stijl and Mondrian in particular (they go so far as to compare him with Ernst Meissonier) provides the general tone of the journal insofar as the visual arts are concerned—that is, yes, we can have a little Cubism, but nothing beyond that.[4] The same can be shown with regard to the journal's approach to literature. Here was the same equivocation, the same denunciation of "extravagances" (e.g., of Dadaism), and the same desire for a return to the "national" tradition, even if that tradition were occasionally one of breaks with the past. (Even the articles devoted to Charles Baudelaire, Arthur Rimbaud, Comte de Lautréamont, and Stéphane Mallarmé were part of a program of recuperating these figures for an essentially *national* heritage.) The opening to anything foreign was strictly monitored by the certainty that French rationality was necessarily more productive than all other experiments carried out abroad. Such a form of chauvinism, which can only be called "petit-bourgeois," led to quite crude errors of judgment. Thus, *L'Esprit Nouveau* was at first highly critical of the Bauhaus, only correcting its assessment at the last minute by giving space in the pages of its penultimate issue to Walter

Gropius. Again, the editors gave the reporting on the Soviet avant-garde to a mediocre defector like Ivan Puni (ten years previously, he had been a talented follower of Kazimir Malevich), and they failed to publish such a brilliant theoretician and valuable informer as El Lissitzky.[5]

Let us look now at *De Stijl*. Here the program underwent a transformation similar to that of *L'Esprit Nouveau*. At first solely concerned with aesthetics (its subtitle during its first year of publication was *Maanblad voor de beeldende vakken* [Monthly journal for fields in the visual arts]), the review quickly made clear its interest in all things modern. With the first issue of the second volume in 1918, the subtitle changed to *Maanblad gewijd aan de moderne beeldende vakken en kultuur* (Monthly journal dedicated to the fields of modern visual arts and culture), and it was to change again three years later to *Maandblad voor nieuwe kunst, wetenschap en kultuur* (Monthly journal for the new art, science and culture). But in complete contrast to *L'Esprit Nouveau*'s defense of a soft Cubism, Van Doesburg set himself up as the prophet of a resolutely avant-garde artistic practice, namely, the new abstraction of Mondrian and his peers. Similarly, *De Stijl*'s openness to the various European avant-garde movements was in strict proportion to their degree of newness. Mondrian, after his return to Paris in 1919, was to play the role of mentor here.[6] As soon as he would to declare an artist "refractory to the new," the latter would disappear from the columns of the review, unless Van Doesburg relented and tried, by means of one of his endless tactical maneuvers, to win the purged artist back as a fellow traveler.[7] This intense desire to be absolutely modern, and certainly to extricate himself from a stifling local tradition, brought out in Van Doesburg a much more radical curiosity in terms of the noises coming from outside his own country than was the case for *L'Esprit Nouveau*. From his collaboration with the Dadaists Hans Richter, Hugo Ball, Jean Arp, Richard Huelsenbeck, Georges Ribemont-Dessaignes, and Kurt Schwitters to the active participation of El Lissitzky, numerous were the occasions where *De Stijl* extolled what seemed at the time the most mordant attacks in the fight that the avant-gardes of the period were leading against the creeping "return to order." No middle ground existed; instead, there was an outright intransigence in favor of the new.

Now, this policy of radical and activist modernism, if it made *De Stijl* into a kind of search device in the jungle of the European movements outside of Holland, was to give rise to one of the most severe dogmatisms with regard to its own homegrown production (except when, from time to time, Van Doesburg was obliged to tone down his principled views so as to avoid seeing the already very small number of the journal's subscribers shrink to naught). The history of the beginnings of the De Stijl movement is made up of a series of exclusions, broken alliances with this or that founding member or even with an invited collaborator unable to bend to the demands of the program.

Peter Alma's misadventures with the journal are highly indicative in this regard (he was to contribute on several occasions to *i10*).[8] Yet, this strict sectarianism did have its advantages, and the review's coherence, even if it often rested upon theoretical contradictions that could erupt at the slightest provocation, was only the more impressive. The cohesion of the De Stijl group, the extraordinary stylistic and theoretical unity that emerged from its members' production in all areas—and that was in large part the reason for the long-lasting effect that the movement was to have on the art and architecture of this century—was certainly to some extent the result of its intolerance.

On the one side, therefore, we have the neo-academic middle ground, and, on the other side, the dogmatism of a clique. Such, then, was the choice (with several shades of gray between these two extremes) that a whole panoply of small reviews in the 1920s offered to their readers. *L'Esprit Nouveau* did manage to pull off the marvel of combining these two incompatible positions, since its arguments on architecture and urban planning (real exceptions to its tame general program) were both rigid and very advanced. Yet—and this is its most striking innovation in this context—*i10* refused point blank to accept the constraints of this choice.

Entering this heady discursive terrain, *i10* was immediately distinguished from its predecessors on three main grounds: firstly, the very diverse intellectual and artistic horizons of its contributors (much more so than with *L'Esprit Nouveau*); secondly, as with *De Stijl*, the manifest desire to be at the cutting edge in all of the areas in which it invested its energy; thirdly and above all—and this is expressed with more acuity in *i10* than in any other avant-garde review of the time—there was the idea that new thinking would arise out of this interdisciplinary "melting pot," and that the review would only have an effect on its readers if it were to have such an effect beforehand on its various authors by confronting them with arguments and theories on the numerous aspects of contemporary life that their isolation in their own research had kept them from even glimpsing. In short, the review aimed to be a work of culture in its own right, in the most etymological of the senses of the term, that is, to prepare the ground and to sow new seeds. We can see this clearly in the quadrilingual (Dutch, German, French, and English) editorial of the first issue, written by Arthur Müller Lehning:[9]

The international review *i10* will be an organ of the modern mind, a documentation of the new streams in art, science, philosophy and sociology.

It will give an opportunity to express the renewal of one domain with that of another and it arms [sic] as large a connection as possible between these different domains. As this monthly asserts no dogmatic tendencies nor represents any

party neither any group, the contents will not always have a complete homogeneous charakter [*sic*] and will be mostly more informative than following at one line of thought. Its idea is to give a general view of the renewal which is now accomplishing itself in culture and it is open, international, for all wherein it is expressed.

Two things are left unsaid in this editorial. Firstly, the editor's anarchist background that underpinned this professed a-dogmatism with regard to the avant-garde, and, secondly, the effect that this background was to have on one of the journal's most remarkable orientations (making it really unique and, even today, still a model to follow), namely, not just its interest in politics and the extraordinarily perceptive contributions it was to make to political discussion, but also the clear consciousness it had that it was impossible to work in the field of culture without at the same time addressing politics. In 1927, Arthur Lehning was already a well-known activist in the international anarcho-syndicalist movement, and he was present at the great libertarian congresses held at the time throughout Europe. Although still very young, he was a productive writer on history and political theory, having already written several political booklets, and he published articles regularly on current political issues, in multiple languages, in the international press. He was a political animal, an intellectual alive to all of the convulsions of modern society, and someone for whom art and literature were an integral part of his struggle. Lehning owed this enormous range of interests and activities to his anarchist education, and it is this education that was, in large part, to guide his editorial work at *i10*.

In fact, this anarchist tradition, immunizing Lehning against any doctrinal fossilization, was responsible for the ineradicable desire, peculiar to *i10*, to always take a political stance, to investigate all institutions of power, to show concern for marginal movements, and to constantly denounce all forms of state barbarism. The idea that there existed an essential bond between artistic and political struggle was not new. However, the link between art and anarchism was less common (the contribution of Paul Signac and almost all the divisionist painters to anarchist tracts, at the end of the previous century, is an exception here, as is the collaboration of Malevich with the journal *Anarkhiya* in 1918). But this was a time when the avant-gardes were globally receding, when Cubism and abstract art were backsliding into Art Deco, and when Constructivism was being suppressed in Russia. Indeed, the fields of art and politics appeared at this moment in time to be diverging as radically as, even only a few years previously, they had seemed to overlap. Furthermore, while the appeals for revolution coming out of *Die Aktion* and *Ma* (two magazines that Lehning credited as inspirations) were made by artists obsessed with the question of how their art and artistic program might connect with society as a

whole, *i10* was to bring to its pages thinkers and theoreticians of the sociopolitical field. These were not "politicians," as was the case with *L'Esprit Nouveau* on the rare occasions when the editors of this journal did feel that a contribution on politics was called for. To take one example from amongst a multitude, *i10* asked Walter Benjamin to contribute to its second issue an essay entitled "Analytische beschrijving van Duitschland's ondergang" (Analytical description of Germany's decline),[10] whilst Le Corbusier's publication had turned to Walter Rathenau, calling attention to his official title as Minister of Reconstruction of the Reich, for a "Critique de l'esprit allemand" (Critique of the German spirit).

It goes without saying that the union of the artistic and political struggles did not happen without there being some occasional resistance. After noticing in the first issue of *i10* a photograph of Mondrian's studio in which there were no paintings to be seen, Max Nettlau, the great biographer of Bakunin, wrote to Lehning to say that he would not be surprised if it turned out that the artist had lost his inspiration. Attacks came also from the artists. It is hard to imagine a man as politically conservative as Kandinsky becoming excited about the review's thundering stands, despite the fact that *i10*'s perceptive and prescient denunciation (starting in 1927 and therefore well before Stalin's purges) of the growing authoritarianism of the Soviet regime may well have brightened his day on occasion. The most difficult to convince was Oud, one of the three section editors (he was in charge of architecture, while Willem Pijper supervised music, and Moholy-Nagy was responsible for photography and cinema).[11] From the beginnings of the De Stijl movement, he had consistently refused to sign any petitions on the grounds that his position as Rotterdam's chief architect obliged him to maintain a certain bourgeois respectability (by which he meant neutrality). He had not assumed that post in order to see his name on the bill alongside Alexander Berkman, Peter Kropotkin, Alexander Schapiro, and other underground dissidents of the Red Revolution!

At this juncture, I cannot resist mentioning a letter that Mondrian wrote Oud in May 1926. This is not simply because the painter's conversations at the time with his architect friend hastened the creation of the journal, and not only because it was this letter that finally persuaded Oud to commit himself to the enterprise, but also because we can see in this letter how well-founded Lehning's ideal of a positive mutual impact emerging from the interaction between the review's contributors really was (one can easily point to texts that betray, from the end of the 1920s, the anarchist tendency in many of Mondrian's political pronouncements, despite their often disconcerting naiveté).

As for Müller Lehning's journal, it seems to me a very fine idea. M.L. is an anarchist, but the journal will not be a journal of the *anarchist party*; I am not familiar with all of the various parties, but I do know that he is very broad-minded, and

above all *in our direction* (i.e., against convention, against capital in the evil sense of the term, against the bourgeoisie, etc.) It will certainly *not* be an exclusively artistic journal, and that is a good thing. I intend to write on Neo Plast[icism] *in society*, and this is something I have been wanting to do for a long time. [ . . . ] M.L. wants (like myself) to help to construct a purer society *by means of ideas*.[12]

Could *i10*'s uniqueness be better expressed? Let us look again briefly at our two magazines taken for comparison. Van Doesburg, for his part, would simply not hear of politics (in 1918, for example, he refused to associate *De Stijl* with a petition from the Dutch artists against the Western capitalist boycott of Russia, and this caused the communist architect Robert van't Hoff to defect from the group). As for *L'Esprit Nouveau*, the very phrase "sciences morales et politiques" was enough to show that it had no intention of exceeding the strict boundaries of academic decorum. The only mention that the magazine made of Soviet Russia was to protest the absence of economic ties between that country and France—as if to say, imagine how much French industry was losing out on when all the other European powers were already making forays into the market of Russian reconstruction! This was all a far cry from Schapiro's lucid assessment of the achievements and failures of the October Revolution, Nettlau's tragic and thoroughly penetrating analysis of the rise of dictatorship in Europe, or Lehning's tract calling for the liberation of Sacco and Vanzetti.

By way of conclusion to this overly brief introduction, let us return once again to the very first issue of *i10*, since the general tone of the review was established right at the beginning. Following Lehning's editorial, we find another editorial piece, this time by Oud, on architecture and the visual arts, in which he announced that, after the dispersion that these fields had experienced during the previous ten or twenty years, he was looking to discern a common line in contemporary production. Next came a rather nebulous article by Kandinsky, entitled "Und," on the synthetic art of the future, and a brief presentation of his work by Adolf Behne. After these we have Mondrian's extraordinary "De Woning – De Straat – De Stade" [Home – Street – City] (which had previously appeared in French in *Vouloir*).[13] Then, separated in the table of contents from these great texts by the presentation of one of Sybold van Ravesteyn's architectural projects (*i10* was to publish his works often, and this shows a certain flexibility on Oud's part since Van Ravesteyn's eclecticism had been denounced many times by *De Stijl*), we find Ernst Bloch's "Doel" (Goal), a text that is essentially the first pages of his *The Spirit of Utopia*, the third version of which had appeared in 1923. After Bloch's piece, there was a long essay on comparative philosophy by Bart de Ligt that was devoted to East and West (Max Nettlau was to reply to this in a later issue), and this was followed by the first installment of a long review, by H. Roland Holst, of Trotsky's latest

book (on the economic and political evolution of England), and a presentation of the Leo Tolstoy Museum in Moscow. Finally, we come back to the arts with an essay by Pijper on "mechanical music;" a text from Moholy-Nagy, illustrated with his own photographs and photomontages, entitled "Geradlinigkeit des Geites—Umwege der Technik" (a title that *i10* translates as "Directness of mind—circuity of technics"); and above all, although printed in smaller font, the remarkable "filmkroniek" by Menno ter Braak (a dazzling essayist whom, one hopes, that a courageous publisher will one day make known to the rest of the world by translating his writings from the Dutch), a chronicle devoted to *Potemkin*, a film whose projection was about to be banned in Holland.

All of the ingredients that were to characterize *i10* were there from the beginning: the long theoretical texts on the visual arts, philosophy, and politics (with, soon, in growing importance, articles on literary theory), and also shorter, incisive reviews of current happenings in all of those areas. But above all, from the outset, there was the characteristic fusion of an anarchist-inspired utopian-socialist outlook (Bloch took some time before he was able to admit this filiation) and the desire for a radical renewal in all areas of culture. These features are to be found in every single issue of *i10*. The second issue, opening its columns even more to architecture with essays by Mart Stam and Oud, also included an article by Vilmos Huszar, a former member of the De Stijl group, on advertising as art. The table of contents also included Benjamin's long text on Germany, already mentioned; the second part of Roland Holst's review; an extensive piece by E. J. Gumbel on Russia in 1926; an ironic note by Lehning (much in the tradition of Karl Kraus) on the state of the Dutch press; a presentation of Pestalozzi's work on education; an examination of Mussolini's foreign policy; and once again a chronicle by Menno ter Braak, this time on *Métropolis*.

There is no need to continue with this list. Throughout the two years of its publication, *i10* was to preserve this extraordinary level of cultural and political debate, and also the admixture, the inimitable imbrication, of the two fields. Let us note, among its high points: Ernst Kállai's investigation of painting and photography (Malevich had responded to Kállai's questionnaire, but his piece never reached the journal); the numerous book reviews by Walter Benjamin; the astounding essay by Mondrian on Neoplasticism and jazz; Kurt Schwitters's *Ursonate*, which was to cause the review the loss of a good number of its subscribers (we should note that this phonetic poem, with its idiosyncratic typography, was immediately followed by Schapiro's "La révolution russe à vol d'oiseau" [A bird's-eye view of the Russian Revolution]; Bloch's articles on music (notably on Stravinsky's "return to order"), and all the pieces devoted to philosophy or current politics.

I mentioned earlier that, for me, *i10* was a model to follow, and this is true today more than ever. In our "postmodern" world, at a time when from

everywhere we are subjected to the preaching of the death of history in order to excuse us in advance for any lack of political responsibility, and when a huge number of artists, in the very name of the putative "death of history" and under the sway of market forces, seem to conceive of their work as nothing more than a series of more or less ironic pastiches, *i10* teaches us that it was really not so long ago that painters, sculptors, architects, poets, and even dancers based their work on the utopian desire for a society of the future in which social relations would be transparent. We hear a great deal today about the "failure" of the avant-gardes of the 1920s. But do we really want to condemn them on the pretext that fascism and Stalinism and then the cynicism of advanced capitalism were to succeed in covering the world with their leaden weight? Should we blame the avant-gardes for having made, as Bloch called it, "the hope principle" the motivating force of their production? The naïve are not the ones we think they are. Knowing that barbarism is always possible now more than ever possible the only solution, wise in its folly, is to resist, and—even if this resistance were to last no longer than a flash—to believe in its indelible and prolonged effect. Such is, as I see it, among many other things, the most valuable lesson that *i10* leaves for us.

Translated by Nicholas Huckle.
First published as "La leçon de *i10*," in i10 *et son époque* (Paris: Institut Néerlandais, 1989), 7–13.

1.   Yve-Alain Bois, *Arthur Lehning en Mondriaan: Hun vriendschap en correspondentie* (Amsterdam: Van Geenep, 1984).

2.   "They had agreed on the program of the newly founded magazine; now it was just a matter of finding a name that would be able to convey the diversity and breadth of its contents. 'If only there were not already so many Internationals,' thought one. 'Why don't we try to guarantee our own longevity through the title?' asked another. And the third: 'The "tenth international" would probably be thinking far enough ahead—"International Ten". . .?' From there, it was only a small step to the coining of the abbreviated title *i10.*" Lucia Moholy, "International Avant-Garde 1927–1929," *Du: Kulturelle Monatsschrift* 24, no. 3 (1964); English translation by Jordan Troeller in *October* 172 (Spring 2020): 109.
    The first twelve issues of *i10* appeared monthly from January to December 1927. After that, the publication was less frequent. The 13th issue appeared in July 1928, and the last one, numbered 21–22, appeared in June 1929.

3.   In contrast to the regular monthly issues of its first years, there were only two issues of *De Stijl* in 1926, three in 1927, and two in 1928; after this, the journal halted publication until a final issue was published as a posthumous tribute to Van Doesburg in 1932.

4.   See Ozenfant and Jeanneret, "L'Angle droit," *L'Esprit Nouveau* 18 (October 1923): unpaginated.

5.   Lissitzky was furious at the publication of Puni's anti-Constructivist article. He sent an essay on Soviet architecture to Le Corbusier, which was not received with much enthusiasm. The journal kept it in limbo for several months and ultimately failed to publish it. Shortly after that, Lissitzky sent his text to *Das Kunstblatt*, which published it in February 1925.

6.   It is Mondrian who enthusiastically alerted Van Doesburg to the existence of Dada (he even signed his letters "Piet Dada" for several months), as well as to the typographic and musical experiments of the Italian Futurists.

7.   On this aspect of Van Doesburg's editorial practice, see Yve-Alain Bois and Nancy Troy, "De Stijl et l'architecture à Paris," in *De Stijl et l'architecture en France* (Brussels: Mardaga, 1985), 25–90.

8.   On this issue, see Carel Blotkamp, "Mondrian's First Diamond Composition," *Artforum*, December 1979, 35; and Cees Hilhorst, "Bart van der Leck," in *De Stijl: The Formative Years,* ed. Blotkamp (Cambridge, MA: MIT Press, 1986): 178–79.

9.   Although Lehning was extraordinarily prolific, he did not publish anything during World War II (his abundant bibliography abruptly breaks off in 1939). When he resumed publishing, in 1947, he dropped the middle part of his name. Müller was actually not his patronym but that of his stepfather, which he had borne since childhood (upon entering high school he had insisted on adding to it that of his biological father, Lehning). I thought he had relinquished "Müller" because of its German sonority, which would have made sense in the immediate postwar, but he told me that it was actually a Dutch name, and that it was his biological father who was a German. He also told me that he had trouble with immigration services when he arrived in England as a refugee in 1939, because a brother of his had become a Nazi—he might have meant a half-brother. His well-known prewar political activity helped him quickly clear his name, and he was soon employed by the radio, where his command of several languages was partic-ularly appreciated. His other activity during the near decade he spent in England was to care for the precious manuscripts collection of the Internationale instituut voor sociale geschiedenis (International Institute of

Social History) that he had co-founded in Amsterdam in 1935. As the Germans were about to invade Holland, Lehning had overseen the shipment of four hundred crates of these papers to Oxford, including the quasi-totality of the papers of Bakunin, whose scholarly publication in multiple volumes he would edit until the end of his life. Among the crates, one contained his personal papers (his correspondence with many writers and artists), and another the archives pertaining to *i10*. The first of these arrived safely in England; the second was lost in transit. This explains, for example, why all the letters that Lehning received from Mondrian are saved (the first from August 1925, the last from November 1938) except for the period corresponding to the life of his journal.

10. The title of this text is that given by Benjamin in 1923 when he presented the manuscript of its draft to Gershom Scholem, who was then leaving Germany for Palestine. It was reworked, and part of it forms a section, entitled "Imperial Panorama—A Tour through the German Inflation," of *One-Way Street*, which originally appeared in German in 1928 (for the English translation, see Walter Benjamin, *Selected Writings*, vol. 1, ed. Marcus Bullock and Michael W. Jennings [Cambridge, MA: Harvard University Press, 1996], 450–54). But while the text of *One-Way Street* comprises fourteen fragments (denoted with Roman numerals), the Dutch translation published in *i10* features twenty fragments. The manuscript on which this Dutch translation was based is lost, but in his critical apparatus Tillman Rexroth, editor of the fourth volume of Benjamin's *Gesammelte Schriften,* provides the text given to Scholem, which includes drafts of these additional fragments, albeit differently organized. The *i10* text also includes an epigraph (*vooraf*), which Rexroth believes to have been penned by Benjamin himself. See *Gesammelte Schriften*, vol. 4, no. 2 (Frankfurt: Suhrkamp, 1991), 916–35.

11. The presence of Pijper among the three associate editors is somewhat of a mystery, for he was not particularly advanced in his taste (he is remembered as a follower of Debussy). While he remained on the masthead until the end, he published only two texts in the journal, neither of them attuned to the militant "apology for the new" characteristic of *i10*, but he welcomed essays by the much more inventive Viennese composer Ernst Krenek, one on the "Neue Sachlichkeit in music," the other on the "mechanization of art," which were contradicting his views—not to mention Mondrian's famous text on "Jazz and neo-plasticism."

12. I have published the whole letter in *Arthur Lehning en Mondrian,* 17–18. In this book, I also trace the impact of Lehning's anarchist views on Mondrian's 1927–31 manuscript, "L'art nouveau, la vie nouvelle, la culture des rapports purs" (The New Art—The New Life: The Culture of Pure Relationships; English translation by Harry Holtzman and Martin S. James in their anthology *The New Art—The New Life: The Collected Writings of Piet Mondrian* [Boston: G. K. Hall, 1986], 244–76). It is in view of publishing it in *i10* that Mondrian began writing this long essay, no doubt with the encouragement of Lehning, whose pamphlet *Rationalisatie en de 6urige arbeisdag* (The Rationalization of the six-hour workday) he paraphrases on several occasions.

13. On this text and its twin publication, see my article "Mondrian en France, sa collaboration à *Vouloir*, sa correspondance avec Del Marle," *Bulletin de la Société de l'Histoire de l'Art Français* (1983): 281–94.

# PEGGY GUGGENHEIM COLLECTION, VENICE

Cover of Angelica Rudenstine, *Peggy Guggenheim
Collection, Venice* (New York: Abrams, 1985).

# Review of Angelica Rudenstine's
## *Peggy Guggenheim Collection, Venice*

*I perfectly remember how and where I met Angelica Rudenstine, but I cannot recall exactly when. It was my friend the art historian Nancy Troy who brought her to the small apartment where I lived, between the Panthéon and Place de la Contrescarpe, as both of them happened to be passing through Paris at the same time. In my mind, this first encounter dates from my "Macula years"—that is, sometime before 1979, when the journal, which I co-edited, ceased publication. This detail is not insignificant, as (per Nancy's account) Angelica thought then that my work was "wild," which is not altogether inappropriate if compared to the extraordinary lucidity and seriousness of her art-historical writing. During these "Macula years," I was waging a war against, among other things, the art-historical establishment in France, its unabashed positivism and its militant refusal of any interpretive endeavor ("counting stones," I dismissively called it). I should also say that, besides not having been trained as an art historian, I had never been taught any of the basic protocols of doing archival research: Nancy was my first teacher at that (the enormous amount of energy she deployed in her research, her indefatigable stamina in hunting for documents and perusing obscure archives, had floored me). But we were both graduate students when we met, and when they came to my place a few years later, she had not yet acquired the gravitas that Angelica, a generation older, projected. Angelica's espousal of "counting stones" as a mandatory exercise before attempting any interpretation was more forceful than anything I had heard on the issue up to then, and by the time I read her book on the Peggy Guggenheim Collection I had long become a convert. Nevertheless, I was still stunned by the way she was able to construct solid interpretations from a myriad of seemingly insignificant details—the "stones"—while discreetly but firmly toppling the critical edifices built by others on shoddy foundations. We arrived at Harvard at the same time (fall 1991) and became close friends. When she asked me to be part of the curatorial team for the Mondrian retrospective at the National Gallery of Art, I jumped at the chance. Needless to say, I learned a lot from her about curating. And later on, when I embarked on the monumental task of establishing the catalogue raisonné of Ellsworth Kelly paintings, reliefs, and sculpture, it was her Guggenheim opuses (both the one on Peggy's collection and that on the Solomon Guggenheim Museum Collection) that I upheld as exemplary models.*

Those who have read *The Guggenheim Museum Collection: Paintings 1880–1945*, a catalogue raisonné published in two volumes in 1976, are well aware of the very high level of scholarship to be found in the work of Angelica Zander Rudenstine. Her most recent book, *Peggy Guggenheim Collection, Venice*, will not disappoint them. In this catalogue of the exceptional collection recently left to the Solomon R. Guggenheim Foundation, Rudenstine's vast command of the critical, aesthetic, and historical problems at stake in the art of the first half of this century is again in full operation.

This book, extremely heavy and filled with illustrations, might well deceive a purchaser: Although it is handsome, with color plates of a rare quality, it is definitely not a coffee-table book. Nor does it provide a detailed documentation of Peggy Guggenheim's life as an art patron, although a very useful summary of her activities as an art dealer is embodied in printed materials from her two galleries (Guggenheim Jeune, in London, 1938–39, and Art of This Century, in New York, 1942–47), reproduced in an appendix.[1]

Furthermore, like the catalogue of the Solomon R. Guggenheim Museum Collection, this book does not contain an entry for every object in the Peggy Guggenheim Collection, although it includes a checklist of its contents again as an appendix. As the preface indicates, a selection of 177 works was made by Thomas Messer, director of the Guggenheim Museum, from the total of more than 300 objects held in Peggy Guggenheim's Venetian palazzo. While one might regret the absence of reproductions or information about her stock of "primitive" art (thirty-six objects altogether), only two artists, on balance, seem unaccountably absent from the catalogue entries: Raoul Hausmann and Hans Richter, both of whom are represented in the collection by works of their significant Dada period.

The selection offered here is thus perfectly coherent: We are presented with the best and major part of the collection. The entries are arranged according to the neutral arbitrariness of alphabetical order; each piece is reproduced (sculptures by at least two views) and accompanied by a full account of its condition (past and present), and a record of its pedigree and of the literature concerned with it. This is the basic frame of the book, and if Rudenstine had limited her project to this alone, to giving each selected work its proper "identity card," her contribution would have been extremely useful and would deserve the gratitude of every scholar of twentieth-century art. Her condition reports are unequaled; her knowledge of the history of each individual object is stunning, as is her mastery of the vast literature concerning the full scope of modern art. But the sense of democratic equality imparted to the various works by this very structure is dismantled by the critical discourse that is the real stuff of

the entries. Although Rudenstine professes from the outset a certain kind of positivism ("the current study focuses primarily on questions and issues that can be addressed objectively or factually"; p. 15), she does not consider each work in the same depth of detail. As she notes herself, "the individual entries vary considerably in length" (p. 17). When no issue is at stake, or when a work is clearly derivative, no detailed analysis is considered necessary. On the other hand, when discussion is offered, it is always specific to the piece in question: "Thus a particular entry may concern a discussion of dating, of iconography, or of preparatory studies and their relationship to the final work. Or it may concentrate on the artist's medium, on his or her expressed attitude towards materials, on the nature of the work's surface, or on the physical changes that have been wrought by time or by human intervention" (p. 15). But if the author claims that the "variations (in entries) do not necessarily reflect the relative importance of the works in question," since they are governed by the presence or absence of "significant art-historical problems" relative to the work (p. 17), the attentive reader nonetheless realizes that it is not by chance that such problems tend to arise apropos the most "important" works, those which have attracted the most interest and discussion and therefore the most potential for controversy. And it is in dealing with those specific issues that Rudenstine's work is most valuable.

If one leaves aside questions of individual dating and the stylistic analyses linked to them—matters that would deserve a far longer treatment than this review allows—one could say than here are two major concerns at the core of this book, both of them essential to our comprehension of modern art. And in both cases, as will be seen, Rudenstine indicates a paradox.

I would describe the first concern broadly as technical or material, a matter that has rarely received such sustained attention with regard to works of this century. Many commentators have observed that during the past hundred years, as art gradually severed its link with a traditional theory of representation and gradually rejected the mimetic function it had embraced since the Renaissance, it gave an ever-increasing role to what Meyer Schapiro called the "non-mimetic elements of the image-sign," which became ultimately, in abstract art, the sole conveyors of meaning. These diverse elements had been considered "natural" by the Western tradition for many centuries, but by calling attention to them modern artists revealed both their historical nature and the possibility of putting them into active play. Among these elements are the support (which in painting had been for centuries a neutral, limited, and smooth surface onto which images were projected); the frame or pedestal (treated by post-Renaissance aesthetics as separate from the work); the properties of the field itself (its irreversibility, size, and format); the texture in painting and patina in sculpture; the graphic quality of line and the interaction of colors; the relationship between figure and ground, and so forth. These non-mimetic elements had played a role in the art of the

post-Renaissance past, but because of a strong Aristotelian tendency in the West to separate matter and form, they had always been codified and enrolled as mere instruments for the production of figurative images. Their non-mimetic quality had consistently been subsumed in the overall mimetic function to which the art was directed. It was the achievement of modern art as a whole (as has been said repeatedly since Baudelaire) to liberate those elements from their "extraneous" mimetic function, from their status as auxiliaries, and to elevate them as the essential repositories of pictorial and sculptural significance.

Rudenstine's analysis proceeds from this canonical view of modern art, but she shows, sadly and paradoxically, that while modern artists were giving the non-mimetic elements an ever-increasing importance in their art both theoretically and in the procedure of its making, those who collected the new paintings and sculptures, those who conserved and even restored them, were often far from grasping the essentials of the new situation. While reading the condition reports in this catalogue, one has the feeling that instead of benefitting from twentieth-century accomplishments in curatorial practice, modern works of art have actually suffered more than the art of preceding centuries from the consequences of casual attitudes and lack of care. This does not mean, of course, that one should reduce the problems faced by the artists of this century merely to technical considerations, but rather that those considerations have, in fact, become more entangled than ever with formal and semantic issues.

The number of damaged objects in the collection is staggering. The harm, it is true, was often inflicted by the artists themselves: For his first one-man show in New York, Mondrian, for example, glued his 1914 "facades" and "sea" drawings (an example of each of which is in this collection) on Homasote panels whose acidity contributed to the deterioration of the primary support. In another case, Mondrian earnestly believed that the multiple layers and the thickness of the paint on his Neoplastic canvases made them sturdier, while in fact this thickness is accountable for the many cracks on the surface of Peggy Guggenheim's splendid 1938–39 Mondrian. One is further shocked to learn that the most visible of the cracks is due to a customs stamp on the reverse. However, many Neoplastic Mondrians have suffered more from careless restoration than from anything else. Even if the Guggenheim canvas has not been too drastically altered by restretching, many others by Mondrian have been, making it nearly impossible nowadays to study the way this artist related his compositions to the edges of the canvas—a fundamental matter in his artistic endeavor and stylistic evolution.

A great deal has been said about the technical deficiencies of modern masters and what appears sometimes as a lack of sensitivity on their part to the fragility of the very diverse materials they used. It is interesting to note that the works of Pollock (popularly thought to be a prime offender in this regard) are

among the few in the collection that have not suffered at some point. In some instances, however, artists were interested in the very unpredictability of the chemical nature of the new materials they used. A case in point is Dubuffet: The behavior of the pigment of works such as *Chataigne aux hautes chairs* (1951), in the collection, was exuberantly characterized by the artist as "changing every fifteen minutes." But more often than not the indifference of those who dealt with the works after they had left the studio of the artist, indifference to the minute formal qualities that were embedded in their materiality, is the real cause of the series of disasters that Rudenstine unveils in her book. As a prime example, her extraordinary technical analysis of Boccioni's *Dinamismo di un cavallo in corsa + case* (1914–15), a sculptural icon of the Futurist movement, shows that only a small portion of the object exhibited in Venice is genuine; approximately half of the object that remains is actually the product of restoration and has little to do with the artist's original conception.

Peggy Guggenheim should be criticized for a certain laissez-faire attitude in handling her collection. The theatrical mode of display invented by Frederick Kiesler for her gallery in New York certainly did not help: Paintings were mounted off the wall, and spectators were encouraged to manipulate these displays, as well as a series of Klees disposed on a turning wheel and viewed successively through a peephole. And the continuous exposure to light of works on paper or the setting of sculptures in her outdoor garden in Venice did not help either. Many of the sculptures have lost their original patina and color, and Rudenstine shows us by the only color reproduction devoted to a sculpture in the book, a detail of Germaine Richier's *Tauromachie* of 1953, to what extent the specific intention of an artist can be entirely misrepresented as a result of such a careless attitude. According to Rudenstine, the symbolic connotations that Richier associated with the golden surface of her works have been completely erased. To cite further instances, one reads that in 1954 Arp was compelled entirely to remake his *Grand collage* (ca. 1918), purchased in 1940, because it had been ruined by its exposure to light; that his *Couronne de bourgeons I* (1936) had been broken in the 1950s, and that (in spite of the artist's stated doubt that his work could or should be restored) a restoration was carried out, in the process of which a very inappropriate, and apparently permanent, pedestal was added to the sculpture. In addition, Arp's papier-mâché piece of the same date, *Mutilé et apatride*, was altered by its presentation in a wooden box tacked vertically to the wall in a manner that entirely contradicts its original object-like horizontal position; the patina of his *Fruit-amphore* (1946?) has been totally lost; and so on. And we are only at the first letter of the alphabet!

Other examples: Cornell's *Untitled (Pharmacy)* of ca. 1942 appears to have suffered some major losses, while the internal organization of his *Soap Bubble Set* (1942) was so severely altered that the artist (when he saw it) apparently

dissociated himself from it. Ernst's *La ville entière* (1936–37) has lost most of its texture, even though one might have thought that Peggy Guggenheim, who was once married to the artist, would have known how much importance he attached to the surface quality of his works. To continue the unhappy list, the elements of Giacometti's *Projet pour une place* (1931–32), already fixed in an inappropriate manner when first exhibited in Peggy Guggenheim's gallery in New York, are still not disposed the way they should be. No explanation is given for why this cannot be remedied, although Rudenstine's research has fortunately led to the restoration of a *Piazza* by Giacometti, dating from 1947–48.[2] A matchbox cover has fallen off a Cubist collage by Gris; two cork balls as well as a large fragment of white china are missing from a Merzbild by Schwitters, etc.

Entry after entry, the condition reports read like a story of decay, as if this particular collection had been in the most uncaring hands. Nevertheless, some of the most severe injuries occurred when the works were not under Peggy Guggenheim's jurisdiction, and if she deserves some blame here, it is for having allowed her collection to travel too extensively. In other words, her desire to advocate for modern art by its free and continuous display paradoxically worked against itself. One nevertheless feels offended by the recent date of some of these damages: Though Guggenheim was always faithful to the wishes of the artists who did not wish their works varnished (Kandinsky, for example, and Braque), Picasso's *Le poète*, a major work of his Analytical period (1911), was covered by a heavy coat of varnish as late as 1968, when it was in the hands of the Guggenheim Museum in New York; Braque's 1912 *La clarinette* was varnished in Venice as recently as 1982 (after her death in December 1979); and Malevich's Suprematist canvas of ca. 1916, lined and varnished in 1968, was radically relined sometime between 1969 and 1979, with its four edges cut. Some of these damages may be remediable, and—perhaps in response to Rudenstine's observations—some appropriate restoration has been or will be undertaken. But such measures have not always proved possible. The most dramatic case is that of Brancusi's *Oiseau dans l'espace* (1932–40), which fell and was bent while in New York, and thus lost the smooth delicacy of the curve that is so essential, as Rudenstine shows, to the dematerializing reflections that the work is supposed to capture on its brass surface.

In each of these tragic examples, and in scores of others she dutifully reports, Rudenstine explains in detail how the alteration of the work is bound to lead to its misinterpretation. But her meticulous analysis of the materiality of the works is not only directed toward their condition and history. She also gives a full account, especially in the field of sculpture, of the specific attitude of the artists toward their materials and shows in each case how this attitude may be betrayed if it is not fully acknowledged. A case is Duchamp-Villon's *Cheval* (1914). In her entry, Rudenstine solves the complex problem of dating its multiple casts

and versions and explains how the enlarged posthumous bronze cast entitled *Le cheval majeur*—authorized by Marcel Duchamp in 1966 and displayed in such museums as the Musée National d'Art Moderne, Paris, and the Hirshhorn Museum and Sculpture Garden, Washington—misrepresents the intention of the artist, who spoke about a shiny, machine-like steel enlargement and would certainly have resented the "old-master" look of this version. Rudenstine's remarkable precision in these matters is extremely valuable: Her accounts correct many wrong assumptions concerning works in the collection and related works elsewhere, and in so doing they establish a standard for future scholarship while providing a series of warnings to public and private collectors.[3]

The second major concern of Rudenstine's book (more related than it might at first seem to the issue of the non-mimetic elements in art) is iconological, or, rather, anti-iconological. Renaissance studies have dominated the field of art history for the past century. Perhaps because of its prestige, scholars of twentieth-century art have been inclined in recent years to borrow the Renaissance scholar's method of iconology, even though it was initially conceived by Panofsky as specifically appropriate to the study of the Renaissance period. This has led to major misconceptions about twentieth-century art, especially about abstract art, whose meaning is often understood simply in terms of a veiled subject matter, either realistic or symbolic, which need only be deciphered. Rudenstine deserves our admiration for the passion with which she struggles against such a reductive concept, which rests on a dualistic separation of form and content that modern art, as a whole, wished to eradicate. This is the second paradox she points out: While the art of the period here considered moved away from this older conception of meaning, scholars of this period, over the past two decades, have moved back toward it and have striven for its restoration. Rudenstine clearly establishes the difference, among abstract painters, between those who, to speak like Mondrian, "abstracted from" and those who genuinely conceived their work as abstract from the start, and even within the first category she strives to demonstrate that a referential origin might not be essential in disclosing the semantic richness of a particular work. An especially good example is again offered by Mondrian: The interpretation of his *Sea* will be considerably weakened if one is satisfied with the mere identification of the original motif that was the starting point of the work. Equally, this artist's drive toward abstraction, based at the outset on the notion of a nonhierarchical equilibrium between horizontality and verticality, will be misunderstood if one adheres too closely to the Theosophic theories that filled his notebooks of the period and that associated the horizontal with the feminine and the vertical with the masculine. It is not a question of denying the importance of such connotations for Mondrian at the time but of cautioning against limiting the meaning of his work solely to these connotations. If one restricts one's interpretation to

them, one cannot appreciate that the all-over quality of *Sea* was imbedded in much more complex issues. These were related to Mondrian's desire in his later Neoplastic works to annihilate the opposition between figure and ground, which he conceived as the major obstacle of Western pictorial aesthetics on the road to pure abstraction.

Time and again, Rudenstine insists on the limitations that iconographical and iconological readings impose on modern works of art. The most thorough treatment of this question in the book is in the long note, at the beginning of the series of eleven entries concerning Pollock, on the various Jungian readings of his work that have been proposed. (No, Rudenstine concludes, one must not try to identify the victim in *Circumcision*; yes, Lee Krasner is correct to insist on the *ex post facto* determination of Pollock's title.) A similar warning is made about most of the works in the collection, from Chirico to Chagall, Duchamp to Gonzalez, Kandinsky to Miró. In this battle against iconographers and iconologists, a particular emphasis is placed on the work of the Abstract Expressionists, whose titles are too often mistaken as offering a denotative indication. Baziotes, for example, certainly does not *depict* a room in his *Room* of 1945; Motherwell's *Personnage (Autoportrait)* of 1943 can only be under-stood as a portrait on an associative level; and Rothko's *Sacrifice* of 1946 is not a stylized presentation of a bloody scene. And even if Gorky proceeded from sketches done outdoors to paint the Guggenheim canvas of 1944, one should not try, as has been done with some Gorkys, to relate the painting to a particular site. On the contrary: "The process of working outdoors liberated his capacity to create compositions that were to some extent free of literal subject matter and of direct references to earlier art, but the imagery which arose from this freedom was essentially indecipherable" (p. 374).

One of the most surprising achievements of this book is the way Rudenstine liberates Surrealist works in the Peggy Guggenheim Collection from this kind of reductive reading. Because the artists of the movement were interested in mythology, Surrealism is often understood as a return to a traditional mode of signification in which images illustrate a text. With the exceptions of Brauner, who wants each of his paintings to tell a "little story" (p. 133), and Masson, who sees his works as rebuses for which he himself provides the solution, most Surrealist painters insisted on the plurality and undecidability of meaning in their works. Rudenstine relies heavily on statements by the artists to stress her point: For instance, Delvaux denies any link to Ovid in his *Aurore* of 1973; Ernst is depicted as "at pains throughout his life to avoid such simple connec-tions, wishing to maintain the ambiguity inherent in his imagery and to thwart simplistic solutions" (p. 300); Magritte refutes any semantic "explication" of his art. In other words, Rudenstine says, "any single interpretation is bound to result in oversimplification" (p. 309). The most extraordinary demonstration

is made with respect to Dalí: Although the painter is known to have relied upon precise autobiographical elements to elaborate the iconography of his works, *La naissance des désirs liquides* of 1931–32 is linked to a vast series of images, texts, and concepts, from his own articles on the "paranoia critique" to Freud's study on Jensen's *Gradiva*, from the myth of William Tell to that of the flaying of Marsyas (via other paintings by Dalí for the former and an antique gem for the latter), from Dalí's film scenario *Babaouo* to Georges Bataille's *L'histoire de l'oeil*. But it is not the sheer number of possible associations that is important here; rather, it is the fact that they are often *contradictory*, exclusive of one another. Rudenstine demonstrates, in other words, that if it is sometimes possible to engage in iconology, one must never forget that meaning is governed by what Freud called overdetermination: Nothing is ever the neutral vehicle of a single signification.

Many other aspects of this rich book could be discussed. Related to the preceding point is the question of giving titles to modern works of art after the fact, a practice for which Peggy Guggenheim seems to have had a pronounced inclination—in many cases enraging the artist concerned with the title she invented. Another issue is that of hanging pictures in their proper positions: Rudenstine shows that the possibility of reversibility interested such artists as Arp, Malevich, and Man Ray. Yet another is the issue of the modern frame: The framing devices of Mondrian and the false frame of Duchamp are discussed at some length, although one misses a general account of how this problem interested Balla. And, as I mentioned earlier, many problems of dating are admirably solved in this book.

In its fundamental objectivity, the book shows that if Peggy Guggenheim was able to gather an extraordinary collection, she did so more often than not on the advice of others. She certainly knew how to get good advisors: Her Neoplastic Mondrian was chosen by Herbert Read, and she purchased Picasso's *L'atelier* of 1928 at the suggestion of Max Ernst. But this was not always the case; we learn that, on her own, she did not fully understand Pollock's importance, which is why she stopped buying works by him after their contract expired in 1947. We are also told that she was sometimes rather casual about her acquisitions (a Calder mobile and a Corneille were bought unseen, and she allowed an unauthorized bronze cast to be made of one of her Giacomettis). But all in all, one must recognize in Peggy Guggenheim an extremely astute collector, sometimes wiser than her mentors—Alfred Barr's exchange of a Malevich from the Museum of Modern Art with one of her many Ernsts is a stunning instance, and Rudenstine's book can certainly not be interpretated in any way as denigrating.

If some criticisms could be made of this volume, they are very minor: One regrets on occasion the absence of illustrations of related works that are

discussed. This is probably not the fault of the author, and in general the book is very rich in documentary material. The artists are, in some cases perhaps unwisely, allowed to have the last word on their production: I am not convinced, for example, about Duchamp's stronger link to Cubism than to Futurism. And, finally, the *Landschaft mit roten Flecken* by Kandinsky (1913), which is reproduced in color, is not the one in the Peggy Guggenheim Collection (properly documented in black and white) but presumably its first version in the Folkwang Museum, Essen. Nevertheless, the book is, on the whole, an extraordinary achievement, well deserving the Alfred H. Barr Prize it recently received; and it will become a standard reference work for all scholars in the field. A final note: Since Rudenstine quotes only the best part of the secondary literature, her book conveys the impression that the twentieth-century field is wonderfully strong and healthy. There could be no better stimulus to maintaining the high level all this advocates.

First published in *The Art Bulletin* 69, no. 3 (September 1987): 481–85.

1.	The famous photographs taken by Berenice Abbott of Frederick Kiesler's legendary design for Art of This Century are also reproduced in the appendix.

2.	Rudenstine: "In 1979 the author noted that the figures were seriously distorted out of position. In each case the bodies and limbs had been bent, and the stance of the figures, the degree of inclination, and the relationships among arms, torso, and legs altered to such an extent that the original configurations and composition were clearly compromised" (condition report, p. 352). As Rudenstine notes further, "The carefully calibrated positions of the individual figures, the insistent straightness of their backs and legs, the slight parallel curves in certain arms, and the perpendicular relationship of each figure to the base—all combine to create the distinctive geometry and uncompromising austerity of the entire composition. Even minimal alterations in these interrelationships . . . constitute major distortions that immediately impinge upon the clarity and precision of the iconography" (p. 355). It must be noted that the alterations in question, especially of the verticality of the figures and their relationship to the base, directly concern what Meyer Schapiro called the properties of the field and its gravitational anisotropy (the fact that, due to our dependance on gravity for our own kinetic balance, we do not give the same semantic and psychological value to every part of a field, and perceive differently the same figure disposed up, down, right, or left on a field). See Meyer Schapiro, "On Some Problems in the Semiotics of Visual Arts: Field and Vehicle in Image-Signs," Semiotica 1, no. 3 (1969): 223–42.

3.	[Addition 2021] I might have learned the virtues of "counting stones," but I still had to make much progress if I wanted to match "Rudenstine's remarkable precision." It so happens that I misread a footnote in her book, which led me to a false assertion. Judith Zilczer, then curator at the Hirshhorn Museum and Sculpture Garden, wrote a letter to the editor of *The Art Bulletin* in order to refute it. I stand corrected: Yve-Alain Bois's thorough and insightful review of Angelica Rudenstine's *Peggy Guggenheim Collection, Venice* gives the impression that the Hirshhorn Museum and Sculpture Garden displayed the 1966 bronze enlargement of Raymond Duchamp-Villon's *The Horse (1914),* known as *Le cheval majeur.* The Hirshhorn Museum in fact neither owns nor has exhibited this particular enlarged cast. As Rudenstine correctly noted, the permanent collection does include one of the late bronze casts of the "original" scale.

All agree that the history of the various casts of *The Horse* is very complicated. The following notes, from the Museum's files, may shed further light on the late bronze edition issued by Louis Carré in the 1950s. Measuring 43.7 cm, the Hirshhorn Museum's *Horse* is no. 6 in an edition of eight bronzes produced sometime between 1954 and 1963 for Louis Carré by the founder Georges Rudier. Although the number is not stamped or incised in the bronze, documentation from Louis Carré, including a label removed from the sculpture, and the catalogue *Duchamp-Villon* (Galerie Louis Carré, Paris, 7 June–20 July 1963, no. 12), indicates the size of the bronze edition and the number of the Hirshhorn Museum's cast. The museum's founding donor Joseph H. Hirshhorn acquired the cast in December 1964 from E.V. Thaw and Co.
See Judith Zilczer, "The Casting History of Duchamp-Villon's Horse," *The Art Bulletin* 71, no. 1 (March 1989): 156.

# The Originality
# of the Avant-Garde
# and Other
# Modernist Myths

## Rosalind E. Krauss

Cover of Rosalind E. Krauss, *The Originality of the Avant-Garde and Other Modernist Myths* (Cambridge, MA: MIT Press, 1985).

# Review of Rosalind Krauss's
## *The Originality of the Avant-Garde and Other Modernist Myths*

Rosalind Krauss's book is a collection of her densely rich essays written between 1977 and 1984 and dealing with topics as varied as Picasso's collages, Surrealist photography, Rodin and the multiple, Pollock and abstraction, LeWitt and obsessionality, Giacometti and primitive art, etc. But more than by this extreme diversity of interests, one is struck in reading the book by its demonstrative stance, something that has as much to do with the polemical posture of a number of the texts as with the particular position of the author as both critic and historian—or rather, as *historian* because critic. Among other things, *The Originality of the Avant-Garde* is a kind of model that should interest *all* art historians, at least those who wish to depart from what Nietzsche called "antiquarian history"; that is, the type of history that collects facts but disdains engaging in their interpretation.

At first sight, the last sentence may seem a gross exaggeration; one may indeed wonder how an analysis of Julio Gonzalez's sculpture or of Duchamp's theory of photography could be of any interest to a Watteau specialist or a medievalist, all the more since in her introduction Krauss presents herself as a *critic* and never uses the term "history" to refer to her work. Yet it is my contention that it is precisely there, in the articulation or juncture between criticism and history, that the lesson of this book can be seen to lie: its theoretical and methodological thrust. This thrust is multiple and is therefore hard to summarize but I would first put it this way: *The Originality of the Avant-Garde* shows that Nietzsche was right; that to be a real historian, one has to be a critic; that one cannot give a historical account unless one has a critical theory; that no historical object exists as such without having first been constituted and evaluated through a system of thought and interpretation.

This point is particularly important here because the method adopted and explicated by Krauss—the theoretical corpus named "structuralism" and "post-structuralism"—has often been criticized, especially from the Marxist front, for being ahistorical.[1] But this is only a particular case of the question. For when I speak of the methodological thrust of this book, I am not referring to the specific methodology it adopts, I am speaking of the way this methodology is annexed, used, in order to enhance not only the critical intelligence objectified by artistic facts and their development but also the way they themselves open onto historical knowledge as such. In fact, one of the charms of this book is that the great voices

of the French modern *épistémè* (Barthes, Foucault, Lévi-Strauss, Derrida, Lacan) are taken as allies. Not applied mechanically, they are rather summoned forth as a reserve of metaphors. This is to say that they are not routinely or unthinkingly imposed on the object of analysis but help in the very constitution of this object. Heuristic models for Krauss, those discourses are transformed in her book by the encounter they are now forced to have with a field—the history and theory of contemporary art—in which they themselves had in fact very little interest. (Indeed, it is possible that there is an added *frisson* available here for a French reader like myself, which comes from the kind of jubilation I feel when I see how the schemas of such an inveterate enemy of modern art as Lévi-Strauss are hijacked by Krauss to chart the domain of sculpture in the 1970s in order to make some sense of its diversity. The sort of pleasure I get from this short-circuiting must not be as intense for an American reader who is not as steeped as I am in the atmosphere specific to Parisian structuralism.)

In other words Krauss shows us not only how to use particular tools (the modes of analysis of structuralism and post-structuralism) within the field of art criticism and history but also *how to borrow* tools in general—what must always be the procedure of borrowing methodological tools (resulting in the transformation both of the tools and of the "visited" field)—and, more important, that such conceptual and methodological importations are necessary if one wants to avoid the illusions of neutrality and objectivity that pervade the discourses of humanism, positivism, and historicism.

Humanism and positivism are the ideological crutches on which traditional art history rests, and they are as much the target of Krauss as they were once the target of structuralism and are today of poststructuralism. But the essential thing here is that they are attacked precisely for their ahistoricity, as is current, mainstream art *history*. This, which accounts for the polemical tone of the book and explains, as Krauss says, that "some of the questions raised by this work [are] flatly incomprehensible to certain of [her] colleagues" (5), is evidently a hard pill to swallow. But the fact that not only current art criticism but also traditional art history is ahistorical by its very humanism and positivism (and its historicism, as paradoxical as that may seem) is demonstrated at many points throughout *The Originality of the Avant-Garde*, especially in those essays where a new historical articulation of a given field is set forth.

Take for example "Photography's Discursive Spaces," the only text of the book that directly concerns a nineteenth-century practice. Krauss's whole procedure is to rescue this object—nineteenth-century landscape photography—from annexation by art historians to the field of the pictorial tradition. This act of resistance and discrimination is not done for the simple sake of taxonomy; rather, it is understood as a fundamental step here because the confusion between those two species (painting on the one hand and photography on the other) engenders a denial of the

historical rupture occasioned by the apparition of photography, one that we are today only beginning to measure and to understand.

Or take "Reading Jackson Pollock, Abstractly," which undertakes the increasingly urgent task of reaffirming the specificity of abstract art as distinct and *living in a different historical time* from the art that traditional art history has chosen as its domain of choice—i.e., that of the Renaissance up to the break created by Cubism. Or take the brilliant essay "Sculpture in the Expanded Field," which contains the Lévi-Straussian schema I mentioned before: It is directly concerted as an attack on the positivist and humanist de-periodization through which most art critics try to read the diversified sculptural practices of the 1970s. Yet only if one persists in analyzing those practices as if they were following the historical codes of sculpture (object, monument) do they remain enigmatic or drive one to search for ancient and irrelevant forerunners (the Nazca lines, Stonehenge); only if one fails to isolate different codes at work within those new practices (not only those of sculpture but also of non-sculpture) does one miss the historical fact that a *change of paradigm* (to speak like a historian of science) occurred in the period in question, and that this change of paradigm is essential to understand what we call postmodernism. Or, finally, look at Krauss's demonstration that LeWitt's art does not have anything to do with Constructivism and its idealist rationalism and hence does not share the same historical language, appearances notwithstanding, as Mondrian or Mies van der Rohe but speaks instead a language of obsession, a kind of absurdist nominalism that was also that of the *nouveau roman* writers and *nouvelle vague* filmmakers of the 1960s.[2]

To show that landscape photography is not an imitation of Luminist painting (and should not be read by the same tools if one wants to give an account of its historical specificity), to insist that Pollock is not employing a kind of stylized version of iconographic themes, to claim that Robert Smithson's art does not belong to the same historical period as Giacometti's—let alone that of the Nazca lines—to rescue Minimalism from a mistaken association with Constructivism and even Cartesianism: Those are historical tasks, but of an art historian who believes in the *historicity of forms*, as did the founders of the discipline, and knows that there is a growing urgency in undertaking those tasks.

Another lesson that is taught by this book, one that benefits as well from its structuralist and poststructuralist approach, is how and when one can dispense with one of art history's favorite chimeras: the notion of style; that is, a kind of taxonomy based on the morphological look of the analyzed artifacts as well as on presuppositions concerning the unity of an epoch or of an oeuvre. I have already mentioned the way Krauss dismisses the assimilation of nineteenth-century landscape photography with the painting of the time merely on the grounds of their formal resemblance as an obvious error, a mistake whose extraordinary persistence might be explained by the interests of the art market.

Another remarkable setting aside of the notion of style is given in the essay "Notes on the Index," where the whole avant-garde production of the 1970s is mapped as an investigation of the photographic model insofar as photography is the clearest example (and understood as such by Marcel Duchamp) of the particular type of sign termed *index* by linguists and semioticians.

More surprising and perhaps more useful for students of the field, considering the quantity of failed attempts at a stylistic analysis of this phenomenon, is the redefinition of Surrealist art that is offered by Krauss in this book and is the focus of two essays, one on "The Photographic Conditions of Surrealism" and the other on Alberto Giacometti's production of the 1930s, "No More Play." "Breton, as the most central spokesman for surrealism," writes Krauss, "is an obstacle one must surmount" (93), not only because of his dogmatism, which certainly does not do justice to the diversity of the movement, but also because his own writings on art are a web of contradictions made to mask his "failure to *think* the formal heterogeneity" of the works of artists involved in the movement. In placing the emphasis on photography as the central visual activity of Surrealism—photography understood as a kind of rewriting of reality, as an exposure, through various distortions, of its surreality—Krauss discovers another Surrealism, historically closer to the life of the movement as a whole than are Magritte or Miró: that of the photographs of Boiffard or Man Ray which appeared in the magazines and illustrated Breton's poetic books. In reading Giacometti's Surrealist production through the concepts offered by a dissident Surrealist like Georges Bataille, Krauss is able to show how the interest the sculptor took in primitive art cannot be explained by stylistic concerns any more than can the close ties of his art, during a brief period, to that of Max Ernst and even of Dalí.

Behind those deliberate dismissals of the notion of style is a kind of dialogue with what is called "formalism." It is well known that at the beginning of her career Krauss was very close to Clement Greenberg—whose discourse is the paradigm of formalist criticism in this country—and that she severed all ties to that critic's method during the development of Minimalism, an art that she chose to advocate for and that he condemned absolutely. Her story of this rupture is given in various essays and can be read between the lines of her previous book, *Passages in Modern Sculpture*. This accounts, in a certain way, for the negative connotations Krauss often gives to the word "formalism" in her essays. Yet the book offers some brilliant formal analyses—like the one of Picasso's famous collage *Compote Dish with Fruit, Violin, and Glass* (1912), which is paradoxically directed, among other interpretations, against Greenberg's reading of Cubism. This means, in other words, that one must be cautious when dealing with a concept like formalism. Roland Barthes once wrote, "It is not certain that the word *formalism* must be instantly liquidated, because its enemies are our

own, namely scientists, causalists, spiritualists, functionalists, expressionists; attacks on formalism are always carried out in the name of content, of the subject, of the Cause (an ironically ambiguous word, since it refers back both to a faith and to a determinism, as if they were the same thing), that is to say in the name of the signified, in the name of the Name." And he added, "We do not have to hold formalism so much at a distance as at our convenience," which is what Krauss does.[3] She advocates for the *form* as a structure in multiple layers (that is, not as a shape) and as a producer of signification. Her formal analysis of collage is set up to dismiss biographical or iconological readings that simply deny "in the name of the Name" what Freud called overdetermination when he analyzed the creation and function of meaning in dreams. If one wants to explain Picasso's Cubist works by some biographical or iconological finding, one simply misses the particular stance of Cubism, its specific exploration of visual signs as necessarily ambiguous, and its joyous and deliberate play on this essential ambiguity.

But Krauss discards *form* as an irrelevant classifier if it is understood as "that which is purely visible." I already mentioned her castigation of a common interpretation of Minimalism as an heir of Constructivism ("Never mind that the content of the one had nothing to do with, was in fact the exact opposite of, the content of the other. Never mind that Gabo's celluloid was the sign of lucidity and intellection, while Judd's plastic-tinged-with-day-glo [*sic*] spoke the hip patois of California" [278]), but her reading of Florence Henri's self-portrait—usually interpreted as an almost abstract image—in terms of sexual commentary (86–91) or her dissociation of Giacometti's early "morphological" primitivism of 1926 from his more elaborated "conceptual" primitivism of the 1930s could serve as even more appropriate examples.

And in, just the same way as there are two conceptions of form (as structure and as shape) and two conceptions of formalism (as an understanding of the device and processes of meaning or as a simple delight in "pure visibility"), there are two conceptions of signification: one trivial, which mistakes the meaning of a work of art for its referent, and one structural.

Krauss's structuralism proves to be a particularly efficient tool of analysis when she stresses repeatedly that we should not take the "object-matter" of a work of art (in the words that Barnett Newman borrowed from Meyer Schapiro) for its "subject-matter." Her reading is especially important when she combats the "referential" (and positivist) conception of signification as applied to abstract art, a whole new genre that is apparently very popular among new scholars of the field ("And so Malevich is seen as making pictures of icons and Mondrian as making pictures of theosophical diagrams or esoteric emblemata or constel-lations" [238]). Instead of looking for the "woman underneath" an abstract work of art, to use Balzac's famous phrase, Krauss tells us that we should try to find

the specific way in which the work signifies, *for it is in this way* that the meaning of the work lies (be it a kind of transcription of the dialectical oppositions of Hegelian logic, as in the case of Mondrian, or an exploration of the binary nature of thought, as in the case of Malevich). But since the structural conception of signification does not participate in what Krauss calls the either/or structure of positivism (a form of exclusion according to which, for example, either a work of art is abstract and hence meaningless or decorative because without a referent, or it is meaningful and must have some kind of hidden referent), it is deliberately inclusive: One after the other, Krauss rejects the explanations given by Michel Leiris, André Breton, Reinhold Hohl, and even the aging Giacometti of the genesis and meaning of the sculpture *Invisible Object*, but she rejects them only insofar as each of these stories and interpretations cancels another and replaces it as the *only valid one*, as exhibiting not only the foremost but the unique *cause* of the work. Nothing prevents her from accepting all those explanations once they have been charted as different instances of a complex structure of meaning that links the sculptor's conception of primitivism to Bataille's concepts of the *informe* and the *acéphale*, to Caillois's and Ernst's fascination with the praying mantis, and finally to Giacometti's own sadistic writings of the period.

So far, because I have wanted to insist on the historical lessons given by Krauss's structuralism, I have spoken very little of what her essays owe to post-structuralism (let us say Jacques Derrida's "deconstruction" and Michel Foucault's "archaeology"), but here again it is not these theories themselves but the particular way she calls upon them that I find of methodological interest. Unlike most of her peers, Krauss follows wholeheartedly Riegl's, Wölfflin's, Nietszche's, and Walter Benjamin's anti-positivist dictum: One must look at the past with the eyes of the present (it is of course almost impossible *not* to do so, but it is important to know that one *does* so and to transform this condition, felt by positivist history as a handicap, into a heuristic tool of analysis). Today's situation is by now commonly called postmodern, and *The Originality of the Avant-Garde* offers some of the first attempts to give a theoretical account of this situation, describing postmodernist art as an art of the pastiche and of the ironic assaults on all the conceptual unities on which modernism was based: originality, oeuvre, stylistic coherence, etc. (conceptual unities that are, by the way, also those of art history, a discipline that was born at the same time as modernism and undoubtedly borrowed its concepts from its system of evaluation).[4] Now, all those unities are also those which post-structuralism submitted to its own analysis; hence Krauss's assimilation of the post-structuralist critique to a postmodernist position. This reading, which is at first metaphorical, offers Krauss, by a simple manipulation, the whole theoretical arsenal of post-structuralism as a means of *demythologizing* modernism, a demythologization that would have not have been possible without the distance given by the change of paradigm that postmodernism constitutes.

Of all the demythologizing essays in this collection, the one that gives it its title is the most important. Moving from the example of Rodin's use of the multiple to the recurrence of the grid within modernist painting, Krauss deciphers modernism as a structure of exclusion based on the repression of *repetition*, a notion that is, paradoxically, essential in defining the historical specificity of modernism (its pursuit of originality). This essay, which is preceded by another one on grids on which it relies, was obviously misunderstood by Albert Elsen. Thus, there follows a long rebuttal of Elsen's reading in which Krauss's talent for polemic is given full rein.

In this last polemical essay is a sentence that I find highly representative of Krauss's way of thinking, something that defines her as a writer: "We can see the transition [between "an original" and "originality"] as the material aspects shade into the conceptual" (185). The passage from the *material* to the *conceptual* is certainly one of the most striking effects of Krauss's method; hence her constant interest in concrete procedures, her distrust of a priori systems, her desire always to start with an object (almost all her essays begin with a minute description of a work). See, for example, the way she distinguishes between the nine-by-twelve-inch plate camera of the landscape photographer and a camera for stereoscopic views: "these two pieces of equipment mark distinct domains of experience" (136), an assertion that is followed, of course, by a little phenomenology of the stereoscope. Or see the way she infers from the famous enigma of Atget's strange numbering of his negatives that the photographer's frame of mind was the documentary space of the archives, "of the card files of the libraries and topographic collections for which he worked" (147).

This "science of the concrete," to use Lévi-Strauss's celebrated expression, is at the base of Krauss's *metaphorical* mode of understanding. But this mode appears also, as I have mentioned, in the way she uses the theories of others. She first got the idea of the grid as a modernist pictorial myth, for example, because Lévi-Strauss presented his Indian myths in grid form; or she looked at the current theory of the proper name—in linguistics and analytical philosophy—because she wanted to revive Wölfflin's slogan about art history *ohne Namen*; or she uses psychoanalytical concepts of repression and schizophrenia analogically, as she says (22), but this analogy helps her to define the repetition of the grid as a neurotic symptom of modernism, etc.

These constant metaphorical displacements locate for me not only the pedagogical force of Krauss's writing but its poetical quality, or rather—to use the expression by which she defines post-structuralist critics as *writers* rather than as *critics*—the way it enters the domain of the paraliterary.

First published in *Art Journal* 45, no. 4 (Winter 1985): 369–73.

1.   [Addition 2021] In this sentence, the words "structuralism" and "post-structuralism" are put in quotation marks for no other reason than to stress their denotative function (as names), quotation marks that are dispensed with around them in the rest of the text. However, at the time this review was written, I was very cautious about using the term "post-structuralism," which I had only recently encountered (that is, after my coming to teach in the US), a catch-all umbrella more or less synonymous with "French theory," under which American academics liked to place thinkers as diverse as Barthes, Derrida, Foucault, Kristeva, Lyotard, and many others, seemingly unaware of their divergences (and even sometimes disputes) on many topics. It would thus not have been out of character for me to put "post-structuralism" in quotation marks throughout the text and for a zealous editor to delete those. The same is true for the word "postmodern" and its derivatives—I felt validated when reading an interview in which Foucault raised doubts about both notions ("I do not understand what kind of problem is common to the people we call post-modern or post-structuralist," in Gérard Raulet, "Structuralism and Post-Structuralism: An Interview with Michel Foucault," *Telos* 55 [Spring 1983]: 205). I was not at all convinced that what was then called "postmodernism" actually existed as such—that the diverse artistic or cultural practices to which this term referred could indeed be characterized as posterior to, and above all as fundamentally different from, modernism. Fredric Jameson's brilliant 1984 essay "Postmodernism, or The Cultural Logic of Late Capitalism" (*New Left Review* 146 [July–August 1984]), rather than persuading me, had exacerbated my skepticism, especially since he listed pastiche and quotations as quintessential "postmodernist" strategies. His calling Gertrude Stein, Raymond Roussel, and Marcel Duchamp *precursors* of postmodernism was too much to swallow (this term has long been banned from my vocabulary, and students of mine, upon using it, have inevitably heard me recite this warning from Alexandre Koyré as reported by Georges Canguilhem, Foucault's mentor: "No one ever considers himself or herself as someone else's precursor; indeed, no one could. And to envisage someone as such is the best way to preclude the possibility of understanding his or her work"). Jameson's listing Samuel Beckett and John Cage among the "most significant postmodernist artists" was another absurdity that could only make sense if one blindly adhered to the very narrow conception of modernism proposed by Clement Greenberg. Unfortunately, all definitions of "postmodernism" on this side of the Atlantic were grounded, knowingly or not, on the same straw-man argument. It took some time for my friends at *October,* and even for Rosalind, with whom I debated the issue, to realize that this notion was shallow and paradoxically made them prisoners of the very logic they wanted to escape. This said, the present review is a period piece, republished here exactly as it appeared—that is, without adding quotation marks to it where they should have been (this goes also for the words "primitive" and "primitivism").

2.   [Addition 2021] In retrospect, it is surprising that I did not distance myself from Rosalind's attribution of an "idealist rationalism" to Constructivism, which is only possible if one makes of a sculptor like Naum Gabo the best representative of the movement rather than, say, Aleksandr Rodchenko (which she constantly did, a common error in the work of American art critics and historians, initiated by Alfred Barr). I had already criticized her for that in my review of *Passages in Modern Sculpture* (see, in this volume, 315–45), so I probably considered the issue not worth raising here, that it would be an unwelcome digression from my main argument about the theoretical stance of the book under discussion.

3.   [Addition 2021] Unfortunately, there is no specific translation in English of the French noun "scientiste," used here by

Barthes. It is rendered "scientist," which corresponds to "savant" or "homme de science" in French and is not at all the same animal (a *savant* is not necessarily a *scientiste*, and a *scientiste* is not necessarily a *savant*). The dictionary definition of a *scientiste* is "Someone who claims to solve philosophical problems through science." The citation is from Roland Barthes, "Digressions" (an interview with Guy Scarpetta, 1971), in *Oeuvres complètes (1968–1971),* vol. 3 (Paris: Éditions du Seuil, 2002), 993.

4.    [Addition 2021] There was some latent polemic in Krauss claiming that art history as a discipline "was born at the same time as modernism and undoubtedly borrowed its concepts from its system of evaluation." At the time, the consensus was still that art history had begun with Winckelmann or, even further back, with Vasari, while I considered neither of them to be historians (the first is spectacularly ahistorical in his construction of ancient Greek art as the alpha and omega of artistic production, the second is a biographer— that is, a writer of fictions). For me, the first art historian proper was (and still is) Aloïs Riegl, whose interest in the art of his time (notably Impressionism) is well known.

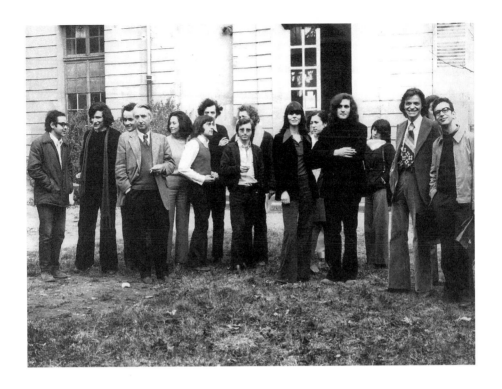

Roland Barthes and students in his seminar (Rue de Tournon, Paris, 1972–1973).
Photo: Irène Wittek.

# Writer, Artisan, Narrator

*After a miserable first year at the University of Pau (for more details, see "An Encounter with Robert Klein" in this volume), I enlisted in the École Pratique des Hautes Études (6th section) to join the seminar of Roland Barthes and write my "mémoire de diplôme" under his direction. At the time, in order to become a student at the prestigious school, you needed nothing other than a research project that interested the advisor with whom you wanted to work. After a (fairly long) interview with your potential advisor, you would be told either that your project did not hold water and would not find any sponsor at the school or that it held great promise but was more the province of a colleague and you should try your luck there or—the dream!—that you were in. I wanted to work on typography, particularly the experiments of the Soviet avant-garde in the 1920s with El Lissitzky as its main character, but while I had fairly good reasons to think that Barthes would be intrigued by the topic—given his oft-stated fascination for the materiality of writing—I was afraid that he would send me away on the pretext that this was more the turf of art history than semiology (for such was the rubric under which he was officially operating at the time), and an art historian was decidedly what I did not want to become (I had a second topic in store as plan B—about intertextuality—for which I was wholly unprepared; fortunately, I did not have to invoke it). To say that I was elated at the outcome of this first encounter would be an understatement. I started attending the seminar in the fall of 1971 and handed in my mémoire two years later, under the pretentious title of "L'outrage aux limites: contribution à une sémiologie de l'art soviétique vers 1920" (it included, among other things, detailed formal analyses of Lissitzky's 1920/1922* Story of Two Squares *and of his Berlin* Proun Raum *of 1923). This allowed me to register as a doctoral student in order to write my dissertation ("L'arbre, le carré, le vol: contribution à l'étude de la pensée plastique en Russie des années 1920"—another pretentious title), which I defended in March 1977. It had been hastily written and did not match my own expectations: One day during the winter of 1976–77, as I was no longer attending his seminar, my time being entirely dedicated to editing* Macula, *the journal I had founded with Jean Clay, I received a note from Barthes mentioning a research position that would be "just right for me" at the Centre National de la Recherche Scientifique (CNRS), but that in order to apply I needed to finish*

*my dissertation—which was then done in a matter of months (followed, as planned, by my joining the CNRS in fall 1977). The defense at the Sorbonne was intimidating (these were public, advertised events, with friends and family in attendance but also whoever had learned about it—one of the surprise guests was the artist Hans Haacke, who happened to be in Paris at the time). The defense committee had three members. Barthes, as my official advisor, was unduly (but typically) generous in his comments—even turning a reproach (that my opus was "à la limite de l'immaîtrisé" [on the brink of the unmastered]) into a compliment. Jean Laude, then the only full professor in the Paris university system who was allowed to teach the history of modern art (and only half the time at that, his other specialization being African art), was also way too kind; but the questioning to which I was submitted by Hubert Damisch (my officious advisor, so to speak) was harsher than I expected: tough love of a kind Barthes was, I suspect, practically incapable.*

•

In looking back, I can say this: One day I thought of his work as a tool. I didn't want only to quote it (for quotations may be used to no other purpose than affection or exhilaration) but to use his text as a crutch, as a theoretical arsenal in the tangle of problems I was trying to solve at the time; to find in his writings the concepts, the vectors, the grid that would address my specific concerns and get me started.

It was just a few months after his death; enough time had finally passed for me to think calmly again about Roland Barthes, as well as a whole area of my past that I had now to mourn. Things had changed long before without my realizing it: I still often recalled his words while I worked (fragments of discourse, recurring mottos that stubbornly lodged in my head); I would sometimes imagine his agreeing or disagreeing with what I was writing as I wrote it; but his image was already coming to my mind through the distance of memory: extreme accuracy in the details, blurry background. His death ratified a departure that had taken place gradually, surreptitiously, and that was in no way a sign of infidelity. And it was undoubtedly this separation that made me want to make use of him in a way that before would have been unthinkable. Yet in this act of returning, in this recourse to Roland Barthes, two unexpected impediments awaited me, and they were heartrending at first, inasmuch as they seemed beyond comprehension.

Almost immediately I realized that Barthes's text was no boon; that it would not serve as a guide to answer specific questions (even though it often broached the topic I wanted to debate, irrelevant here). Far from operating as a focusing mechanism or synthesizer, his text indolently dispersed the inter-twined threads of my thought. It removed none of the obstacles, but always

answered with indirection to point out another track in an already overly complex labyrinth. For the first time it was not a trustworthy ally therefore it was a useless, unusable one.

The second blow was directly linked to this sense of loss, of disorientation. I had always loved in Roland Barthes his very maternal, word-giving presence. I had become so familiar with his language during my regular attendance in the seminars and lectures that I thought of it as a second mother tongue. But that was to forget that the child learns to *speak* as well as understand the language spoken by the mother. And so if some of the atoms of language had succeeded in passing from the discourse of the master to that of the pupil, it was only as tics, as caricatural vestiges. I was finding out that I had partly forgotten that language! Inflections had lost their precision; certain statements no longer found their echo in me. A gentle amnesia had transformed my reading, and that language sounded again scratchy to my ears.

I had returned in a certain way to my first discovery of Barthes, to my first astonishment in reading him; when he was neither *maître-à-penser* nor giver of language, neither father nor mother, still unknown to me—when he was just the Writer. I realized that his death restored him to me in that form, reinstated his text, naked, free of baggage and of his responsibility toward me.

•

Then what? Had I been his pupil only to find myself suddenly confronted with his work in the same manner as ten years earlier? If it isn't his "thought" (its structure, conclusions, and so forth), if it isn't his "language," what, then, is Roland Barthes's *bequest* to me? The same that it was to everyone—his text. But to me personally? What is there of his that will always be with me? What do I owe him in return?

The answer occurred immediately, and with it, the need to write it down: I am indebted to him for what painters call "studio techniques." No, not a method, but a thousand practical recipes, which may eventually be thoughts, but, if so, general enough to address all contexts; for example: "Always look, behind Nature, for History." This could be called a meager inheritance. I would like, on the contrary, to convey its greatness (not so much that of the actual precepts as of the pedagogy and the practical instruction that it inadvertently imparts). Using this approach, I am following what was for me Roland Barthes's "first" lesson: Nothing that seems trivial is meaningless. To begin with, we have to look at things very closely, *at the end of our nose*, as materially as possible, because only this slight nearsightedness frees us at the outset from the myth of Depth. (Questioned about his "working method," Barthes gives the make of his pen, mentioning his hatred for ballpoints.)[1] The real flavor is found in the grain, on the surface of things.

There were other revelations. Rereading my seminar notes, I found it hard to believe that I really attended it regularly for only three years, followed by a fourth year of irregular attendance, before quietly freeing myself from the group (attended might give the impression of active participation, while in fact I was as shy and circumspectly mum as could be). I was also surprised to see that Barthes has often spoken to us of what I was just evoking, the "studio techniques," which he called "work protocols." I even found out that certain metaphors that had occurred to me (and that I thought were "mine") were buried there, in these faded notebooks, and had come from him. What are these two additional lapses of memory worth? They tell me this: You thought you had been in thrall to his voice for a longer time than you actually had, because its resonance is stronger in you than you think. Why is this? Because it wasn't so much what his voice said that left its mark as the way, thronged with images, in which it was said.

In a text Barthes devoted to the seminar form he set forth a rule of instruction: "Let us write in the present, let us produce in the others' presence and sometimes with them a book in progress: Let us show ourselves in the speech-act."[2] This is exactly what I was witness to during my "stay" with Roland Barthes, in the many books and articles, and, yes, even this text ("To the Seminar"), which was pieced together before us, and with us, over many sittings, several years running, before being set down on paper. Like everyone else in our group, I could measure the discrepancy between the feverish, groping, self-in-dulgently peripatetic research (in the seminar) and the inevitably anticlimactic published text; like everyone else, I was able to appreciate the disproportion between the wayward practice of writing and its tactful printed result. When I read "To the Seminar" at the time of its original publication, I remembered very well how I had already been disappointed at the appearance of certain texts that had issued directly from the first seminar I attended. Whereas then that disappointment had served to teach me nothing, now, suddenly I could detect a rule, an approach. Far from indulging the hackneyed idea (so uncharacteristic of Barthes) that spoken language is richer than mute writing, the difference between "To the Seminar" and what I remembered of the sessions spent developing it as a text taught me this: Writing involves a great deal of wasted effort; you have to let go of everything and then, bit by bit, allow only the germane stuff to surface.

In "To the Seminar," Barthes identifies three types of pedagogical practice. The first is the most common: the transmission of academic knowledge through "oral or written discourse, swathed in the flux of statements." It is the typical "teaching relationship": One distills the science, the other drinks it in. The second is *apprenticeship*: The master "works *for himself* in the apprentice's presence. [ . . . ] A proficiency is transmitted in silence; a spectacle is put on (that

of *praxis*), to which the apprentice, taking the stage, is gradually introduced." The third is *mothering*: "When the child learns to walk, the mother neither speaks nor demonstrates; she doesn't teach walking, she does not represent it (she does not walk before the child): she supports, encourages, calls (steps back and calls)."[3]

Here again is an instance of the parental opposition that Barthes had discarded. Not wanting to be the father (the preceptor, authority), unable to be the mother, he chose the second way, the other way; and we were his happy apprentices (a little bit mothered even so). He who lamented the disappearance of a certain art of living, he who often made the culture industry the target of his attacks, belonged to the world of the artisan. But an artisan of a strange sort, one who would have been unfazed by the transformation of the means of production and the advent of the machine. He communicated not knowledge but knowhow; he passed on to us his experience. "My difference" [and he meant the difference between himself and us, his students] comes from this (and from nothing else): *I have written*."[4]

Barthes insists upon the silence of the master before his apprentices: "He does not speak, or at least he sustains no discourse; his remarks are purely deictic. 'Here,' he says, 'I do *this* to avoid *that*.'"[5] One could say that there is something paradoxical about wanting to make himself into such a master: Did he ever deprive us of his speech? In spite of his reserve, which was proverbial, wasn't he always generous? Of course, but Barthes's *silence* rings through his voice and amounts to this: He never gave us a set of commandments. The recipes I spoke of had to be deciphered by each of us, in our own way, between the lines of his discourse. Because he didn't show us how to write, really, but how to put ourselves in a situation to write. His method was only partly deictic: Barthes didn't supply explanations; he gave us advice. Walter Benjamin writes that "counsel is less an answer to a question than a proposal concerning the continuation of a story which is in the process of unfolding."[6] The suggestions that Barthes made were nonviolent, since they were so often implicit, but there was always a *moral* to what he said, an intimated morality.

The artisan who transmits his experience, who does not provide explanations but allows his audience to elaborate for themselves the moral of his stories—he is precisely the one who knows how to tell a story; he is the narrator whose portrait Benjamin drew with such skill. It seems that there has been very little thought given to how much Barthes borrowed from and brought to the great tradition of oral narrative (not only in his teaching, but also in the very texture of his critical writing); yet everyone who heard him recognized and spoke of how extremely musical his voice was. He was a quintessential storyteller. There is clear evidence of it only in his later work (discovery of the biographeme, theme of "writers without books," and so forth), but all his metaphorical verve, all the

pleasure of incongruous lists, of contradictory examples (often the best, in his opinion),[7] his great love of the concrete, all this testifies to it. It also explains his preference for small, classroom-size space, and his discomfort at having to speak before large gatherings. A story cannot be told anonymously; a group of listeners must first have come forth. Barthes liked the space of the seminar because he could sense our listening to him and rediscover it, even as it changed, week after week.[8]

The art of the narrator, linked to the repetitive, endless temporality of the craftsman, began to crumble, according to Benjamin, with the invention of the novel, for a novel takes on meaning only with the appearance of the words "the end." But narration received its death blow from the rise of the modern demon of Information, the news—indifferent and blind to the past, an *énoncé* without *énonciation* (see note 8 above), the daily fatuity on which the world gorges itself, mass media. Barthes set the novelistic *(le romanesque)* in opposition to the novel; and to the vast indifference of the news, the "knife of value."[9] If he resisted the novel so stubbornly, it wasn't only because he knew that one could no longer (innocently) write one, but also because a much earlier past was revived within him that rebelled against the entire teleological structure of the novel, against what makes this art a story of the Fall.[10] And if he devoted an entire book to the way fashion is written and written about, it is undoubtedly because it is the purest form, the emptiest form, of news; as if the only possible response to this second, definitive offensive against the art of storytelling was for him to analyze its structure in its most innocuous form.

•

"Storytelling is itself an artisanal form of communication," according to Benjamin. "It does not aim to convey the pure 'in itself' or gist of a thing, like information or a report. It submerges the thing into the life of the storyteller, in order to bring it out of him again. Thus, traces of the storyteller cling to a story the way the handprints of the potter cling to a clay vessel."[11] For the first seminar I attended, Barthes's program was to relate the history of semiology, a topic with which his audience was already theoretically acquainted, an apparently neutral choice, and too much of a current issue to hold any dark secrets. Yet from the beginning it appeared that we would be listening to a very peculiar account: Roland Barthes's own "initiation" into semiological studies (Brecht rather than Saussure was the first writer to be considered).[12] The story of that slow passage was a delight: We were apprentices and we were being told a story of apprenticeship! (A somewhat special case, however, since Barthes-the-pupil had been almost entirely self-taught, and as he had familiarized himself with semiology, he had been contributing to its theoretical foundation.) But what was riveting about the seminar was that as Barthes reeled off a critical survey of

everything we were reading at the time, he himself, at that very moment, was withdrawing from semiology. The narration (transmission) and the desire to pass on to other things were perfectly synchronized. So it was that very early on I was confronted with one of the great practical principles of Roland Barthes, which is undoubtedly the precept written with a capital *P*, and which I will call the Principle of Unbelief.

Expressing a point of view then currently adopted in the history of science, Alexandre Koyré wrote that "arriving at a theoretical formulation, even if it is false, represents an enormous advance over the pretheoretical state."[13] Barthes would certainly have added that no theory remains true forever: "Even the science of desire, psychoanalysis, must die one of these days, though we all owe it a great deal," he wrote, "for desire is stronger than its interpretation."[14] His slight skepticism, this absence of fanaticism, is not a sign of defeat, but a tactical maneuver that refurbishes and endlessly improves the condition of the critic's weapons. Two corollaries follow from the Principle of Unbelief: *the right to abjure*, which is often asserted,[15] but especially its contrapositive, *the right to safeguard*. Critical ideas should not be let go of prematurely, he often told us; it's better to take our ease with them than to keep our distance. "Ease, on the order of desire, is more subversive than distance, on the order of censure."[16]

"I believe, in the end, that he did not believe in this opposition [ . . . ] or in any others," Derrida observed concerning the Nature/History opposition in Barthes's writings.[17] He was right to extend his observation to other dualities. It would apply, for example, to what Barthes had to say about connotation: "An idea that has always greatly interested me, and that I cannot manage to dispense with, even though there is a certain risk involved in presenting denotation as a natural state, and connotation as a cultural state of language."[18] But what the effort to shore up crumbling oppositions taught us, above all, is the necessity of oppositions in general; we must "posit a paradigm in order to produce a meaning and then be able to divert, to alter it."[19] This, as Barthes often showed us, is how one begins.

Many more of Barthes's ideas remain alive for me—an endless resource of which I gradually become conscious during the course of my work. A substantial number of these precepts are simply the moral of the stories he told us; there are others that reflect the wordless influence he had over me, whatever it is that constitutes his craft.[20] One of these indelible marks is what I shall call the *click*. Rereading the notebooks that I've kept from those apprentice years, I agree with his description of the notes taken in the seminar: They were "giddy,"[21] equivalent transcriptions, perhaps, of the kind of listening psychoanalysts call "floating." Barthes applied this floating quality to the entire sphere of language, to reading, to every utterance, to all conversation. I was astounded, like everyone else, when I saw him take out a notebook from his pocket one day

while I was speaking to him and write down several lines before answering. A little later, I again observed the same action, but as I glanced at his scribbling hand, I realized that there was no apparent connection between the fragments of language that were circulating in the air and what he was consigning to his notebook: That was the click, that turning of the key that released the association of ideas.

"It's when you lift your head that you're really reading," Roland Barthes often said. That is what I had been willing to forget when I thought of his text as a tool. To my embarrassment, I understood I could not escape the click, even if I would ever want to. If Barthes's text didn't answer my questions, it was because I had been summoning him too willfully, without feeling any compulsion from that sudden, insouciant turning of the key. It's not only the many flashes of insight that I remember from the seminar but the way they were meant to be heard—at least that is my hope: Let a swarm of thoughts bounce off a snap; let the signs proliferate over and around an opposition, an analogy, before putting them in order.

First published as "Écrivain, artisan, narrateur," *Critique* 425 (special issue dedicated to Roland Barthes, August–September 1982): 785–96. Translated into English in *October* 26 (Fall 1983): 27–33.

1.   Roland Barthes, "An Almost Obsessive Relation to Writing Instruments" (1973), in *The Grain of the Voice,* trans. Linda Coverdale (New York: Hill and Wang, 1985), 177–82.

2.   Roland Barthes, "Au séminaire" (1974), translated as "To the Seminary" in *The Rustle of Language* (Berkeley: University of California Press, 1989), 339–40.
     [Addition 2021] The quote here is taken from Richard Howard's translation, which had not yet appeared when my own text was published in English. As it often is, Howard's translation is imprecise. In the (even poorer) original translation of my essay, the end of Barthes's sentence was rendered as "Let us show ourselves in a state of enunciation," which is literal for "montrons-nous en état d'énonciation" but makes little sense in English. In defense of both translators, it should be noted that no satisfying and consensual equivalent in English of the French concept of "énonciation" (forged by Émile Benveniste in the late 1950s and which became absolutely crucial for Barthes, especially after his hard-core structuralist phase of the early '60s) seems to have yet emerged. A common translation is "utterance," but this word erases the opposition between "énoncé" and "énonciation," important for Barthes (as well as Benveniste), because it is used to translate either of them. Barthes often characterized his shift from structural analysis to what he called "textual" analysis as a shift from a semiotics of the "énoncé" to one of the "énonciation" (signs of his or her "presence" in the discourse, intentionally left or not, by the uttering subject; indices of the actual context of the utterance, etc). Barthes continuously stated his admiration for Benveniste (and in the seminar he very movingly mentioned his regular visits to the old linguist whose sickness had made him aphasic). See, notably, Roland Barthes, "Why I Love Benveniste" (1966), in *The Rustle of Language,* 162–64.

3.   Ibid., 336–37.

4.   Ibid., 339.

5.   Ibid., 336.

6.   Walter Benjamin, "The Storyteller" (1936), in *Selected Writings*, vol. 3, ed. Michael Jennings (Cambridge, MA: Harvard University Press, 2002), 145–46.

7.   "Is not the heterological example often the best?" in *Roland Barthes by Roland Barthes*, trans. Richard Howard (New York: Hill and Wang, 1977), 86.

8.   Was he happy at the Collège de France? I don't think so. The seminar, as I had the good fortune to know it (a small group of people—approximately fifteen— seated around a table), was Barthes's solution to a growing problem that had finally reached crisis proportions. In the fall of 1971, attendance had increased to the point that the École Pratique des Hautes Études had to rent a large hall located near the Champs de Mars. It was actually a theater, with footlights, wings, a backstage, etc. The funny thing about it was that it belonged to the French Theosophical Society. But Barthes's agony can well be imagined, alone there on the stage, in the spotlight, forced to preside *ex cathedra* before those hundreds of shadowy faces. The inevitable happened. Using some pretext, one of those in the overcrowded hall—undoubtedly expressing the frustration of everyone there—suddenly lashed out at the speaker. After that anonymous attack, Barthes closed his teaching to all but the students he was officially advising, and reconvened his (now thinned-out) seminar in a more suitable place. To facilitate a closer rapport, he divided the group of nearly forty-five people into three subgroups, devoting two hours a week to each throughout a whole afternoon.

9. The phrase (borrowed from Nietzsche?) appears in 1973 in *The Pleasure of the Text,* trans. Richard Miller (New York: Hill and Wang, 1975), 41. This is referred to in *Roland Barthes by Roland Barthes*, 129.

10. See Barthes's dialogue with Alain Robbe-Grillet in *Prétexte Roland Barthes* (Paris: UGE, 1978), 251–52; and "Réponses," *Tel Quel* 47 (Fall 1971): 102: "I like the *romanesque*, but I know that the novel is dead: that, I believe, is the place from which I am writing."

11. Benjamin, "The Storyteller," 149.

12. For more on this 'history of semiology" seminar, see "Tough Love" in this volume, 155–66.

13. Alexandre Koyré, *Études d'histoire, de la pensée scientifique* (Paris: Gallimard, 1973), 117.

14. Roland Barthes, *Leçon* (1978), trans. Richard Howard as "Lecture in Inauguration of the Chair of Literary Semiology, Collège de France," *October* 8 (Spring 1979): 10.

15. Ibid., 11; *Roland Barthes by Roland Barthes*, 71.

16. Roland Barthes, "Digressions" (1971), in *The Grain of the Voice,* 115. [Addition 2021] To the right to abjure and the right to safeguard, I should add the *right to bypass.* I remember my jubilation when I read this sentence in *Roland Barthes by Roland Barthes*: "And if I had not read Hegel, or *La Princesse de Clèves*, or Lèvi-Strauss on *Les Chats, or l'Anti-OEdipe?*" (p. 100). The visceral repulsion I had for Heidegger was absolved. I would like also to recall another of these Barthes nuggets that helped me as a scholar (but also as a teacher): At the beginning of every year, he would say something like, "Méfiez-vous de La Méthode, c'est une grande castratrice!" (Beware of Method, it is a great castrator!)

in order to lower the temperature of our compulsion to theorize before having fully examined, in all its details and facets, the object we wanted to study.

17. Jacques Derrida, "The Deaths of Roland Barthes" (1981), in *The Work of Mourning* (Chicago: University of Chicago Press, 2001), 37.

18. Barthes, "Réponses," 98.

19. *Roland Barthes by Roland Barthes*, 92.

20. [Addition 2021] This must be one of the very few times in which I used the term "influence." In banning it from my vocabulary, I was actually faithful to Barthes's teaching, for the critique of this notion, to which he substituted that of the inter-text, was part and parcel of his rebellion against traditional literary history. (His most eloquent explanation of the opposition influence/inter-text is to be found in an essay written in 1976 about Saul Steinberg, which was only published posthumously ["All Except You," in *Oeuvres complètes, 1972–1976,* vol. 4 (Paris: Éditions du Seuil, 2002), 968].) In a fragment of *Roland Barthes by Roland Barthes* entitled "What is influence?" he admits the possibility of influence, but only after having reduced it to prosody: "A kind of music, a pensive sonority, a more or less dense play of anagrams (I had my head full of Nietzsche, whom I had just been reading; but what I wanted, what I was trying to collect, was a song of sentence-ideas; the influence was purely prosodic)" (107). Interestingly, in an interview published in Japan in 1973, where he again states his refusal of the notion of influence "in view of certain theory or of a certain ethics of language," he is ready to admit having been "influenced" by one author: Bertolt Brecht ("Pour la libération d'une pensée pluraliste," in *Oeuvres complètes,* vol. 4, 469). Barthes is "my Brecht."

21. Barthes, "To the Seminary," 336.

Cover of Rosalind E. Krauss, *Passages in Modern Sculpture*
(Cambridge, MA: MIT Press, 1981).

# The Sculptural Opaque

*I met Rosalind Krauss in the summer of 1977, toward the end of her stay in Paris, where she was taking the famous Cours de Civilisation Française de la Sorbonne in order to perfect her French. I had corresponded with her the previous year, having learned from Hubert Damisch about the launching of the journal* October *(which she founded with Annette Michelson) at almost exactly the same time as the publication of the first issue of* Macula, *the (short-lived) journal I edited with Jean Clay. Upon exchanging our inaugural issues, we had immediately agreed to carry reciprocal advertisements in our respective periodicals, but I have to admit that, while I was impressed by what I had read of her, my knowledge of her work was not very deep (it consisted mostly of a few articles published in* Artforum*). We immediately hit it off and soon started sending our publications to each other—she had provided me with her current bibliography and many texts through which I was ploughing in order to determine what I should translate for* Macula; *my offerings were meager by comparison: I was just a graduate student then. I remember feeling very proud of her praise for my essay on Lissitzky and axonometry that appeared a few months after our encounter.[1]*

*I do not recall if Rosalind gave me* Passages in Modern Sculpture *during her 1977 stay in Paris (it is not impossible, since in her letters she does not mention sending it to me, while she does so for every other piece of her writing she sent, but my guess is that it appeared later in the year). Whatever the case, reading it was a watershed experience for me—all the more surprising since when speaking to me about it, Rosalind had tended to dismiss it as something hastily written for a commercial press. I had absolutely never read anything of both this breadth and depth on modern art—and I still think that it is unparalleled.*

*I have to admit that I was not extremely well versed in the history of sculpture at the time. What I knew best was the recent production of American artists, which I had discovered not long before, in 1969–70, as an exchange student in the United States. Visits to New York galleries and museums had left me panting for more and had led me to devour* Artforum *(this was not always rewarding: I specifically remember being frustrated at not finding anything in the journal about Fred Sandback, whose now legendary second show at the Dwan Gallery had mesmerized me). I had kept abreast of the fast-paced development of sculptural practices on the American side of the Atlantic and of*

the critical debates surrounding it. Other than that, my knowledge of modern sculpture was spotty: I had just been made aware of all the radical aspects of Rodin's work by Leo Steinberg's brilliant essay on the sculptor that had been recently reissued in his Other Criteria (those were still deliberately hidden from the Rodin Museum in Paris: On that score, nothing had yet changed from the dire description given by Steinberg of his visit in the early '60s); my memory of the extraordinary presentation of almost all of Picasso's sculpture in the Petit Palais in 1966 was still vivid but haphazard (I was fourteen at the time); I had never had the slightest interest in Surrealism; the only sculptural corpus with which I was familiar enough was that of Brancusi, whose bequest to the French state had been assembled for decades, in a so-called reconstruction of his studio, in the basement of the Musée National d'Art Moderne, a cordoned-off room to which I made a pilgrimage every time I came to the museum. Those Brancusi works were the only important prewar sculptures to which I had been regularly exposed before reading Passages, which is also to say before the museum moved to the Centre Pompidou and began acquiring anything other than late-Cubist and sentimental ("existentialist") works by local (all-too-French) celebrities. Another corpus with which I was well acquainted was that of Russian and Eastern European Constructivism—but in that case my knowledge was almost entirely bookish (based on texts and photographs) since there had been little occasion to see any work (one exception had been the stunning exhibition of [reconstructed] 1921 works by the Stenberg brothers at the Galerie Jean Chauvelin in 1975). By the time I read Passages, I had absorbed all that was available, in either English or French, on Russian and Eastern European Constructivism (including the translations of numerous manifestos by artists), which probably explains why I felt confident enough to criticize the treatment that Rosalind gave of it.

For the rest, I felt that I had to educate myself before I could do justice to the book, and it was only after several months, during which I explored every (art-historical or theoretical) text ever mentioned in it (all the more necessary since I had little access to most of the actual works discussed), that I dared to jump in. The review itself bears all the signs of having been written by a neophyte, but despite its numerous warts, it has withstood, in my mind, the test of time. I would write certain things differently today, for sure—I notably feel that I had been unfair to Michael Fried, who, being far less "dogmatic" than I portrayed him, would invite me to come and teach at Johns Hopkins University just a few years after the publication of this essay (an invitation that Rosalind vehemently pushed me to accept).

My friendship with her blossomed as we met more frequently after my permanent installation on American soil. We became each other's first reader (and very critical ones at that), exchanging drafts of our essays before their

*publication. I oversaw the French translation of several of her books under the Macula label (including* Passages*) and eventually joined the editorial team of* October. *Perhaps the most tangible result of our long comradeship was the exhibition* L'informe, mode d'emploi *at the Centre Georges Pompidou in 1996, which we curated together and whose jointly written book-catalogue was published in English by Zone Books the following year. Over more than four decades, Rosalind has been the most generous friend, unflinching in her support. My debt to her is beyond words.*

•

The fiction of a diachronic/synchronic opposition, introduced by Saussure, is like all those other binary pairs for which our metaphysics is simultaneously the guarantee, product, and originator. And like them, once its theoretical foundations are questioned, it ceases to function. The skirmishes between theories of structure and theories of history that had been ceaseless during the 1960s have come to appear as resulting from a simple misunderstanding; one now speaks of "complementarity," a classic figure of the harmonic resolution of "opposites."

However, there is one field that the champions of the binary opposition persist in dividing into two parts, however unequal, each situated on either side of a line of demarcation that is just as clear-cut as it is poorly reflected upon. That field is art history—or rather, since the absence of structural analysis in art history is nearly complete, it is art criticism, and at that, it is the only one that has been capable over the last thirty years of constituting a theoretical corpus, namely, American art criticism. Briefly—and we'll come back to this later—one must state that the work of Clement Greenberg, universally called formalist, provided a fundamental lesson for American criticism: a method of visual analysis, a theoretical-practical knowledge, a skill for looking at pictures. But after 1968 the dogmatic excesses of his evaluative system (based on a certain number of teleological postulates and exclusions) led most of his followers to break publicly with his doctrinaire art-for-art's-sake position (except for his persistent disciples like Michael Fried) and to fall into a kind of naive militancy, often deliberately anti-structuralist, and which, despite new political options, was based on all the humanist presuppositions of art history before Riegl and Wölfflin. It always seems to work the same way: The insufficiently theorized reaction against the abuses of a given theoretical practice produces a sort of caricatural regression—the achievements of the theory in question are abandoned for a return to baby talk.

Among all those who opposed Greenberg's rigidified certitudes, only Leo Steinberg and Rosalind Krauss escaped this danger.[2] Both are art historians (the immense superiority of American art criticism to the literary effusions of French criticism, avant-garde or not, is that it bases its work on a real knowledge of

art history), and thus their point of departure is identical. Both are strenuously opposed to the historical schema that Greenberg's modernist teleology has set up;[3] both demand an artistic status for all that his schema anathematizes. However, though many comparisons can be drawn between their analyses, their conflictual relation to Greenbergian criticism differs radically. For while Steinberg, a specialist on Michelangelo and Picasso (but writing on Jasper Johns and Rauschenberg as well), had never been captive to Greenbergian formalism, Krauss had for a long time been one of the most fervent followers of the author of *Art and Culture*, and this undoubtedly accounts for the singularity of her position.

*Passages in Modern Sculpture* must therefore be read both in its historical context (as the trace of a transformation) and for its own qualities: as a formal analysis that constantly moves from the static work to an experience of process; and as a structural archaeology that denies to all work the atemporality of self-presence that the immanent criticism of Greenberg and his imitators want to claim for it. And further, *Passages*, whose title evokes the promenades of Walter Benjamin or the involuntary memory of lost time (the last sentences of the book are devoted to Proust's madeleine, an experience the author compares to the mode of perception modern sculpture requires), shows how a critical practice was compelled to change when confronted with sculptural works that have now made time one of their motifs. In the introduction of *Passages,* one reads: "The history of modern sculpture is incomplete without discussion of the temporal consequences of a particular arrangement of form. Indeed, the history of modern sculpture coincides with the development of two bodies of thought, phenomenology and structural linguistics, in which meaning is understood to depend on the way that any form of being contains the latent experience of its opposite: simultaneity always containing an implicit experience of sequence" (4–5). Among other things, this book demonstrates the passage from a static conception of both criticism and the work of art to an active theory of both the perception and the mode of symbolization of contemporary sculpture, a theory that no longer excludes either the utterance or the history of the perceiving subject.

Krauss's first book, a monograph on the work of David Smith, the great American sculptor still unknown in France, had already attempted an escape from Greenbergian dogmatism.[4] It probably did so with difficulty, as we will later show, so efficacious was this theoretical corpus at the time. But with *Passages*, which follows the catalogue raisonné of Smith's sculpture[5] and rehearses the substance of a great number of essays Krauss had written during the 1970s, the rupture is elaborated theoretically. If the author retains from her apprenticeship the remarkable visual acuity that constituted Greenberg's own analytic attention, from this point on she shows that sculpture does not concern only visuality but that a whole episteme is engaged in acts of perception and of enunciation.[6] *Passages* documents as well a rite of passage: It reveals

how critical discourse was transformed by contemporary sculpture (a certain contemporary sculpture that Greenberg excluded from his analyses because it had begun, precisely, to hold the very notion of "visuality" suspect) through a reinterpretation of the recent past, of the history of sculpture since Rodin.

•

Beginning with the Renaissance quarrels about the *paragone* among the arts, all theoretical texts on sculpture have set up a preliminary definition: For Michelangelo, it was direct carving—defined as the perfect model of an *aphaeretic* art (the idea unveiled by subtraction, as truth, once purified of its material matrix, the block of marble); for Lessing, who held the Laocoön group as the paragon of the spatial arts, it was the need for the sculpture to choose "the most pregnant moment (of action), the one most suggestive of what has gone before and what is to follow[7];" for Adolf von Hildebrand, it was the bas-relief, proposed as the plastic archetype of a totality distinct from and closed off from its environment, in conformity with the requirements of any formalist aesthetics. More recently, Carola Giedion-Welcker conceived of modern sculpture, in a wholly Aristotelian manner, as the transformation in space of inert matter by the inscription of formal work. Thus all treatises, whether they originate from artists or from critics, immediately pose the ontological question (the *ti esti*) and respond by choices and invectives, by impassioned defense.

No more than any other work, *Passages* makes no claim to neutrality. It is certainly not an encyclopedia, but rather a study of specific cases taken as para-digmatic.[8] But even if the book ends with an examination of American Minimal art, so that a teleological aim might seem to underlie its propositions (whereas its order is simply chronological), the author depends upon no postulate, upon none of the theoretical a prioris that, since the beginning of the century, artists and their explicators have produced as texts. Krauss's lack of confidence in the aesthetic justifications artists offer for their activity, of the mass of declarations of intent that too often permit commentators to avoid having to do any real interpretive work, gives *Passages* and many of her essays a radically new tone, at times rather insolent (as when she declares, for example, that "Brancusi was among the worst of his critics"[9]). Far from attending to Rodin's analysis of anatomical movement, to Boccioni's proclamations about the dissolution of the object in space, to David Smith's declarations of allegiance to Surrealism and to Gonzalez, or, finally, to Donald Judd's statements about the nonillusionist and noncompositional character of Minimalism, far from holding all this literature as adequate to the work of its authors, Krauss stays with the objects themselves, demonstrating their actual functioning and the theoretical implications of this very functioning. Thus, a new taxonomy is based on uncompromising formal analysis: Duchamp is paired with Brancusi; Boccioni with Hildebrand; Rosso with [François] Rude;

Gabo with lbram Lassaw; Arp with Giacometti; etc. . . . In fact, this book is both structuralist and impassioned. Far from being intimidated by the multiplicity of -isms that the art of this century exalted as if to flaunt its protean force of invention, this book decodes the systems it sets in relation to each other in a vast historical fresco. Certainly, the author takes the side of modernity; but she defines it as transitory and bases her evaluation on actual sculptural production rather than on general and abstract principles. Further (and the word *strategy* comes up often in *Passages*, whether it is a question of Surrealism, Claes Oldenburg, Robert Morris, or Carl Andre), the concept of modernity has only a structural function for Krauss; it is a fiction that allows the historical novelty of a work to be characterized but does not permit another, more classical work to be ignored under the pretext that it is marginal with respect to the royal, linear road of who knows what progress. When it shows how certain "modernists" are more attached to tradition than one might have thought, *Passages* is convincing, and it is fundamental when it treats of ruptures accomplished by others who are often considered more classical. The overall field of sculpture in the twentieth century is analyzed as a play of multiple oppositions. Thus, in relation to judgments that valorize certain works and analyses of what they open and the systems they set up, a visual counterexample is always provided, clarifying the author's thought: The modernity of Rodin can only be understood with respect to the hidden classicism of Rosso's waxworks; the modernism of Picasso's constructions only with respect to the works of Gabo and Boccioni; that of David Smith only in opposition to Jacques Lipschitz's totems. Krauss shows us that it is not impossible to escape from the pervasive critical aphasia engendered, at this point in time, by the illusion of a profuse diversity. In the same way that Matisse could connect Ingres and Delacroix, long held to be wholly incompatible, *Passages* produces a new map of this century's sculptural corpus by means of criteria, born of confrontation with the works themselves, that are absolutely original.

•

Carl Einstein, who shared Lessing's postulate concerning the purely spatial character of sculpture, condemned the frontality of Western sculpture (with its corollaries: *modelé* and silhouette) as an expedient, a makeshift solution to what he saw as the main difficulty for sculptor and viewer alike, that of "fixing three-dimensionality in a single act of optical representation and viewing it as a totality, so that it may be grasped in a *single* integration."[10] Frontality, arising from a pictorial origin and based solely on the constitutive activity of the eye of the onlooker, effaces volume (which Einstein calls "the cubic") or, more exactly, "cheats the viewer out of its experience" in the attention given to mass or drawing. ("All of these approaches are characterized by pictorial or graphic procedures; depth is suggested, but rarely constructed directly as form. These

techniques are rooted in the prejudice that the cubic effect is more or less a guaranteed by-product of material mass, that the metaphorical inscription of an inner excitation into that mass or a single-sided formal directive would suffice for the cubic to exist as form.")[11] Even though Einstein's fundamental criticism of Western sculpture concludes with a defense of African art based on a set of theses that are opposed to those of Krauss, one could say that their premises are identical. "The viewer of a sculpture readily believes that his impression is constituted by a combination of seeing on the one hand and of imagining the most distant parts on the other, yet because of its ambiguity, such an effect would have nothing to do with art."[12] Sculptural frontality in the West has flattered the spectator with an illusion of mastery, a belief in his or her knowledge of a volume even while he or she does nothing but intellectually reconstitute its effects from a repertory of cultural knowledge (proportions, harmony, equilibrium) and by means of constant reference to his or her bodily condition as a vertebrate (anatomical knowledge).

According to the remarkable picture of the development of modern sculpture sketched by Carola Giedion-Welcker as early as 1937, there were two great propositions presiding over the interpretation of that sculpture since the beginning of the century. Einstein's text is perhaps the earliest formulation of the first (it would be taken up again by Kahnweiler in direct opposition to Adolf Hildebrand's *Das Problem der Form in der bildenden Kunst*),[13] but he was still too much a prisoner of a neo-Kantian philosophy of the subject and of vision to be able to come to any other conclusion than that of the need for a "restoration" of sculpture as autonomous volume. In analyzing the attacks on this causal aesthetic of totality, what Krauss reveals to us is that, whether situated in a niche as in the Renaissance or placed all alone in the middle of a square, sculpture has always privileged a unique vantage point in the sense that apprehension of it has been grounded on the immediate and implicit understanding of its structure, and this very understanding has rendered the movement of the spectator if not always impossible then at least superfluous.[14]

The other of the two generic propositions concerning the meaning of modern sculpture arises from a reading of Picasso's constructions made by the Italian Futurists and by certain Russian Constructivists, a reading that extolled transparency and mobility as opposed to mass, recognized the plastic existence of interstitial space (of the void that is opened between forms), and wanted to abolish the monumental weight of direct carving.

Both of these propositions were based on specific practices whose exemplars were, for Giedion-Welcker, Brancusi's sculptures in the round, on the one hand, and Gabo's "stereometries," as the artist called them, on the other. These two poles permitted a simple classification of the fundamental works of early-modern sculpture, but they proved totally useless for the analysis of works produced

after the war. What must indeed be called Krauss's theoretical discovery is the abolition of this taxonomy by the revelation of its ideological presuppositions.

Whether one speaks of Platonic simplification of volume—which is how Brancusi's work is most often presented—or of pure revelation of internal structure, both of these conceptions seem a recourse to the idealism that has governed aesthetic thought since the Greeks. Both take the formal work as a whole as the realization of a projected idea (whether the referent be geometric or "figurative") and both bracket out the materiality of the sculpture to the profit of a univocal meaning and a sense of the self-presence of the idea.[15]

The shock of the confrontation with the work of David Smith is what probably, very early on, provided Krauss with the logical instruments of her analysis.[16] Remarking on how the various aspects of one of Smith's sculptures are simply unpredictable from a fixed point of view (and that while walking around his works, one sometimes has the distinct impression of seeing two or three different sculptures, so that this art no longer offers to the spectator the synthetic possibility of constructing a stable image), Krauss questions the functioning of this "grammar of extreme visual disjunction" (157). "As early as 1933, Smith had focused his energies on the notion of an elusive object. His primary insight grew out of an instinctive refusal to erect his sculpture around a central core. By rejecting the idea of a spine or inner core he had freed his own work from the formal conservatism that persisted even the most open of the European constructed sculptures of the 1930s."[17] It is therefore less in the illusion of the organic nature of its material than in the structural principle generating that illusion that Krauss characterizes the anti-modernist (classical) sculptural tradition.[18] That principle involves the regular submission of what one thinks of as the "superficial shell" of the visible materiality of the sculpture to a center of projection that informs it, guides its contours, and functions as a reassuring specular double of the perceiving subject's consciousness of self.

And it is from this structural principle that the illusion of possession issues for the spectator, and with it the enslavement of the perception of the work of art to the monosemic aesthetic of representation, and the foreclosure of materiality in the idea and of temporality in narration. It is this same illusion of possession that leads to the exclusion of real space from the aesthetic field (as did pictorial illusionism), the real space within which the work of art is placed. Consequently, whether the core is hidden, as in the classical work of art, where the surface of the work is not valued for itself but rather for the manner in which the beats of an imaginary heart are registered upon it, or whether it is unveiled, in the name of a functionalist truth of transparency and of materials, as in the Constructivism of Gabo, whether the formal vocabulary is centripetal (the "static" containment of Michelangelo) or centrifugal (Baroque "dynamism"), it is always a certain notion of the center that is at the root of traditional Western sculpture, as it is for all of

the metaphysics that supports it. As Bachelard showed, the preferred figure for Romantic and Symbolist idealism was crystalline reverie. Without naming it as such, *Passages* reveals that the unavowed model of sculptural art up to Rodin had been that of crystallography. I would add that there are few sculptors who would not share Kandinsky's enthusiasm: "The crystals grow around a core = central point of crystallization. The forms of the crystal being born are ambiguous and the form that 'prevails' and maintains itself by eliminating the others is the one closest to the core (N.B. the greatest central tension!)."[19]

·

After a marvelous formal reading of Rude's *La Marseillaise*, presented as an example of the traditional sculpture of the nineteenth century (10–14), Krauss shows that Rodin was the first to escape from the narrative constraints that had determined the aesthetic of the art of this period.[20] Taking up Leo Steinberg's striking essay on the wholly misunderstood modernity of Rodin's work,[21] Krauss describes the figurative discontinuities Rodin sets up in the famous *Gates of Hell*, "for which almost all of his sculpture was originally fashioned" (14–15). While traditional bas-relief suspends the figure between its literal protrusion forward from the background and its virtual or illusionistic existence in the matrixial space of the relief ground, Rodin uses the very molten material of the *Gates'* opaque bronze clouds, in which he embeds his figures, to isolate them (20–21). But this strategy of fragmentation, which the *Gates of Hell* dramatizes by the multiple repetition of the same figures, possesses a critical import that extends beyond the questions raised by Steinberg of composition by assemblage or collage. The group of *Three Shades* (which also exists as an independent sculpture) perched above the *Gates* is a critical parody of the antique motif of the *Three Graces*, of which Antonio Canova produced the most famous example. This neoclassical tradition in which three connected figures are grouped (one frontal, the second seen from the back, and the third in profile) responded to a demand for clarity; it was a matter of informing the spectator about the appearance of the "hidden aspects" of the sculptural object in order to immediately provide him or her with the impression that he or she intellectually possessed it—without loss—in its totality. To create still more illusion, the neo-classical bas-relief (*The Three Graces* by Thorwaldsen, for example) added to this artifice an entire skiagraphy of suggestion, a whole play of literal *clair-obscur* that orchestrated the shadows cast by the projecting figures onto the ground of the relief. This use of shadow constituted the supplement that blurred and erased all perceptual discontinuity, creating an atmospheric bond between the real front face and the imaginary verso. Medardo Rosso brought this practice to its apogee by having the figures cast shadows mutually (22–23), but his work clearly shows how much the single, fixed vantage point was indispensable to

this misty illusionism.[22] For Rodin, it was no longer a question of adding some sort of imaginary supplement to what the eye discovers, but of insisting on the qualities of the surface of the work itself. (Some of his sculptures, Krauss remarks, could serve as illustrations for a manual on bronze casting, their frequent accidents highlighting the very process of fabrication.) The background no longer serves as a unitary space joining the figures in a fictional continuity that makes this ground transparent; rather, it is declared brute matter, which dissociates the figures and which no shadow manages to elide. Even more, the additive composition announces what will appear in a spectacular way in the berobed column of the *Balzac* (with its suspended head that had impressed Rilke so): Anatomical movement can no longer function as a reference for and a criterion of truth. The comparison the author makes between the group called *"Je suis belle"* (a conglomerate, in fact, composed of the *Falling Man* and the *Crouching Woman*)[23] and those of Antonio del Pollaiuolo or of Canova where Hercules and one of his adversaries are depicted shows how Rodin abolishes all dynamic reciprocity of movement through the referential opacity of his figures, and how any cultural acquaintance with the rhetoric of tension and of gravity can no longer be used to consolidate the unity of a perceptual a priori referring back to a viewing subject's consciousness of self. It is not by chance, Krauss tells us, that the *Balzac* is contemporaneous with the work of someone like Husserl, and that the meaning of Rodin's sculptures cannot be grasped without the real experience of their broken surfaces that no longer refer to a transcendence of any sort.

•

"Whereas painting is a fiction that repudiates the wall it hangs on, opening on to a figmentary world which simulates not merely the objects placed in it but also its own space and light, sculpture is established in the same dimensions as its spectator; it accepts the same light and its highlights and shades are *real*. [ . . . ] Every step the observer takes, every hour of the day, every lamp that is lit, can endow the sculpture with a certain aspect which is quite different from *all the others*."[24] These remarks by Paul Valéry seem to point to what both the classical sculptural aesthetic and the "formalist" approach that reacted against it found as a common enemy, though for diametrically opposed reasons. For the former (and it is similar to pictorial illusionism at that), any accentuation of the literal space torpedoes the bracketing of the real that is an essential condition of the imaginary act of contemplation in the mimetic system. It is the function of frame and base alike to abstract the work of art from that wholly real context where mirages are not permissible. For the latter (and this argument is advanced not only by Kahnweiler, preacher of the volumetric, but also by Hildebrand, apostle of the frontality that Kahnweiler condemned), sculpture, in order to

affirm itself as an autonomous entity, should radically distinguish itself from the world of objects, in which it has the mortal misfortune to take part. As the Renaissance texts on the *paragone* already could state, and as Clement Greenberg indicates, sculpture has maintained a "post-medieval" prejudice that promotes "the greatest possible tension between that which was imitated and the medium that did the imitating": a bias that favors the "abstraction" upon which pictorial illusion is based, to the detriment of the physical immediacy of sculpture.[25] The whole of Michael Fried's famous attack on Minimalism ("Art and Objecthood"), which Krauss examines in *Passages*, is nothing but a dogmatic application of Greenberg's statement: Modern sculpture can (Fried says *should*) be as two-dimensional as it pleases because it will always be literal enough not to "violate the limits of its language" by becoming painting.[26] Consequently, the paradoxical ambition of this champion of modernism is to reintroduce pictorial illusionism into sculpture, this latter becoming, in the system of exclusions Greenberg sets in place, the metaphysical guarantee of the ontological status of sculpture and of the essential difference that sets it in opposition to the category of things and of the mundane space that envelops it (and which, by a curious sleight of hand Fried denotes as the space of "theater"). *Passages* argues to the contrary. Since, beginning with Rodin, the perceiving subject is not constrained to a search for a transcendental "beyond" (whether it be structural or narrative) and can from that point on fix perception at the surface of phenomena themselves—illusionism thus being suspended—the contextual space in which the work is seen cannot undermine the apprehension of the sculpture. It can even be explicitly invested, becoming an active part of the sculptural work.

Duchamp had been fascinated by the mechanical impersonality and verbal opacity of Raymond Roussel's auto-referential "narratives." The tautological circularity of his own paranomastic aphorisms, which blocked the generation of meaning by their impassable phonetic interlocking of the verbal signifier, deprived language of all transparency, transforming the autonomous functioning of language itself into the sole agent of signification. Duchamp's readymades—which numerous commentators have been quick to affiliate with a demonstrative rhetoric of intentionality ("It's art because I say so," a proposition taken up again by champions of Conceptual art)—took part in the same perverse foreclosure of the referent. So that any attention given to the object—rudely transplanted from its utilitarian domain to the realm of art—had to concern the metamorphosis of its status: an ontological displacement that brought into question all of metaphysics. The scandal of the 1917 *Fountain* (a urinal, signed R. Mutt, shown in the Independents' exhibition in New York) can probably be more accurately understood because the object in question, offered up for consumption as an art object, simultaneously abolishes all the

philosophical assurances upon which aesthetic contemplation has been based since antiquity than because of the object's outrageous triviality; which is to say more by the very functionality of the object than by its own function. The *Fountain*, of course, can be read anthropomorphically by seeing in the curved form of its concavity some misogynist uterine image of femininity. However—and Duchamp's conspicuous neutrality, with regard to the endless symbolic interpretations of his work that the Surrealists and many scholars have proposed, is instructive here—this metaphorization is shown to be patently the exclusive act of the spectator-explicator. The urinal refers to nothing other than the urinal—an asyntactical thing authorizing no formal analysis; it thus leads to an interrogation of the strangeness of its accession to that closed field of aesthetic phenomena. Placed alongside other sculptures, it raises the epistemological question of their similarity and their difference. It thus arouses suspicion about the homogeneity of the cultural space that includes them (and with them, the spectator) and about the very metaphysical division of the world that assures the heterogeneity of their status. Duchamp's works on glass set the same deconstructive strategy of suspicion in motion: Culminating with the *Large Glass*, which provokes attempts to decipher its figurative components in terms of some mythic tale for which only the artist would have the key, the works on glass respond to the illusionist demands of the aesthetic of classical bas-relief by a display of excess. To the traditional fictive transparency of the support, they oppose a real (glass) transparency that no longer opens onto a virtual space that refers to the creative intention of the artist but now shows the exhibition space itself in which both work and spectator stand.

Krauss reads these three aspects of Duchamp's work (puns, readymades, and works on glass) as logical enterprises whose aim is to cancel the referential function of the sign systems to which they resort (spoken language, statuary, bas-relief). Beyond this, the aim is to supplant the legislative force of the referential context by that of the real context, which it had been the mission of representation to repress. A further aim is to reverse the linguistic proposition that assimilates the contextual order to the referential function of language,[27] and to work in such a way that the message itself is nothing other than this context to which it is no longer a question of referring but of simply affirming.

These analyses by Krauss would be indispensable even if they did nothing but ridicule the plethora of literary commentaries for which, by a remarkable misunderstanding, Duchamp's work has become a favorite target. But their heuristic efficacy arises from the way they permit an examination of Brancusi's sculpture in terms that no longer owe anything to the mystico-ideological mishmash to which we have become accustomed. The chapter *Passages* devotes to the work of these two great totems of modernity—Duchamp and Brancusi—is probably the book's richest and most surprising, the one whose operational

displacements are the most fertile. Even though Duchamp's ironies and Brancusi's calls for meditative contemplation seem utterly contradictory, Krauss shows that their gestures and their practices converge. In effect, Brancusi's ovoid is no less a readymade than is a bottle rack, being an "already-there" that the artist transposes into the aesthetic domain (the first belonging to the repertory of geometry, the second to the class of things). No more than the urinal does the *Beginning of the World* permit any syntactic reading. Further, both objects call attention on the effect that the space in which they are displayed has on them: "Placement is all," Krauss says of Brancusi's work, invoking the photographs he took of his own sculpture in preference to the statements he made about it. The few lines she devotes to the sculpture just mentioned deserve to be cited in full:

> Polished to mirrorlike smoothness, the bronze "egg" is placed in the center of a circular metal disk. The effect of this conjunction of the object and the surface on which it rests is to ensure a difference in kind between the reflections that will register on the lower portion of the form and those that will fall upon its upper half. Fraught with distorted patterns of light and dark reflected from the space of the room in which the object is seen, the smooth shape of the top half is contorted by myriad and changing visual incidents. The lower portion, on the other hand, simply reflects the underlying disk, and this reflection has the smooth, uninterrupted flow of a gradual extinction of light. Where the object touches base with the disk, the reflection it receives is the shadow of its own nether side cast back onto its surface, as if by capillary action. One therefore perceives the underside of *Beginning of the World*, outlined in velvety darkness, as a distinctly rounded curve in contrast to the upper surface of the form, whose contour is flattened by the invasion of light. It is this differential that gives to the geometry of the form something of a kinesthetic quality that recalls the feeling of the back of one's head, resting heavily on a pillow, while the face floats, weightless and unencumbered, toward sleep (86–87).

With Brancusi, it is no longer a question of examining the formal relations by which such and such a part of the sculpture relates to another part; rather, faced with their polished shape, the question is now to study how the material is inserted into the world. Further, this closed immediacy, which refers to no internal armature (and Krauss sees the unstable vertical shadow projected from the outside onto the streamlined volume of *Bird in Space* as the parody of the axial structure of all traditional sculpture), this formal atomism of the object is the pawn of no cognitive perceptual certainty: The meaning of Brancusi's sculptures in the round depends entirely upon their situation in space and the luminous reflections that modify their absolute geometries, dissolving their

contours to the point where no fixed identity can any longer be established. Consequently, the filiation to the work of Rodin that Brancusi persisted in claiming—a claim that has always been read as a stylistic comment upon the tormented surfaces of his early sculptures—takes on a completely different meaning. His mature work extends the phenomenological exploration that his early sculptures had made of the surface of volumes. So that if Brancusi returns to the practice of direct carving that Rodin had abandoned, it is less in order to embrace the Platonic *idea* (*aphaïresis*) than to cancel the metaphysical postulates by which this art had justified itself, and to do this as effectively as possible through sheer physicality, though without any faith in the truth of materials (for Brancusi most often transposes his marble works into smoother, and therefore more reflective, polished bronze).

•

It would seem logical at this point to turn to Minimalism as a logical extension of what has just been dealt with. However, I shall follow the author of this book in concluding with Minimalism only after having examined the diverse movements that precede it and against which it reacts. The historicism to which we are habituated is such that the "grandfather law"[28] always presupposes a semantic displacement at the point when certain works programmatically return to the formulations due to the penultimate generation. Thus, Minimalism directly re-engages the problem of literal space that Duchamp and Brancusi had charted, but it does so in opposition to the tradition of Cubism and Surrealism, which had ignored this problem.[29]

The all-too-brief chapter Krauss devotes to Cubism, Futurism, and Constructivism is probably one of the book's most interesting (it is there that the theory of the "crystallographic core" is formulated with the greatest clarity), yet the reader is left with a certain feeling of frustration.

Given the idealism of the concave form it uses for its center, it may be fair to analyze Boccioni's *Development of the Bottle in Space* by using a cliché, based on a complete misunderstanding, of the literature on Cubism (a misunderstanding that reads: The object is painted not the way it is perceived but as it "is," from all its sides and aspects, frontal information having to make up for the immobility of the spectator; and the activity of vision is patterned on the notion of a total perceptual penetration that affords a kind of X-ray of the material substance). And it may be important to see Boccioni's work in terms of a structural opposition to Picasso's constructions—from which it had originally developed. However, neither the Futurist conception of the object as a tool of cognition nor the latent symmetry of Boccioni's work (axiality, causality) are sufficient to indicate what sets this work apart, for example, from the 1915 *Counter-reliefs* by Tatlin. (The fact, upon which Krauss touches, that the *Counter-reliefs* engage the real space of

their installation—the very one that the illusionism of the "bottle" has to exclude in order to function—seems to me much more conclusive.)

In contradistinction to the sculptures of Boccioni, Picasso's constructions (especially the *Violin* of 1914, which is even more frontal than the *Guitar* of the same year) are all just as static as the wall they project from: No generating center from which vectors and planes could issue is there to supplement, by its constructive dynamism, the perceptual paucity that the spectator experiences before the real object to which the work refers.[30] Two plastic orders, without which no synthesis is possible, meet one another here. On the one hand there is a formal dispersion of the referential object in the disjunctive surface, composed of textured planes and of intervals of shadow; on the other hand, there is a distribution of decorative elements that mimic, in real space, the traditional codes of pictorial illusionism (e.g., the engraver's hatch marks, perspectival foreshortening). There is nothing more foreign to Picasso's work than the famous slogan about the supposed fictive and intellectual rotation of the viewer that the first supporters of Cubism alleged of this work. And, on the contrary, there is nothing closer to this definition than the work of Boccioni, completely captive to the tradition of the "hidden side," exemplified by Rosso, which the author shows to be regressive with respect to Rodin.

For Krauss, the clearest examples of this will to assimilate sculpture to a cognitive model and perception to an intellectual act of reconstruction are Gabo's transparent structures. The conceptual penetration of volume that his axial "stereometries" suggest (whether they use clear Plexiglas or present the heart of a volume to vision by indicating only the radial edges that bind the volume's material "envelope" to its core) participates, in Krauss's view, in the same idealist assimilation of rational form to the consciousness of the perceiving subject. However, the opposition *Passages* marks between Tatlin's *Tower* (where the structure, according to the author, is displaced from the inside to the outside and real time is made evident by the rotation of internal volumes) and Gabo's work does not seem to me as productive as the difference established between Picasso's reliefs and Boccioni's bronzes. Nothing really distinguishes the automatic kineticism of the cylinder, the cone, and the cube of the *Tower* from the causal rationalism displayed by the geometric sculpture brought forth by Gabo. The fact that the rhythm of the rotations is differentiated and linked to that of days, months, and years in no way sets Tatlin's *Tower* (titled *Monument to the Third International*) in opposition to the gyratory performance realized in space of Moholy-Nagy's *Light-Space Modulator* of 1923–30, a mechanical ballet derived both from Gabo's *Column* and from the virtual volume of his famous vibrating stem (*Kinetic Construction*, 1920). Krauss shows that this mechanical ballet (like almost all of "kinetic" sculpture) is gathered into the bosom of metaphysics in its most current and horrific form: that of scientific technology. Further, nothing

supports the assertion that the structure of Tatlin's *Tower* identifies itself with the weighty armature that encloses the rotary volumes and that their revolution might not itself be the generating, structural principle of this spiral construction.

I shall continue these few critical remarks elicited by the book with two small regrets: First, that the author has followed Giedion-Welcker in taking the work of Gabo (even if Krauss opposes it to Tatlin's) as an archetype of Constructivist sculpture. Rodchenko's sculpture, for example, is not always conceived on the model of transparency, and the massive brutalism of some of his work in wood could be seen as anticipating the formal principle of accumulation announced later by the Minimalists (Judd's "one thing after another"). As well, the work of Lissitzky and Van Doesburg, to which the author refers, does not for a moment share this infatuation with symmetry that she extends from Gabo to all of Constructivism. The disproportionate bases of the Steinberg brothers, placing the sculpture well above the eye level of the spectator, tried to accentuate the real space surrounding them no less than did the perverse frontality of Picasso's reliefs. Finally—and this second regret is nullified by the introduction of *Passages*, which itself announces that the book will not attempt to be exhaustive—it is a shame for the reader that Krauss should have given no attention to the masterly work of Katarzyna Kobro, whose disjunctive syntax, very close formally to that of someone like Anthony Caro, would have added substance to the general portrait of Constructivism she sketches. Despite her declared fidelity to the ideology of transparency,[31] Kobro, no less than David Smith, leaves the spectator guessing at the form the sculpture will take from another point of view. To be sure, there is a projective system, but the projected element is no longer a radiational core: It is a pictorial cut-out of space that the artist uses as a module, a module that she transposes onto all the surfaces via the geometric rhythm of their assemblage. But these surfaces are not "anterior" to the projection, they are not the receptacle of a formal inscription that decorates them; they are congruent with the projection that solely concerns their articulation.

•

For Surrealism, on the contrary, the object is often only the support for surface transformations, for a camouflage whose aim is to transport objecthood to the domain of fantasy. Magritte's repulsively painted bottles in the form of female torsos are widely known. Surrealism's oneiric preoccupations produced a good many of these materialized metaphors of which *Passages*, in one of its most picaresque chapters, offers us a revisionist view. For at stake in these objects is a denial of the notion of the core (the volumes are ostensibly hollow)—though not its deconstruction—since Surrealism reintroduces the narrative and causal order that is at the basis of the core as principle. Its formal determinism is now no longer structural but rather psychological, and the misuse Surrealism made of

psychoanalysis renewed the scarcely suppressed certainties of the philosophy of consciousness.[32] Whether or not the object revealed in Breton's "objective chance" coincides with the desired object, whether or not reality is skirted by a parallel surreality that must be disclosed, there is nothing that questions the unity of the subject or the metaphysical dualisms that secure the very concept of the "subject." For Surrealism (and this is probably the one common trait of its diverse factions), matter is only something inert governed by the energetic omnipotence of the Idea (or, in Surrealist terms, of desire): The erotic manipulations that Meret Oppenheim or Man Ray inflict on the (fur-lined) coffee cup or the (nail-studded) iron are no less involved with projection than the organic, neo-baroque momentum Jean Arp and his popularizer Henry Moore give to their marble volumes.

Giacometti, whose early works are unfortunately too often overshadowed by his later filament-like silhouettes, probably formulates the aesthetic principles that underlie Surrealist sculpture with the most precision. On the one hand, these principles are the result of a projective fantasy ("the realization of the work is nothing but a material task that, for me in any case, presents no difficulty at all").[33] In this sense, it is logical that for Giacometti, "only the drawing counts" and sculpture is conceived in terms of tension, like a volume set in motion by a "core of violence."[34] On the other hand, the relation to the referent is unstable, since the object of representation and the object of desire—real time and psychological time—are supposed to blend in an ideal, metaphoric surreality. ("Were these things I saw that I wanted to reproduce, or was it something affective, or a certain feeling of forms that is interior and that one would want to project outside? That's a mixture we'll never get out of, I believe!")[35]

Yet Giacometti's *Suspended Ball* (1930–31) is probably the sculpture whose operation is the least literally Surrealist, the object whose metaphorization is least dependent on the facile mythological bric-a-brac that Breton wanted to forcibly impose:

Aside from its explicit eroticism, there are two features of *Suspended Ball* that make it a central object of Surrealist sculpture. The first of these has to do with the kind of movement it incorporates, for unlike Boccioni's *Development of the Bottle in Space*, which projects an *illusion* of movement around the work through the agency of the corkscrew spiral, *Suspended Ball* engages in movement that is real [...] It is not the pregnant moment of Hildebrand and Rude, or the analytical time of Boccioni and Gabo—the compacted instant in which a sequence of moments before and after are contained and mentally projected. It is, instead, the real time of experience, open-ended and specifically incomplete. This recourse to real movement and literal time is a function of the meaning of surreality as taking its place alongside and within the world as a whole, sharing the temporary conditions of that world—but being shaped by by an interior need.

And this shaping by desire accounts for the second feature of the sculpture, one that makes it quintessentially surrealist: by placing the suspended ball and the crescent within the cubic volume of a cage, Giacometti is able to hedge his bet on the situation of the object within literal space. He is able to make it an ambivalent participant in the space of the world, in that, while its movement is obviously literal, its place in that world is confined to the special theater of a cage—it is boxed off from the things around it. The cage functions, then, to proclaims the specialness of its situation, to transform it into a kind of impenetrable glass bubble floating within the spatial reservoir of the real world (113-14).

But the scenographic space Giacometti brings out in the *Suspended Ball* is set to work in a whole series of horizontal sculptures conceived on the strategic model of the board game and requiring the programmed participation of the spectator: He or she can move the pieces along the hollowed-out tracks in the wooden base but without fail will be frustrated in the theatrical expectation of an event. In this matrix-like place conceived as an oneiric and tragic metaphor of everyday life, the tracks never meet and the effects are irremediably separated from their cause. This board-game aesthetic, however, leads Giacometti to concentrate his effort on the notion of object. A certain number of his horizontal sculptures are placed unceremoniously on floor or table and are distinguished from the world of ordinary objects only by a slight deformation, of which the spectator is not immediately aware. It is from the shock provoked by the perception of this slight deviation that Giacometti draws the sense of uneasiness bred by this class of strange objects: a veritable short circuit or discontinuity is produced in the fabric of reality, a crack through which all the repressed fantasies of the spectator-victim escape, once the taxonomic deviance strikes him or her. (*Disagreeable Object*, 1931, is the most notorious sculpture of this kind in Giacometti's corpus.)

Along the same structural lines as the board game, Arp considers the problem of sculpture's entry into the real space of thingness, a problem that formalist aesthetics was never able to take into account. But Arp transforms the givens of Surrealism by reversing the proposition. Sculpture for him is only a particular species of the genre constituted by natural objects. The organic metaphors Arp uses to talk about his own work are no theoretical fictions (138): They coincide perfectly, not just with the formal vocabulary he establishes (Giedion-Welcker's book on Arp abounds with comparisons between his "concretions" and the curves of snowy or desert landscapes) but also with the syntax that articulates his biomorphism—*Bell and Navels* (1931), based on the horizontal model of the still life (objects arranged on a pedestal-table), sets up a narrative poetics of growth, each form progressively deriving from its neighbor—and especially with the way he considers the malleability of matter, which recalls all the classical arguments

of the Renaissance theory of the *idea* as they have been exposed by Panofsky.[36] From Giacometti's manipulable objects and their implication of real time, one is led by Arp's work to the illusion of metamorphosis; from the rupture (of a psychological order) introduced within the compact tissue of reality, one comes back to the inferential aesthetic of rational causality; so it is not by chance that most of Arp's sculptures (like all of those by Moore) are once again constructed in the frontal mode (139–40).

In adopting a semantic combinational system, Picasso (one of the Surrealist-elect) directly opposes Arp's vitalist unity. The way Picasso joins two colanders to shape the skull of his *Woman's Head* (1929–30, Musée Picasso, Paris) and juxtaposes them with an oval surface in the guise of a face marks a wholly structural understanding of the notion of metaphor: Each of the elements loses its referential connotations to constitute an overall "image" that only exists in the flash of perception. The oval "mask" affixed to the assemblage of the colanders no longer refers to the centrality of a core, any more than does the spheric and hollow bulb formed by the joining of household utensils. But, as distinct from the Surrealist proliferation of transformed mundane objects, Picasso's sculpture never ceases to focus on syntax, thereby avoiding all symbolistic bric-a-brac. What Picasso says is not that a bottle could become a woman with the help of some make-up, but rather that a colander is a hemispherical surface that can define a sculptural volume and at the same time demonstrate that there is nothing beyond this surface. The referent is no longer the use-value of the object (which Surrealism as well as kitsch made a point of ostentatiously canceling) but the ensemble of the formal qualities of the object.

If one compares to this *Woman's Head* the great *Figure* of the same period (1928), welded for Picasso by Julio Gonzalez, one sees that its deconstructive irony rests upon a very incisive analysis of the presuppositions of traditional aesthetics.[37] This "drawing in space," which projects the exterior surface of the work by means of a linear geometry from which the central armature is then constituted, is an intriguing critique of the very notion of transparency it seems to exalt. By explicitly referring to the antique *Charioteer of Delphi*, it shows that neither the principle of coherence linking the exterior to the interior nor the biunivocal relation upon which all sculptural mimesis is based can be abolished by the simple, limpid revelation of the infrastructure of the object.[38]

•

Just by taking Surrealist work seriously, *Passages* breaks with a particular modernist dogma (Clement Greenberg's) that almost entirely excluded Surrealism from its teleological field. And in this regard the chapter of *Passages* that treats the work of David Smith maps the path the author has taken since her first book on the sculptor, a book still deeply allied to Greenberg's aesthetic, down to the very manner in which it attempts a breach with it.[39]

In her monograph, the author recapitulated what constituted for her the characteristics of Smith's mature work as follows: "1) It eludes possession insofar as it cannot be mastered in terms of tactile experience, nor understood through an a priori intellectual concept; 2) it can be possessed completely by vision alone, unlike the real objects of our experience; 3) Smith's sculpture seems totally comprehensible from a single viewing point, even where it makes sense to move around the work; 4) the very availability of the surface sets into motion expectations about the availability of objects; 5) the work composes itself into an image related to the carefully guarded private feelings Smith had about his work."[40] The first of these points is reworked by the analyses in *Passages* of Rodin, Brancusi, and the Constructivist tradition it places in opposition to them. But the three following points are derived from the pictorial conception Greenberg and Michael Fried (to whom explicit reference is made) had asserted for sculptural modernism. For Fried, the condition of sculpture should be one "of existing in, indeed of evoking or constituting, a continuous and perpetual *present*,"[41] and its goal is to abolish duration by instantaneity and to render all confusion between real space and aesthetic space impossible. For whoever adopted these postulates, it was necessary to show that the structural a-causality of the most interesting of Smith's sculptures (the unpredictability of their look or aspect from different angles) was subsumed in the evanescent apparition of a visual mirage.[42] However, having at that time already perceived that the essential in Smith resided in his elaborate negation of both the concept of a "core" and the demand for information about the "hidden aspects" of the object, Krauss was left with concepts that were wholly inadequate for her analysis. These were the rule of frontality and the constraint of a unique, fixed point of view that went along with it. This is why the monograph was stuck in contradictions, decreeing in an unconvincing way the coherence that a specific structure by Smith assumed from a given point of view,[43] or demonstrating, on the contrary, that the general opacity of his sculpture was not at all alleviated by the pursuit of other points of view,[44] and that this visual disappointment was the very principle of his work. The singleness of the point of view either was praised as an agent of anti-illusionism or as an agent of illusion, and sometimes as both at the same time.[45] It never seemed wholly to fit the object of the analysis nor to go with the equally contradictory theses made about the absence of this sculpture's "wholeness," a quality which, on the contrary, Minimalism was going to rediscover and exalt in Smith's work.[46]

The fifth point of Krauss's summary refers to Smith's iconography (he was never abstract),[47] which she examined (like his biography) in order to go beyond the purely syntactic analyses that a formalist Modernism had established for his work without ever taking its thematic range into account. Strategic necessities sometimes cause the author of *Terminal Iron Works* to fall into the inverse

excess and to repeat the error committed by all traditional art history, namely, a flattening of the signified beneath the referent, the assimilation of the content of a work to its motif.

The great merit of *Passages* is to have brought out all these misunderstandings (the monograph on Smith remaining in any case a model of stylistic analysis). In effect, in *Passages* Krauss has not only abandoned determinist assurances concerning the all-powerful status of vision but shows how much the absence of a single point of view (the absence of *point* of view, one might say) in the work of Smith coincides with the repertory of themes it shapes.

While the concept of totemism that fascinated many American artists in the 1940s derived from a Surrealist reading of psychoanalytic texts on fetishism, Smith had carefully studied Freud's theoretical constructions elaborated in *Totem and Taboo*. Far from wanting to *illustrate* the notion of the totem figuratively (as in the "primitivism" of his peers), he attempted to give form to the taboo itself—that is, to its principle, whose meaning concerns the interdiction of possession. The description Krauss gives of Smith's *Blackburn* (1949–50), contrasting it to Lipschitz's *Figure* (1926–30) and Lassaw's *Star Cradle* (1949),[48] supports her contention. Seen from the "front," the empty center of Smith's work reveals no structure, the axial swiveling of the figurative elements that populate the work's linear periphery conjure up no overall "image." Seen from the "side," the compact filling in of the torso contains no stable truth (with the exception of the head, all the various elements that in the frontal view occur on the exterior of a lozenge-shaped frame are reassembled on the interior of this same frame when viewed in profile). The radical discontinuity Smith sets up in the perception of the sculpture threatens both the linear concept of time and the position of mastery of the subject of consciousness. This totemic distance he establishes between the spectator and the now elusive sculptural object is intimately linked to the thematic obsessions that run through all of his work. In a series of penetrating iconological and structural analyses, Krauss shows us how Smith could elaborate a formal poetics from his private obsessions (sometimes this is a question of a "phallic canon"—symptom of a sado-masochistic relationship to the fragility of iron, to the violence of war, and to the fantasy of rape; sometimes it is the "sacrificial object"—the human torso becomes a table-bound still life to be consumed); she examines to what extent a structural homology between the disjunctive syntax of his assemblies and the thematic material itself constitutes the originality of his work.

The sculpture of Anthony Caro, which no longer demonstrates this congruence of the semantic and the formal, might seem to be an academization of the work of his predecessor. Although his best work (for example, *Early One Morning* (1962), of which *Passages* gives us a beautiful analysis [187–92]) played with the incompatibility, accentuated by color, between the physical

structure of the work, with its architectural determinates ("post and beam"), and the vertical pictorialism of its frontal aspect (a logical exclusion—either/or—not a dialectical one), the growing pictorialism of his work ends by totally destroying this tension and causes it to fall into a decorative prettiness.

The article from which the analysis of the work of Caro given in *Passages* is taken makes explicit the polemical base upon which this appreciation rests.[49] In characterizing this sculpture for the text of the catalogue of the Museum of Modern Art Caro retrospective, William Rubin begins with one of Greenberg's early propositions about sculpture. In 1949 in *Partisan Review*, Greenberg had written,

> Sculpture has always been able to create objects which seem to have a denser, more literal reality than those created by painting; this, which used to be its handicap, now constitutes its greater appeal to our newfangled, positivist sensibility and this also gives it its greater license. It is now free to invent an infinity of new objects and disposes of a potential wealth of forms with which our taste cannot quarrel in principle, since they have a self-evident physical reality, as palpable and independent and present as the houses we live in and the furniture we use.[50]

Yet as Krauss notes, never does Rubin's text refer to this worldly and objective quality of the sculpture—no more, for that matter, than do the texts Greenberg and Fried devote to Caro's work. On the contrary, Rubin exalts Caro's pictorial illusionism for the way it turns the steel sculpture into a colored drawing floating in space, denying all material gravity.

This polemic brings to light an antagonism of prime importance: an antagonism stemming from two opposing ways of reading the work of David Smith, two modes of reading that are the symptoms of two opposed notions of sculpture. The first (which led to the support of Caro and the rejection of all that has been denoted as "postmodernism") bases its judgment on an aesthetic of attention, referring in the final analysis to the Cartesian a priori of the philosophy of consciousness. This is the direction Greenberg and his followers took despite the idea advanced by Greenberg's text about the possible assimilation of future sculpture to furniture or to architecture (for that matter, it is not by chance that his sentence no longer figures in the version Greenberg gives of this text in the famous collection of these articles in 1962).[51] The second reading of Smith takes part in an aesthetic of *distraction*, for which Walter Benjamin and Matisse have provided the best definitions,[52] an aesthetic that no longer tries to reassure the subject with an illusion of mastery but, on the contrary, plays with a loss of mastery in order to force the subject to explore the pre-semiotic sensuality of a certain opacity of things. To a certain extent, *Passages* attests, in the critical work of Krauss, to a slippage from the first conception to the second.

The aphorism that Barnett Newman distributed in the invitations for his second solo show (at the Betty Parsons Gallery in 1951) is well known: "There is a tendency to look at large pictures from a distance. The large pictures in this exhibition are intended to be seen from a short distance."[53] The impossibility for a spectator to examine the totality of the visual field and to intellectually constitute an image interested Newman, just as the spectator's inability to "possess" his sculpture and perform a compositional analysis of it is what David Smith wanted to achieve. Sight does not penetrate a blank wall, it slides along it; and an inaccessible sculpture does not evaporate into the abstraction of a fictive space, it asserts its coexistence in this one.

In a certain sense, it is logical that in 1964 Donald Judd should have praised Smith's *Cubis* by speaking of their "objectness" and the "wholeness" by which they exclude any compositional, syntactic analysis.[54] These are the very qualities Minimalism was going to exacerbate in the multiple directions of its activity. (We might recall here how Robert Morris spoke about his own sculptures to David Sylvester: "I only feel the kind of presence of these things without really looking at them. [ . . . ] I can be in the same room and not be especially attuned to them, and I like that situation too, I guess. [ . . . ] They don't have to require my attention always.")[55] Yet despite appearances (and the violence with which Michael Fried attacks it), the work of Judd still participates in the illusionist aesthetic from which it claimed to dissociate itself. In an early text that caused her to be pejoratively characterized by the sculptor as a "Greenberger,"[56] Krauss demonstrated that, despite his statements to the contrary, Judd always conceived his work in an a priori space (spatial coordinates) and dialectically made reference to a "universal" perceptual knowledge anterior to experience. Of course, the article in question took a position against the (anti-"formalist") theory elaborated by Judd and argued *for* his sculpture in "modernist" (or, more exactly, Greenbergian) terms, to which the author then still subscribed; however, and here Krauss's impertinence founded the pertinence of her discourse, the defense she had made for Judd's sculpture becomes a misgiving in the present, and this reservation concerns if not all of Minimalism then at least the interpretation it has prompted. The best example is probably given by the analysis often proposed of Morris's three L-shaped beams (*Untitled*, 1965). In this work, Morris presents three identical geometrical volumes variously placed on the floor. One of the L's is upright, another lies horizontally on the floor, and the third is poised on its two points. For Marcia Tucker, curator of the large Morris exhibition at the Whitney Museum in 1970, these different positions, recalling the manipulations of a child's play with blocks, are demonstrations of the unassailable identity that constitutes any object's mode of existence in the world; and so, the inalterability of the object would be the basis of its stability and the meaning of this sculpture. For Krauss, to the contrary, this interpretation comes from a misunderstanding

of Gestalt theory (to which Morris's writings refer)[57], for which the importance
of context—due to its influence on the perception of forms—is always basic:
Thus, the L's are never identical objects for the spectator. By the logic of visual
compensation, the horizontal arm of the upright L seems elongated, whereas
the L resting on its two ends appears swaybacked under the imaginary pressure
of gravity.[58] This difference (or rather, this difference between identity and
difference) is the meaning of this sculpture, and this meaning depends upon the
relation these forms have with the space of experience. Far from referring to
some a priori knowledge that it acts to confirm, thereby reassuring the perceiving
subject of the calm unity of his or her consciousness, Morris's sculpture (despite
the metaphysical word "presence" he uses, as do all the Minimalist and "Post-
Minimalist" artists to justify their work)[59] happens to cancel any position of
mastery for the cognitive subject and to give back to memory the disseminating
and disruptive function ("visual compensation," for example, attests to this) that
classical philosophy and historical formalism have tried to obliterate.

•

To make a schema of the change in sculptural sensibility to which the art of the
twentieth century has testified, Carl Andre spoke of the successive transforma-
tions of sculptors' interest in the Statue of Liberty: "In the days of form people
were interested in the Statue of Liberty because of the modeling of Bartholdi
and the modeling of the copper sheet that was the form of the Statue of Liberty.
Then people carne to be interested in structure and they were not interested in
Bartholdi's form anymore. They became interested in Eiffel's cast iron interior
structure: the girders and the cantilevers and the supports; in a sense, taking the
copper sheets off the Statue of Liberty and looking at the row iron or steel that
constituted the structure on which the copper plates were hung. Now sculptors
aren't even interested in Eiffel's structure anymore. They're interested in
Bedloe's Island and what to do with that. So, I think of Bedloe's Island as a
place."[60] *Passages* shows that it is from this new conception of "sculpture
as place" that the whole sculptural practice of the last twenty years derives.

It is not possible to summarize here the hundred or so pages Krauss
devotes, in the last two chapters of the book, to the exploration of real time
and literal space made by American art since the 1960s. To a certain extent,
this part of *Passages* collects all of Krauss's critical activity on the art of her
contemporaries—that is, on very diverse experiences (whether it be Oldenburg's
happenings or the dance performances of Yvonne Rainer or Frank Stella's
paintings or the precarious balances of Richard Serra or the landscapes shaped
by Robert Smithson) that permitted her both to separate herself (to the point
of rupture) from the "modernist" verities her first work vouched for and to
reinterpret the entire history of modern sculpture. I would simply like to stress

this question of place, indicated by Andre, which in a diffuse way runs through the analyses in *Passages* in what might seem to be a response to the classic approaches toward modern sculpture.

For Hegel, sculpture could not be abstracted from the architectural place that contained it, architecture even constituting its essential determinate.[61] But for Rilke, as for a great number of historians of the subject, the origin of modern sculpture at the beginning of the twentieth century greatly depended on the absence of any architecture capable of either receiving or being informed by it, a lack supposed to have led artists to concentrate their attention on the formal autonomy of the objects they were shaping.[62] Paradoxically, the rejection formulated by Hildebrand (whose "bas-relief" solution nevertheless aligned sculpture to architectural friezes) against panoramas (half-sculptural, half-pictorial), wax figures, and the tombs of Canova was aimed less at the confusion of genres than at the partaking of these hybrids in public space.[63] And when he claimed only to like minuscule works in past sculpture, "in any case sculpture not attached to architecture or to a precise place," Giacometti confirms the analyses that ground the origin of modern sculpture on the rejection of architectural space.[64]

Rosalind Krauss's book (from the chapter devoted to Brancusi on) demonstrates how much this "modernist" interpretation was preparing the resistance that Minimalism, and the movements issuing from it, were to encounter. Of course, architecture was at first considered as merely a neutral frame, the stable and monosemic support of sculpture. The kinesthetic fragility by which every perception of architecture is threatened (parallax, fragmentation) was not being questioned. And if Wölfflin had already remarked—anticipating Merleau-Ponty's formula on the visual "presence" of what is behind us—that one could not look at the facade of Saint Peter's in Rome without feeling the presence at one's back of the gigantic entirety of the colonnade, he was doing so with a totalizing aim, wanting theoretically to obliterate the whole perceptual loss of which the architecture is the object.[65] In a recently published text, Robert Morris speaks of Bernini's colonnade—as well as of ruins and of various examples of non-Western architecture—on the contrary, as open spaces that cannot be controlled or mastered with any authority, and as veritable models for the shaping of real, literal space, to which contemporary sculptors, annulling all frontality, are currently aspiring.[66] But "modernist" sculpture, by separating itself from architecture as the stable milieu of its display, rejected it a fortiori as a precarious space of dissolution. By the same token it excluded from its definition all garden art, of which the architecture of the post-Renaissance was so fond and which Mondrian consider as "closer to pure sculpture than an image."[67]

Everything that is called "postmodernism" today, far from accepting restrictive definitions (sculpture is what is neither architecture nor landscape), shifts from the essentialist logic of the exclusive (either/or; neither/nor) to the

plurality of the hybrid. It thus elaborates a conceptual space of a very great diversity whose taxonomy is based more on complementarity than on opposition. Krauss formalizes it thus in a recent article that returns to and continues the analyses of *Passages* (see diagram on page 148).[68]

Disputing the modernist definition of sculpture as *neither* landscape *nor* architecture, the constructed sites of Robert Smithson (landscape *and* architecture), the marked sites of Michael Heizer, Robert Smithson, Dennis Oppenheim, or Richard Long (landscape *and* not-landscape), the axiomatic structures of Sol LeWitt, Carl Andre, Donald Judd, and Robert Morris (architecture *and* not architecture) map a structure of inclusion.

This conceptual classification that Krauss proposes has the merit of no longer having recourse to the humanist notion of "style" (it does not distinguish between individual "styles" since a single artist can work simultaneously in diverse categories); at the same time, it reveals how, for all their apparent diversity, the current sculptural practices are grounded in a common structural system, a synchronic system that thus become intelligible.

*Passages* began with an analysis of the sculpture of Rodin. It is the work of the author's contemporaries, I would repeat, that led her to see in Rodin's art all the signs of rupture to which his practice bore witness, a rupture that would lead to the full recognition of the material space from which sculpture had been abstracting itself since the Renaissance. In a certain sense, Rilke wasn't far from this discovery when he spoke of the whiteness of the plaster of Rodin's maquettes rather than of their shape ("It's immense," he writes to his wife after having visited the studio in Meudon, "but it is also terribly demanding: first because of the quantity, then because everything is white; one wanders among all these dazzling plasters, in the middle of the brilliant studio, as in the snow. My eyes hurt, my hands too. . .").[69] However he still lacked the experience of what modern art would produce and the theoretical means that would allow it to be accounted for. *Passages* is the essential book that came to fill this gap.

Translated by Kimball Lockhart and Douglas Crimp.

First published as "Opacités de la sculpture," *Critique* 381 (February 1979): 183–214. Translated into English as "The Sculptural Opaque," in *SubStance* 10, no. 2 (Winter 1981): 23–48.

1. "Lissitzky, Malevich, and the Question of Space," in *Suprématisme*, exh. cat. (Paris: Galerie Jean Chauvelin, 1977), 29–46.

2. Leo Steinberg's critique of Greenberg "Other Criteria" was first published in *Artforum* (March 1972) before being reprinted in the collection of articles to which it gave its name (Oxford: Oxford University Press, 1972).

3. See especially Clement Greenberg, "Modernist Painting" (1960), reprinted in the 4th volume of his collected essays edited by John O'Brian, *Modernism with a Vengeance* (Chicago: University of Chicago Press, 1993), 85–93.

4. Rosalind Krauss, *Terminal Iron Works: The Sculpture of David Smith* (Cambridge, MA: MIT Press, 1971).

5. Rosalind Krauss, *The Sculpture of David Smith: A Catalogue Raisonné* (New York: Garland, 1977).

6. See note 2 on p. 311 for more on the concept of "enunciation" as it is used here (derived from the French).

7. Gotthold Ephraim Lessing, *Laocoön*, as cited in *Passages*, 10. This is also the aesthetic upon which Freud bases his analysis of Michelangelo's *Moses*.

8. "There are many sculptors, some of whom have produced works of high quality, who have been left out of this text, while others, some of lesser merit, have been included. Guiding these choices was a decision to address the primary issues that distinguish modern sculpture from the work that comes before it" (Krauss, *Passages*, 6).

9. This statement is not actually found in *Passages* but in the conclusion of an earlier article that foretells the chapter of the book devoted to Brancusi: "Brancusi and the Myth of Ideal Form," *Artforum*, January 1970, 39.

10. Carl Einstein, *Negerplastik* (1915), trans. Charles W. Haxthausen and Sebastian Zeidler as "Negro Sculpture," *October* 107 (Winter 2004): 132.

11. Ibid.

12. Ibid., 134.

13. Hildebrand's book was published in 1893 and was translated into English in 1907. Kahnweiler's article, "L'essence de la sculpture" (1919), is reprinted in his *Confessions esthétiques* (Paris: Gallimard, 1963). The book by Carola Giedion-Welcker, first published in Zurich in 1937, was revised and expanded for the English edition (*Modern Plastic Art*) in 1955 (New York: Wittenborn).

14. On these points, see the short historical summary that Panofsky gives in "The Neo-Platonic Movement and Michelangelo" in *Studies in Iconology* (New York: Harper, 1967), 172–75. The apparent Mannerist exception (and the will of Cellini, detested by Hildebrand, to allow of his sculpture "*cento vedute o più*") takes nothing away from Krauss's project: If there was an appeal made to the imagination and to the movement of the spectator, it was in order to assure the completion of an "image."

15. See Erwin Panofsky, *Idea: A Concept in Art History* (1924; New York: Harper and Row, 1968).

16. "The Essential David Smith" was published in *Artforum* in February and April of 1969.

17. Krauss, *Terminal Iron Works*, 16.

18. For Clement Greenberg, "the illusion of organic substance or of texture in sculpture" is "analogous to the illusion of the third dimension in pictorial art" (*Art and Culture*, 143). For Wölfflin, this organic illusion was proper to the Baroque, and it was logical that "every time since then that a classic tendency has revived

and defended the rights of line, it has considered it necessary to protest against this illusionism in texture in the name of the purity of style." See Heinrich Wölfflin, *Principles of Art History*, trans. M. D. Hottinger (New York: Dover, 1950), 55.

19. Wassily Kandinsky, *Cours du Bauhaus* (Paris: Gonthier, 1975), 148–49. See also Gaston Bachelard, "Les cristaux, la rêverie cristalline," in *La terre et les rêveries de la volonté* (Paris: Corti, 1948).

20. Rodin's enthusiasm for the narrative structure of Rude's sculpture like all his leisure analyses of "movement in art," shows the gap that can be opened up between an artist's practice and the discourse he or she uses to justify it. See Auguste Rodin, *L'Art* (Paris: Gallimard, 1967), 41–74.

21. Leo Steinberg, "Rodin," in *Other Criteria*, 322–403.

22. "Rosso insisted that his sculpture be reproduced only from photographs taken by himself because he felt that his impressions should be seen in one light and at one angle." Margaret Scolari Barr, as cited in *Passages*, chapter 1, note 7, p. 290. Just as the *St. James* of Sansovini, about which Wölfflin complains of having only one photograph taken from a bad point of view (59), Rosso's sculptures direct the spectator to stay in place. It is obviously for wholly different reasons that Brancusi and David Smith take the trouble of photographing their sculptures.

23. Steinberg, "Rodin," 377. The most astonishing example of this system of collage in Rodin is probably the famous *Cathedral*, consisting of two right hands.

24. Paul Valéry, "My Bust" (1935), in *Degas Manet Morisot*, volume 12 of his collected works, trans. David Paul (New York: Pantheon Books, 1960), 179.

25. Greenberg, *Art and Culture*, 140.

26. See Michael Fried, "Art and Objecthood" (1967), reprinted in a collection of Fried's essays bearing the same title (Chicago: University of Chicago Press, 1998), 148–72.

27. "To be operative the message requires a context referred (the 'referent' is another, somewhat ambiguous, nomenclature), graspable by the addressee, and either verbal or capable of being verbalized." Reprinted in Roman Jakobson, "Linguistics and Poetics" (1960), in *Language in Literature* (Cambridge, MA: Harvard University Press, 1987), 66.

28. This "law" was coined in 1925 by Walter Friedlaender with regard to the Gothic resurgence in Mannerist art (see *Mannerism and Anti-Mannerism in Italian Painting* [New York: Schocken, 1973], 10–11).

29. [Addition 2021] It might be surprising that I did not challenge Krauss on this point with regard to Cubism, given that one of the main arguments of my 1987 essay "Kahnweiler's Lesson" was precisely to credit Picasso for the transformation, via a play of structural oppositions, of literal space into sculptural material, and to enlist him, along with Carl Einstein, in a proxy battle against Hildebrand and Greenberg (essay reprinted in *Painting as Model* [Cambridge, MA: MIT Press, 1990]; see in particular 74–79 and 91–94). But at the time I had not yet figured out that Greenberg's thesis about Picasso's Cubist constructions, which Krauss follows to the letter in *Terminal Iron Works* and (though less declaratively) in *Passages,* according to which they proceeded *from* his "pasted papers" or collages, was based on faulty chronology. The December 1912 *Guitar* that is discussed at length in both of Krauss's books and characterized as "inaugural," thus following Greenberg's description of it (inventory no. 244 of the Musée Picasso, Paris), is, in fact, like his collages, a by-product of the fall 1912 *Guitar* (Museum of Modern Art, New York), in which I came to locate Picasso's

breakthrough (following at that the artist, as well as visitors of his studio such as Tatlin). More surprising to me, in retrospect, is that I did not allude at all to Krauss's early take in my Kahnweiler essay. At the time she had definitively swerved from a Greenbergian assessment of Cubism to a structuralist one (of which she was, indeed, the most eloquent proponent), and I probably thought that critiquing her old points would be futile.

30. [Addition 2022] I have left unchanged the dates in the original text because they are those given by Krauss, but the *Violin* is now dated 1915 and the *Guitar* is very precisely dated December 3, 1912. Both works are in the Musée Picasso, Paris (Pierre Daix and Joan Rosselet, *Picasso: The Cubist Years 1907–1916, A Catalogue Raisonné of the Paintings and Related Works* [London: Thames and Hudson, 1979], respectively no. 835 and 555). Their inventory numbers in the Musée Picasso are 255 and 244.

31. See Katarzyna Kobro and Władysław Strzemiński, "Composing Space/ Calculating Space-Time Rhythms" (1931), trans. Ania Soliman, *October* 156 (Spring 2016): 31–32.

32. As *Terminal Iron Works* formulated it already, "the Surrealist core posited knowledge without judgment: the essence of the object is knowable but ineffable" (125).

33. Alberto Giacometti, in Gaston Charbonnier, *Le monologue du peintre*, vol. 2 (Paris: Juillard, 1959), 160.

34. Ibid., 164–65.

35. Ibid., 163.

36. See Panofsky, *Idea*. The words of Barbara Hepworth cited by Krauss (*Passages*, 141), are even more explicit than those of Arp from this point of view: "The idea—the imaginative concept—is what gives life and vitality to matter."

37. The title used by Krauss, which was common at the time of the book's publication, was "Construction in Metal Wire." This work, which Picasso had conceived as a model for a monument to Guillaume Apollinaire (it was rejected), is in the collection of the Musée Picasso, Paris (no. 264). An enlarged version was realized in 1972 in COR-TEN steel for the Museum of Modern Art, New York.

38. The difference in the analyses of these two Picasso sculptures provided by Krauss in *Terminal Iron Works* (18, 33) and in *Passages* (134–37) is particularly eloquent with regard to the transformation of her critical stance between the two books.

39. All the chapters of *Passages* start off with an anecdote, except for the one devoted to Smith and "totems." I see this as the mark of a special importance.

40. Krauss, *Terminal Iron Works,* 37.

41. Fried, "Art and Objecthood," 167.

42. Krauss, *Terminal Iron Works*, 99.

43. "From any other point of view the sculpture seems capricious." Ibid., 144. Panofsky and Wölfflin speak of the work of Bernini in the same way.

44. About Smith's late sculptures, the *Cubis*: "The resolute frontality of the works makes it clear that no real knowledge of them will come from a change in the spectator's point of view." Krauss, *Terminal Iron Works*, 181.

45. Ibid., 36–37.

46. See ibid., 13. On pages 30–31, a very strange analysis of Picasso's constructions, even going so far as to deny the figurative silhouette of his *Violin* of 1914, issues from these little-supported premises.

47. On this point Krauss was already opposed to Greenberg in *Terminal Iron Works*, 54.

48. The exact title of Smith's sculpture is *Blackburn: Song of an Irish Blacksmith*. The original (painted) plaster of Lipchitz's *Figure*, which Greenberg considered his chef-d'oeuvre (*Art and Culture*, 107), has been in the Musée National d'Art Moderne, Paris, since 1976.

49. Rosalind Krauss, "How Paradigmatic is Anthony Caro?," *Art in America*, September 1975.

50. Clement Greenberg, "The New Sculpture" (1949), reprinted in the second volume of his collected essays edited by John O'Brian, *Arrogant Purpose, 1945–1949* (Chicago: University of Chicago Press, 1986), 318. Cited by William Rubin in *Anthony Caro* (New York: Museum of Modern Art, 1975), 17.

51. *Terminal Iron Works's* adhesion to this aesthetic of attention is made explicit on p. 99, where the concept is examined.

52. "Under certain circumstances, this form of reception shaped by architecture acquires canonical value. For the tasks which face the human apparatus of perception at historical turning points cannot be performed solely by optical means—that is, by way of contemplation. They are mastered gradually—taking their cue from tactile reception—through habit." Walter Benjamin, "The Work of Art in the Age of Its Technological Reproducibility," second version (1936), in the third volume of *Selected Writings*, ed. Michael W. Jennings (Cambridge, MA: Harvard University Press, 2002), 120. The whole passage, in which Benjamin extols a "distracted mode of apperception" to which he thinks film is "predisposed," would deserve to be quoted. Matisse's famous plea for an "architectural" painting that would be distinguished from the tableau (the latter "cannot be penetrated unless the attention of the viewer is concentrated especially on it") is one of the clearest texts of this new aesthetic of distraction. (Matisse, March 17, 1934, letter to Alexander Romm, in *Matisse on Art,* ed. Jack Flam [Berkeley: University of California Press, 1995], 117.)
[Addition 2021] I have often come back to this topic, notably in an essay in which Benjamin is not only paired with Matisse but also with Lissitzky ("Exposition: Esthétique de la distraction, espace de démonstration," *Cahiers du Musée National d'Art Moderne* 29 [Fall 1989]: 57–79).

53. Untitled statement, 1951, reprinted in Barnett Newman, *Selected Writings and Interviews* (New York: Knopf, 1990), 178.

54. See Donald Judd, "In the Galleries," *Art Magazine*, December 1964, reprinted in Donald Judd, *Complete Writings, 1959–1975* (Halifax: Nova Scotia Press, 1975), 145. See also Krauss, *Terminal Iron Works*, 175–78.

55. Interview in *Robert Morris* (London: Tate Gallery, 1971), 19.

56. Rosalind Krauss, "Allusion and Illusion in Donald Judd" (1966), reprinted in *Perpetual Inventory* (Cambridge, MA: MIT Press, 2010), 91–100. Judd's remark is in "Complaints: Part I," *Studio International*, April 1969 (reprinted in *Complete Writings*, 198), and is commented upon by Krauss in "A View of Modernism" (1972), also reprinted in *Perpetual Inventory* (116–17).

57. See Robert Morris, "Notes on Sculpture, Part 1," *Artforum*, February 1966, and "Notes on Sculpture, Part 2," *Artforum*, October 1966, reprinted in Robert Morris, *Continuous Project Altered Daily* (Cambridge, MA: MIT Press, 1993), 1–21.

58 See Krauss, *Passages*, 266–67, and Rosalind Krauss, "Sense and Sensibility," *Artforum*, November 1973, 49–50.

59. This point is of extreme complexity and could easily turn into a logical circle. Formalist immanence, which dissimulated its constant reference to the teleological linearity of history, seems replaced here by another form of immanence based on the *hic et nunc*, on the unicity of experience and the naive evaluation of the event as what only happens once, excludes repetition. In a certain way, *Passages*, here closer than elsewhere to the theoretical texts of the artists, is not totally exempt from this behaviorist reintroduction of metaphysics that Jacques Derrida stigmatizes in "Signature Event Context," *Margins of Philosophy* (Chicago: Chicago University Press, 1982), 307–30. See Krauss, *Passages*, particularly 267.

60. Phyllis Tuchman, "An Interview with Carl Andre," *Artforum*, June 1970, 55. Reprinted in Carl Andre, *Cuts*, ed. James Meyer (Cambridge, MA: MIT Press, 2005), 183.

61. G. W. F. Hegel, "Lectures on Aesthetics," in *Philosophy*, ed. C. J. Friedrich (New York: Random House, 1954), 386–87.

62. Rainer Maria Rilke, *Auguste Rodin* (first part, 1903), trans. G. Craig Houston (New York: Dover, 2006), 6.

63. Adolf von Hildebrand, *The Problem of Form in Painting and Sculpture* (New York: Stechert, 1907), 56–57, 113.

64. Charbonnier, *Le monologue du peintre*, 162.

65. Wölfflin, *Principles of Art History*, 118.

66. Robert Morris, "The Present Tense of Space" (1978), reprinted in *Continuous Project Altered Daily*, 175–209.

67. Piet Mondrian, "Natural Reality and Abstract Reality" (1919–1920), in *The New Art—The New Life (Collected Writings)*, ed.

and trans. Harry Holtzman and Martin S. James (Boston: G. K. Hall, 1986), 101.

[Addition 2021] The translation was faulty and is slightly modified here; yet it still cannot do justice to Mondrian's play on the words "beeldhouwkunst" (sculpture) and "beeld" (image).

68. Rosalind Krauss, "Sculpture in the Expanded Field" (1979), repr. in *The Originality of the Avant-Garde and Other Modernist Myths* (Cambridge, MA: MIT Press, 1985), 292–301. On this essay, see "Not [on] Diagrams" in the present volume, 148–53.

69. Rainer Maria Rilke, *Correspondance* (Paris: Seuil, 1976), 28.

*Picabia* (Paris: Flammarion, 1976), marked for withdrawal from publication. ("Au pilon" here means "to be pulped.")

# Picabia: From Dada to Pétain

*One lesson I learned very early about the world of art-book publishing is that authors are at the bottom of its food chain, especially in the case of work for hire (or "typing for dollars," in my jargon). I wrote "Picabia: From Dada to Pétain" out of spite, furious at the publisher, who not only recalled and removed my monograph on Francis Picabia from distribution just a few weeks after it came out but even threatened to sue me for financial compensation if I should issue any public statement about the affair.*

*It is perfectly readable without any knowledge of the context, but in finding out that I had kept almost all related documents over the years, I realized I must be holding something of a grudge and could use the occasion of the text's republication to tell the saga, and thus let go of my resentment. Skip this introduction, dear reader, if you are not interested in the details of the story . . . In mid-May 1975, I was contacted by Francis Bouvet, at the recommendation of his friend Hubert Damisch. Bouvet was the editor in charge of all books on art published by Flammarion, a major French press—a delicious man with an immense knowledge of art history, which sharply contrasted with the general incompetence of his peers and accounts for his championing of dense scholarly volumes such as the translation of Panofsky's* Renaissance and Renascences *and Julius von Schlosser's* Die Kunstliteratur *in the "Idées et Recherches" collection directed by his friend the poet Yves Bonnefoy. The bread and butter of Bouvet's editorial activity, however, was glossy art books, and it was to write the text for one such volume that he contacted me. As he presented the case to me, the press was in panic mode: It had just discovered that the Musée National d'Art Moderne was preparing a vast Picabia retrospective, scheduled to open in January 1976, and did not want to miss the boat. I believed him at the time, but came later to doubt this—for if a young student like me had already known of this plan for a while, how could a well-connected editor like him have missed the information?—suspecting, rather, that he, or rather his co-publisher (more on that below), had first appealed to one of the belletristic writers usually drafted for the series* Les maîtres de la peinture moderne *(every one of them representing what I detested most in French art writing) and that this first choice, for whatever reason, had recently, unexpectedly recoiled.*

*The task was challenging, almost ludicrous: Could I write a fifty-page (double-spaced) manuscript within a month? Given the grotesque rush, the*

fee would be higher than usual (7,000 francs, which, adjusted for inflation, corresponds to about $5,000 in 2021 dollars). I was living on a shoestring then, and the offer was hard to turn down. Scrupulously, I let Bouvet know that my knowledge of Picabia's work (and life, as biography was to be an important component of the book) was spotty. "You'll learn fast" was his response. I asked for an additional month.

After this initial encounter, Bouvet took a back seat on this project, or rather played the role of the good cop in a good cop/bad cop dyad. At the end of our meeting, it was revealed to me that, while the book series was published under the Flammarion label, the press acted mainly as a distributor and the real publisher (producer as well as editor) was a private contractor based in Brussels, Madeleine Ledivelec-Gloeckner, who sent me a contract the next day. I was to provide her with a list of possible illustrations within two weeks, something that I was miraculously able to put together after a frantic foray into the available bibliography (at top speed, I read everything then available on Picabia either in French or in English, which was not much—the most helpful being the excellent catalogue of the retrospective curated by William Camfield at the Guggenheim Museum in 1970).[1]

In mid-July, as I was "in the final state of writing" (or so I claimed rather optimistically), I wrote to Ledivelec-Gloeckner asking for a two-week extension of the deadline, which was granted (another bewildering miracle: I would only miss this new date by a few days). I also asked for more precision on the length (how many characters per page?) and wondered about the possibility of footnotes, having remarked that other books in the series had none. In early August, I was reassured about the length (not to worry, one can cut text later at the proofs stage). As for the footnotes, she would prefer that there were none but would do as I pleased.

On August 10, I sent my manuscript to Ledivelec-Gloeckner, along with a long letter in which I explained how I conceived the book: as the "simulacrum of a biopic film-script," in order to provide some distance with regard to the biography genre in general, as well as to take into account Picabia's own recurrent attacks with regard to the cult of the artist-hero. In her response, dated September 2, Ledivelec-Gloeckner stated that she was too busy securing illustrations to read my manuscript as attentively as she would have wanted and reiterated that corrections would be made on the galleys. Two weeks later, I finally received from her a long letter, the first half of which was dedicated to her problems obtaining illustrations (in retrospect, I should have been alarmed by her proposal to find "substitutes" in private collections). It then launched into a long diatribe against my text, ending with a list of corrections she had made before sending the text to the typesetter, promising she would forward the proofs to me as soon as she received them—so that I could stet "expressions that

*I deem essential to the color of [my]text"—and that this would be followed soon thereafter by a second set of galleys.*

*I was too taken aback to respond and wrote instead to Bouvet, arguing against Ledivelec-Gloeckner's letter point by point (the most grotesque being perhaps her request that ADN [DNA in English] be spelled out: "Does she prefer 'acide désoxyribonucléique'?" I asked. There is no further correspondence extant until the invitation to a meeting with my Belgian tormentor in Bouvet's office, in early October, to deal with the book's design—a meeting I have no memory of attending). But on December 3, in response to a postcard I had sent him asking when I would I receive the promised second set of galleys, I received this response from Bouvet: "There will be no such thing because the book has already appeared," mentioning, to make things even worse, that four pages of my text had been cut. Needless to say, I was disgusted and—to this day—never had the courage to reread that infamous opus (I did stumble upon an awfully misguided "correction" of my text as I opened the book the day I received it, and that was that). On December 9, I went to Flammarion's headquarters to sign the press copies (fifty of them, which, together with the twenty I was given, and the few that were bought during the few weeks it was for sale in bookstores, are the only possible extant copies, since the whole run was pulped: a real collector's item!).*

*On January 26, I got an anxious note from Bouvet: "Can you call me ASAP? The daughter of Gabrielle Buffet requests that your book be recalled." The same day, the* Nouvel Observateur *published a review of the Picabia show, which had just opened, written by Bernard Teyssèdre, a highly regarded philosopher whose specialization was aesthetics and who was doing all he could to shake French art history out of its torpor. In it, he briefly praised my book in a footnote, calling it "ironic, savory, perspicacious." Still the same day, a letter full of scatological insults was sent to Ledivelec-Gloeckner by a grandson of Picabia, an artist named Patrick Bailly-Cowell, which she forwarded me without comment (the letterhead of his stationery was "Francis Picabia Catalogue Raisonné"— very official-looking). That was just the beginning of the assault.*

*On February 16, Jeannine Picabia (the daughter of Gabrielle) sent a letter to the editor of the* Nouvel Observateur *protesting Teyssèdre's review. In her rant, she claimed that my book (the immediate recall of which she had already secured) was the sole source of the charge that Picabia had denounced Jews during the war and went on to say (without giving any evidence) that he had in fact been arrested by the Gestapo and that his imprisonment at the Liberation had been recognized as a mistake (we know now that the first assertion is true—he had indeed been also arrested by the Gestapo but immediately released—and the second, not).[2] Teyssèdre's excellent response was that he had never accused Picabia of delation and that he had only stated*

that his *"equivocal behavior during the Occupation caused him some troubles at the Libération." Which is,* sensu stricto, *exactly what I had done myself. The sentence that ostensibly provoked the rage of my censor appears on the book's penultimate page; it translates as: "Courage, we have noticed, was not his forte, and while Gabrielle throws herself in the Resistance, his antisemitic and rightist declarations will result for him in four months spent in prison at the Liberation."*

*If in "From Dada to Pétain" I devote a certain amount of space to the published sources from which I extracted the information about Picabia's imprisonment, it was not just to debunk Jeannine Picabia's argument (I had not invented anything but relied on previously published accounts, none of which had been challenged by her or any other member of her family). It was also to make plain that Ledivelec-Gloeckner's fear of a lawsuit from the Picabia family, should Flammarion return the book to circulation, was completely unwarranted. I stressed this point to her, announcing that I would write a piece about all this. In response, she forbade me to publish such a piece and, in turn, threatened a lawsuit if I did (to be more precise: She wanted me to wait, while I felt that one should strike while the iron is hot).[3] Needled by this unexpected reaction, I set out to write said text, which involved hours of poring over reams of microfilm at the Bibliothèque Nationale and copying (by hand) whatever quotation I could chance upon while rolls of* Comoedia *or other journals of the period zoomed by (at the time, the only writings by Picabia that had been gathered in a volume were his Dada productions—thus not at all what I was looking for). Once my text was drafted, I went to see a lawyer, a friend of my father: "I am not particularly inclined to defend this book—which I don't like much, as it was written too fast and only for money—but the censorship is political, and I can't let that pass," I told her. Upon examining the corpus delicti, she confirmed that the Picabia family had not the slightest ground for litigation, that she doubted they would even try to proceed, and that if they did, it would automatically be dismissed as frivolous. She also said that should my publisher sue me for circulating a text on the matter, she would defend me pro bono and, in turn, sue her for dereliction of duty.*

*On February 27 and 28, there was a symposium dedicated to Picabia in the auditorium of the Grand Palais, where the exhibition was held. I had earlier declined to participate and now, given the circumstances, refrained from even attending. A few days later I received a note from my friend Hélène Klein (then Seckel), one of the two co-curators of the show: "It was almost the Battle of Hernani. Picabia, the sower of paranoia. You missed Arturo Schwartz [a scheduled speaker but also, among other things, one of the leading international dealers of Picabia's art at the time] bellowing with his stentorian voice that Picabia had made a flattering portrait of Hitler!"*

There is no way of knowing if that is indeed the case (at least until the last volume of the Picabia catalogue raisonné appears, covering the years 1940–1953).

This last episode points to a major flaw of the book that, in retrospect, I am perfectly willing to admit: The text basically stops in 1924, which marks, with the performance of the ballet Relâche, including its filmic interlude (Entracte), Picabia's definitive farewell to Dada. The three remaining decades of the artist's life and work are expedited in just two pages! A staunch modernist at the time, I considered Picabia's post-1925 production kitsch at best, deliberately reactionary at worst, and felt that it did not warrant any longer treatment than did the Impressionist landscapes he had churned out in his youth. I simply had not yet acquired the dialectical skill I would have needed (a dose of Bakhtin, perhaps) to make sense of the multiple and contradictory paths his art would take after the radical years that had interested me (and had prompted me to accept, despite my ignorance, Bouvet's offer). My take at the time regarding the family onslaught was that my teeny allusion to Picabia's troubles at the Liberation was just a pretext—that the real reason for which the book was attacked with such violence was that it did not put the artist's late works on a pedestal, works that I (probably wrongly) assumed to be unsalable and thus overfilling the family's coffers.

My critical failing regarding the late period of Picabia, much more complex than what I assumed then and deserving a lot more than a mere mention in passing, is certainly the main reason why I kept the book at bay all these years, never reopening it and never wanting to see it reprinted. But there is one more reason, which is also part of the lesson I mentioned at the outset (concerning the lowly status of authors of art books). Despite my having sent in due time the list of illustrations that Ledivelec-Gloeckner had requested from me, she only started working on obtaining them much later—as if she had forgotten that the month of August, for many European institutions and private persons, implies a total freeze of activity. That, and the poor communication between us, resulted in my having to entirely relinquish any control over the illustrations (many works that I discuss at length, some of them not particularly difficult to access and which I had asked to illustrate from the start, are nowhere to be found in the book; I remember being particularly devastated to find that there were no images of the set of Relâche, for example). In the mad rush of the book production, all I could do, I was told, was trust the editor's prowess at iconographic sourcing, which I did with a shrug of resignation. This would come to haunt me.

At the opening of the Picabia show (January 23, 1976), I was confronted by a Dada scholar (for whom I had a lot of respect), who lambasted me for having reproduced a fake in my book. I was dumbstruck; and rushing to consult the volume, I had to recognize, to my shame, that it contained the photograph

*of a dubious drawing I had never seen (nor, of course, asked for), belonging*
*to a private collector in New York (titled* Dessin mécanique *and dated 1919).*
*Two decades later (in November 1998), I received a letter from the lawyer of a*
*famous German art gallery asking me what I thought of the work, adding that*
*"Mme Picabia" did not think it was authentic (the letter did not specify which*
*"Mme Picabia" it was—there were already three in the generation preceding*
*Jeannine—but it was amusing to think that, perhaps, I was finding myself in the*
*same camp as my persecutor). Cautiously (as I was told never to get involved in*
*authentication issues), I replied that I was not qualified to give an expert opinion;*
*that there was a good chance that the work was a fake, as suggested by Mme*
*Picabia; but that the person to consult was Bill Camfield. A few months later, I*
*received a letter from Camfield, on behalf of the Comité Picabia, asking me*
*about the reproduction of this drawing in my book: He and his colleagues were*
*being threatened with a lawsuit by the German gallery for refusing to include it*
*in their catalogue raisonné. I sent an account of what had happened to Camfield,*
*who immediately asked me if he could forward it to the Comité's lawyer.*

*The Comité must have won the battle: The drawing in question does not*
*figure in the second volume of the catalogue raisonné, covering the period*
*1915–1927. There is a moral to this story, which is that neither an abusive*
*estate, nor a dishonest dealer can have the last word—sooner or later, their*
*machinations are uncovered. I could not realize this at the time, of course, but*
*maybe this early baptism by fire, unpleasant as it was, gave me a healthy dose of*
*skepticism with regard to all actors within the art world (including publishers)*
*and reinforced, by contrast, my faith in scholarship.*

•

Biographers are fixated on their heroes in a quite special way. In many
cases they have chosen the hero as the subject of their studies because—for
reasons of their personal emotional life—they have felt a special affection
for him from the very first. They then devote their energies to a task of
idealization, aimed at enrolling the great man among the class of their
infantile models—at reviving in him, perhaps, the child's ideal of his father.
To gratify this wish they obliterate the individual features of their subject's
physiognomy; they smooth over the traces of his life's struggle with internal
and external resistances, and they tolerate in him no vestige of human
weakness or imperfection.
—Sigmund Freud, *Leonardo da Vinci and a Memory of His Childhood*
(1910)[4]

The quasi-identification of the biographer with the character he or she writes
about is more than a convention: It is without doubt one of the most artless

ways in which the institution of culture, taken as a whole (mass media, museum, university, etc.), constructs an official collective memory: one founded on a certain degree of oblivion and destined, in the name of the grand pathos of the cult of the hero to whom it is laying claim, not merely to substitute for other forms of historical investigation but to prevent these from occurring at all.

When, on the other hand, the author of a monograph, on an artist, for example, consciously takes a position of critical distance and chooses not to play the role of hagiographer, attempting instead to locate the life and work of the person he is dealing with in relation to the sociopolitical events of that person's time, there will sometimes be a bit of a collision. Everything depends on *both* what occurs at the point where these two narratives intersect (that of the life of the particular individual and that of the social and political history) *and* on the attitude of those whom civil law sanctions as the "rights holders," adding to their inherited wealth a prodigious power of moral proprietorship that defends the "interests" of the deceased artist.

Among the illusions that civilized men would like to maintain about death, Freud (again) was the one who remarked on the strange reverence that is commonly accorded the deceased:

> We suspend criticism of him, overlook his possible misdeeds, declare that "*de mortuis nil nisi bonum*," and think it justifiable to set out all that is most favourable to his memory in the funeral oration and upon the tombstone. Consideration for the dead, who, after all, no longer need it, is more important to us than the truth, and certainly, for most of us, than consideration for the living.[5]

To be flippant about a departed one, even if his words and deeds often had the cheerful thrust of disrespect—that remains inadmissible.

Let's take an example.

In 1975 I wrote a short book on Picabia (published by Flammarion). Several days after the opening of the painter's retrospective at the Grand Palais, the book was removed from the museum bookstore's shelves at the request of some of the Picabia family members. Subsequently, it was removed from distribution altogether.

Why should a book that was recommended to its readers by journals as ideologically diverse as *Le Figaro*, *France-Soir*, and the *Nouvel Observateur*,[6] among others, be called anathema, be characterized publicly by those same members of the Picabia family as a "book filled with errors, vulgar in style, vengeful in spirit, blatantly political"?[7] There is something to be gained from attempting to answer this question, for in so doing we attack a form of censure which is itself political in kind.

The tone of the book does not appear to have pleased the "rights holders" (though it would grieve the author to know that he had offended Gabrielle Buffet, Picabia's first wife; for anyone who knows how to read would understand that the entire book is a sort of homage to her), and they used a pretext to present the book as a collection of slanderous gossip and to brandish threats of legal action. *The pretext?* That it resurrected the difficulties Picabia experienced at the time of the Liberation because of the stands he had taken during the Occupation. The sources include, among others, the following:

September 1944: È in prigione a Cannes per quattro mesi per una genèrica accusa di "collaborazionismo" (Maurizio Fabiolo dell'Arco).[8]

He remained voluntarily unconscious of what was going on in the world and, throwing caution to the winds, defied by his words and actions, both the collaboration and the Resistance, effecting this tour de force of being hounded by one and prosecuted by the other. So it was that he made a display of being a *fierce racist* when personal animosities were at stake. Yet he didn't hesitate to set up a joint exhibition of pocket-sized paintings and sculptures with the Jewish sculptor Sima at Cannes in 1942 (Gabrielle Buffet).[9]

For his political or rather apolitical attitude, his shying away from any sort of engagement, and the unbelievable comments he let slip on political events—in and out of season, when the wisest course would have been to hold one's tongue—he paid a very high price during the months following Liberation in August 1944. The artist, whose work German censors had previously vilified as degenerate, found himself jailed in Cannes for "collaboration" during four months, from September 1944 to January 1945. However, he was acquitted (Michel Sanouillet).[10]

All of this has been confirmed in a beautiful book published at the same time as mine, the facsimile edition of the scrapbook of Olga Mohler (Picabia's second wife, who lived with him during that time and knows very well what she is talking about). Beneath the reproduction of a two-page manuscript dated February 18, 1945, by Mohler, we find the following caption in Mohler's hand: "Here is a short account written by Francis after questioning by Mr. Malenfaut [or Malenfant?] (of Cannes) during his four months of internment! from September 30, 1944 to January 30, 1945." And in a note appended at the end of the book by its editor, Maurizio Fagiolo: "Picabia is imprisoned in Cannes in September, 1944, accused of being a collaborator. He remained in jail for exactly four months. In these two pages in the artist's hand there is a summary of the ironic answers given to the police authorities."[11]

I am not interested in playing prosecutor. I am as ready to admit that Picabia was not a collaborator as I am that I never wrote that he was. What I did try to convey is that *indifference*[12] is always, first and foremost, reactionary, whether one knows it or not, and can serve to justify the most reprehensible actions (in addition to the worst kind of art). But the attempt to present Picabia today as an innocent martyr is really ludicrous, since it is not at all certain that he could have dismissed the following statements with one of his little "sallies." *Words, sometimes, have a literal meaning once they've passed into history*. We can say if we wish that Picabia was neither an anti-Semite nor a rightist; but that did not prevent him from publishing a certain number of texts of which I give here a little anthology without any commentary:

On Lenin:

The ideal of this unbeliever tended probably toward an esoteric form of domination that is potential within democracy: the forcible impounding of all gold, either earned or inherited, belonging to individuals of a nation that it has corrupted; gold, precious metal that nowadays signifies religion, country, art, love, dissolving all feelings in the manner of nitric acid and in that way comparable to certain states of the Jewish mind. . . .

I wish he would tell us [ . . . ] whether the fact of being the leader of a Communist democracy makes him any different from the Czar, who also headed a democratic country, at least in terms of the number of its democrats. [ . . . ] Only the uniform has changed; your dirt is no better than the eau de cologne worn by the grand dukes, and when I stop to think of it, I would actually rather breathe the cologne. [ . . . ] You have forgotten that there is something stronger than you: Life, nature itself, which is not Communist. . . . Nature is unfair? So much the better; inequality alone being bearable, the monotony of equality can only lead to boredom. [ . . . ] You've been having a grand old time for several years now, and your jokes have taken on a grim aspect for your countrymen, the unfortunates who only get to see your facade and haven't realized that your way of thinking is a little bit like that of those individuals who lend money to young men from wealthy families, but who are themselves starved for experience. Sir, your role is a pitiable one, and without even the prestige of the Emperor of China [ . . . ] I detest imbeciles capable of doing harm [ . . . ] and the man who will cut the throat of his neighbor on the right in order to save his neighbor on the left, is quite simply a murderer.[13]

From an article written at the time of Einstein's arrival in Paris:

I have a friend who likes Einstein the way he likes the cinema, Dada, or Lenin, the way he would like a new illness and would be flattered to be its first victim, because this illness would be described as a modern illness! [. . .] My friend also likes his wife's lovers—but he doesn't like me, he doesn't think I'm modern enough! It's true that my French and Spanish origins derive from old Latin races, which will soon be disappearing to make room for the children of Einstein, good looking Israelites . . .

"The Germans are great thinkers, and great artists," some say. "They proved it by buying the first Cubist paintings." But it was not the Germans who bought these Cubist paintings, it was the sons of Israel, and they bought them in Paris, in New York, throughout the entire world, as well as in Berlin, thinking that these paintings, which are unverifiable, could become the perceptible expression of an era in which nitric acid replaces love. These paintings, moreover, were indeed made for them, it was easy to buy them at low price and sell them without regret.

This spirit I'm bringing to your attention is part of what contributed to making Dada unbearable: Dada, which I presented to you four years ago and which we were forced to show out the door because it didn't know when to leave!

Léon Bloy, who is still covered in silence, is ten thousand times more likeable and more intelligent, for example, than a certain pale, greasy-haired "modernist". . .[14] If Bloy had been Jewish, he would probably be a god . . . Indeed my growing impression is that all the gods are Jewish! "But," you'll tell me, "haven't they made a god of the Douanier Rousseau?" "Probably, but he had a Jewish spirit," I remember Apollinaire once said to me, "Rousseau works less well when he's getting paid more!" That's also in the Dada spirit, isn't it? [. . .] The last thing I want is for you to see an anti-Semitic attitude in my article, but [. . .].[15]

From the catalogue preface of his exhibition at Cannes, when Mussolini's Fascist regime had already been in power for five years:

Everything can be, or not be, a joke, isn't that so? Things only have the value one gives them. All the same, we shouldn't confuse force and fashion; force rises up, fashion stays small and petty, petty like Communism, therefore idiocy. Mussolini may be a dangerous madman, but he will always be more sympathetic to me than the effigy of a Lenin, sculpted in such a manner that men divide it up among themselves like the little lumps of sugar one gives to dogs![16]

Finally, in March 1941, a few months after the anti-Semitic laws were put into effect by the Vichy government (October 3 and 4, 1940) and several days

before the creation of a General Commission on the Jewish Question (March 29, 1941), there is this hymn to youth:

To serve, to give, you see, that truly is youth: set materialism completely aside. France is the least materialist country in the world, the youngest in the world, if young people willingly understand that they can be happier standing up than sitting down, than wallowing! That there is greater joy in singing than in wasting one's saliva to season a new—or often an old—pipe so as to make oneself look good and resemble what we call a man. . . .

The country that will undoubtedly emerge from the horrible materialism that has been overrunning everything for years will be France, it seems to me, for in this country there is no longer any room except for the young, true youth, in fact, life, for those who believe, live, and think without having to stretch out on the couch of commercial and political ambition.

I could speak at still greater length on how to stay young, although I hope I have already made myself understood.

Marshal Pétain is a young man, younger than all our representatives or ministers, since those poor creatures, for the most part, were no more than ignoble egotists, malefactors, who have easily exploited a country like France, which only asks to believe, to love, and to live in freedom.[17]

These excerpts require no great amount of decoding. I refer those who would not believe in the tremendous power sometimes contained in the literal meaning of a word to the various studies published on the discourse of the Pétainist or Fascist regimes.[18] Further comment seems unnecessary. I have assembled these examples only to show that although official culture—the museum and art history—can rehabilitate practically anything, there still remains an extremely bad taste: a highly criminal *indifference* (conscious or unconscious) that sticks in its throat, like a fish bone.

Translated by Thomas Repensek.
First published as "Picabia, de Dada à Pétain," *Macula* 1 (August 1976): 122–23. Translated into English in *October* 30 (Fall 1984): 121–27.

1. Camfield's catalogue is not mentioned in "De Dada à Pétain," simply because he does not allude to the artist's troubles at the Liberation—neither is, for the same reason, Marc Le Bot's 1968 *Francis Picabia ou la crise des valeurs figuratives* (both of them are dutifully referenced in the book). But most of the secondary sources I had at my disposal to write the book are those referred to in this short essay.

2. In *Aires abstraites*, Gabrielle Buffet had alluded to Picabia's problems with the Gestapo, but said he only began to realize they were a dangerous gang after hearing of a close friend's summary execution, adding that he was in Monaco when the Nazi police came to search his house, implying, wrongly, it seems, that he was thus not arrested.

Rachel Silveri's chronology of Picabia's life in the catalogue of the 2016 retrospective of his work at the Museum of Modern Art, New York, and the Kunsthaus Zürich, based on a remarkable foray into numerous achives, including legal ones, is at present the most reliable source. On the Gestapo episode, it says: "On July 12 [1944], Picabia is arrested and questioned by German intelligence, then quickly released." On what happened at the Liberation: "Oct. 5 [1944], the French Sécurité militaire charges Picabia as a 'collaborator, and for gold trafficking'; five days later he is charged as well for 'being in relation with the German Intelligence Services.' He is arrested and placed under police guard in the hospital, though owing to his condition he is not properly interrogated. Olga Mohler (his wife) is likewise arrested and sent to prison in Grasse, where she is not released until Dec. 25." By February 15, 1945, Picabia "has been released from the hospital as well as police custody," but "the circumstances are unclear." Maurice Mével, a friend of Max Romain, Picabia's closest friend in the Côte d'Azur, "files a complaint with the military authorities in Antibes and the Comité d'Épurarion de Nice, accusing Picabia and Mohler as Nazi collaborators, responsible for Mével's own arrest and that of Max Romain, as well as the imprisonment of six other individuals." See Silveri, "Pharamousse, Funny Guy, Picabia the Loser: The Life of Francis Picabia," in *Francis Picabia: Our Heads Are Round So Our Thoughts Can Change Direction* (New York: Museum of Modern Art, 2016), 335.

3. She was afraid that the family, on top of having forbidden the sale of the book, would attack her for libel. They had only three months to do so from the last day the book had effectively been sold, which was impossible to determine, given that the book had been distributed to many bookstores. A more precise reference date would be the last day copies of the book had been shipped from Flammarion's warehouse, but there was no certainty this would be the date chosen by a judge. She asked me to stay quiet until May 9. Little did she (or I) know that the first issue of *Macula,* to which I destined my protest text, was to appear only after that cut-off date!

4. Sigmund Freud, *The Standard Edition of the Complete Psychological Works*, vol. 11, ed. and trans. James Strachey (London: Hogarth Press, 1957), 130.

5. Sigmund Freud, "Thoughts for the Times on War and Death" (1915), in *The Standard Edition of the Complete Psychological Works*, vol. 14, ed. and trans. James Strachey (London: Hogarth Press, 1956), 290.

6. *Le Figaro*, January 27, 1976; *France-Soir*, February 4, 1976; *Le Nouvel Observateur*, January 26, 1976.

7. Jeannine Picabia in "Courrier des lecteurs," *Le Nouvel Observateur*, February 16, 1976, in reply to the article by Bernard Teyssèdre in the issue of January 26, 1976.

8. "He was imprisoned in Cannes for four months on a vague charge of 'collaboration.'" Catalogue of the exhibition *Francis Picabia: Mezzo secolo di avanguardia* (Turin: Galleria Civica d'Arte Moderna,

1974), 96, in relation to the compilation of which the "gracious cooperation" of Gabrielle Buffet-Picabia and Olga Mohler-Picabia was publicly acknowledged.

9. Gabrielle Buffet-Picabia, *Aires abstraites* (Geneva: Pierre Cailler, 1957), 42.

10. Michel Sanouillet, *Picabia* (Paris: Le Temps, 1964), 59. It goes without saying that those paintings of Picabia's that were referred to by the "Germanic censors" as "degenerate" have nothing in common with most of the paintings he did during the war. Not from a thematic point of view, but stylistically, these works are not very different from paintings by the official artists of the Third Reich (see Jean-Louis Houdebine, "Le fascisme en représentation," in *Peinture, cahier théoriques*, nos. 10–11).

11. Olga Mohler, *Francis Picabia* (Turin: Edizioni Notizie, 1975), 137. The English translation of Fagiolo's note is given on page 179.

12. See his "Indifférence immobile," *Comoedia*, March 31, 1922, 1; reprinted in Francis Picabia, *Écrits critiques,* ed. Carole Boulbès (Paris: Mémoire du Livre, 2005), 121–23.

13. Francis Picabia, "Souvenirs sur Lénine, Le communisme jugé par un peintre cubiste," *L'Eclair*, August 23, 1922, 1; reprinted in *Écrits critiques*, 142–43.

14. Germaine Everling, who lived with Picabia for fourteen years, at the height of the Dada movement, sees here an allusion to Tristan Tzara, in *L'anneau de Saturne* (Paris: Arthème Fayard, 1970), 135.

15. Francis Picabia, "Jusqu'à un certain point. . . ," *Comoedia*, April 16, 1922, 1. Translated by Mark Lowenthal in Francis Picabia, *I Am a Beautiful Monster: Poetry, Prose, and Provocation* (Cambridge, MA: MIT Press, 2012), 289–90.

16. Francis Picabia, "Lumière froide," *Journal des Hivernants*, Cannes, January 20–30, 1927; handwritten manuscript reproduced in facsimile in the catalogue of the Picabia exhibition at the Cercle nautique, Cannes, January 28–February 7, 1927. It was also reprinted, under the Pétain regime, in *L'Opinion du Sud-Ouest* on December 14, 1940. Translated in *I Am a Beautiful Monster*, 324–25.

17. Francis Picabia, "Jeunesse," *L'Opinion*, Cannes, March 1941; reprinted in Mohler, *Francis Picabia*, 125, and in *Écrits critiques,* 238–40.

18. For example, Gérard Miller, *Les Pousse-au-jouir du Maréchal Pétain* (Paris: Seuil, 1975), with a preface by Roland Barthes.

# Appendix

# Review of Hubert Damisch's
## *L'origine de la perspective*

The sheer number of art-historical studies devoted to perspective, and the abundance of references to perspective in theoretical discussions concerning the image, may lead one to believe that this topic is more than adequately covered. With *L'origine de la perspective* (*The Origin of Perspective*), Hubert Damisch, a professor at the Écoles des Hautes Études en Sciences Sociales and perhaps the major exponent of the new art history in France, gives a persuasive argument that there is more work to be done. In this fully illustrated volume, soon to be published in English by MIT, he shows how both a certain type of art history and the clichés of the vulgate succeeded in erasing the epistemological questions raised, during the Italian Renaissance and after, by the invention of monocular perspective.

With regard to perspective, Damisch's enemies are two: the positivist tradition, which totally ignores Erwin Panofsky's 1927 work *Die Perspektive als symbolische Form* (*Perspective as Symbolic Form*), and the "avantgardist" cinema and literary criticism of the 1960s and 1970s, which treated perspective very superficially. Damisch does not reply directly to the latter. He only lightly rebukes, here and there, various writers for confusing dreams and reality: No, Brunelleschi's first experiments had nothing to do with a perspectival box; No, it is not possible to integrate the system of perspective with that of the camera obscura and then to make of it, via the Marxist metaphor of ideology as an upside-down image of the world, the paragon of bourgeois ideology in painting. Damisch's rigorous method is his answer: Let the loudmouths become informed before spouting nonsense.

Since rigor is at stake—logical, philological, and geometrical rigor—it is to the two strains of the positivist tradition that Damisch devotes most of his attacks. Historians of the first strain, which goes back to Vasari, see no more in the invention of perspective than a progressive elaboration of the empirical devices used by artists in studios. For this group, which dominates thinking in France and Italy, perspective is merely technique; it has no more theoretical implications than the art of marquetry (from which, claimed André Chastel, it derived). Historians of the second strain (which, as a whole, is more Anglo-Saxon) swing in the other direction: They treat *perspectiva artificialis*, the perspective of the painters, as a pure application of *perspectiva naturalis*, or the science of optics, which had been making steady progress in medieval Europe under the influence of Arab culture. Panofsky first led the discussion in this direction when he presupposed that a perspectival image was the representation of a retinal image and hence that the geometrical conditions of the former were to correspond to the optical conditions of the latter. Damisch

brilliantly refutes this absurd exigency and, as a result, the tedious current debate on the so-called native condition of perspective can be dismissed as irrelevant.

Damisch, however, is not attempting a rejection of Panofsky. On the contrary, he considers Panofsky's work as a theoretical starting point. After demonstrating the extraordinary depth and subtlety of Panofsky's text, Damisch examines what has to be called his fundamental theoretical error, a consequence of his misunderstanding the philosopher Ernst Cassirer's notion of "symbolic form." For Cassirer, who was at the time Panofsky's colleague in Hamburg, a symbolic form was any constitutive human activity—such as language, religion, myth, or art—organizing the chaos of the world; but Panofsky interpreted the notion as meaning "cultural symptom." Panofsky, in other words, transformed a transcendental concept into a commonplace of the history of ideas, an index of the *Weltanschauung*.

This transformation is critical because Panofsky would be imitated on this point by most of his successors. This slippage led to a kind of cultural history that can account neither for the three-century gap between the invention of perspective during the Quattrocento and the mathematical theorization of its implicit notions of infinity and the continuum nor for the fact that perspective as such, by way of the growing importance of photographic images, is far from having lost its synthetic function in our daily life. In fact, the Cassirerian notion of the symbolic allows Damisch, by means of a phenomenological detour, to mark the rift separating visual space (perceived) and geometrical space (conceived). In doing so, he manages to skillfully avoid such red herrings as "verisimilitude."

The author next moves on to the historical "invention" of perspective—that is, Brunelleschi's two famous experiments. Closely discussing Filarete's, Manetti's, and Vasari's accounts of these experiments, and showing the ways they contradict each other, Damisch points to many features that had been left aside or badly discussed by other scholars (for example, the role of the mirror in these experiments, to which he gives a fundamental status, connecting it to the psychoanalytic notion of projection). With Brunelleschi (this is Damisch's main thesis), we have what Edmund Husserl called "the inversion of practice in theory." Although Vasari had deliberately repressed the theoretical nature of Brunelleschi's experiments, which, as Manetti would say, were made to "demonstrate painting," Damisch shows how they inaugurate in all their details, and especially in the way one experiment responded to the other, a new episte-mological paradigm. After such a rupture, painting could never remain the same—nor, for that matter, could architecture, philosophy, and geometry—even if very few paintings strictly obey the specular coincidence between vanishing point and point of view.

In the first really successful application of the "structuralist" method in art history, with the exception of Michel Foucault's analysis of *Las Meninas* at the beginning of *The Order of Things*, Damisch treats the three paintings of the so-called Ideal Cities—sometimes thought to be in the school of Piero della Francesca—as a transformational group. He shows that while every analysis of these paintings has been reduced to iconographical discussions—their relationship to theater, to architecture, or to marquetry—one does not necessarily have to find what those panels represent to be able to speak about their hallucinating presence. It is the quest for an original "referent" that has led all other historians (with the exception of Richard Krautheimer) to ignore the fact that the pictures comprise a dialogue among themselves. And perhaps it is to insist on the dialogic status of those three eerie panels that, breaking with the usual impartiality of tone characteristic of art-historical prose, Damisch wrote this section in the form of an indirect dialogue.

After a long examination and discussion of the previous work done on the panels, Damisch sets out a structure of oppositions in a pure Lévi-Straussian manner, but with a brilliance as yet unequaled in the field. This structure involves all the elements represented in the paintings (thoroughness is a prerequisite of structural analysis), and particularly those or the pre-iconographical order: the constitution of the ground level(s); the tracing of the checkerboard on the floor; the placing of the vanishing point and role of the various *vedute*; the source of light; the various types of symmetry. All of these are related to the role of the mirror in Brunelleschi's inaugural experiments, the angle of vision, etc. Having traced this structure of oppositions, Damisch is then able to sort out the "aberrations," i.e., the "exceptions" to the rules, and to define their negative structure: Put together, all these exceptions refer to the theories of Piero della Francesca and Serlio as they relate to the distance of the beholder and lateral deformations. This leads directly to the problem at the core of the last chapter, which is discussed in terms of Carpaccio's works and *Las Meninas*: the placement of the spectator and the growing discrepancy between the geometrical point of view (vanishing point) and the imaginary one, this discrepancy constituting the classical system of representation, as Foucault had well foreseen.

From Brunelleschi, who staged the perfect coincidence between the two points, to Velázquez, who emphasized the gap which separated them, via the three late Quattrocento panels of "Ideal Cities," whose interest resides in the "abstract" way they present the problem here outlined, the whole history of the perspective paradigm is traced, with a full discussion of the theoretical implications or these three constitutive moments. The book is certainly not a general survey of the history of perspective, but by examining in three case studies the variations the system had to go through, often with minute precision, it does

constitute perspective as a historical object in a manner better than anything since Panofsky's 1927 publication. And that is no small achievement.

*Note: This text was published in the December 1990 issue of* The Journal of Art *during the brief moment when its American edition was produced by Rizzoli and Barbara Rose was its editor-in-chief. She had roped me in as a "contributing editor," and I enjoyed having a monthly column. Rizzoli abruptly terminated the venture. Barbara was fired, and I never got paid for my last two columns.*

## Review of Hubert Damisch's
## *Moves: Playing Chess and Cards*
## *with the Museum*

I am not a great fan of the fad for guest-curated exhibitions culled from a museum's collections. How vain is the notion of the curator-as-artist that they convey! There are exceptions, of course: the *Artist's Choice* series at MoMA, for example, was unexpectedly lacking in pretense while providing valuable information about the way artists thought.

But what if it is the very form of the exhibition, the exhibition as form, that is at stake rather than the subjectivity of the curator? The first guest-curated show to have been conceived in such reflective, typically modernist terms was *Raid the Icebox I with Andy Warhol* at the Museum of Art of the Rhode Island School of Design in 1969 (it also traveled to Houston and New Orleans). Warhol not only pulled things out of storage but also foregrounded the storage itself—its absurd accumulations, its dormancy in oblivion. He zoomed in on series, masses, pinnacles of randomness: a whole cabinet full of two hundred pairs of shoes, all as thoroughly documented in the catalogue as the Seurat drawing or the Cézanne painting shown alongside its neighbors on the storage racks; a chest of Navajo blankets; a row of unremarkable Windsor chairs, etc. As David Bourdon wrote in the catalogue, Warhol picked a group of "sixteenth to eighteenth century paintings" just as they were stacked in the cellar—some with "only their backs showing [ . . . ] including the miscellaneous sandbags that were strewn around on the floor." The matter, as always with him, was choosing the non-choice.

And what if it is a matter of showing not a *particular* choice but choice per se? The pair choice/non-choice is dialectical, in fact, and the one is perceptible only against the background of the other. So just as Warhol was able to display

randomness as entropic resistance to the structure of exclusion that lies at the foundation of any museum installation, any attempt at exhibiting choice as such will have to be pitted against indeterminacy: One must define a boundary between an ordered inside (where not every choice is possible) and an infinite, indiscriminate outside (where no choice is really possible because all are equally insignificant). This is exactly what art historian Hubert Damisch did in *Moves: Playing Chess and Cards with the Museum*, the show he recently curated at the Museum Boijmans Van Beuningen in Rotterdam.

How to materialize, to make tangible, the finite space of decision? Damisch takes chess as a model, "for at any time during a chess game," as he writes in the catalogue, "the distribution of pieces on the board can be considered either the product of a given history (the succession of moves from which it results) or a 'position'—in other words, a system—which contains all the necessary and sufficient information for the player whose turn comes next to be able to decide a move in an informed manner." The basic idea behind this "experiment," as Damisch calls it, is that any museum visitor plays a kind of chess game with the collection (a certain number of moves, among which he or she must choose, are at his or her disposal in a space that is organized in a manner at once linear and simultaneous), as does any curator (having a limited choice, once again, since "works of art . . . are like chessmen, each possessing its own, preinscribed movement"). But if this condition is usually ignored by both kinds of players, Damisch proposes to underscore it.

So the floor of the central portion of his exhibition was conceived as a vast black-and-white chessboard with some squares empty and others containing a single art object (paintings were mounted on freestanding traveling crates). The pawns, more uniform than the other "pieces," were drawn from the Boijmans's spectacular collection of applied art (for one "side" or "team," silver objects; for the other, mainly glass or china). The most striking effect was the geometrization of traffic: As one was moving through the field to examine the content of the various occupied squares, one was necessarily performing a chess move (straight, oblique, crooked). Each move was freely chosen (there was no linear path to follow, no sequential numbers given to the artworks), but none was free: Choice is not free will.

One need not be a chess adept to make sense of the game. On a sheer iconographic level, Damisch provided easy access: Bruegel's *Tower of Babel* was an obvious rook; one of Kandinsky's *Blue Rider* canvases, a knight; the queen (*Torso*, 1936–71, a sculpture by Man Ray) and the king (Rodin's key-bearer in the *Burghers of Calais* group, 1885–86) were prominently displayed. Man Ray's *Obstruction*, 1920—the first suspended sculpture in twentieth-century art, a kind of readymade mobile consisting of a cascade of coat hangers—functioned as a reminder that one of the two diagrams usually given to chess in game theory is

that of a treelike structure (the other being that of a grid, which is undoubtedly why *Obstruction* was next to a Sol LeWitt lattice). But the strategic model was also used to experiment with the possible clash of independent themes: on one "side" works reflecting on vision (a perspectival church interior by Pieter Jansz Saenredam, a blurred *Chair*, 1965, by Gerhard Richter); on the other, works dealing with the notion of narcissistic reflection (Rubens's *Narcissus* or Magritte's *Reproduction interdite*, 1937). And, to mimic the huge memory bank of past moves that is activated by a chess master during the course of a game, the walls enclosing the vast hall were adorned with several clusters of works that functioned as footnotes to those featured on the "board" (drawings and prints but also paintings, e.g., Dubuffet's *Stairs in Commemoration of Jacques Ulmann*, 1967, which Damisch related to the Bruegel; a Lichtenstein *Mirror*, 1970, with its obvious reference to narcissism; or an interior by Emanuel de Witte, *Interior with a Lady Playing at the Virginal*, with its typical checkered marble floor).

These footnotes conveyed the idea of possible substitutions (once again, not entirely freely made): How would the economy of the "board" be affected if a Fragonard drawing replaced Man Ray's tree or if the Dubuffet rather than the Bruegel were the rook? The structural operation of permutation was the central topic of the second section of the show, consisting entirely of drawings and prints. The chess metaphor was abandoned for that of the card game, which more immediately elicits the idea of a reshuffling, and Damisch took pains to theatricalize the notion of permutation (thus, to have us acknowledge both the arbitrariness and limitation of choice). If one hangs a classical study of a horse next to a drawing of two camels, or a sequence of Jan van Huchtenburg's seventeenth-century prints of horses indecently sprawling or lying on their back, one produces a debasement. If one displays a Richard Serra paint-stick drawing next to a Hiroshi Sugimoto photograph of a luminously blank movie screen, one induces reflections about light and dark contrasts (or is it about the void?). A grotesque figure by Goya is enough to underline the generally unnoticed foreshortening distortions in Tiepolo's sketches. Depending on what's in storage, one can envision meaningful substitutes for each combination (once again the curator's choice, though statistically wide, was not infinite). The guiding principle for this particular selection was neither aesthetic excellence nor subjective taste but the quest for the maximal power of transformation that one image can exercise over a neighboring one.

The final two sections of the show were, so to speak, "site specific." The first, through a series of photographs and architectural drawings, reflected on the history of the Boijmans, including plans for renovation (the most striking image, taken during the bombing of Rotterdam in May 1940, showed the building in profile against the city in flames). The other, alluding to the iconoclastic

crisis that stirred Holland at the time of the Reformation, showed two filmic sequences on large screens facing each other: the scene in *Batman* in which the Joker and his crew deface the entire painting collection of an art museum, except for a canvas by Francis Bacon; and the race through the whole Louvre, lasting precisely nine minutes, forty-three seconds, in Jean-Luc Godard's *Bande à part*. While neither section was essential to the exhibition, the first served as a useful reminder that the game was not entirely abstract or theoretical but was situated in time and place, and the second underscored that, if such "experiments" must be iconoclastic (assuming their goal is to cast a blow against the exclusory structure of museums), they have to be conducted according to a strategic plan, without which they end up being mere grist for the mill of the culture industry and its irrepressible transformation of museums into amusement parks. Even the Joker realized, in front of the Bacon, that a random attack would not do.

First published in *Artforum* 36, no. 4 (December 1997).

# In Memoriam:
# Hubert Damisch
# (1928–2017)

In a moving interview with Alain Veinstein on the France Culture radio channel in 2012, our friend Hubert Damisch invoked with pleasure a rave review of his only book of fiction, *Le messager des îles* (The messenger of islands). The review in question, published in *Le Monde*, was entitled "L'archipel Damisch" (The Damisch archipelago). Imitating Arletty in a famous scene of the film *L'Hôtel du Nord*, Hubert exclaimed: "Archipelago, archipelago? Do I look like an archipelago? . . . Well, yes, what's in my head, it functions a bit like an archipelago." Always very precise in his use of metaphor, he did not say, "Yes, I am an archipelago," but, "What's in my head functions a bit like an archipelago." That is, like a myriad of islands that he would first explore one by one and then attempt to link by all sorts of bridges, dreaming of revealing overlooked camaraderies of language.

Hubert was what the French call a *passeur*; what he liked above all was to have the terms and processes of one discipline glide into another so as to electrify both and, in so doing, to transform them.

Linguistics, semiotics, ethnology, anthropology, sociology, mathematics, economics, philosophy, and so many other disciplines were relentlessly hurled by Hubert against history to buttress his doubts concerning the validity of the

"historical attitude" with regard to the objects of his love—painting, but also film, photography, architecture, and, one tends to forget, literature. Who could tell which fields, in the realm of the symbolic, Hubert had not surveyed at one point or another?

In the interview, Veinstein spoke of his hesitation to categorize his guest either as a philosopher or as an art historian—the two labels most often applied to him. Hubert answered, "It's a problem for booksellers. They can't stand me because they do not know where to place me," adding, with some pride, "I see this as an indication that I succeeded in my line of work, because the problem is precisely to find a way not to be localized, imprisoned in a rigid frame, cornered at a specific point."

Hubert did succeed. Volumes will have to be written on the way he did it—the time will come for that. For the moment, I would only add a few words on his teaching, which played an essential role in the ever-expanding curiosity that characterizes his multifarious scholarship. These words are extracted from a long testimony about his seminar I wrote more than ten years ago:

> I shall never forget the first session of Hubert's seminar that I attended in the fall of 1971, the first of the academic year. The medium-sized room that the École Pratique des Hautes Études was renting on the rue de Varennes was packed with about thirty people surrounding a huge table, and soon filled with smoke. Hubert spoke nonstop at top speed for two hours, with the sonic background of thirty pens furiously scratching paper. Later in the term, the rhythm became less frantic, the sessions expanding to three hours with a fifteen-minute break, and the second half often devoted to discussions or, eventually, presentations by participants. But the vivid impression of being in the midst of some intellectual fireworks, exploding with ideas, never left me during the four or five years I was in regular attendance.

With the distance of time, I would add today that the initial shock I received during this very first excursion on Hubert's raft while he was exploring his archipelago is akin, *mutatis mutandis*, to his own first encounter with Merleau-Ponty as the latter enjoined him to study Cassirer and Panofsky. "In a few minutes," Hubert noted, "he understood what I was aiming at and to what I would devote more than ten years of labor. I would not dare hope," he added, "that one day a student will tell a similar story about me."

Hubert decidedly "succeeded in his line of work," and there are many of us, I am sure, who can identify with this student he had hoped for.

First published in *October* 164 (Spring 2018): 133–34.

# An unpublished letter to the *New York Times*

Topping the usually philistine relationship of the *Times* to just about everything academic, and its habit of entrusting the composition of obituaries to overt opponents of the deceased supposed to be memorialized, the article by a Jonathan Kandell on Jacques Derrida, who died this past Friday, reaches a peak of populist anti-intellectualism—not to speak of the countless distortions it contains—that I thought only possible in a Murdoch publication.

Rather than trying to explain Derrida's philosophical enterprise and give at least some ideas about his trajectory—from phenomenology to structuralism to, yes, their "deconstruction"—Mr. Kandell sets the tone right away, already dismissing Derrida as an "Abstruse Theorist" in the title of his hatchet job. After a caricatural description of deconstruction as "the method of inquiry that asserted that all writing was full of confusion and contradiction," and a not-so-subtle underscoring that Derrida was French (and thus anti-American, I suppose: One wonders if Mr. Kandell works for the Bush administration), Mr. Kandell spouts one derogatory term after the other. Structuralism is a "slippery philosophy," Derrida's explanations are "murky," his books "off-putting to the uninitiated," and so on.

The lowest point of the article involves Derrida's long contribution to a symposium organized by Paul de Man's many admirers, following the discovery, shortly after his death, that as a young man, between the age of twenty and twenty-three, from 1940 to 1943, de Man published literary columns in several Belgium journals controlled by the German occupiers. After telling us that de Man "contributed numerous pro-Nazi, anti-Semitic articles" (a flat-out lie, as anyone who has done his or her homework knows—the homework of reading de Man's complete wartime essays, anthologized and republished by the organizers of the symposium I just mentioned), here is what Mr. Kandell has to say: "In defending his dead colleague, Mr. Derrida, a Jew, was understood by some people to be condoning Mr. De Man's anti-Semitism." "Was understood by some people" sounds like a "news" broadcast on Fox TV. But Mr. Kandell does not stop there, he even quotes one of his fellow journalists arguing that "borrowing Derrida's logic, one could deconstruct *Mein Kampf* to reveal that (Adolf Hitler) was in conflict with anti-Semitism."

The obituary is full of filth, and I do not have the energy to rebut it point by point. Derrida would have: He always hoped against hope that stupidity could be countered by patient analysis, that, in the end, philosophers would win against the philistines—even if it meant that philosophers, from Socrates on, often had to die during this age-long battle.

One thing is certain: The *Times* failed in its mission of informing its readers, and instead of recapitulating Derrida's formidable accomplishments,

it confirms this opinion of a "journalism professor" quoted by Mr. Kandell according to which "many otherwise unmalicious people have in fact been guilty of wishing for deconstruction's demise—if only to relieve themselves of the burden of trying to understand it." The only thing is, Mr. Kandell is anything but unmalicious.

Written on October 10, 2004, the same day Jonathan Kandall's obituary of Jacques Derrida ran in the *New York Times*.

# Acknowledgments

Acknowledgments seem mandatory in every academic book published in America, but until very recently this bit of writing was almost entirely ignored in France. The fact that I did not "grow up with it" might explain why engaging in the ritual always made me uncomfortable, though, of course, I am always grateful for the help I inevitably receive. My discomfort likely stems in part from a fear of forgetting (and thus inadvertently hurting) someone who had helped me in one way or another. In the present case, such risks are compounded by the fact that the essays assembled here were written over nearly a half-century. To avoid being inequitable, given that I cannot possibly remember everyone deserving my gratitude with regard to the original publication of these texts, I see no other solution here than to focus on those who assisted me in the production of the current book.

My biggest debt is to the team of no place press: Geoff Kaplan, Rachel Churner, and Jordan Kantor (as editor of the volume), without whom this idiosyncratic project would never have materialized.

I began writing in English in 1988 (my first essay in this language was a text on Barnett Newman that was generously edited by Michael Fried, whom I dutifully thanked at the time, as I have anyone who cleaned up my prose). After that date, I wrote in the language of the publication to which the text was destined (in French if it was to appear in a French journal or exhibition catalogue, and otherwise in English). Many essays gathered here were written in French but had been published in English long ago; three of them (including "J.C. or the Critic") were translated specifically for this volume by Nicholas Huckle, with whom it is always a pleasure to work. Aside from the short contextualizing notes introducing most of the essays—which greatly benefited from the input of Paul Galvez and Jordan Kantor—three texts were written specifically with this volume in mind: The text on J.C. just mentioned, benefited from critical remarks from Olivier Weil, Thierry Davila, and Daniel Heller-Roazen; "An Encounter with Robert Klein" and "Angels with Guns" were vetted by my faithful editor Eric Banks, but early drafts were commented on by Jérémie Koering (for the first), and Benjamin Buchloh, Rachel Churner, and Adam Lehner (for the second). This last text would not have been written without the full support of Alejandra Altamirano Brett, who let me quote at will from my correspondence with her late husband.

I am also extremely grateful to Thomas Hollier-Larousse, Teodoro Maler, Jack Shear, Teri Wehn-Damisch, and Irène Wittek for allowing me to include their photographs, as well as to Michèle Reiser (for the covers of Charlie Hebdo drawn by her late husband, Jean-Marc Reiser) and to Brigitte Léal and Perinne Renaud from the Musée National d'Art Moderne, Centre Pompidou (for the view of Brancusi's studio).

Finally, this book would not have been possible without the help I received from the Institute for Advanced Study here in Princeton, first in the form of a publication grant, but more importantly through the continuous assistance of Brett Savage, as well as that—particularly precious under pandemic conditions—of Marcia Tucker and the whole staff of the IAS library.

To all those mentioned, thank you very much indeed, and to anyone I've forgotten, please do accept my apologies.

Yve-Alain Bois
An Oblique Autobiography
Published by no place press

@ 2022 Yve-Alain Bois, no place press

Edited by Jordan Kantor
Designed by General Working Group
Photo credits: Teodoro Maler (16); Jack Shear (130);
Teri Wehn-Damisch (154); Centre Pompidou, MNAM-CCI,
Service des Collections (222); Thomas Hollier-Larousse
(258); Irène Wittek (303)

ISBN-13: 978-1-949484-08-3 (paper)

Yve-Alain Bois. An Oblique Autobiography.
Edited by Jordan Kantor.

Bois, Yve-Alain [author]

New York and San Francisco: no place press, 2022.
376; pages : 27 illustrations; 20.32 cm

English
First edition of 1000
Printed in USA

no place press
New York and San Francisco
noplacepress.com

 no place press

Distributed by The MIT Press,
Cambridge, Massachusetts and London, England

no place press catalogue:

*Jordan Kantor: Selected Exhibitions 2006–2016*
Conversation with Yve-Alain Bois

Bill Berkson
*A Frank O'Hara Notebook*
Contributions by Ron Padgett and Constance Lewallen

Pamela M. Lee
*The Glen Park Library: A Fairy Tale of Disruption*
Foreword by Michelle Kuo

Anne Walsh
*Hello Leonora, Soy Anne Walsh*
Contributions by Dodie Bellamy, Julia Bryan-Wilson, and Claudia LaRocco

Amy Franceschini and Michael Swaine, Futurefarmers
*For Want of a Nail*
Contributions by Peter Galison, Patrick Kiley, Lucy Lippard, Megan Prelinger and Rick Prelinger, and Anne Walsh

Yvonne Rainer
*Revisions: Essays by Apollo Musagète, Yvonne Rainer, and Others*
Contributions by Gregg Bordowitz, Douglas Crimp, Emily Coates, and Anna Staniczenko

Geoff Kaplan, ed.
*After the Bauhaus Before, the Internet: A History of Graphic Design Pedagogy*
Contributions by Danielle Aubert, Tim Barringer, Audrey G. Bennett, Andrew Blauvelt, Gui Bonsiepe, J. Dakota Brown, Annika Butler-Wall, Craig Buckley, Rachel Churner, Hugh Dubberly, Colin Fanning, Adam Feldmeth, Silvia Fernandez, Hal Foster, Shiraz Abdullahi Gallab, Yasmin Gibson, Denise Gonzales Crisp, Maria Gough, Basma Hamdy, Geoff Kaplan, Yara Khoury, nicole killian, Prem Krishnamurthy, Juliet Koss, Chris Lee, Pamela M. Lee, Deborah Littlejohn, Ian Lynam, Brett MacFadden, Katherine McCoy, Lucia Moholy, Wael Morcos, Thomas Ockerse, Sharon Helmer Poggenpohl, Polymode: Brian Johnson and Silas Munro, Joe Potts, James Sholly, Sydney Skelton Simon, Sulki and Min, Gail Swanlund, James Merle Thomas, Jordan Troeller, Fred Turner Jessica Wexler, Ignacio Valero, Lorraine Wild, and Lauren Williams